Ultimate Bathroom Design

Editor in chief: Paco Asensio

Project coordination and texts: Anja Llorella Oriol

Art director: Mireia Casanovas Soley

Layout: Nacho Gràcia

Copy editing: Susana González

English translation: Robert Nusbaum

French translation: Marion Westerhoff

Spanish translation: Almudena Sasiain

Italian translation: Beate Simeone-Beelitz

Published by teNeues Publishing Group

teNeues Publishing Company
16 West 22nd Street
New York, NY 10010, USA
Tel.: 001-212-627-9090, Fax: 001-212-627-9511

teNeues Book Division
Kaistraße 18
40221 Düsseldorf, Germany
Tel.: 0049-(0)211-99 45 97-0, Fax: 0049-(0)211-99 45 97-40

teNeues Publishing UK Ltd.
P.O. Box 402
West Byfleet
KT14 7ZF, Great Britain
Tel.: 0044-1932-403509, Fax: 0044-1932-403514

teNeues France S.A.R.L.
4, rue de Valence
75005 Paris, France
Tel.: 0033-1-55 76 62 05, Fax: 0033-1-55 76 64 19

www.teneues.com

© 2004 teNeues Verlag GmbH + Co. KG, Kempen

ISBN: 3-8238-4596-9

Editorial project: ©2004 **LOFT** Publications
Via Laietana 32, 4º Of. 92
08003 Barcelona, Spain
Tel.: +34 932 688 088
Fax: +34 932 687 073

e-mail: loft@loftpublications.com
www.loftpublications.com

Printed by: Anman Gràfiques del Vallès, Spain
www.anman.com
anman@anman.com
2004

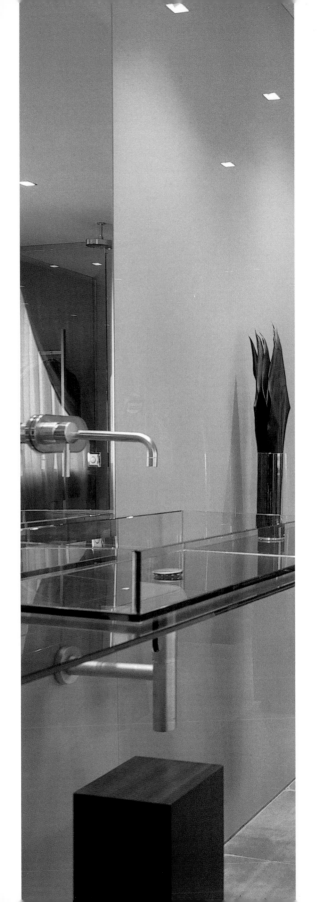

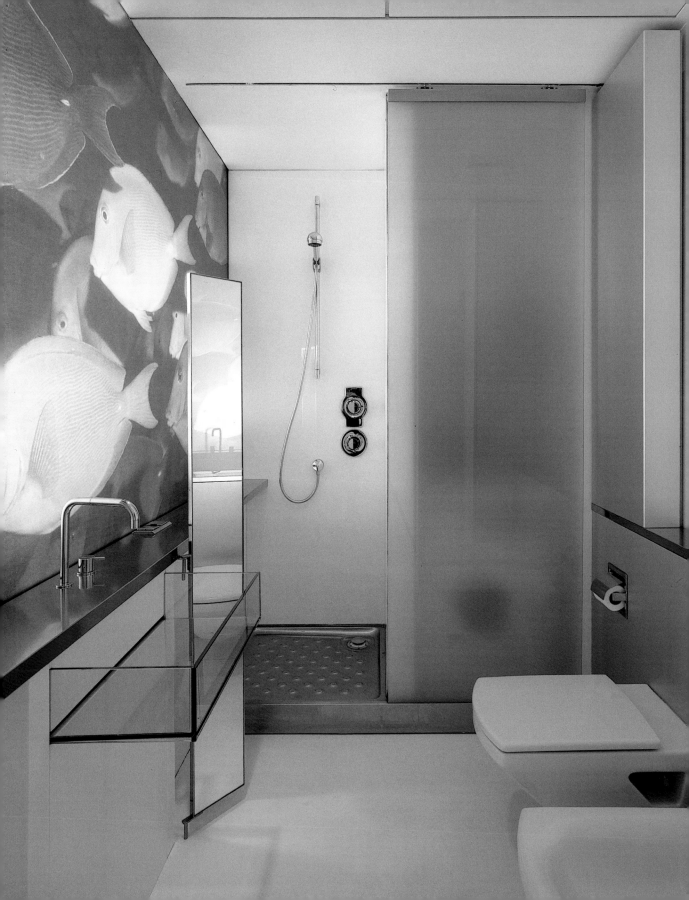

Mankind has always associated the washing of the body with a restorative cleansing of the soul. However, washing rituals and attitudes toward hygiene have changed and varied greatly over the course of human history.

During the classical period, public baths were a place for social interaction where the cult of the body was practiced, and even assemblies were held there. But there have been other historical periods in which no social class regarded hygiene as being important, bathrooms were rarities and those that existed did not have a fixed location within the home. Hygiene began taking on greater importance only in the nineteenth century, during which the bathroom was accorded a fixed location and was regarded as a separate room.

Today's bathrooms are elaborate, light and clearly delineated spaces that provide their users with highly functional and reliable facilities. This trend has provided the impetus for the development of new products, materials and surface coverings that are resistant to dampness and water and that meet users' aesthetic expectations. This also makes it possible to create small bathrooms that are rendered comfortable and convenient to use through the installation of customized furnishings and fittings such as shower head bars and wall-mounted sinks.

The influence of Scandinavian and Japanese culture has changed attitudes toward bathrooms. In these cultures, the bathroom is regarded as a natural part of everyday life in which mental and spiritual well-being are as important as hygiene. This has given rise to the widely held view that the bathroom is a place not only to wash oneself but also to relax and enjoy a sense of well being.

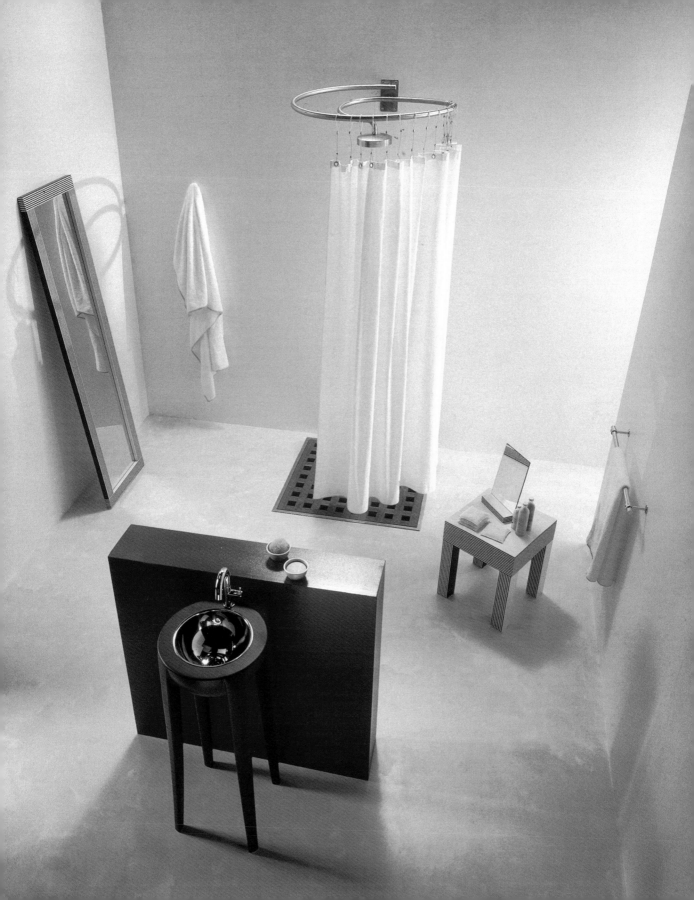

Schon immer verband man mit der Reinigung des Körpers auch eine wohltuende Reinigung des Geistes. Allerdings waren die Vorstellungen über Waschrituale und Hygiene im Laufe der Zeit sehr vielen Wandlungen unterworfen.

In der Antike war das Badezimmer ein Ort des Körperkults und des Zusammentreffens. Öffentliche Bäder wurden sogar genutzt, um Versammlungen abzuhalten. In anderen Epochen hingegen wurde der Hygiene in keiner der sozialen Schichten eine große Bedeutung beigemessen. Das Badezimmer war praktisch nicht vorhanden oder nahm zumindest keinen festen Platz in der Wohnung ein. Im 19. Jahrhundert gewann die Hygiene dann wieder an Bedeutung. Man gab dem Bad einen eigenen Platz in der Wohnung, den man unabhängig vom restlichen Haus als einen selbständigen Raum betrachtete.

Heutzutage werden Badezimmer als ausgedehnte Räume mit Licht und klar abgegrenzten Zonen entworfen, um dem Benutzer einen funktionellen Gebrauch zu garantieren. Diese Entwicklung führt zu neuen Modellen, Materialien und Verkleidungen, die widerstandsfähiger gegen Feuchtigkeit und Wasser sind sowie den ästhetischen Ansprüchen seiner Benutzer gerecht werden. Dadurch kann auch der Platzmangel bei kleinen Badezimmern durch den Einbau von angepassten Möbelkombinationen, wie zum Beispiel Duschleisten und Wandwaschbecken, gelöst werden.

Die Einflüsse anderer Kulturen, wie zum Beispiel die der skandinavischen und japanischen Badkultur, haben zu einer veränderten Haltung gegenüber dem Bad geführt. Dort wird das Badezimmer als ein natürlicher Raum angesehen, in dem das seelische Wohlbefinden genauso wichtig ist wie die Pflege des Körpers. Somit entsteht eine Kultur des Bades, in der das Badezimmer nicht nur ein Ort ist, um sich zu reinigen, sondern auch, um sich zu entspannen und wohlzufühlen.

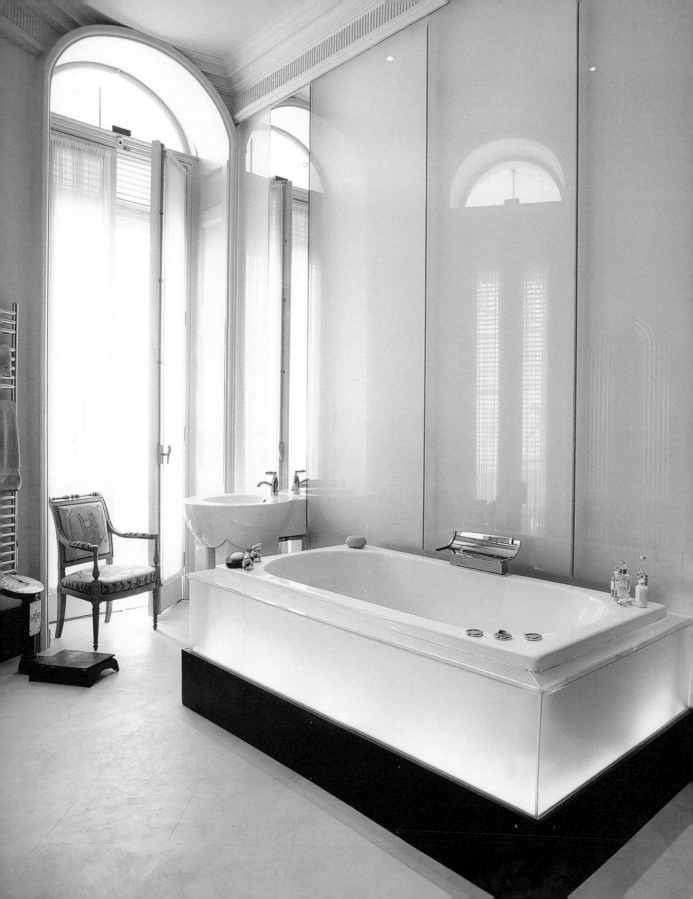

Depuis toujours, hygiène corporelle et bien-être spirituel vont de pair. Au fil du temps, les idées concernant l'hygiène ont évolué différemment.

Dans l'Antiquité, la salle de bains était un lieu dédié au culte du corps et aux rencontres. Les bains publics ont même souvent servi de lieu de réunion. En revanche, à d'autres époques, toutes les classes sociales se souciait vraiment peu de l'hygiène. La salle de bains n'existait pratiquement pas et n'avait pas de place attitrée dans l'habitation. Il faut attendre le 19e siècle pour que l'hygiène reprenne ses droits. La salle de bains reprit sa place dans l'espace de vie, devenant une pièce à part entière, indépendante des autres.

De nos jours, les salles de bains sont conçues comme des pièces à vivre spacieuses, lumineuses, aux lignes claires et assurément fonctionnelles. Cette évolution entraîne la création de nouveaux modèles, matériaux et revêtements plus résistants contre l'humidité et l'eau et qui correspondent au souci d'esthétique des utilisateurs. Désormais, le manque de place dans les petites salles de bains est facilement résolu en installant des éléments de mobilier adéquat comme les colonnes de douches et les lavabos suspendus.

L'influence d'autres cultures, à l'instar de la Scandinavie et du Japon, a modifié la conception de la salle de bains. Dans ces pays, la salle de bains est un espace naturel où le bien-être de l'esprit est tout aussi important que le soin du corps. C'est ainsi que naît une « culture » de la salle de bains où cet espace n'est pas uniquement réservée à la toilette. C'est aussi un lieu de détente et de bien-être.

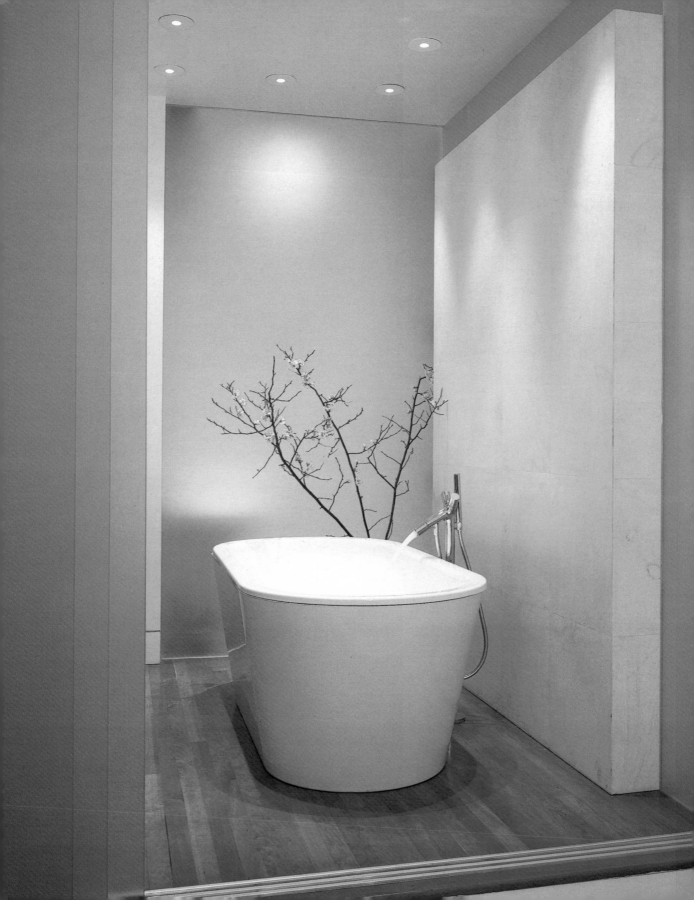

Desde siempre se ha asociado la limpieza del cuerpo con una reconfortante higiene mental. Sin embargo, a lo largo de la historia las concepciones de los rituales de purificación han sido muy diferentes.

En la antigüedad, los baños eran una lugar de culto al cuerpo y de encuentro social. Las termas públicas solían servir incluso para celebrar reuniones. En épocas posteriores, por el contrario, ninguna clase social otorgaba importancia a la higiene y el cuarto de baño prácticamente no existía, o por lo menos no ocupaba un lugar fijo en la vivienda. En el siglo XIX, la higiene volvió a tener relevancia. Se acondicionó una estancia específica de la casa para el baño que ya gozaba de un carácter privado y separado de las demás habitaciones.

Hoy en día, los cuartos de baño son espacios amplios con luz y zonas claramente delimitadas para garantizar al usuario un uso funcional. Este desarrollo ha llevado al empleo de nuevos modelos, materiales y revestimientos que son resistentes a la humedad y al agua, y que al mismo tiempo responden a los requerimientos estéticos de sus dueños. Por otro lado, la falta de espacio en el baño puede mitigarse con la elección de muebles y accesorios adaptados como duchas de pared y lavabos empotrados.

La influencia de otras culturas, como la escandinava o la japonesa, ha contribuido asimismo al cambio de actitud con respecto al cuarto de baño. En ellas, esta pieza se ve con toda naturalidad como una estancia en la que el bienestar anímico es tan importante como el cuidado del cuerpo. Así florece la cultura del baño, que ahora no es simplemente un lugar para lavarse, sino también un espacio en el que relajarse y sentirse bien.

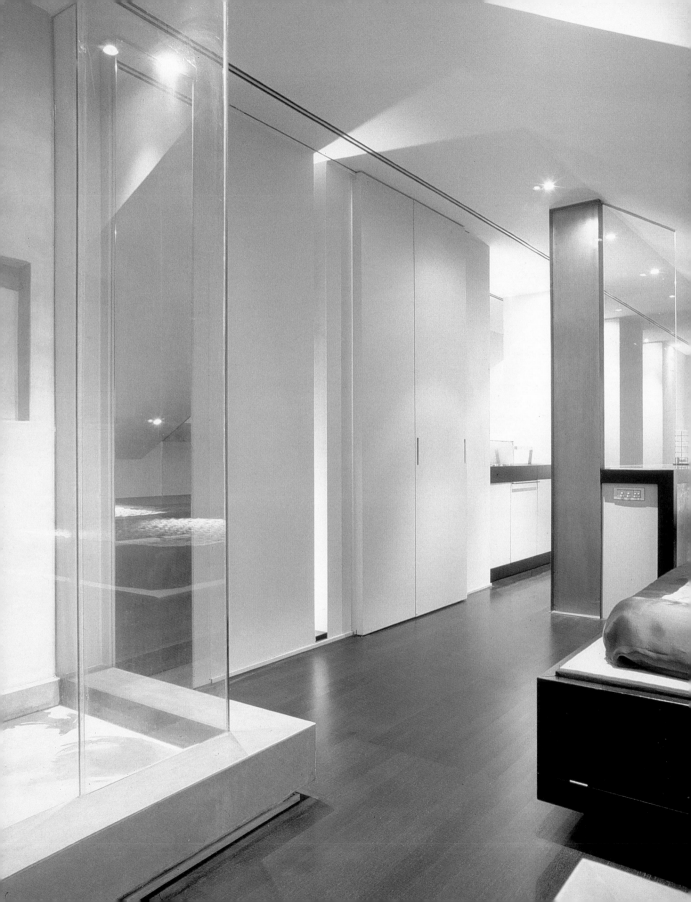

Sin da tempi remoti, la pulizia del corpo viene collegata ad una benefica pulizia dello spirito. Tuttavia i concetti riguardanti i rituali di lavaggio e l'igiene nel corso del tempo sono stati soggetti a trasformazioni molto varie.

Nell'antichità, il bagno è stato un luogo per il culto del corpo e per incontri sociali. I bagni pubblici sono stati perfino utilizzati per tenere delle riunioni. In altre epoche, invece, nessuno dei ceti sociali ha attribuito grande importanza all'igiene, con l'effetto che il bagno praticamente non esisteva o perlomeno non occupava un posto fisso nelle abitazioni. Nel 19° secolo l'igiene guadagnava di nuovo importanza. Al bagno fu assegnato un suo proprio posto all'interno delle abitazioni che, indipendentemente dalla casa restante, veniva considerato un locale autonomo.

Oggigiorno i bagni vengono progettati come ambienti spaziosi pieni di luce e dotati di zone ben definite, per garantire agli utenti un uso funzionale. Questo sviluppo comporta l'introduzione di nuovi modelli, materiali e rivestimenti che resistono sempre meglio all'umidità ed all'acqua e che, allo stesso tempo, soddisfanno le esigenze estetiche dei suoi utenti. In questa maniera si riesce a risolvere il problema dello spazio nei piccoli bagni, incassando combinazioni di mobili fatti a misura o con docce a fila, o lavandini incassati nel muro.

Anche le influenze di culture diverse, come ad esempio la cultura del bagno scandinava o giapponese, hanno cambiato il nostro atteggiamento verso il bagno. In queste culture, il bagno viene considerato come un ambiente naturale in cui al benessere spirituale spetta la stessa importanza della cura dedicata al corpo. Cosi nasce una cultura del bagno nella quale il bagno non è soltanto un luogo per pulirsi bensì per rilassarsi e per sentirsi a proprio agio.

Styles >>>>>>>>>>

Today's bathroom designs are not readily categorizable because nowadays designers are using an increasingly broad range of decor elements. In most cases an overarching design concept is combined with various such elements.

In recent years many interior designers have been devising minimalist bathrooms in which space and light play a key role. Most minimalist designs involve generously proportioned rooms that eschew unnecessary decoration and emphasize the use of clear lines and forms, transparent materials, minimal furnishings and innovative materials such as steel, cement and glass.

Maximalism is the exact opposite of minimalism. Whereas minimalism is based on the principle that less is more, maximalism emphasizes sumptuousness and the extensive use of color and embellishment. Maximalism takes its cue from 1970s colors such as orange and red and from luxuriant eighteenth and nineteenth century gold and purple ornamentation.

This design style reflects wanderlust and an interest in other cultures, both of which are manifested by an exoticism that borrows themes from tropical, Arabic and African cultures and that is expressed through the widespread use of hand-crafted wood, stone, fabric, bamboo and clay objects.

In contrast, classic bathrooms are mainly decorated with marble and ceramic. The vast majority tend to be elongated in form and are often divided into a sink, a tub/shower and toilet area. Such bathrooms are often equipped with bathtubs rather than showers.

However, in designing a bathroom, choice of aesthetic style should not be the foremost consideration. Instead, the designer should strive to combine various elements in such a way as to create an individualized bathroom that is a pleasant place to spend time in.

> Today's bathroom designs are not readily categorizable because nowadays designers are using an increasingly broad range of decor elements.

Heutzutage ist es nicht immer einfach Badezimmer klar definierten Stilen zuzuordnen, denn immer mehr Designer benutzen eine Mischung von verschiedenen Stilelementen. Meist gibt es aber einen dominierenden Stil, der dann mit diversen Dekorationselementen komplettiert wird.

In den letzten Jahren wurde vor allem der minimalistische Stil von vielen Designern bevorzugt. Bei diesem Stil spielen Raum und Licht eine zentrale Rolle. Meist handelt es sich um großzügige Räume, bei denen auf jede unnötige Dekoration verzichtet wird. Klare Linien und Formen und ein Minimum an Möblierung, sowie die Verwendung von transparenten Materialien kennzeichnen diesen Stil. Charakteristisch sind auch innovative Materialien wie zum Beispiel Stahl, Zement und Glas.

Das genaue Gegenteil dazu ist der Maximalismus. Ist beim Minimalismus weniger oft mehr, geht es hierbei um Üppigkeit und eine Explosion von Farben und Dekorationen. Inspirationen für diese Stilrichtung finden sich zum einen in den 70er Jahren mit Farben wie Orange und Rot, zum anderen im 18. und 19. Jahrhundert mit ihren üppigen Gold- und Purpurdekorationen.

Das Interesse an anderen Kulturen und eine ausgeprägte Reiselust zeigt sich in einem exotischen Stil, der die Ästhetik tropischer, arabischer und afrikanischer Kulturen aufnimmt. Handgefertigte Elemente aus Holz, Stein, Stoff, Bambus und Keramik prägen hier das Erscheinungsbild.

Klassische Badezimmer verwenden dagegen meist Materialien wie Marmor oder Keramik. Die Bäder, meist mit einer eher länglichen Form, sind dabei oft in drei Zonen aufgeteilt: der Waschtisch, die Nasszone und der Sanitärbereich. In klassischen Badezimmern werden oft Badewannen den Duschen vorgezogen.

Bei der Gestaltung eines Badezimmers sollte allerdings weniger die Frage nach dem zu verfolgenden Stil im Vordergrund stehen. Vielmehr geht es darum eine Mischung verschiedener Elemente zu finden, um ein individuell gestaltetes Badezimmer zu schaffen, das den Aufenthalt zu einem wahren Vergnügen werden lässt.

Design by Sarah Folch
Photo © Nuria Fuentes

Photo © Ricardo Labougle, Hugo Curletto

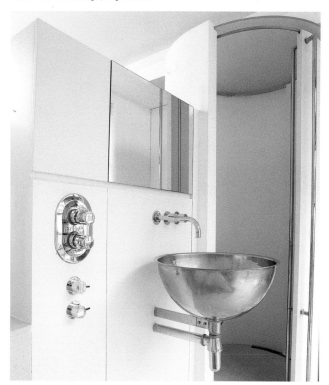

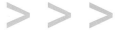

22

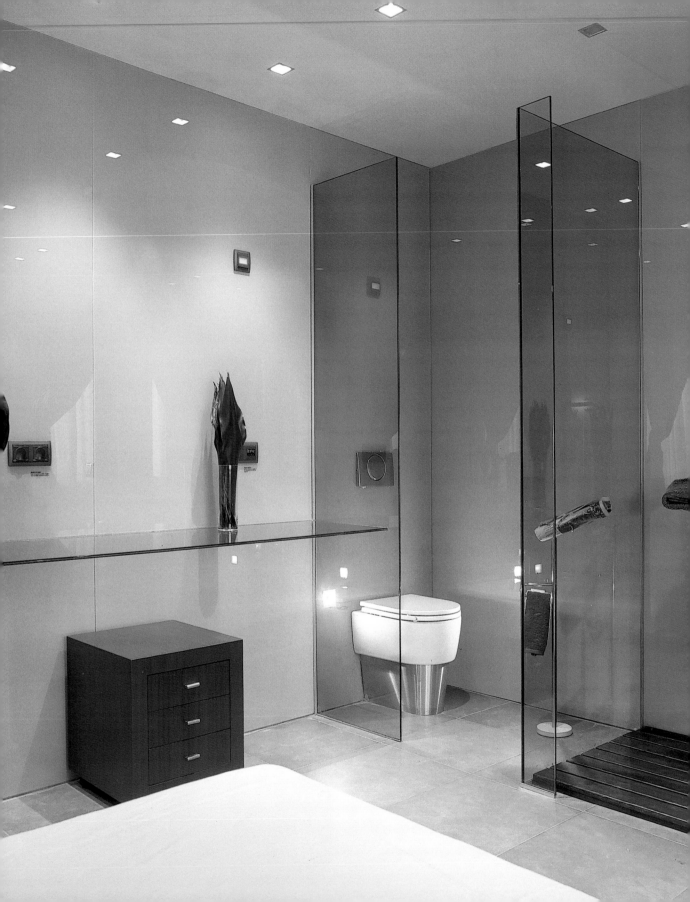

Styles

De nos jours, il n'est pas toujours évident de donner une définition claire du style des salles de bains, car de plus en plus de designers en créent de nouveaux en combinant divers éléments. La plupart du temps, on sélectionne un style dominant auquel on ajoute ensuite divers éléments décoratifs.

Au cours de ces dernières années, de nombreux designers ont montré une préférence pour le minimalisme. Ce style accorde un rôle clé à l'espace et à la lumière. Ce sont souvent de grands espaces dépourvus de tout objet de décoration superflu. Lignes et formes épurées, mobilier réduit au minimum et matériaux transparents définissent ce style. Une de ses caractéristiques est aussi l'emploi de matériaux innovants tels que l'acier, le ciment et le verre.

Le maximalisme est l'autre extrême. Si dans le minimalisme le moins l'emporte sur le plus, ici explosion et profusion de couleurs et décorations dominent l'espace. Ce style s'inspire des années 70 pour le rouge et l'orange et des 18e et 19e siècles pour la richesse de décorations or et pourpre.

L'intérêt pour les autres cultures et une intense envie de voyage se retrouvent dans le style exotique qui s'inspire de l'esthétique des civilisations tropicales, arabes et africaines. Objets d'artisanat en pierre, étoffe bambous et céramique donnent le ton.

En revanche, les salles de bains classiques utilisent la plupart du temps des matériaux comme le marbre et la céramique. Les salles de bains, en grande partie de forme allongée, sont souvent divisées en trois parties : le plan de toilette, la zone bain-douche et les sanitaires. Les salles de bains classiques préfèrent souvent la baignoire à la douche.

Toutefois, la conception d'une salle de bains ne doit pas forcément mettre le style au premier plan. Il s'agit davantage d'associer divers éléments pour créer une salle de bains individuelle, véritable source de plaisir et de bien-être.

Both pages
Design by Mario Connío
Photo © Ricardo Labougle

24

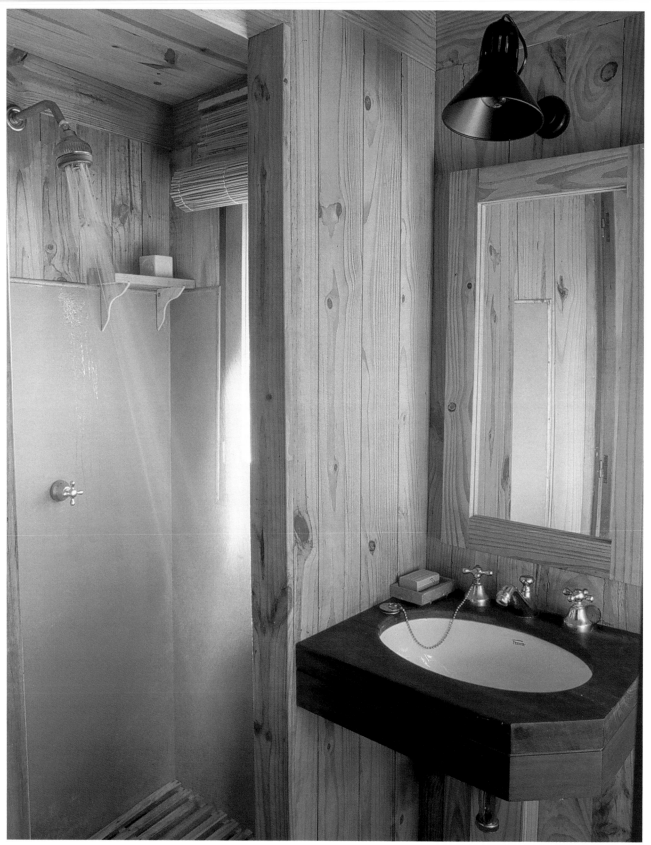

Estilos

Hoy en día no resulta fácil definir un estilo determinado para el cuarto de baño, ya que cada vez más diseñadores se decantan por mezclar elementos de tendencias diferentes. Aun así, suele primar una tendencia dominante que se completa con elementos decorativos diversos.

En los últimos años, muchos diseñadores han mostrado una clara preferencia por el estilo minimalista. En esta corriente estilística, la luz y el espacio tienen un papel primordial. La mayor parte de las veces se utiliza para decorar habitaciones de generosas dimensiones en las que se prescinde de elementos ornamentales innecesarios. Las líneas claras y un mobiliario mínimo, así como el uso de materiales transparentes, son los rasgos fundamentales de este estilo. Otra característica del minimalismo es el empleo de materiales innovadores como el acero, el cemento o el cristal.

La corriente de decoración opuesta es el maximalismo. Si el minimalismo predica el principio de menos es más, el estilo maximalista busca, por el contrario, la exuberancia en una explosión de formas y elementos ornamentales. El maximalismo suele inspirarse en los tonos naranjas y rojos propios de la estética de los años setenta y también o en la decoración de dorados y púrpuras de los siglos XVIII y XIX.

El interés por otras civilizaciones y un marcado gusto por los viajes se suelen expresar en un estilo exótico que recoge la estética de culturas tropicales, árabes o africanas. Elementos hechos a mano en madera, piedra, tela, bambú y cerámica son la nota dominante en estas tendencias decorativas.

Los cuartos de baño clásicos presentan, por otra parte, materiales como el mármol o la cerámica. De una forma casi siempre alargada, este tipo de baños está dividido por lo general en tres zonas claramente delimitadas: el tocador, la zona húmeda y el sanitario. Además, acostumbra tener bañera en lugar de ducha.

Sin embargo, a la hora de concebir un cuarto de baño, el objetivo no debería depender de un estilo determinado; es mejor buscar una combinación de elementos adecuada para crear una estancia individual cuyo uso sea todo un placer.

Both pages
Design by Lizarriturry Tuneu Arquitectures
Stylism by Silvia Rademakers and Virginia Palleres
Photo © José Luis Hausmann

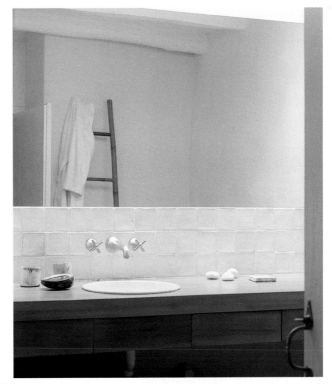

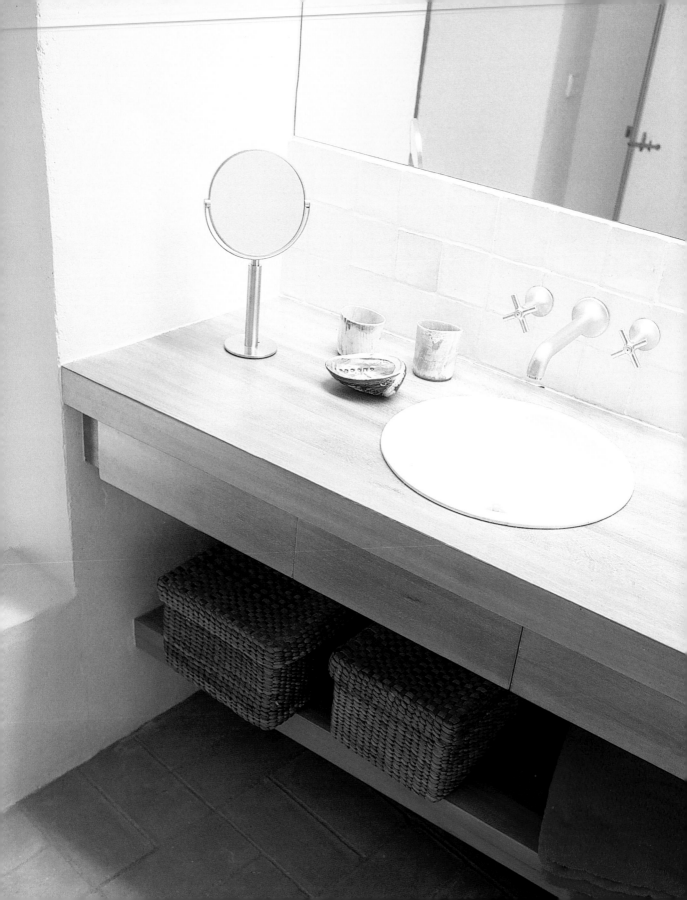

I stili

Oggigiorno non è sempre facile attribuire ai bagni uno stile ben definito, visto che sono sempre più i designer a servirsi di un insieme di diversi elementi stilistici. Tuttavia, nella maggioranza dei casi vi è uno stile dominante che viene completato con i diversi elementi decorativi.

Durante gli ultimi anni, molti designer hanno dato la preferenza ad uno stile minimalistico. Questo stile attribuisce un'importanza centrale allo spazio ed alla luce. Solitamente si tratta di locali spaziosi in cui si rinuncia a qualsiasi decorazione non essenziale. Questo stile si distingue per linee e forme chiare, per un minimo di arredamento nonché per l'utilizzo di materiali trasparenti. Altri materiali caratteristici sono anche quelli innovativi, quali acciaio, cemento e vetro.

Il preciso contrario a ciò, è il massimalismo. Se, nel caso del minimalismo, il meno diviene spesso il di più, nel caso del massimalismo si ha a che fare con l'abbondanza e con un'esplosione di colori e di decorazioni. Le ispirazioni a questa tendenza si trovano, da un lato, negli anni 70', con prevalenza per i colori arancione e rosso, dall'altro lato nel 18° e 19° secolo, con decorazioni sontuose in oro e porpora.

L'interesse in culture diverse nonché una spiccata voglia di viaggiare si rivela nello stile esotico che esalta l'estetica di culture tropicali, arabe ed africane. Sono gli elementi fatti a mano e realizzati in materiali quali legno, pietra, tessuto, bambù e ceramica a dare l'impronta generale a questo stile.

Nei bagni classici invece, viene prediletto l'utilizzo di materiali quali marmo o ceramica. Questi bagni che solitamente si distinguono per una forma allungata, sono spesso suddivisi in tre zone: il tavolino da toilette, la zona bagni e la zona sanitari. Nei bagni classici si preferiscono spesso le vasche alle docce.

Tuttavia, nella progettazione del bagno non dovrebbe stare in primo piano la questione di quale stile sarà da perseguire. Piuttosto sarà importante trovare un insieme di elementi diversi che consentano di creare un bagno individuale che permetta di rendervi il soggiorno in un vero piacere.

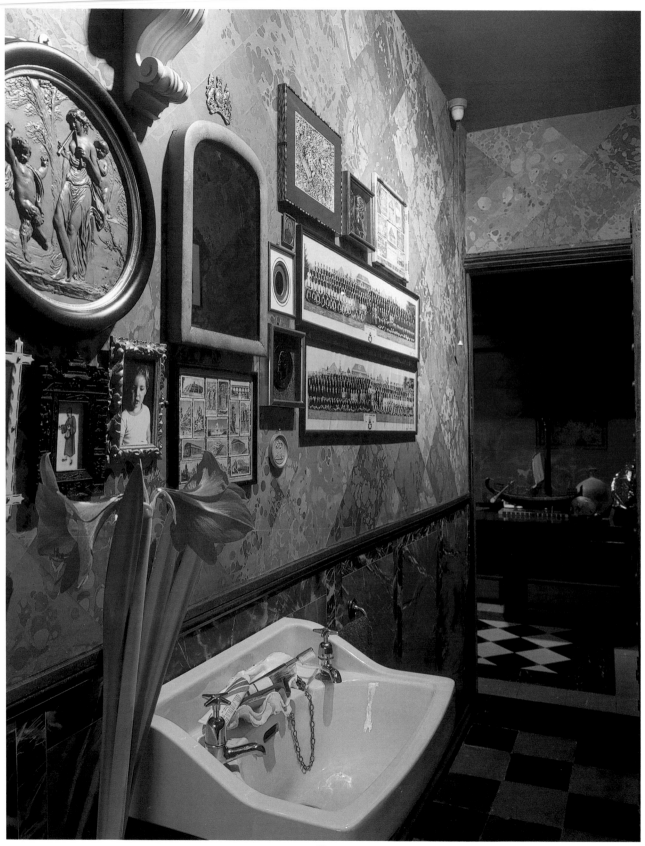

29

Minimalism

Both pages
Design by Deborah Berke
Photo © Fabien Baron

Space and light play a key role in minimalist bathrooms, which mainly feature clear lines and forms, eschew unnecessary decoration, and use transparent materials.

Beim minimalistischen Stil spielen Raum und Licht eine zentrale Rolle. Charakteristisch sind klare Linien und Formen, der Verzicht auf jede unnötige Dekoration sowie die Verwendung von transparenten Materialien.

Dans le style minimalisme, l'espace et la lumière jouent un rôle essentiel. Lignes et formes épurées, absence de toute décoration superflue et transparences des matériaux en sont les caractéristiques principales.

El espacio y la luz resultan fundamentales para el minimalismo. Son características de este estilo las líneas y las formas claras, la renuncia a cualquier decoración innecesaria y el uso de materiales transparentes.

Nel caso dello stile minimalistico, ai concetti quali spazio e luce spetta un ruolo centrale. Caratteristiche sono linee e forme chiare, la rinuncia a qualsiasi decorazione non essenziale nonché l'utilizzo di materiali trasparenti.

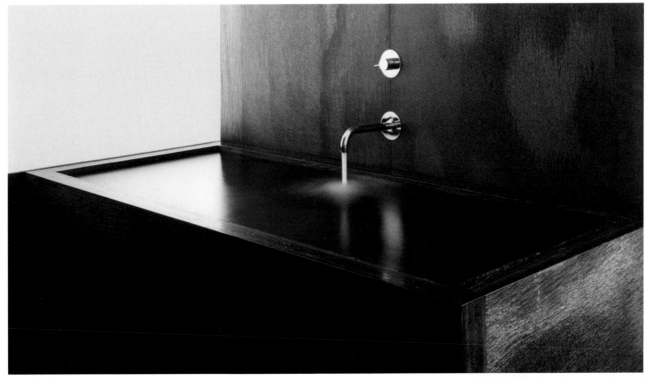

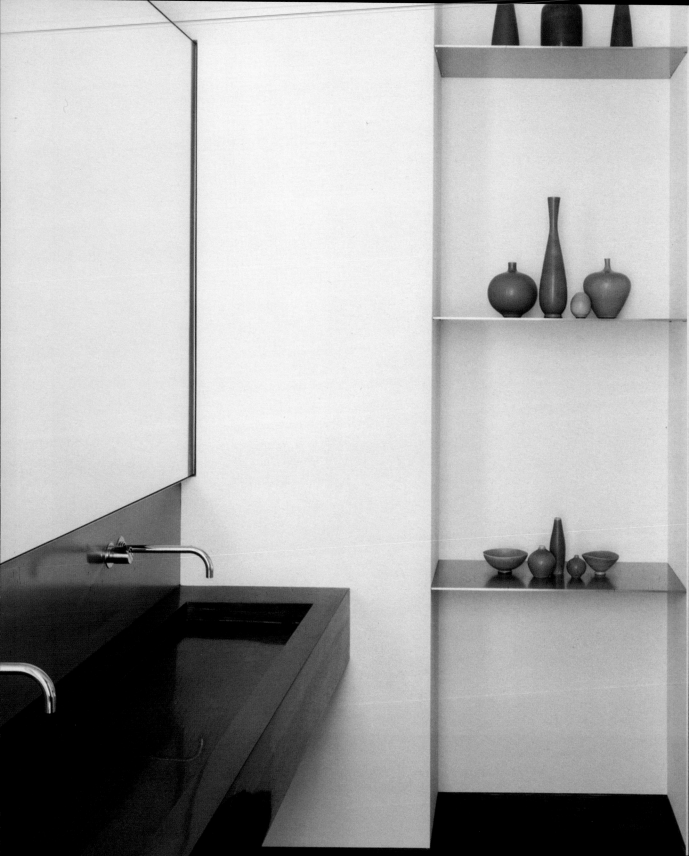

Both pages
Design by Original Vision Limited
Photo © Kudos Photographic Design

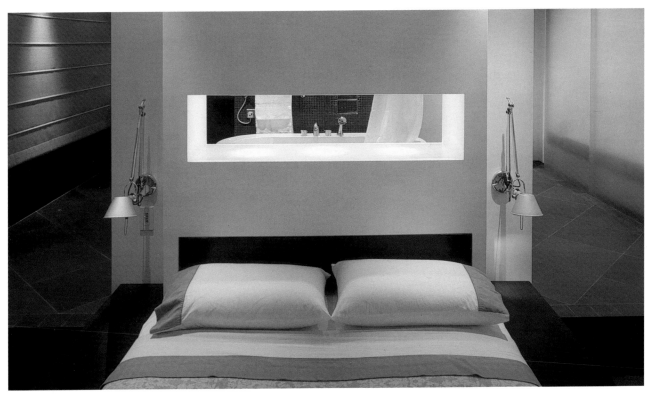

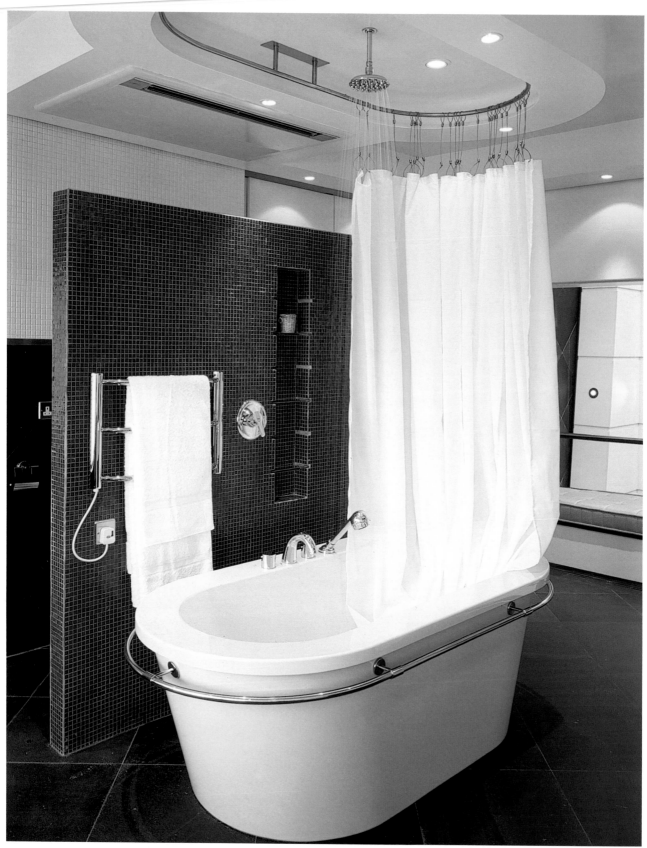

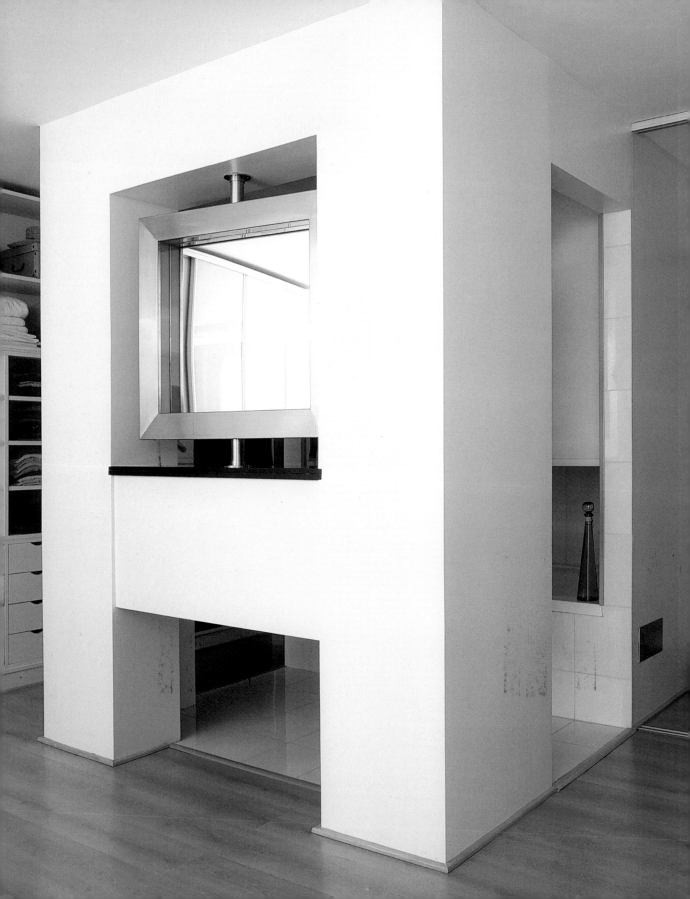

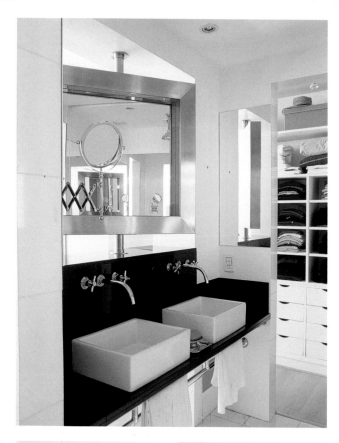

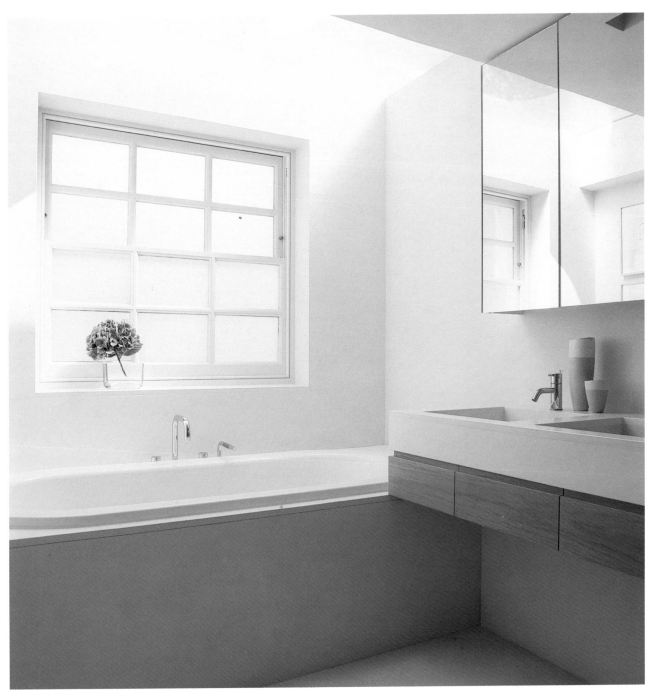

Design by Florence Lim
Photo © Henry Wilson/Red Cover

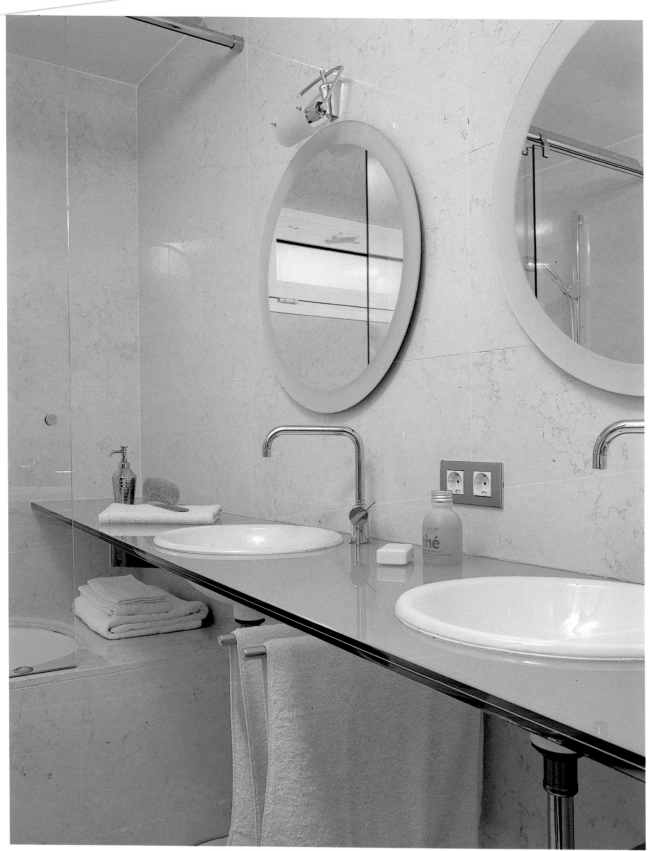

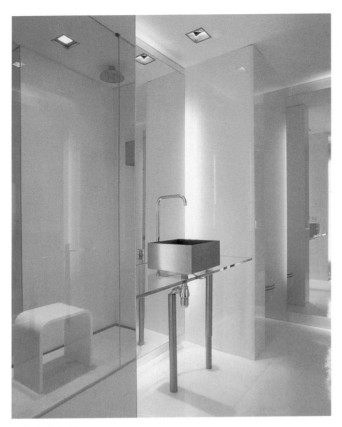

Photos © Matteo Piazza

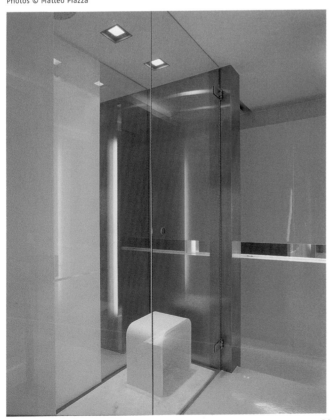

Design by Michael Reeves
Photo © Andrew Twort/Red Cover

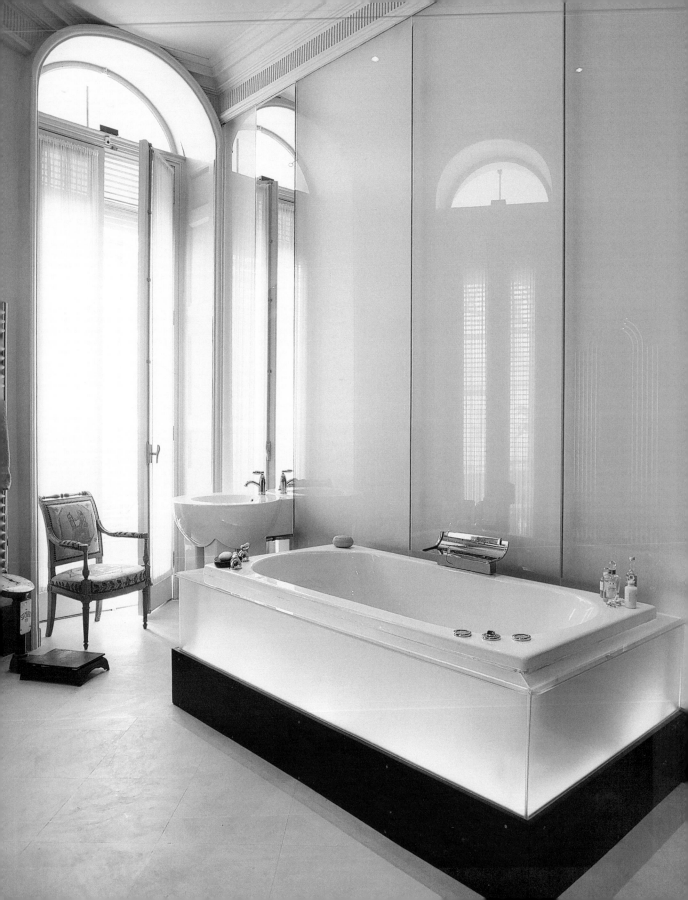

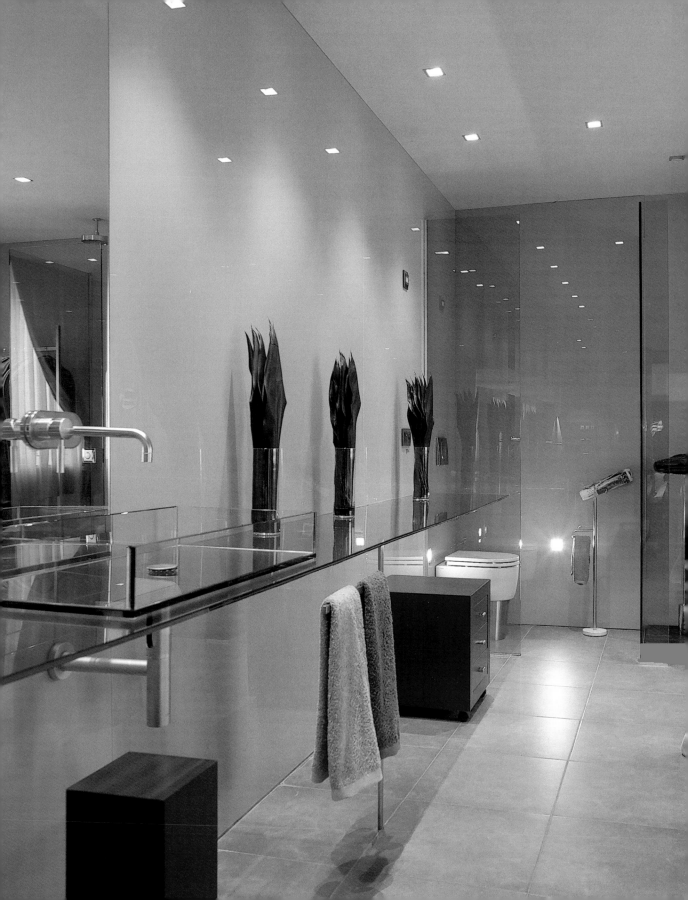

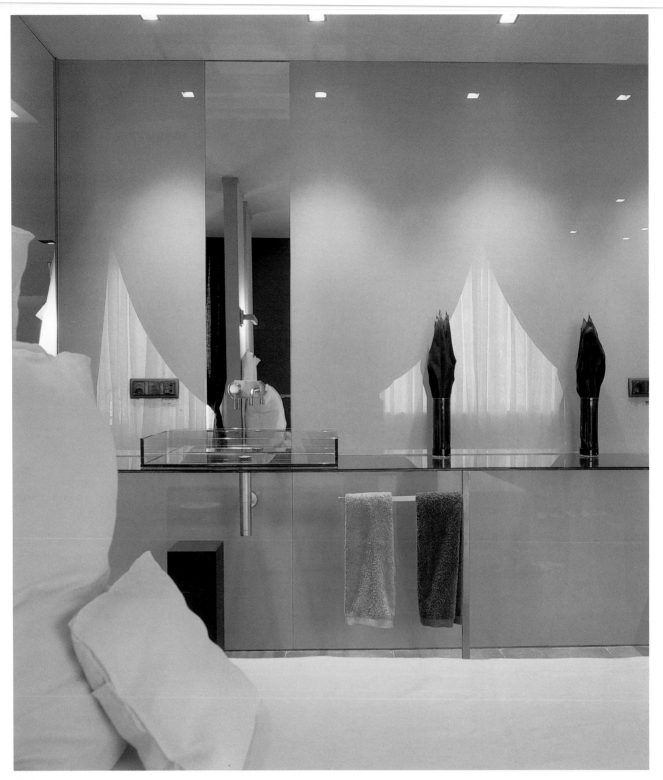

Both pages
Design by Sarah Folch
Photo © Nuria Fuentes

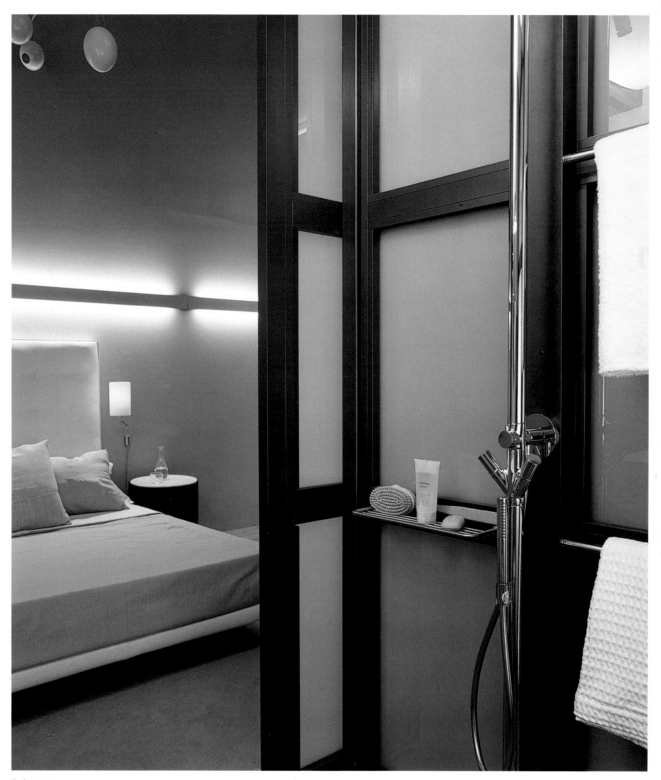

Both pages
Design by Nancy Robbins and Blau-Centre de la Llar
Photo © José Luis Hausmann

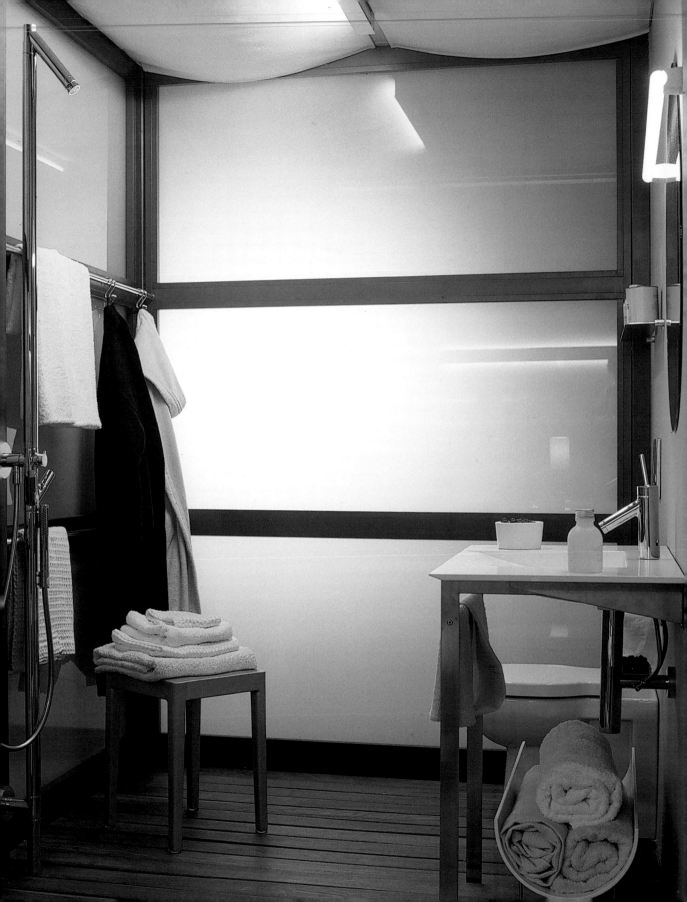

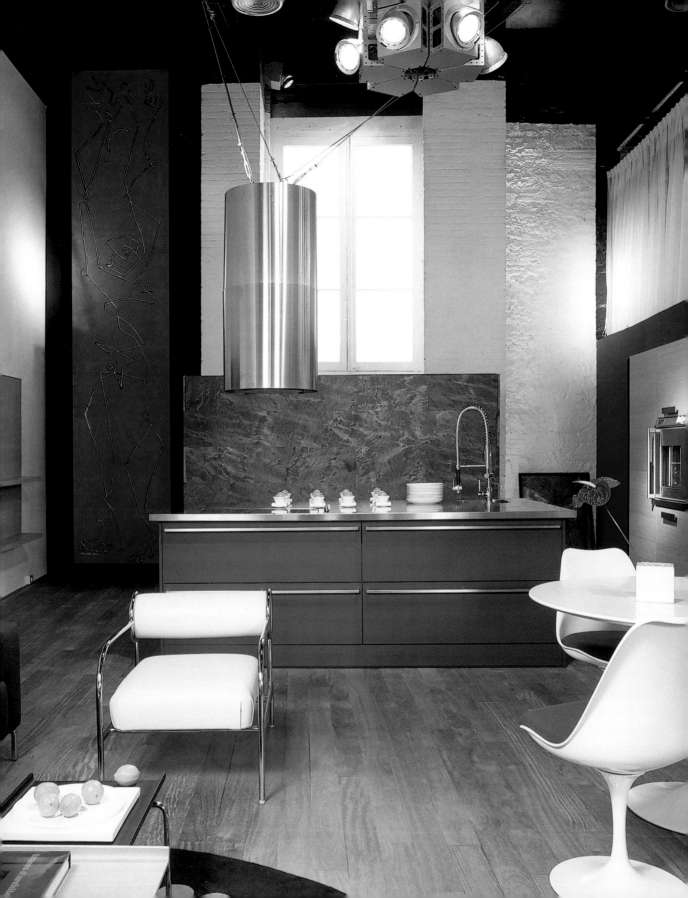

Both pages
Design by MINIM Arquitectos
Photo © José Luis Hausmann

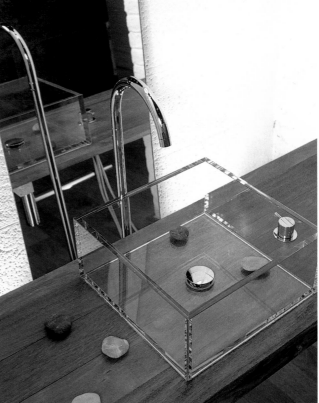

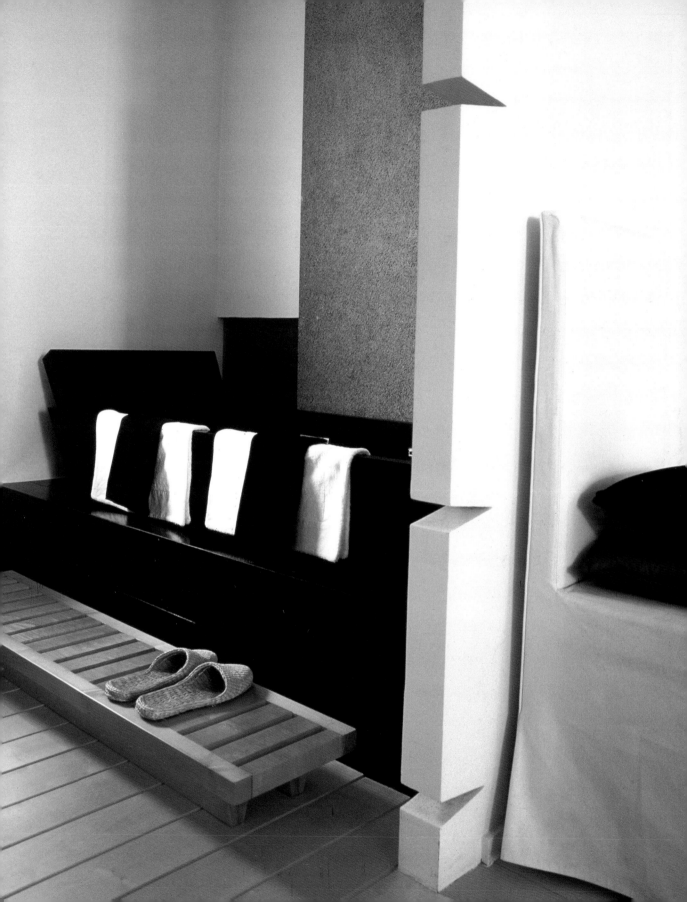

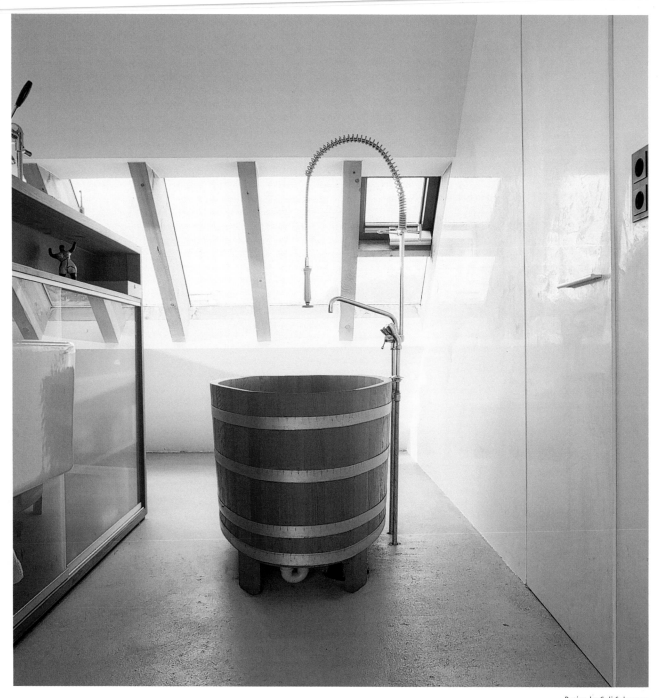

Design by Geli Salzmann
Photo © Ignacio Martínez

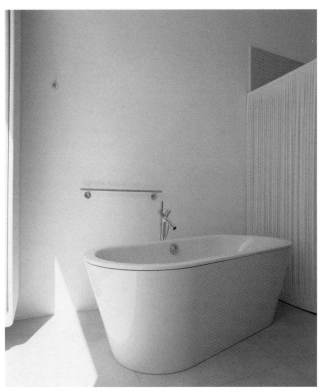

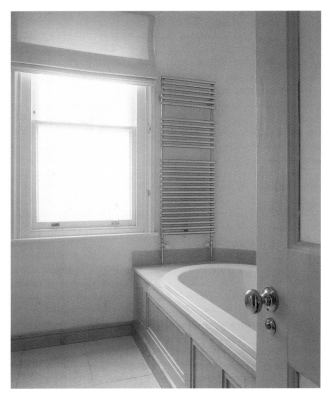

Design by Carlo Donati
Photo © Matteo Piazza

Photo © Jake Fitzjones/Red Cover

Design by Claudio Silvestrin
Photo © James Morris/Axiom

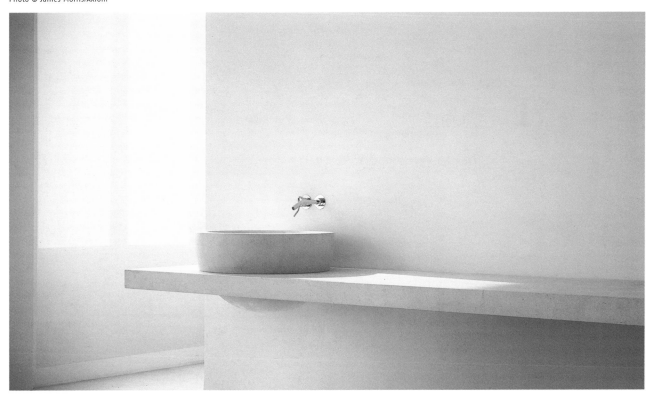

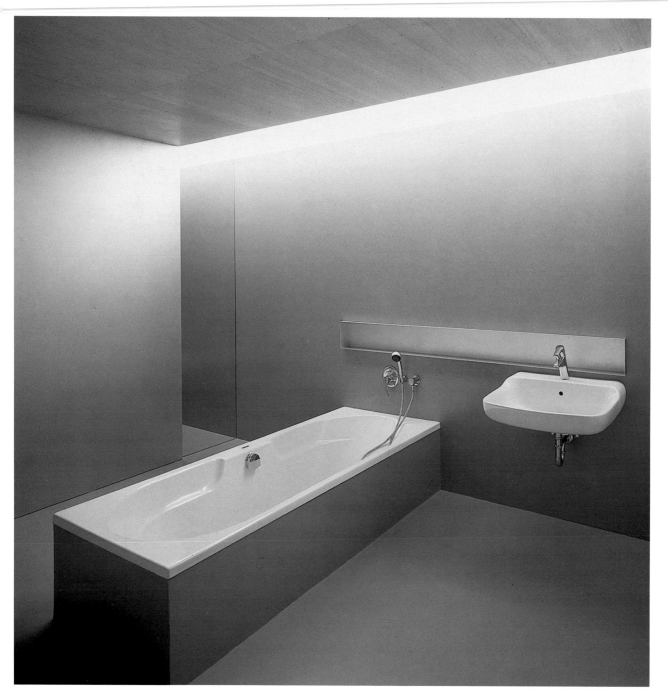

Maximalism

Design by Cristina & Alexandre Negoescu
Photo © Mihail Moldoveanu

Maximalist designs use sumptuous gold and purple embellishment and make extensive use of color. This architectural style is based on eighteenth and nineteenth century designs, as well as designs from the 1970s.

Üppige Gold- und Purpurdekorationen sowie explosive Farben kennzeichnen diesen Stil. Der Maximalismus orientiert sich dabei in der Ästhetik des 18. und 19. Jahrhunderts sowie an Elementen der 70er Jahre.

Ce style allie profusion de décorations aux teintes or et pourpre à une explosion de couleurs. Le maximalisme s'inspire de l'esthétique des 18e et 19e siècles ainsi que d'éléments décoratifs des années 70.

Este estilo se caracteriza por una opulenta decoración en tonos dorados y púrpuras, así como por los colores intensos. El maximalismo se inspira en la estética de los siglos XVIII y XIX, y en elementos ornamentales de los años setenta.

Questo stile si distingue per le sue decorazioni sontuose in oro e porpora nonché per i colori acuti. Con ciò, il massimalismo si orienta all'estetica del 18° e 19° secolo nonché ad alcuni elementi caratteristici degli anni 70'.

Design by Jennifer Randall & Associates
Photo © Jordi Miralles

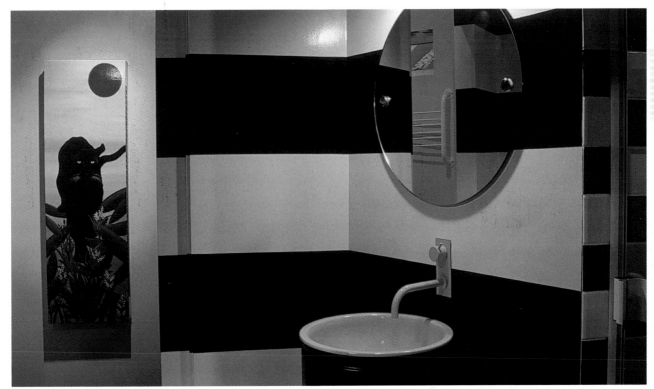

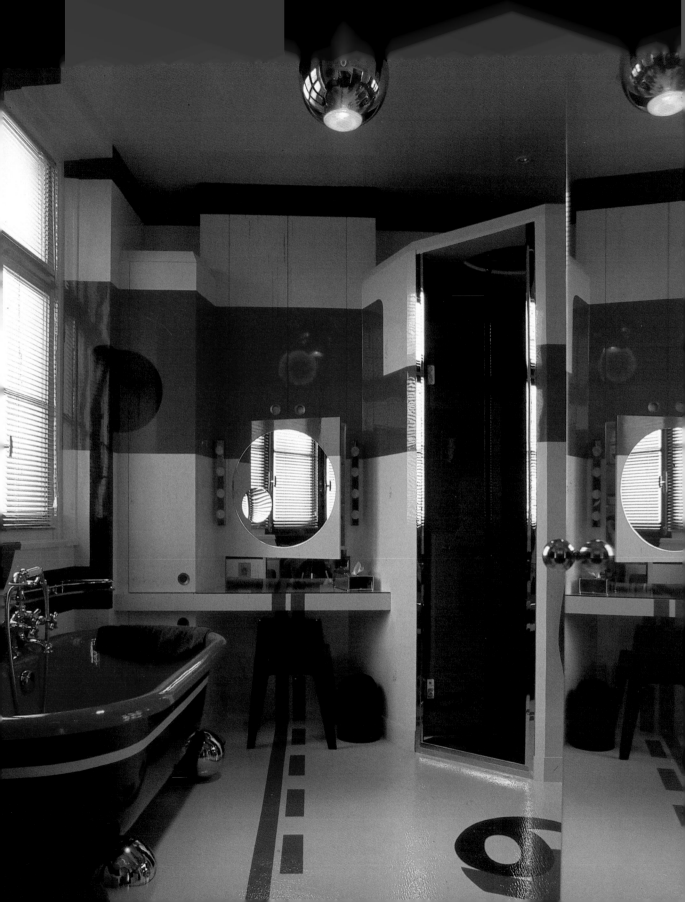

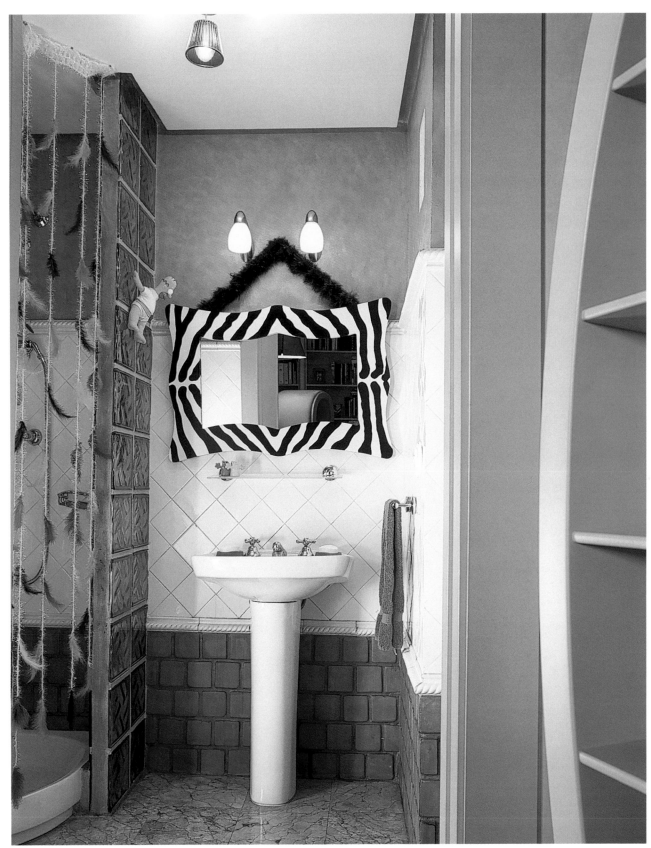

Design by Salvador Llobet
Photo © Pep Escoda

Design by Teresa Sepulcre
Photo © Artur G

53

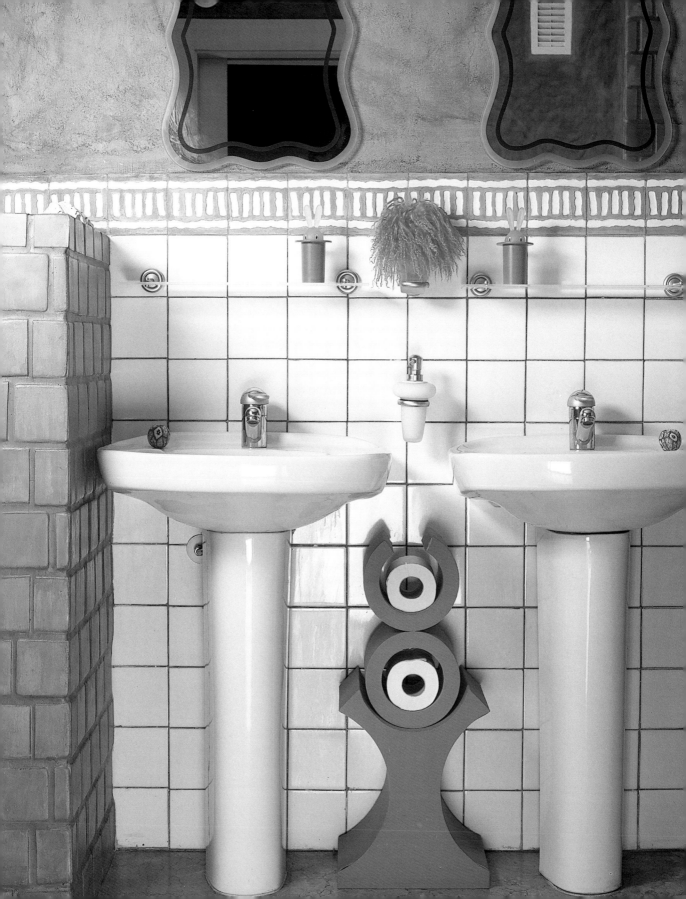

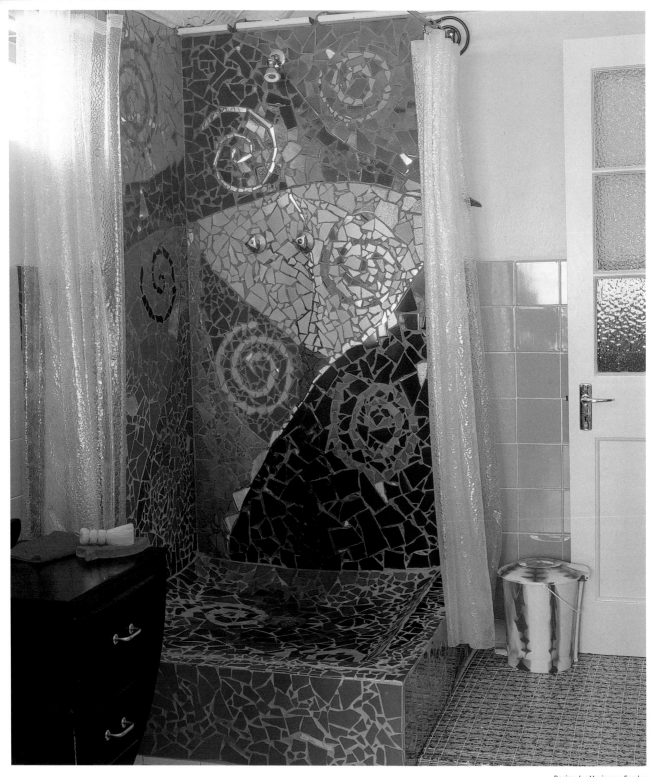

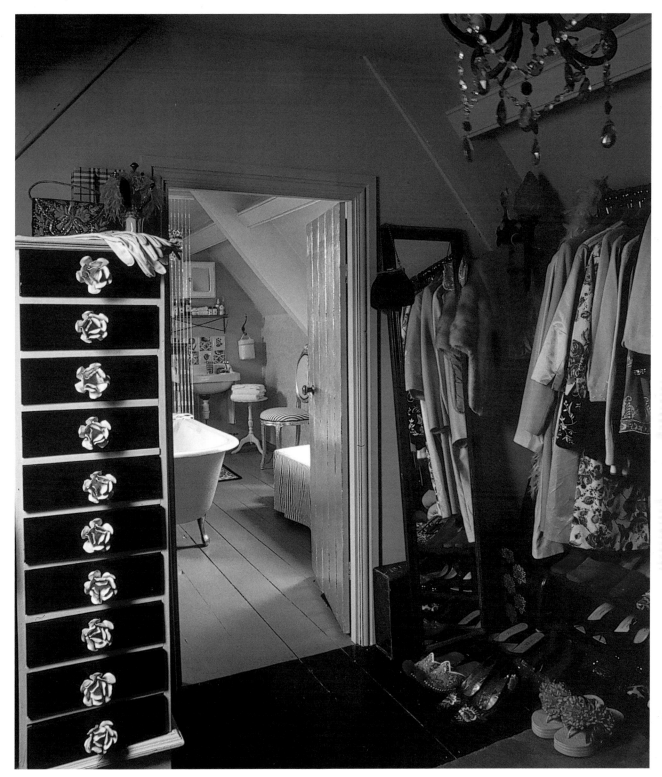

Both pages
Design by M. Chippendale, H. Morris, R. Morris
Photo © Deidi von Schwaewen/Omnia

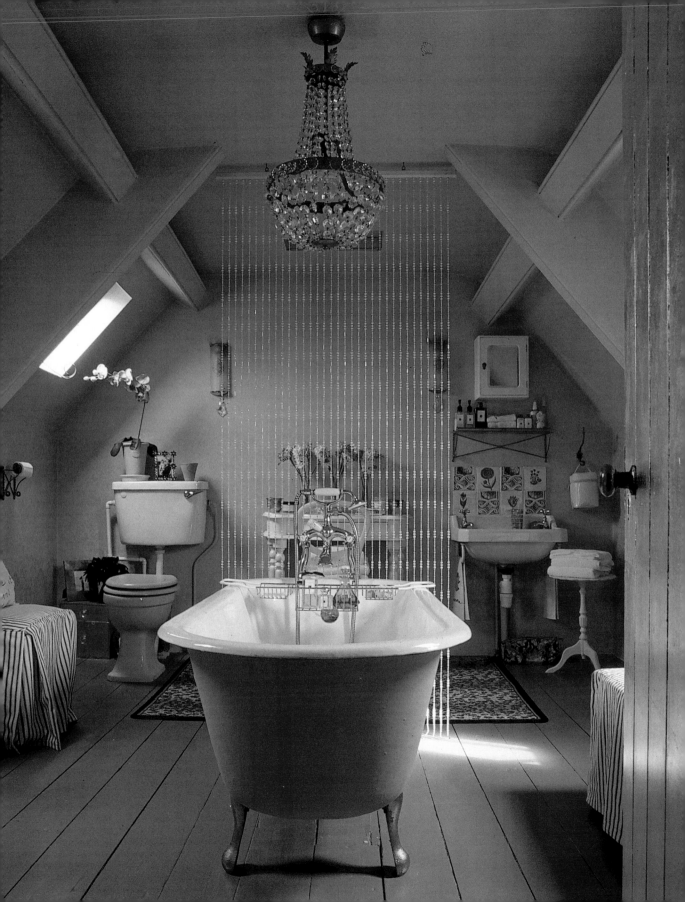

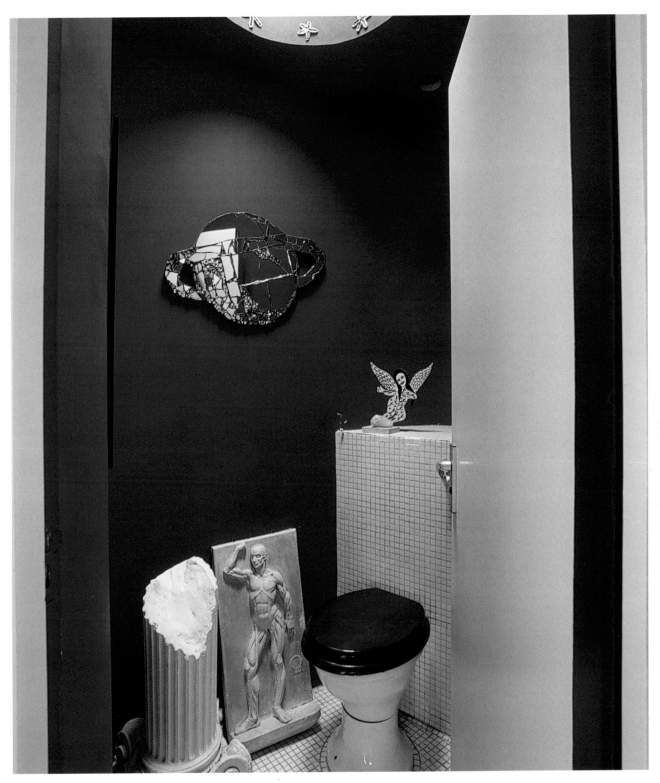

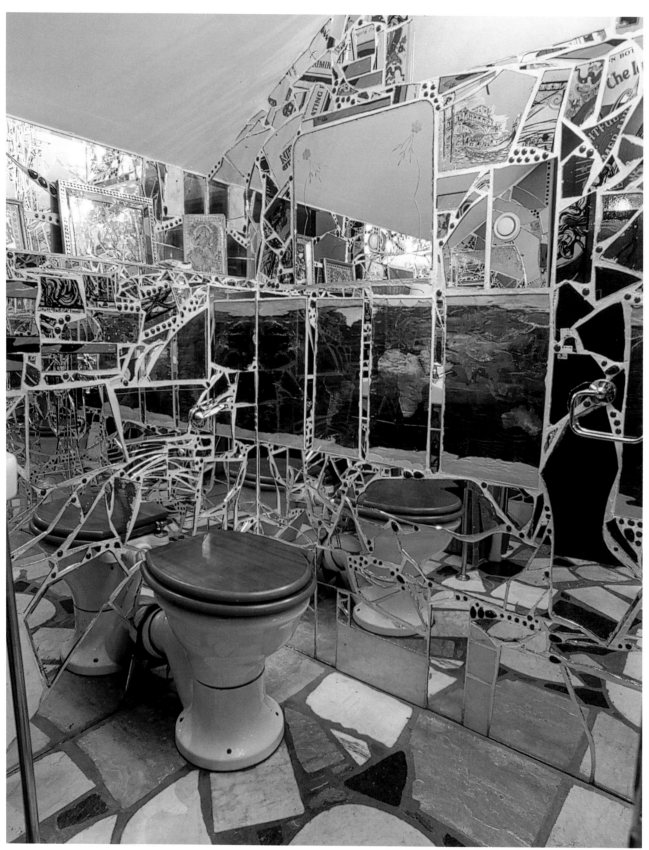

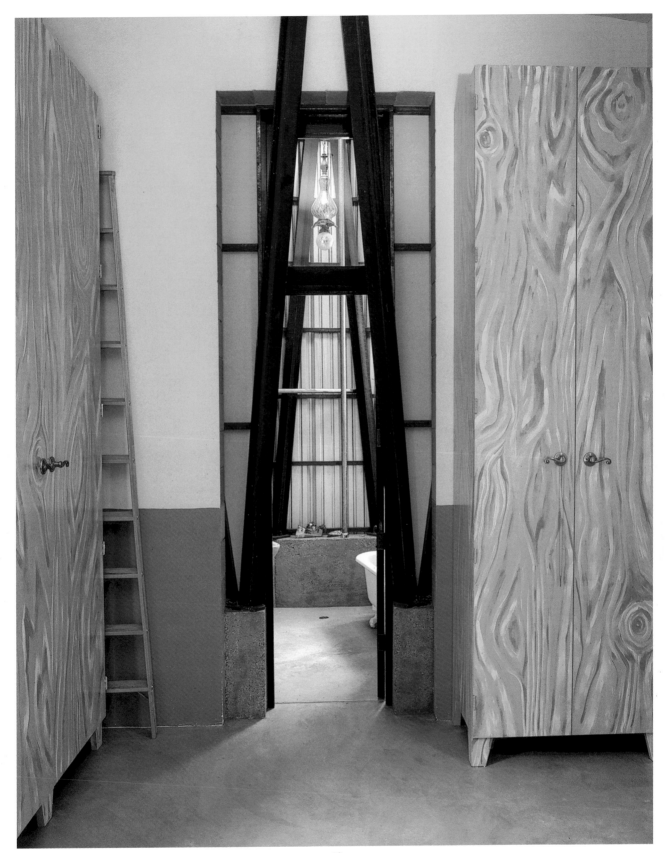

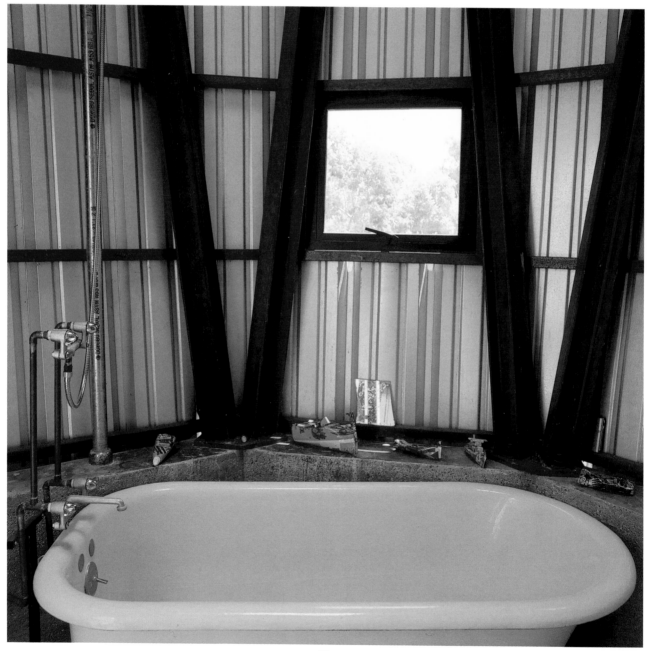

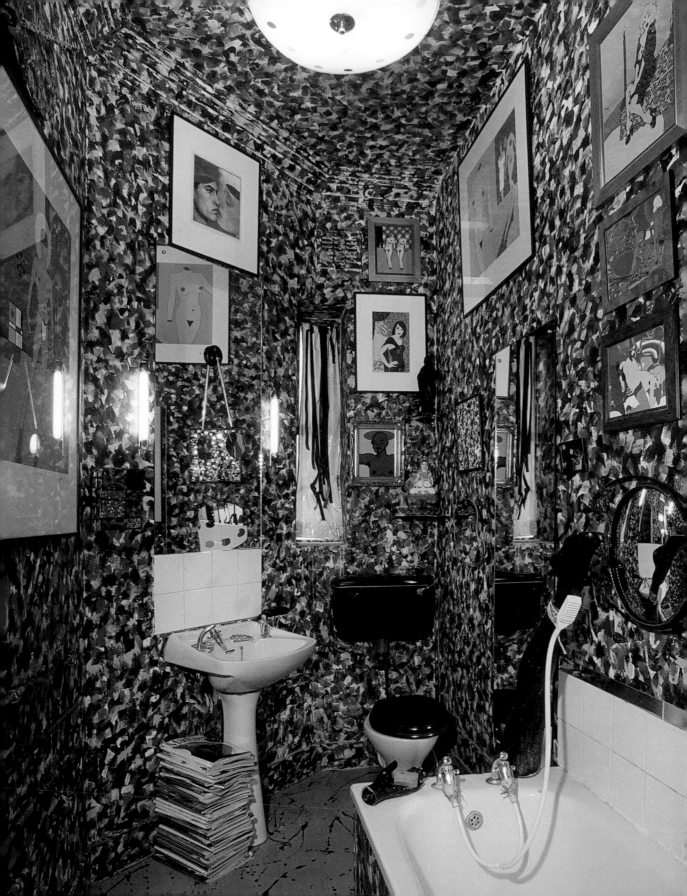

Both pages
Design by Virginia Bates
Photo © Deidi von Schwaewen/Omnia

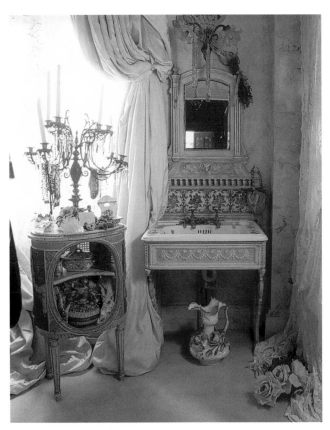

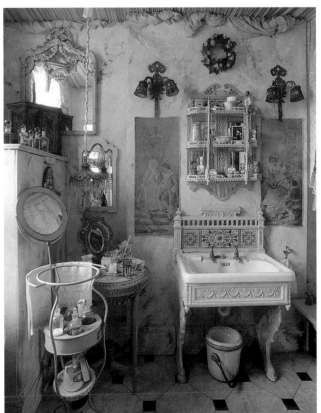

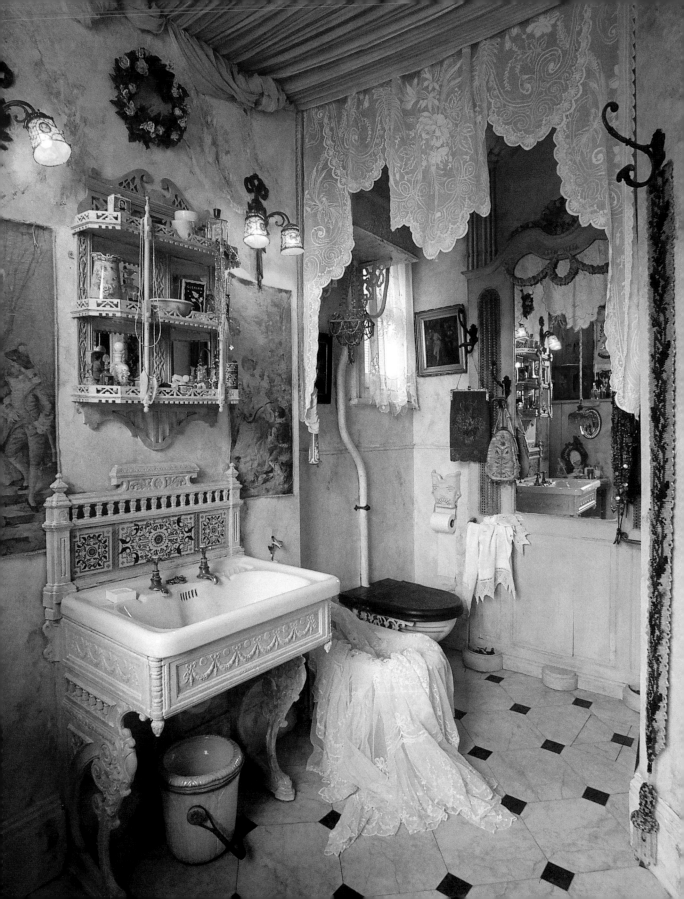

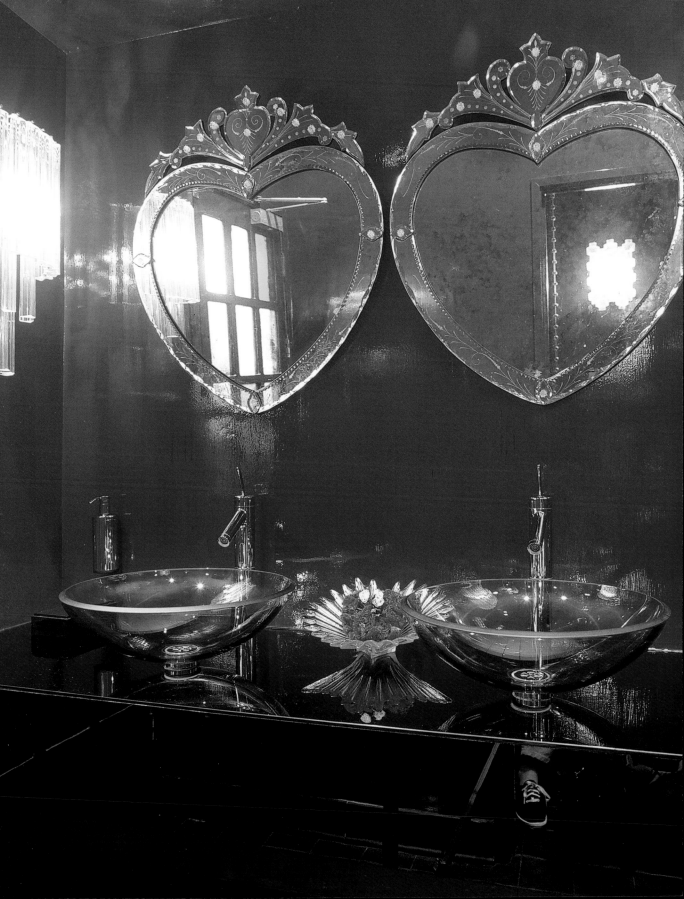

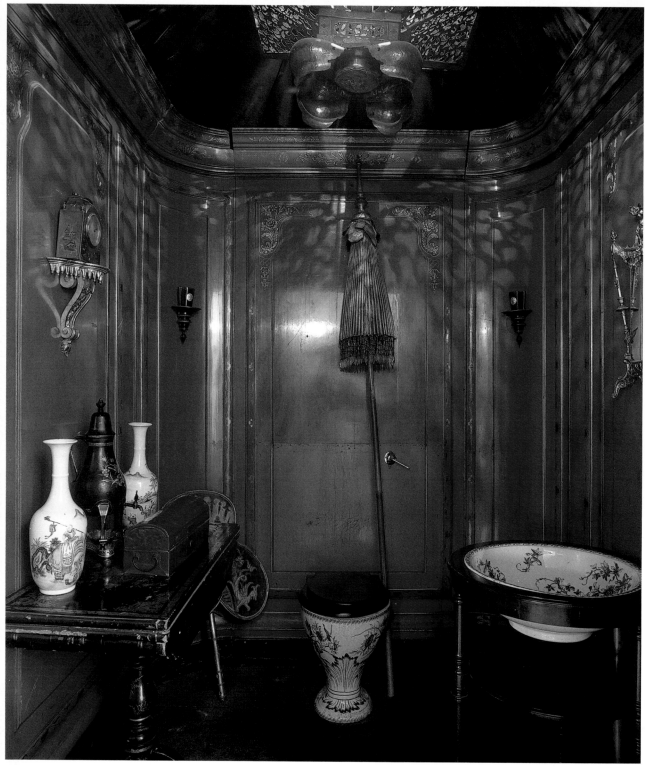

Both pages
Design by Hassan Abdullah
Photo © Yael Pincus

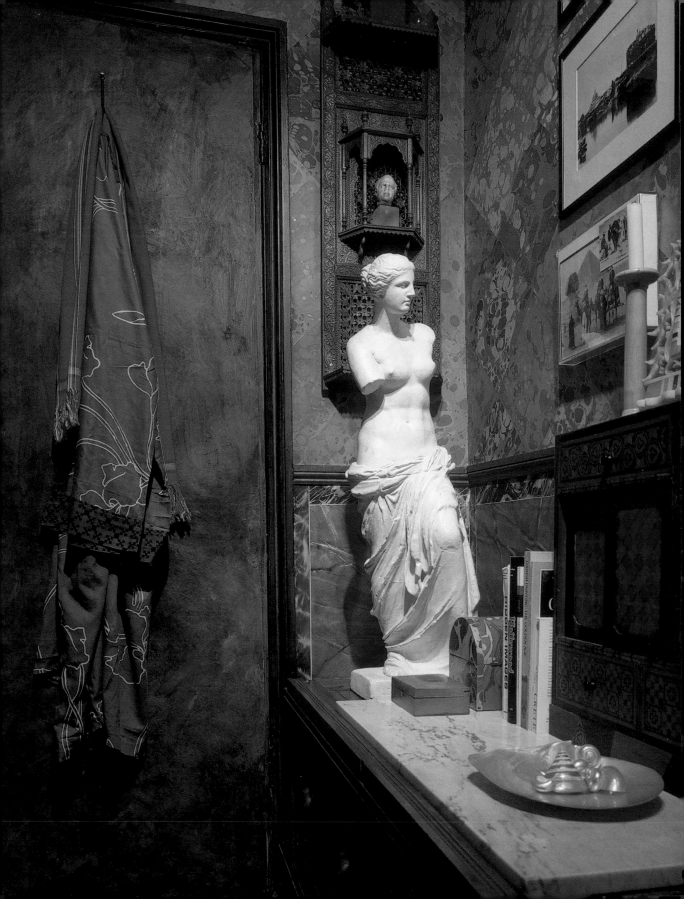

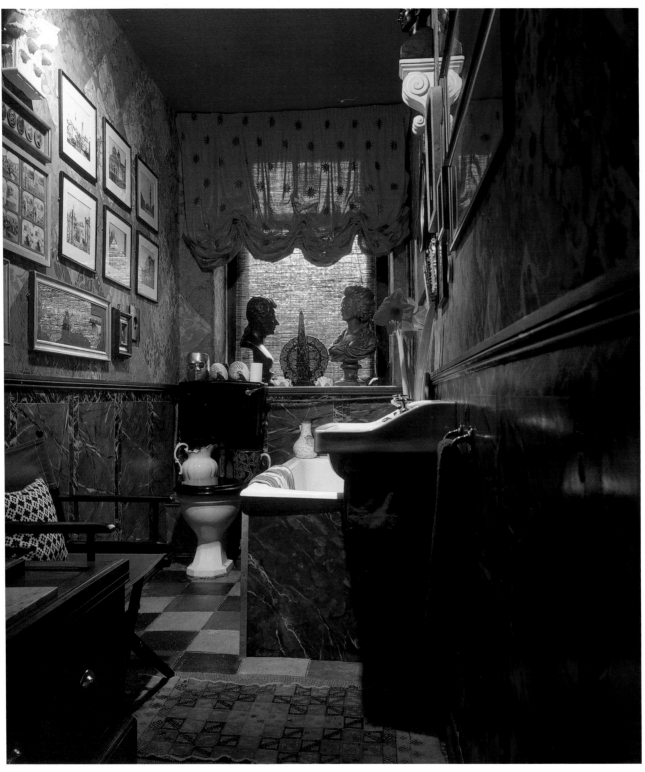

Both pages
Design by Christopher Drew
Photo © Julie Phipps/View

Exotic designs

Both pages
Design by Christophe Simeon
Photo © Pere Planells

Exotic bathroom designs take their cue from tropical, Arab and African cultures. In most instances, distinctive hand-crafted wood, stone and ceramic elements set the tone.

Der exotische Stil greift die Ästhetik tropischer, arabischer und afrikanischer Kulturen auf. Zumeist handgefertigte, originale Dekorationselemente aus Holz, Stein oder Keramik geben die entscheidende Note.

Le style exotique s'inspire de l'esthétique des civilisations tropicales, arabes et africaines. Objets décoratifs originaux de l'artisanat, en bois, pierre ou céramique apportent une touche d'exotisme.

El estilo exótico se remite a la estética de culturas tropicales, árabes y africanas. La nota decorativa decisiva viene dada por elementos ornamentales originales hechos a mano en madera, piedra o cerámica.

Lo stile esotico esalta l'estetica delle culture tropicali, arabe ed africane. La nota decisiva la danno elementi decorativi originali e fatti a mano, creati con materiali quali legno, pietra o ceramica.

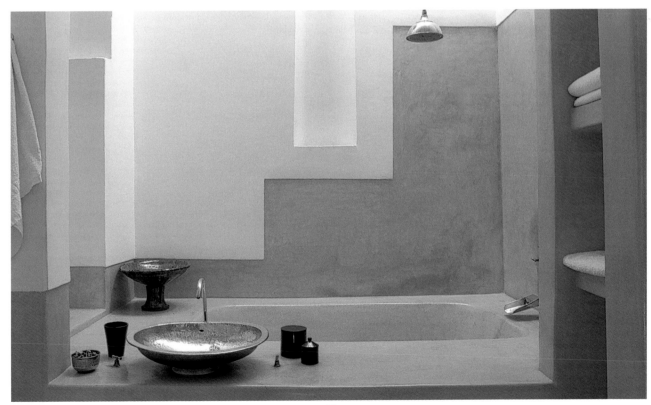

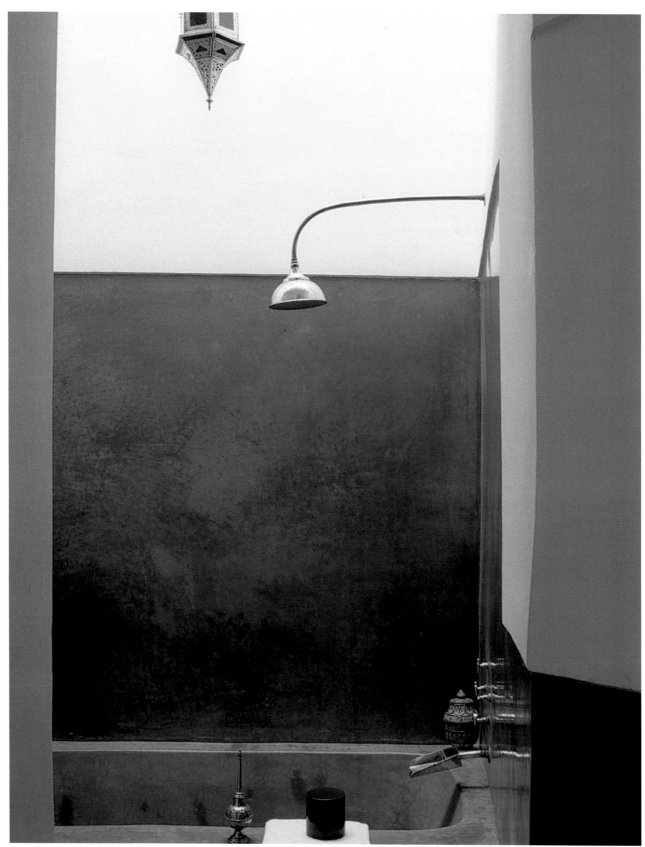

Design by Mathieu Boccara
Photo © Pere Planells

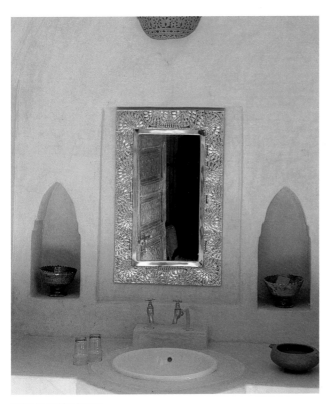

Design by Mathieu Boccara
Photo © Pere Planells

Photo © Ricardo Labougle, Hugo Curletto

Design by Max Lawrence
Photo © Pere Planells

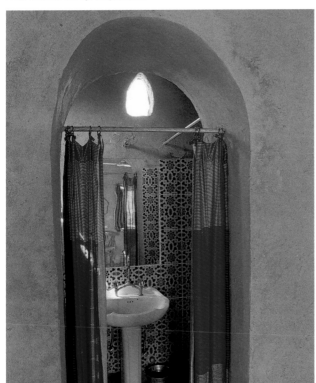

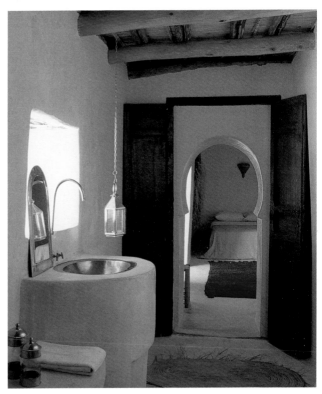

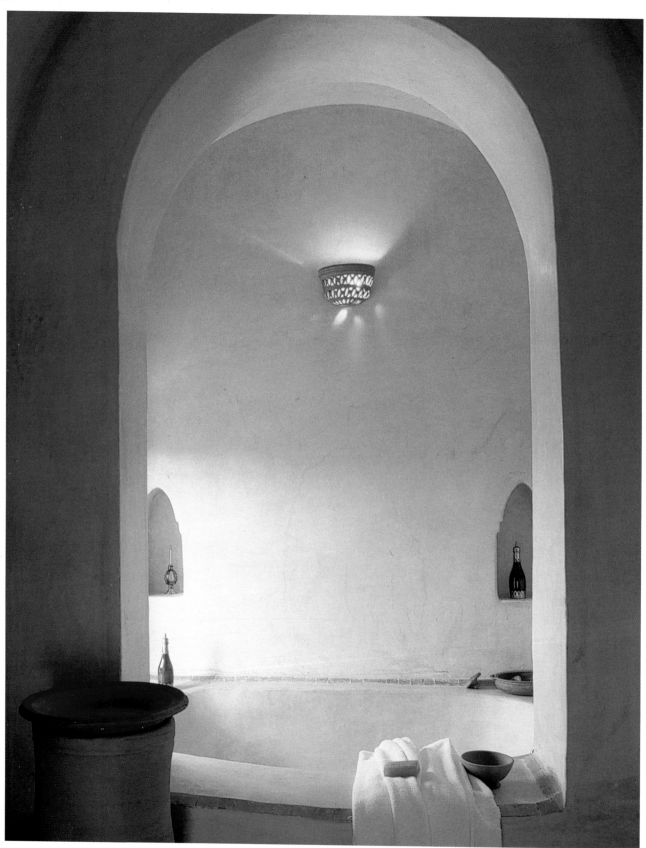

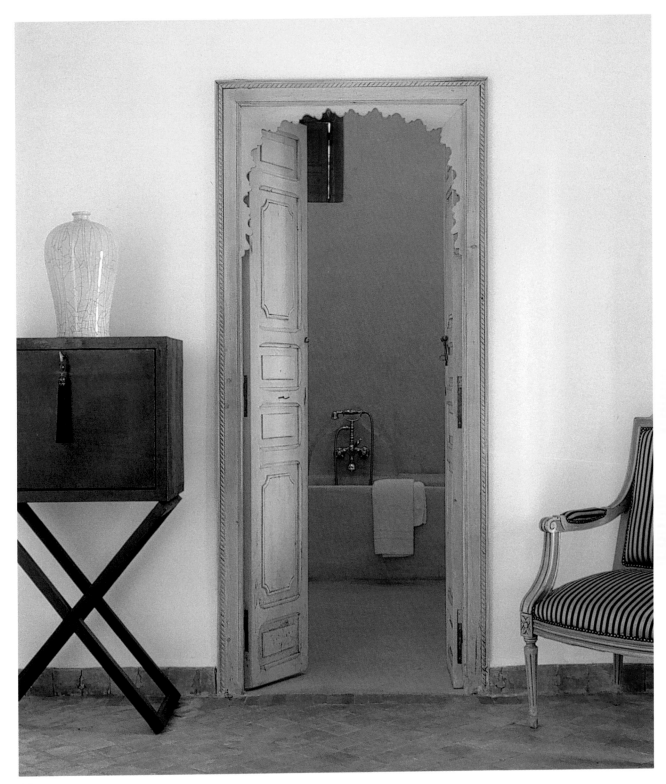

Both pages
Design by Gerôme Vermelín & Michel Durand-Meyrier
Photo © Pere Planells

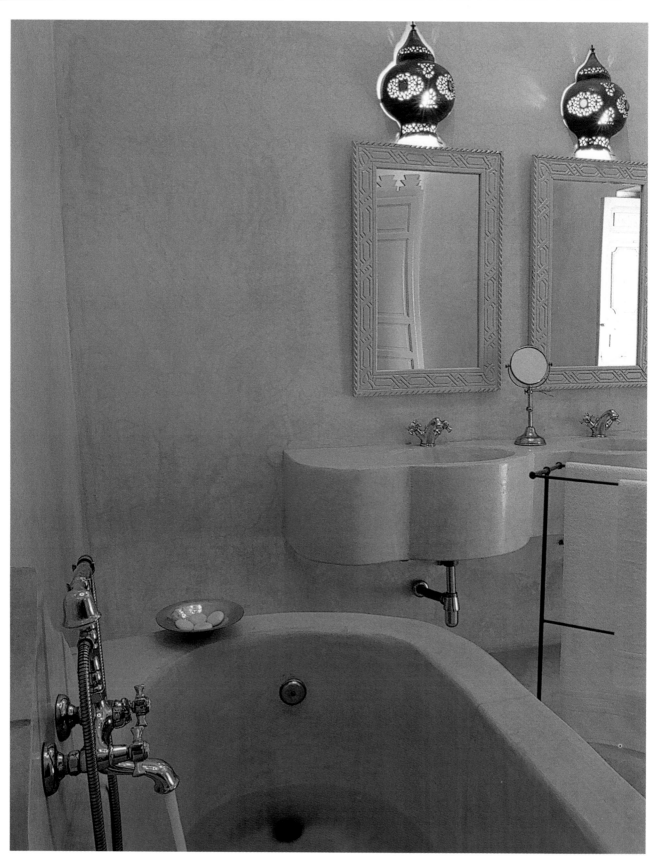

Both pages
Design by Alan Faena
Photo © Reto Guntli

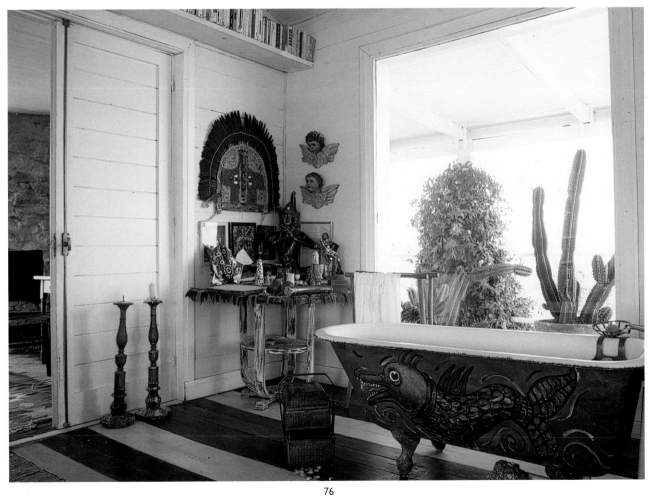

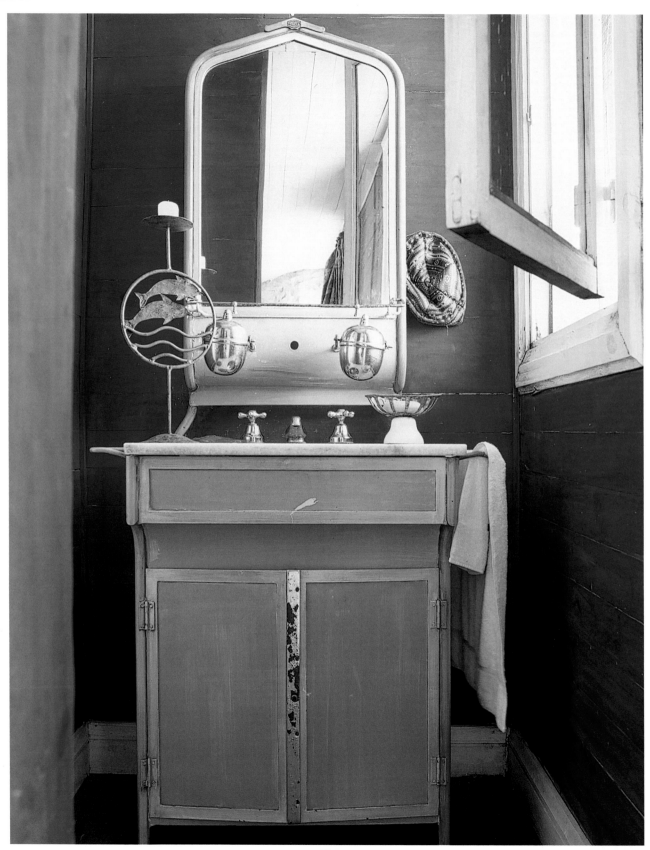

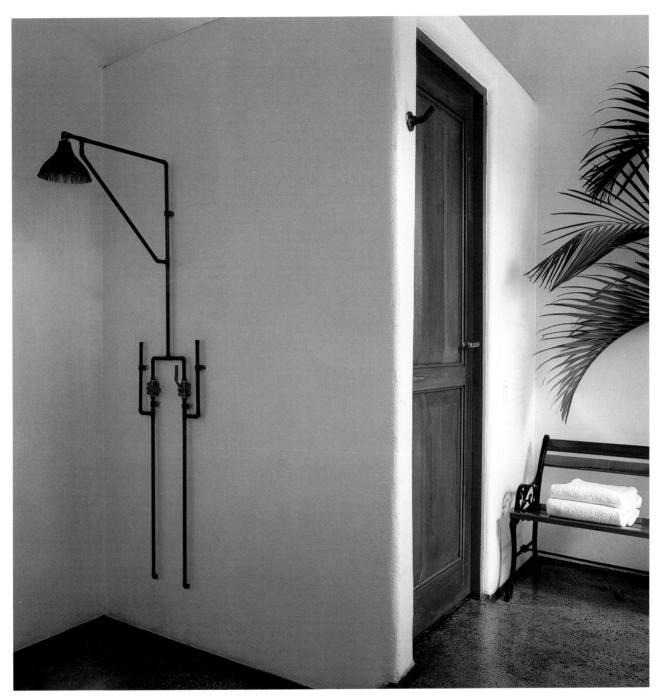

Both pages
Design by Simon Vélez
Photo © Undine Pröhl

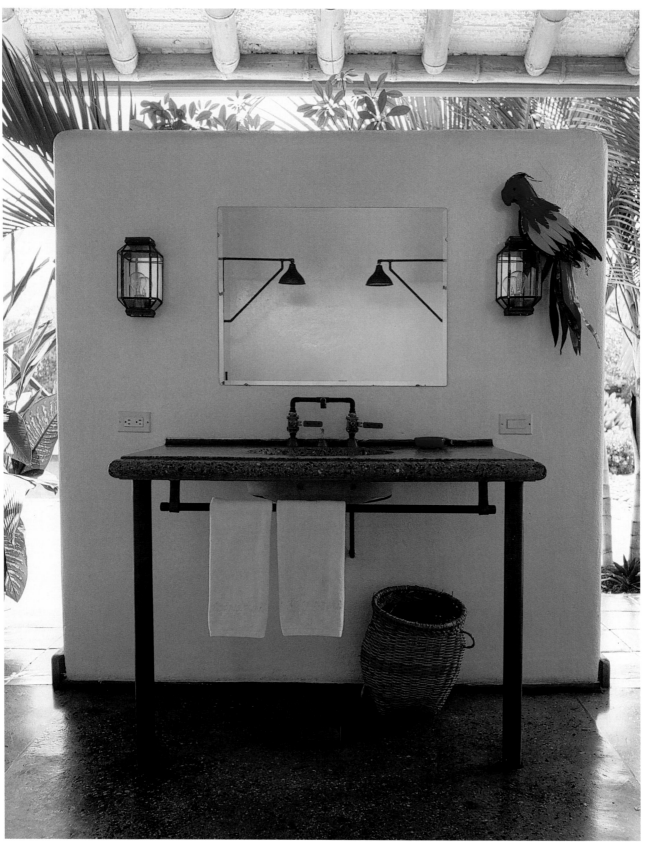

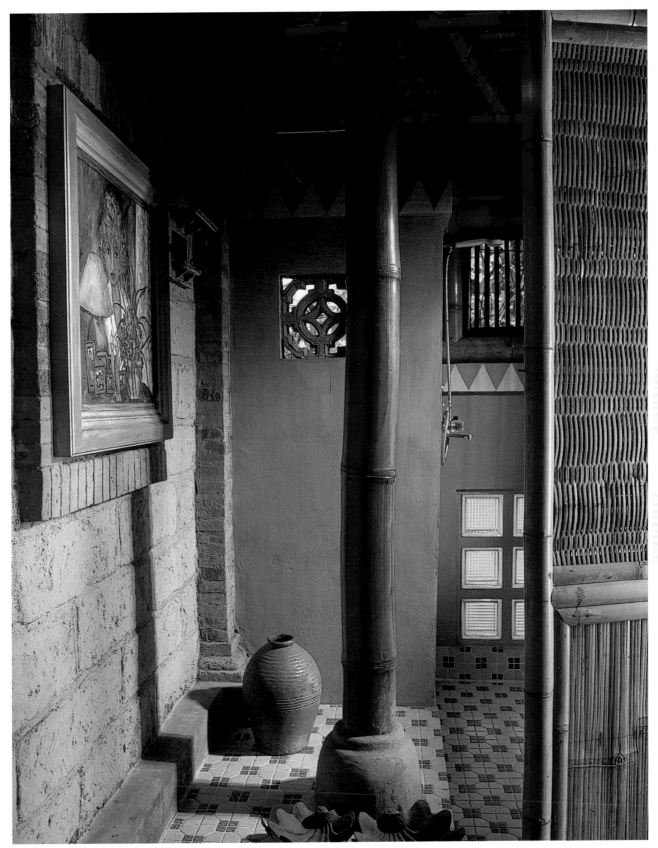

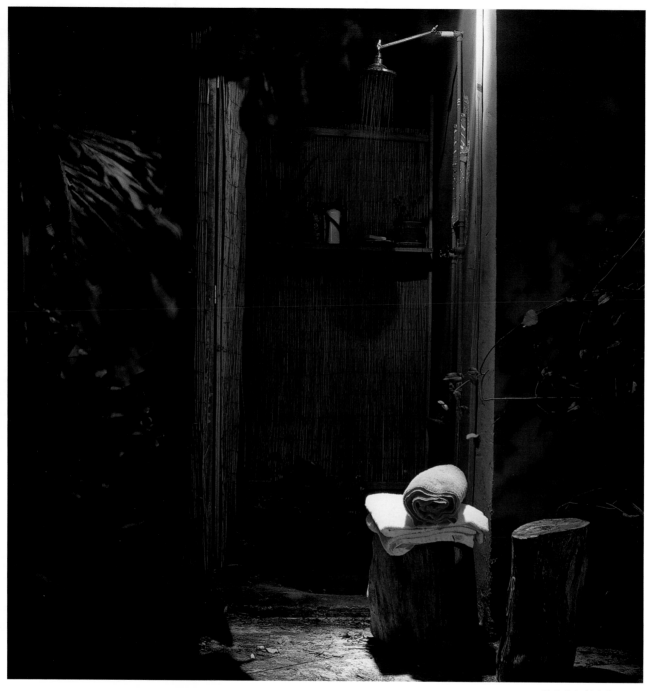

Photo © José Luis Hausmann

Design by Putu Suarsa
Photo © Reto Guntli

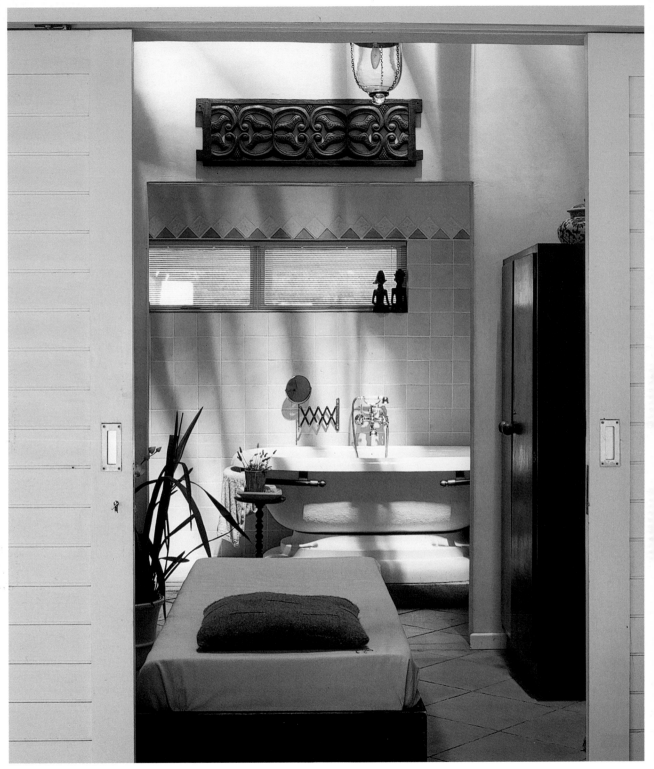

Photo © Jordi Miralles

Design by Rina López
Photo © Ricardo Labougle, Naty Abascal

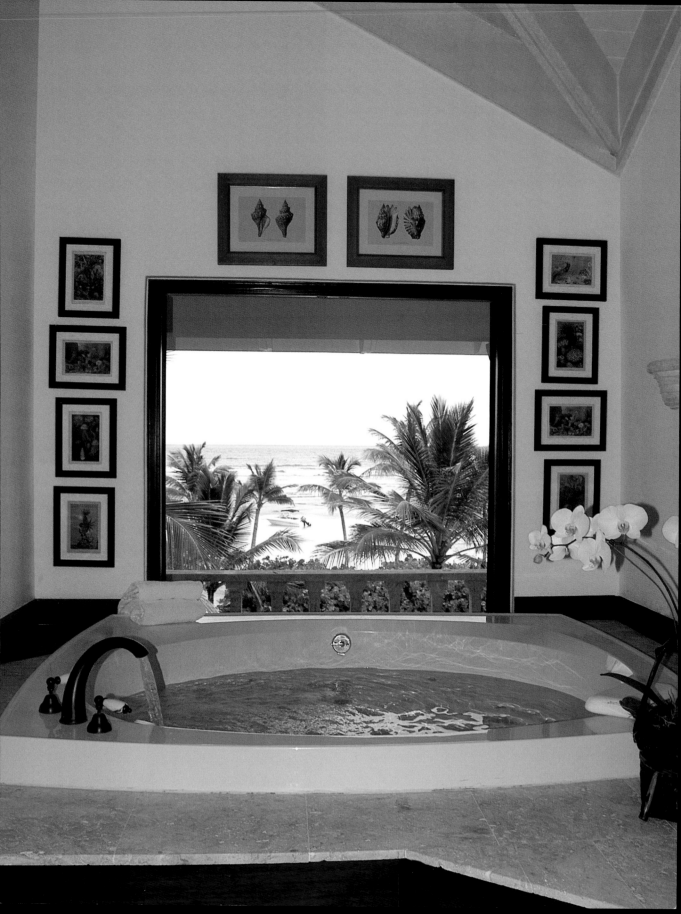

Classic bathroom designs

Design by Steven Capaldo
Photo © Roger Casas

Classic bathrooms require a large amount of space in order to bring their full beauty and elegance to successful fruition. It is best to outfit such bathrooms with a large, classic bathtub.

Bäder klassischen Stils erfordern große Räume, um ihre Schönheit und Eleganz voll entfalten zu können. In der Regel sollte man bei einem geräumigen, klassischen Bad eine Badewanne mit großen Abmessungen platzieren.

Les salles de bains classiques ont besoin d'espace pour déployer parfaitement la beauté et l'élégance qui sont leur apanage. En règle général, une salle de bains classique spacieuse peut accueillir une grande baignoire.

Los cuartos de baño de estilo clásico necesitan mucho espacio para poder mostrar toda su belleza y elegancia. Por lo general, en un baño amplio de carácter clásico no puede faltar una bañera de grandes dimensiones.

I bagni appartenenti allo stile classico richiedono ambienti spaziosi per poter sviluppare in pieno la loro bellezza ed eleganza. È buona norma piazzare in un bagno classico e spazioso una vasca con grandi dimensioni.

Design by Tsao & McKown
Photo © Roger Casas

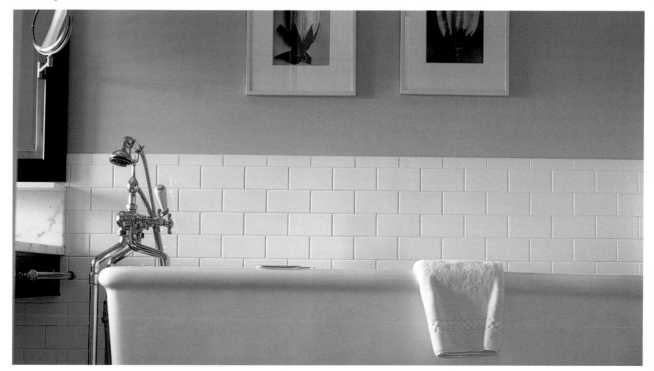

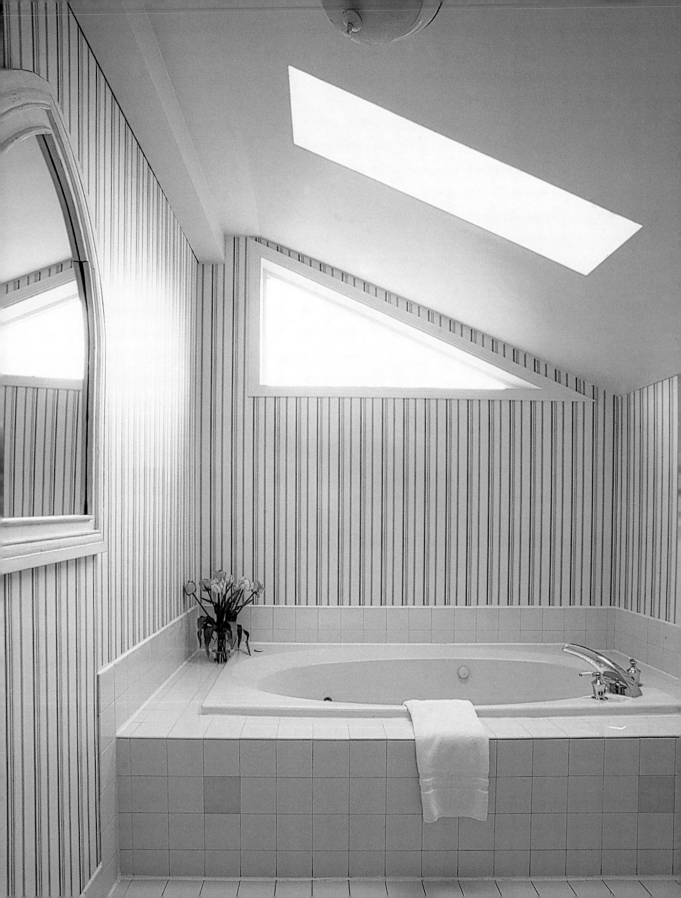

Both pages
Design by Pler Arquitectos
Photo © José Luis Hausmann

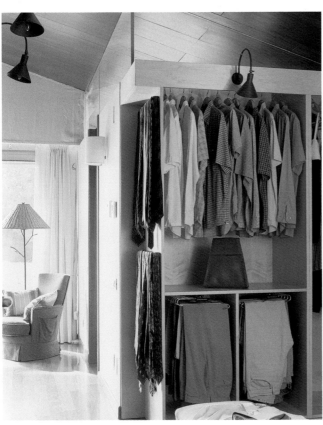

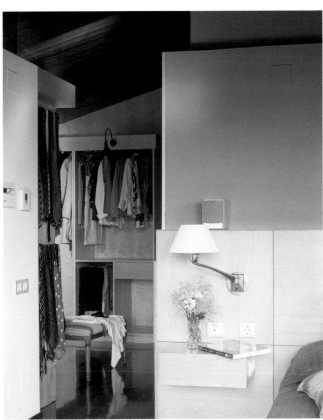

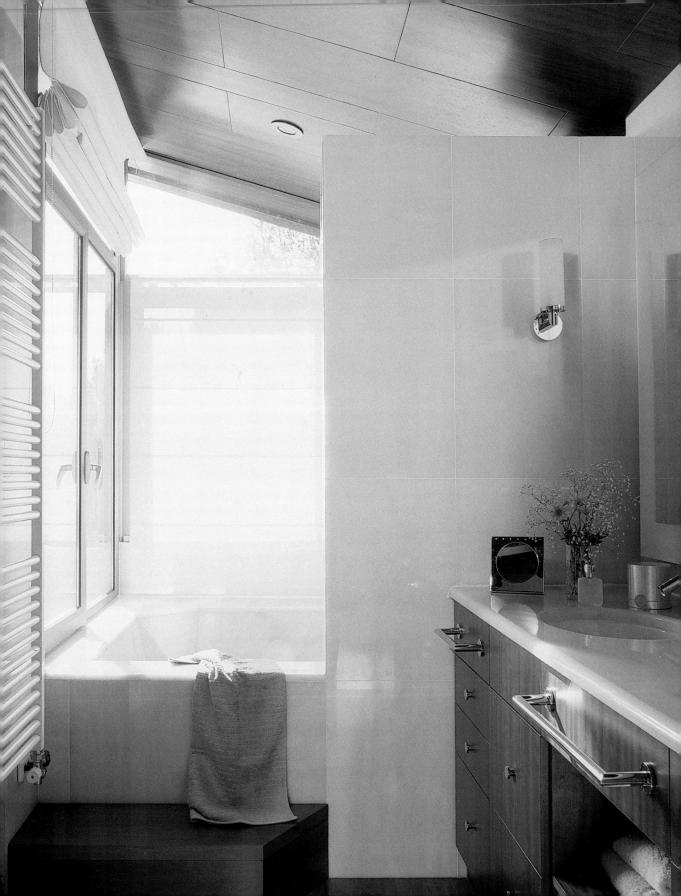

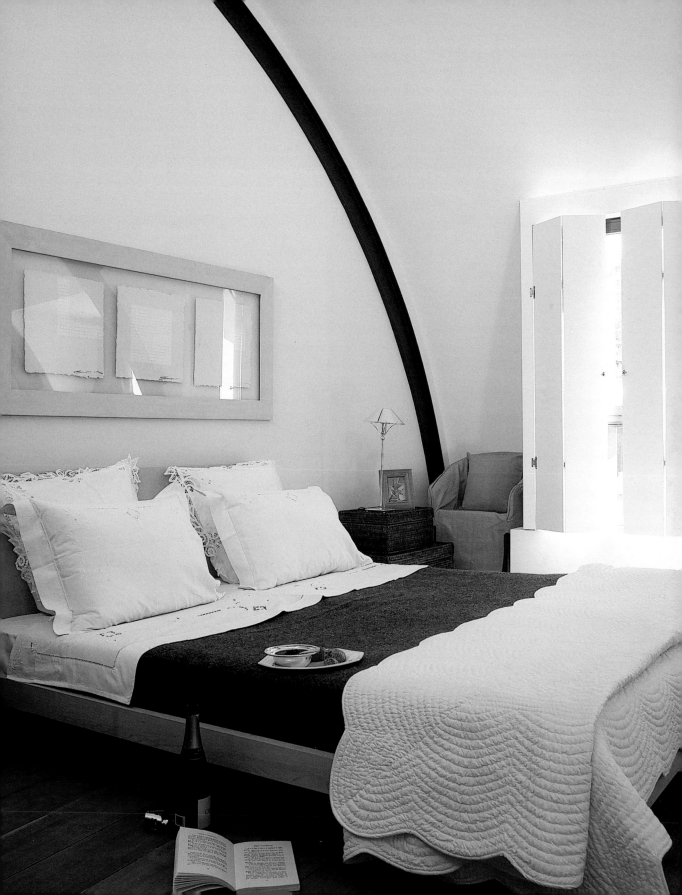

Both pages
Design by Marie Veronique de Hoop Scheffer
Photo © Virginia del Guidice

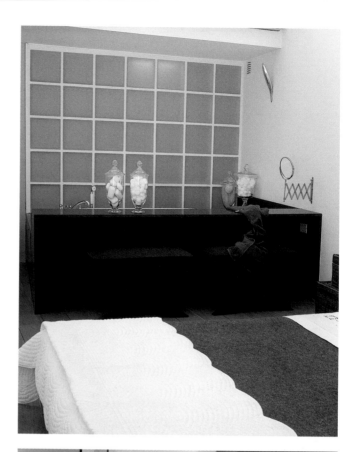

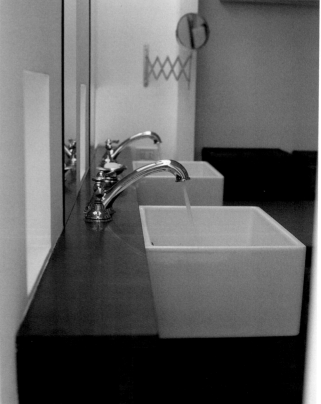

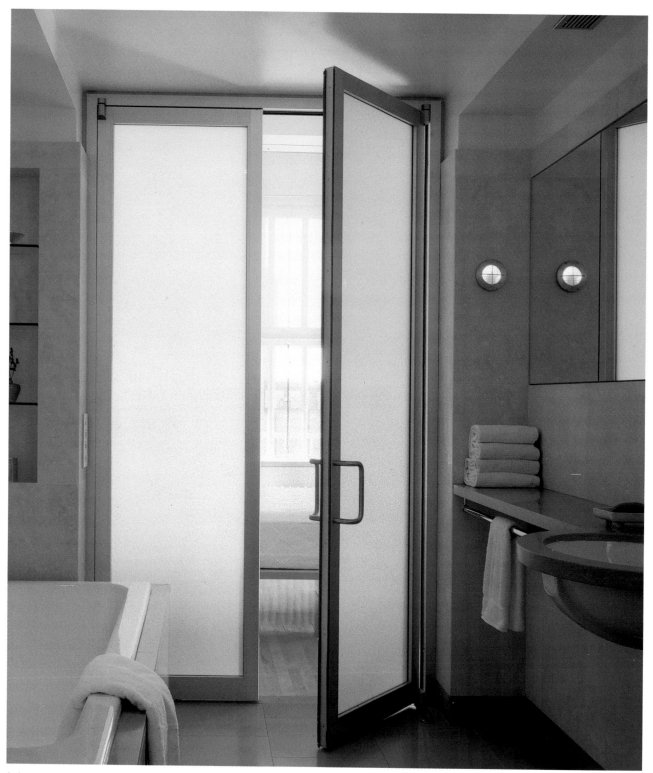

Both pages
Design by James Gauer
Photo © Catherine Tighe

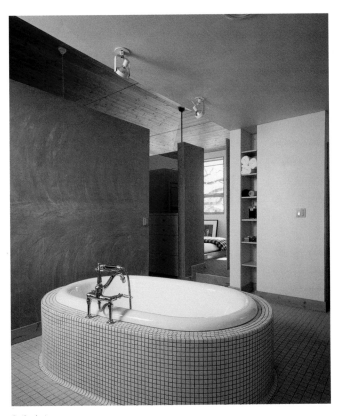

Both photos
Design by Cunningham Architects
Photos © Undine Pröhl

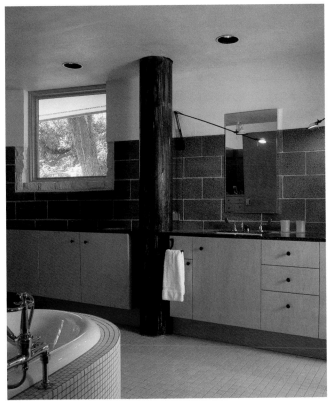

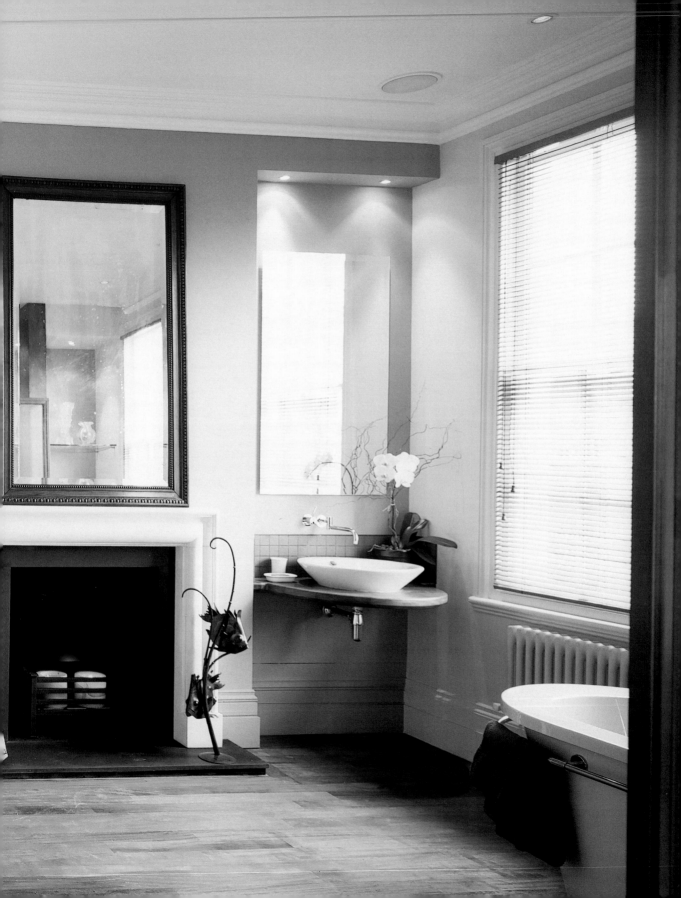

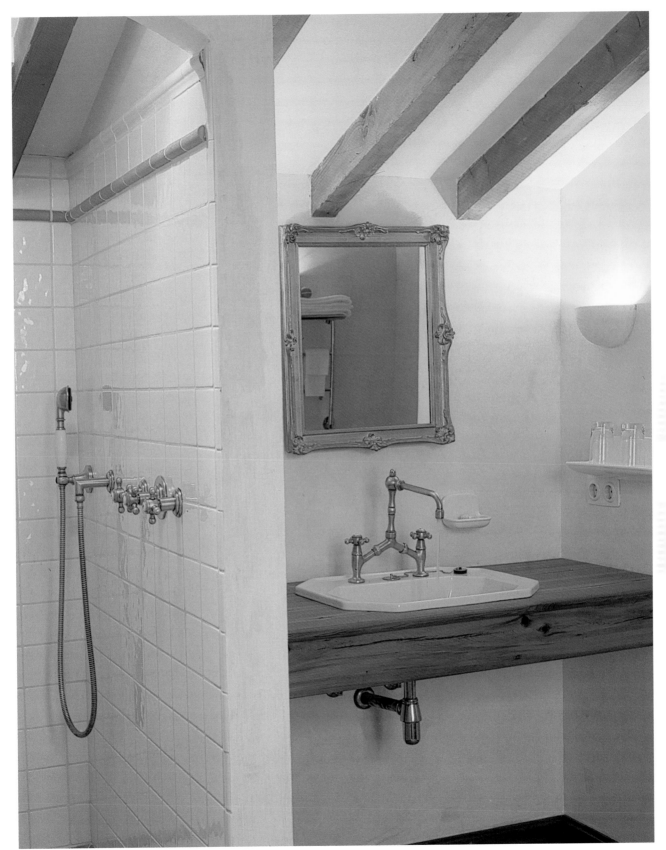

Both pages
Design by Wolfgang Nikolaus Schmidt,
Juan Puigserver, Mariano Barceló
Photo © Pep Escoda

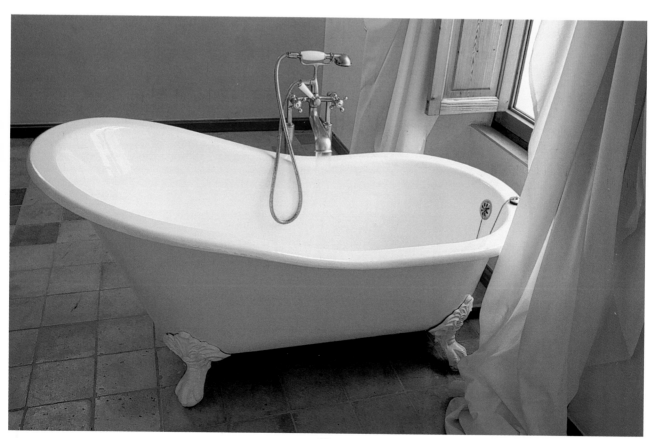

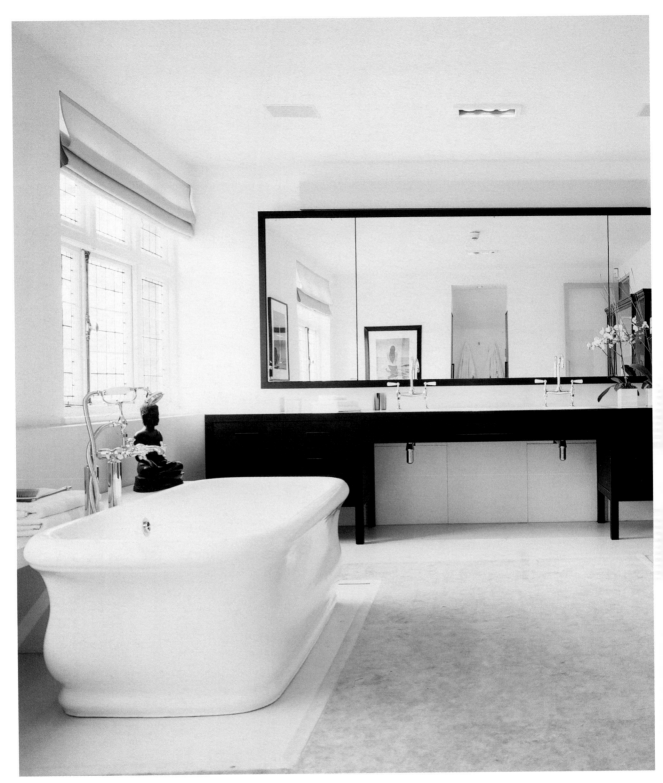

Design by India Mudave
Photo © Ken Hayden/Red Cover

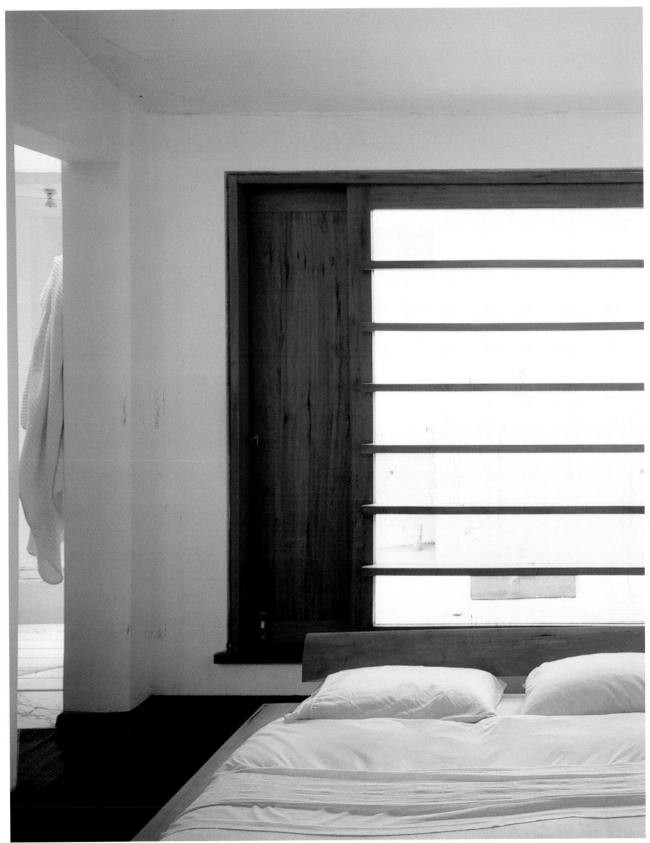

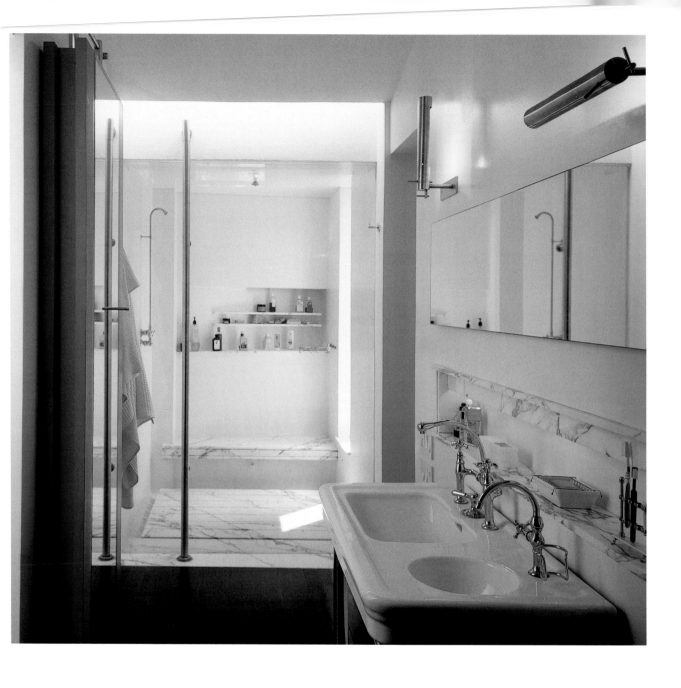

Both pages
Design by Guillermo Arias
Photo © Eduardo Consuegra, Pablo Rojas

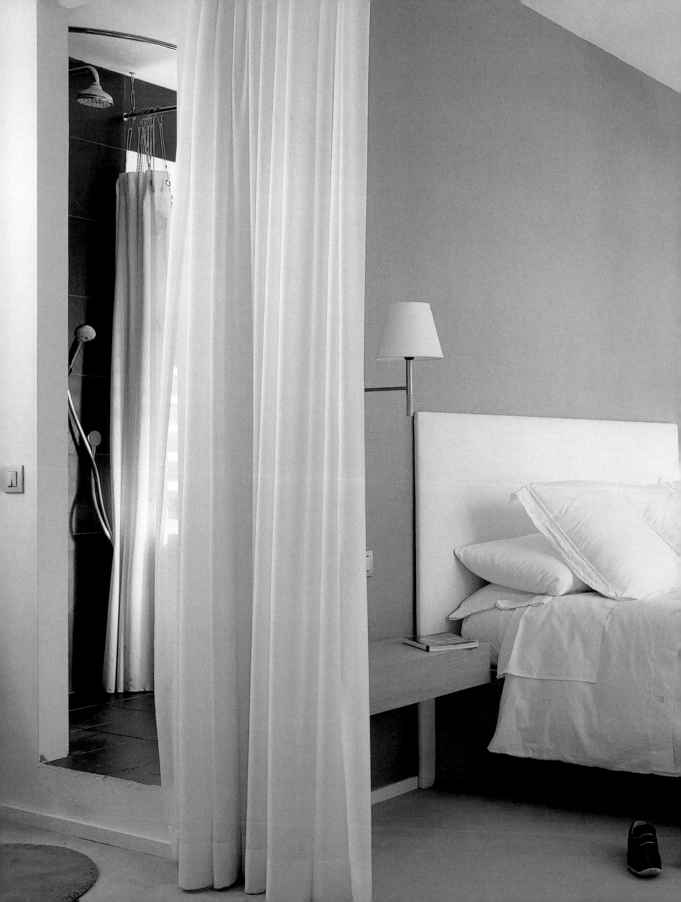

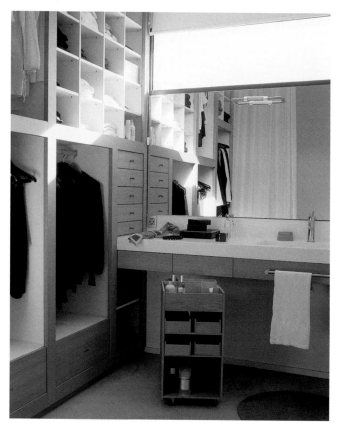

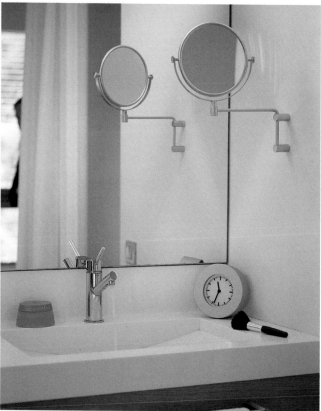

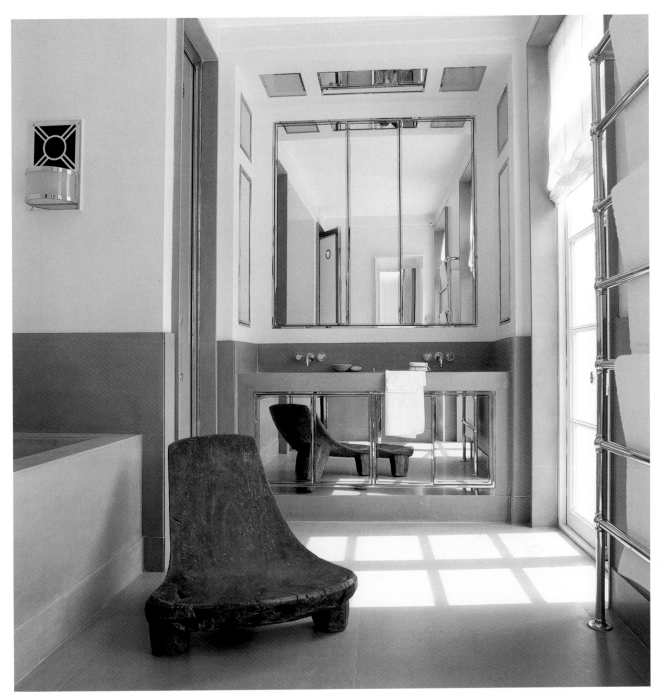

Design by Andrzej Zarzycki
Photo © Ken Hayden/Red Cover

Design by Jacqueline Morabito
Photo © Chris Tubbs/Red Cover

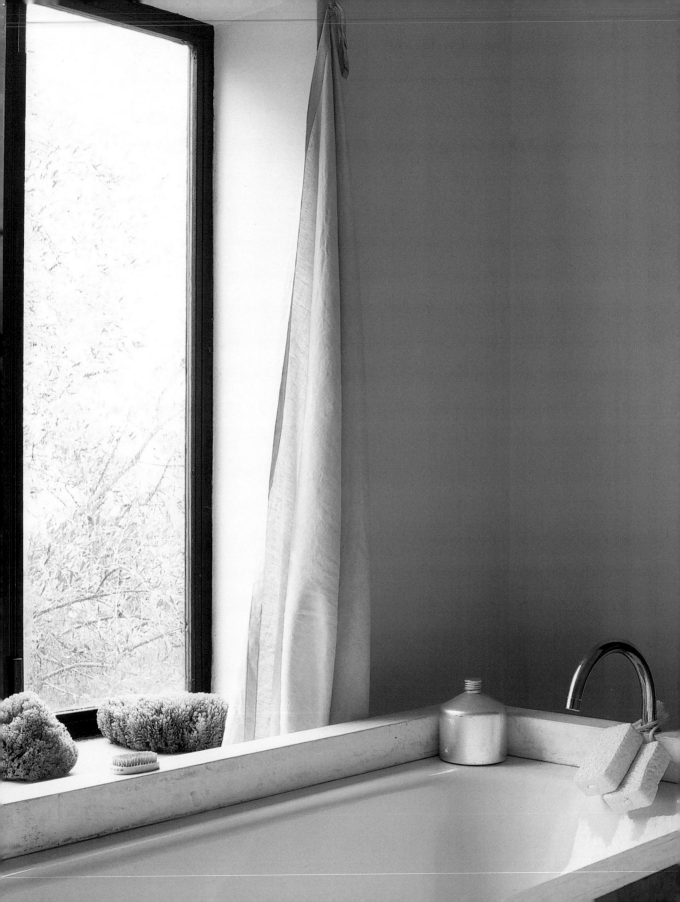

Both pages
Design by Christian Aglás and Patricio Martínez
Photo © José Luis Hausmann

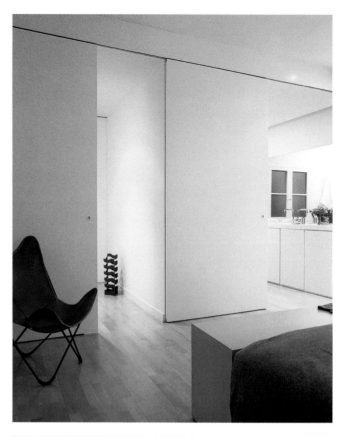

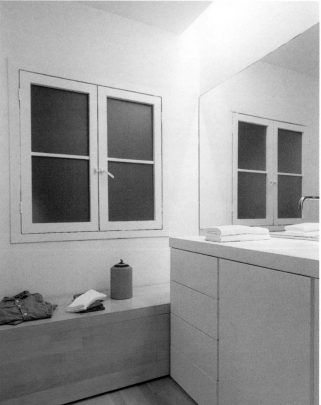

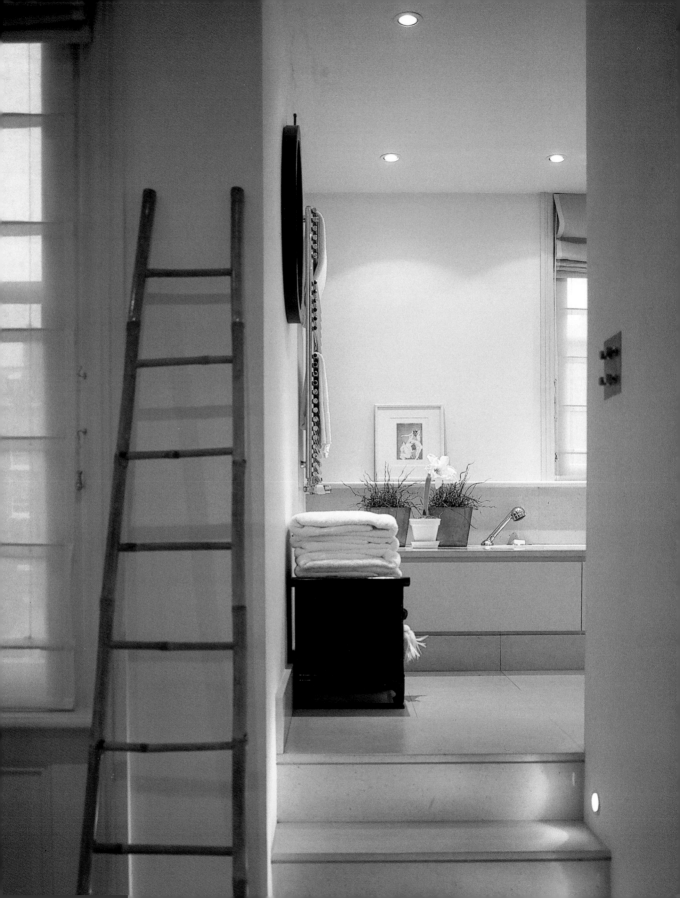

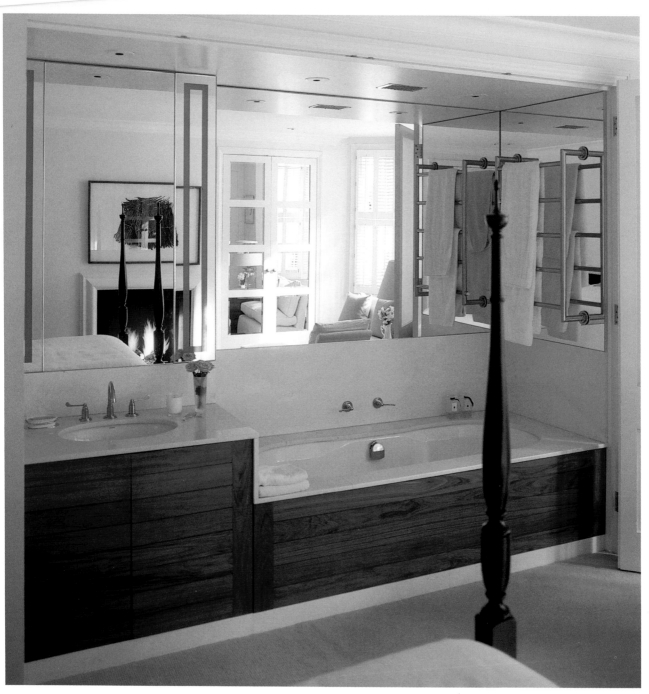

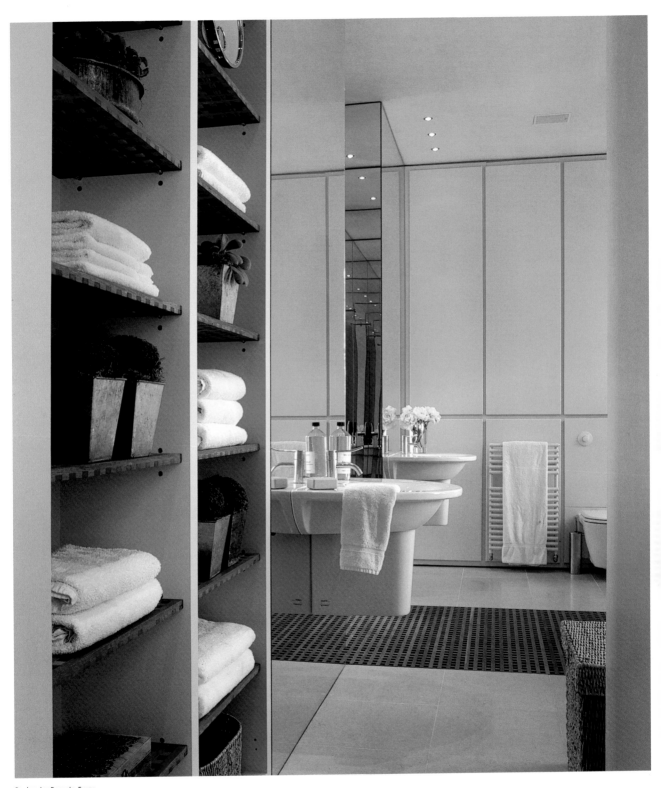

Design by Pamela Furze
Photo © Ken Hayden/Red Cover

Design by STUDIO A (Giovanni Longo, Alessandro
Palmarini, Igor Rebosio, Federico Spagnulo)
Photo © Andrea Martiradonna

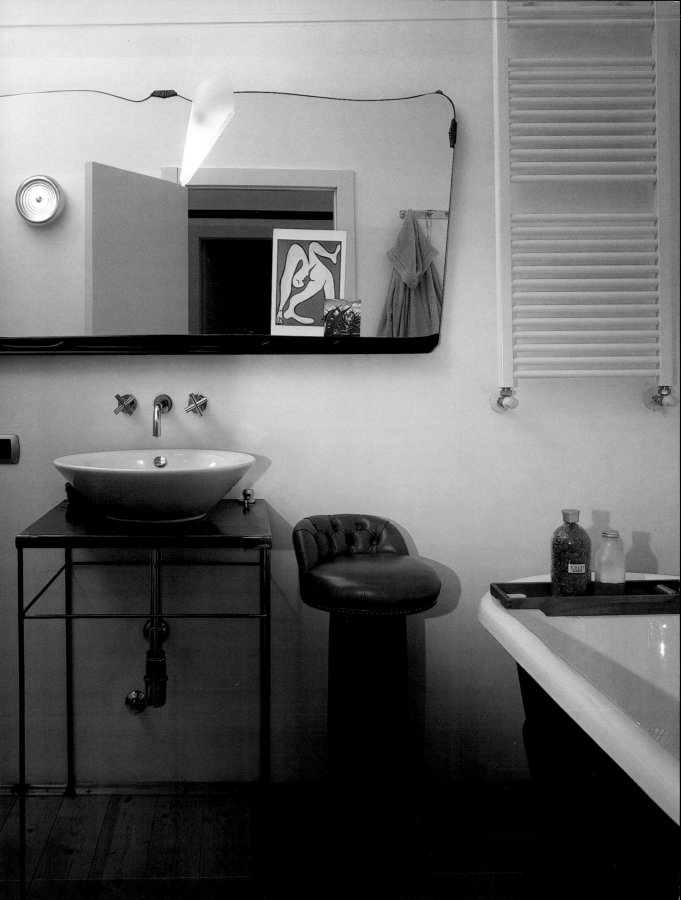

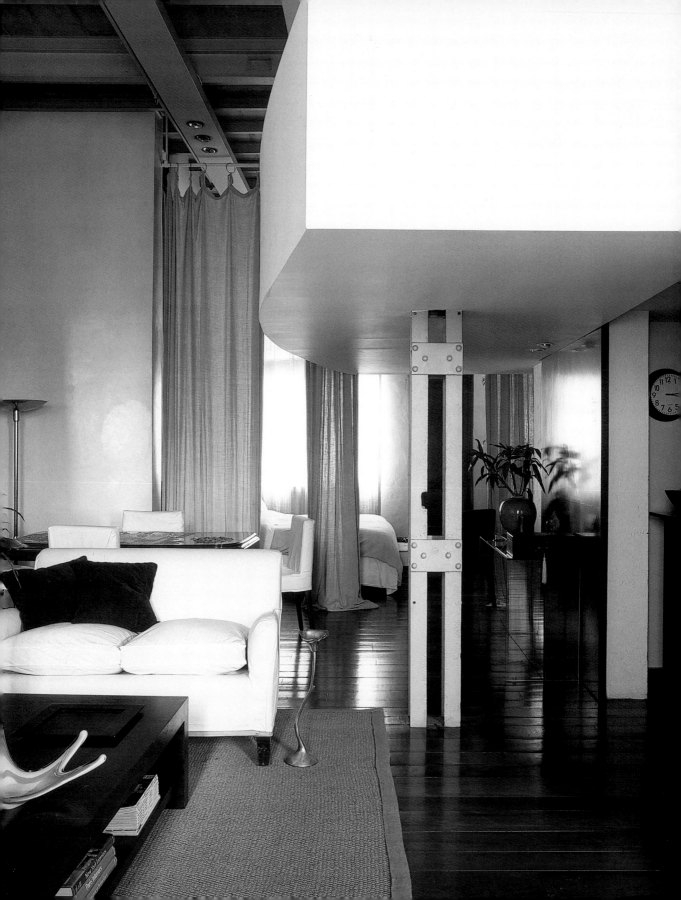

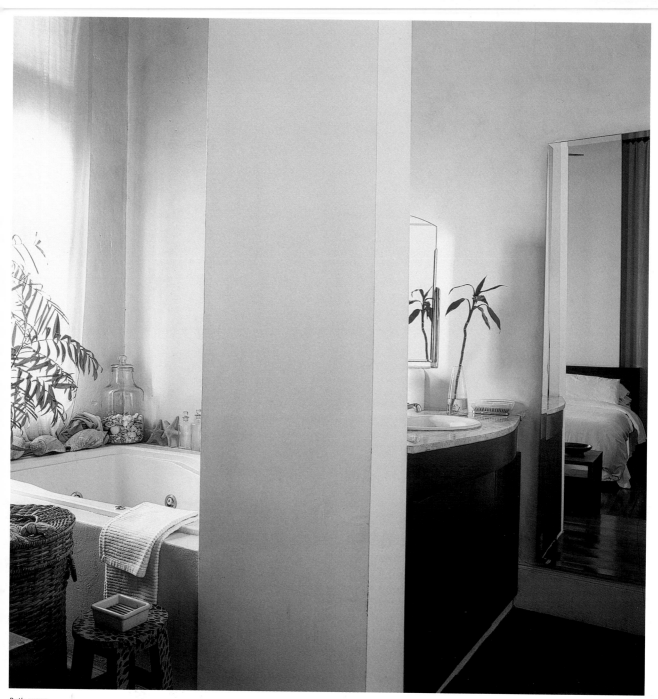

Both pages
Design by Pablo Chiaporri
Photo © Virginia del Guidice

Materials >>>>>>>

Bathroom surface materials should be not only practical and decorative but must also be highly resistant to the substances they come in contact with. Today's designers use materials such as cement, metal and glass, which are generally quite robust and impressive looking.

Wood is also a material that is frequently used for bathrooms, mainly in furnishings. This natural material has the capacity to create a warm atmosphere in any room. Inasmuch as the high oil content of tropical woods such as Bolondo, Merbau, Wengue and Teak renders them impervious to water, they are particularly suitable for surfaces that are exposed to dampness. Other types of wood such as cherry, oak, beech and cedar can also be used in bathrooms if their surfaces are treated with specialized products. Moreover, the fact that wood is available in a range of tones allows for the creation of both classic and modern interior design styles.

The excellent water resistance and outstanding robustness of marble and ceramic make these materials particularly suitable for use in bathrooms as well. Marble in particular lends bathrooms a great deal of character and is thus the material of choice for elegant decors. One problem with marble is that it tends to look rather cold, but this characteristic can be mitigated by combining marble with other materials.

Designers are also fond of using mosaic tiles in bathrooms. This material is composed of numerous small ceramic or glass tiles that are optimal for use in areas that are often exposed to water. The most commonly used mosaic tiles are 1.5 x 1.5 cm, though numerous other sizes are available.

> Bathroom surface materials should be not only practical and decorative but must also be highly resistant to the substances they come in contact with.

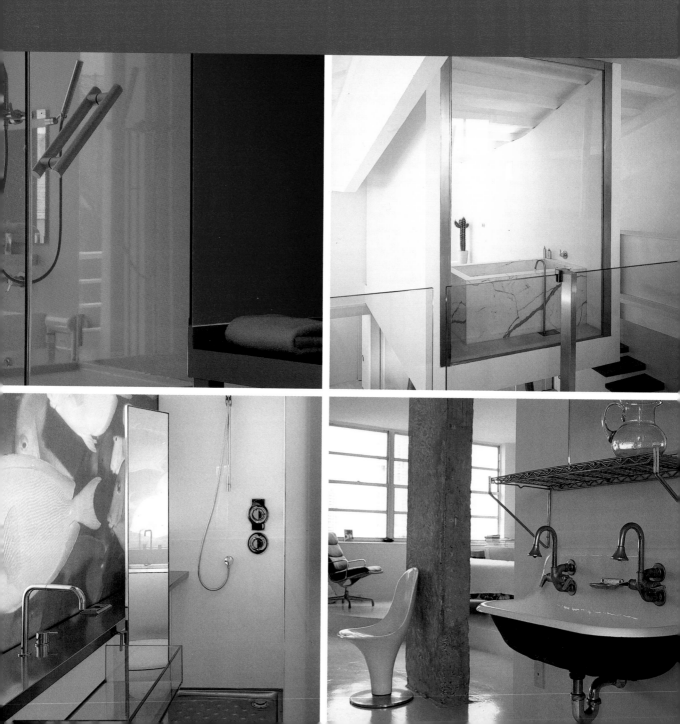

Materialien

Die Oberflächenmaterialien des Badezimmers sollten nicht nur praktisch und dekorativ sein, sie müssen auch eine hohe Widerstandsfähigkeit aufweisen. Moderne Designs experimentieren heutzutage mit Materialien wie Zement, Metall und Glas. In der Regel sind diese Materialien sehr robust und erzeugen spektakuläre Effekte.

Ein besonders häufig verwendetes Material, vor allem für Badezimmermöbel, ist Holz. Es ist ein natürliches Material, das in der Lage ist, jedem Raum eine warme Ausstrahlung zu verleihen. Für den Nassbereich sind besonders Tropenhölzer wie Iroco, Bolondo, Merbau, Wengue und Teak geeignet. Durch ihren hohen Fettgehalt sind sie gegen Wassereinwirkung unempfindlich. Aber auch andere Holzarten wie Kirschbaum, Eiche, Buche und Zeder sind gut verwendbar, sofern sie einer speziellen Oberflächen-behandlung unterzogen werden. Da Holz in unterschiedlichen Farbtönen erhältlich ist, kann man sowohl klassische, als auch moderne Stilrichtungen kreieren.

Marmor und Keramik sind wegen ihrer hohen Widerstandsfähigkeit und Wasserresistenz für den Einsatz im Badezimmer prädestiniert. Besonders Marmor vermittelt einen anspruchsvollen Charakter und wird daher bevorzugt für elegante Ambiente verwendet. Ein generelles Problem bei der Verwendung dieser Materialien ist jedoch ihr kaltes Erscheinungsbild, dem man jedoch durch die Kombination mit wärmeren Materialien entgegenwirken kann.

Auch Mosaikkacheln werden gerne im Bad eingesetzt. Sie bestehen aus einer Vielzahl von kleinen Teilchen aus Keramik oder Glas, die optimal für Bereiche sind, die oft mit Wasser in Berührung kommen. Die am weitest verbreiteten Mosaikkacheln haben eine Größe von 1,5 x 1,5 cm, sie werden jedoch auch in anderen Größen hergestellt.

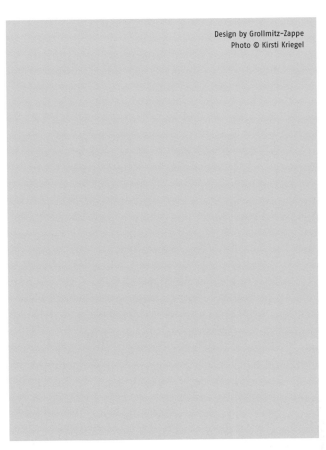

Design by Grollmitz-Zappe
Photo © Kirsti Kriegel

Design by Archikubik
Photo © Eugeni Pons

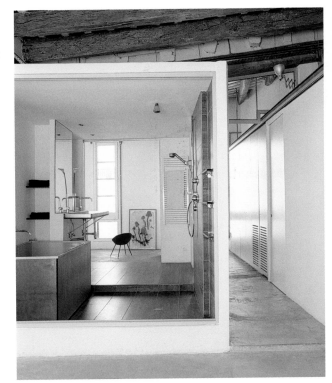

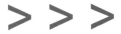

Matériaux

Les matériaux de revêtement pour salles de bains doivent être pratiques, décoratifs, certes, mais également résistants. Le design moderne utilise aujourd'hui des matériaux tels que le ciment, le métal et le verre. En général, ces matériaux sont très robustes et produisent des effets spectaculaires.

Le bois est un matériau souvent employé, pour le mobilier de salles de bains en particulier. C'est un matériau naturel qui crée une ambiance chaleureuse dans la pièce où il est. Dans la salle d'eau, on utilise fréquemment les bois tropicaux tels que l'iroko, le bolondo, le merbau, le wengué et le teck. Grâce à leur forte teneur en huiles, ils résistent à l'action de l'humidité. Mais on utilise également d'autres sortes de bois comme le cerisier, le chêne, le hêtre et le cèdre, à condition d'en traiter la surface. Le bois se présente dans des teintes différentes, ce qui permet toutes les variations de style possibles, classiques ou modernes.

Le marbre et la céramique, dotés d'une grande robustesse et résistance à l'eau, sont idéals pour les salles de bains. Le marbre en particulier, aux qualités prestigieuses, est la matière par excellence pour créer une ambiance élégante. Le problème général qui accompagne l'utilisation de ces matières, c'est la froideur qu'elle dégage. Mais on peut la contrecarrer en les combinant avec des matériaux plus chaleureux.

Les carreaux de mosaïque sont très appréciés dans les salles de bains. Ce sont de nombreux petits carreaux de verre ou de céramique, parfaits pour les zones qui sont souvent en contact avec l'eau. Les carreaux de mosaïques, les plus fréquemment utilisés, sont en général de 1,5 x 1,5 cm, mais peuvent être fabriqués dans des dimensions plus grandes.

Design by Himmel Haus, Andrea Held
Photo © Nacása & Partners

Design by Ellen Woolley, Peter Tonkin
Photo © Richard Glover

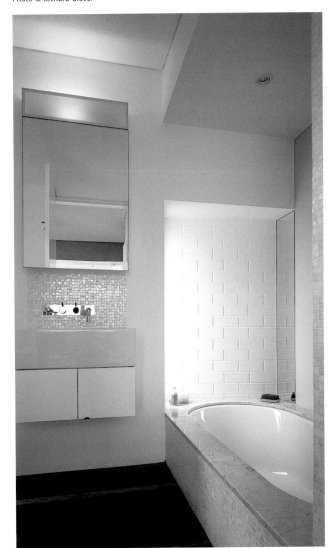

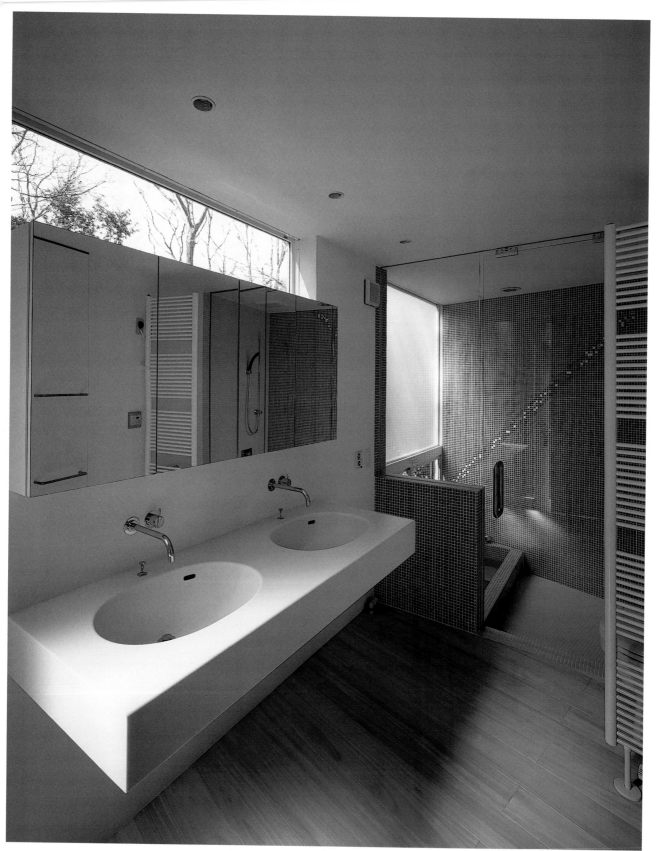

Materiales

Los materiales y revestimientos del cuarto de baño no sólo deben ser prácticos y decorativos, sino también extremadamente resistentes. Los diseñadores modernos experimentan hoy en día con materiales como el cemento, el metal y el cristal, que suelen ser fuertes y, desde el punto de vista decorativo, resultan muy efectistas.

Un material muy usado en los cuartos de baño, sobre todo para los muebles, es la madera. Este material es natural y por ello capaz de dar a cualquier habitación un ambiente cálido. Para la zona húmeda son especialmente aconsejable las maderas tropicales como el iroco, el bolondo, el merbau, el wengue y la teca. Gracias a su alto contenido oleaginoso resultan muy resistentes al agua. Pero también otros tipos como el cerezo, el roble, el haya y el cedro resultan adecuados para el cuarto de baño siempre que hayan recibido un tratamiento adecuado. La madera se puede encargar en diversos tonos, lo que permite elegir entre estilos clásicos o modernos.

El mármol y la cerámica son perfectos para la decoración de los cuartos de baño por su gran resistencia e impermeabilidad. El mármol, en especial, satisface a los más exigentes y por ello suele elegirse para crear ambientes elegantes. El inconveniente que presenta es una apariencia fría; sin embargo, este efecto puede mitigarse si se combina con otros materiales más cálidos.

Las baldosas de mosaico son también muy apreciadas en la decoración de baños. Formadas por pequeñas teselas de cerámica o cristal, resultan ideales para aquellas superficies que se mojan a menudo. Las más utilizadas suelen tener un tamaño de 1,5 x 1,5 cm, aunque se fabrican en varias medidas.

Design by B & B Estudio de Arquitectura, Sergi Bastidas
Photo © Pere Planells

Photo © Alberto Piovano

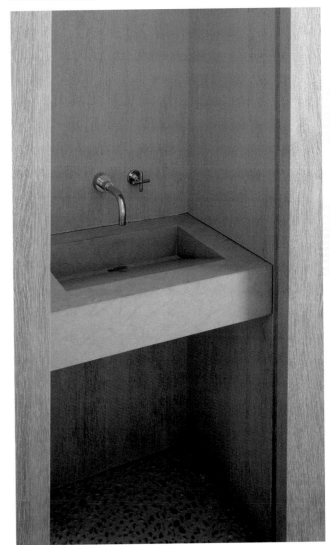

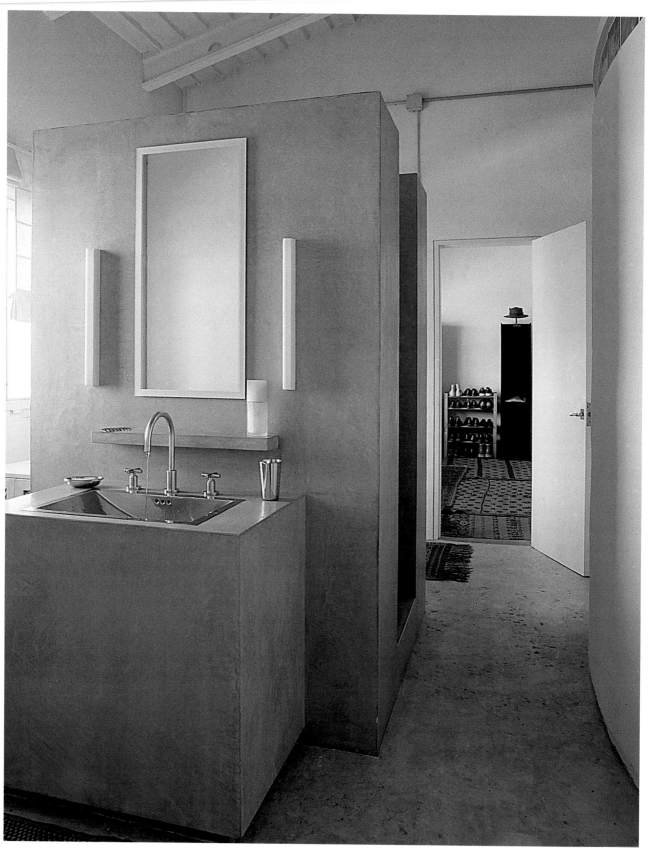

Materiali

I materiali adoperati per il rivestimento del bagno dovranno non solo essere pratici e decorativi ma dovranno anche distinguersi per un'alta resistenza. Oggigiorno, i design moderni sperimentano con materiali quali cemento, metallo e vetro. Normalmente, questi materiali sono molto robusti ed in grado di produrre degli effetti spettacolari.

Un materiale utilizzato particolarmente spesso, sopratutto per i mobili dei bagni, è il legno. Si tratta di un materiale naturale che è in grado di conferire ad ogni ambiente un aspetto caldo ed accogliente. Particolarmente adatti per la zona bagni sono legni tropicali quali iroco, bolondo, merbau, wengue e teak. Grazie al loro alto contenuto di grassi, essi sono resistenti agli effetti dell'acqua. Ma si prestano bene anche altri tipi di legno, come ciliegio, quercia, faggio e cedro, purché essi vengano sottoposti a trattamenti speciali delle superfici. Poiché il legno è disponibile in tonalità diverse si potranno creare degli arredamenti in stile sia classico che moderno.

Il marmo e la ceramica, grazie alla loro alta robustezza e resistenza all'acqua, sono materiali predestinati all'impiego nei bagni. In particolare il marmo trasmette una sensazione di lusso e per questo motivo viene utilizzato prevalentemente per ambienti eleganti. Tuttavia, il problema comune di questi materiali è il loro carattere freddo che si cerca di attenuare, abbinandoli ad altri materiali più caldi.

Spesso e volentieri vengono anche utilizzate nei bagni le piastrelle a mosaico. Sono composte da un gran numero di piccole tessere in ceramica od in vetro e si prestano benissimo per tutte le zone che sono spesso in contatto con l'acqua. Le piastrelle di mosaico utilizzate in maggioranza sono della dimensione 1,5 x 1,5 cm; tuttavia si trovano anche formati diversi.

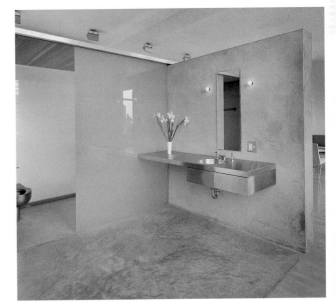

Design by Mark Guard
Photo © John Bennett

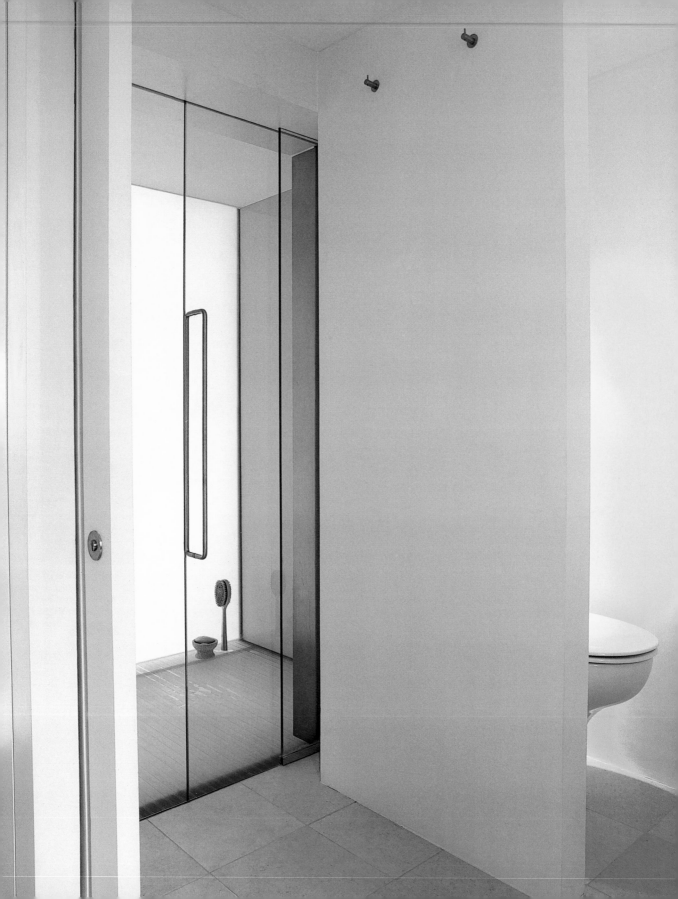

Metal

Metal is an innovative material that has taken on increasing importance through its use in modern designs. In addition to its robustness and water resistance, metal also allows for the creation of dynamic designs.

Metall ist ein innovatives Material, das gerade durch moderne Designs an Bedeutung gewonnen hat. Abgesehen von seiner Widerstandsfähigkeit und Wasserresistenz, ermöglicht Metall interessante Gestaltungsmöglichkeiten.

Le métal est un matériau innovant, qui grâce au design moderne, connaît un regain d'intérêt. Résistant à l'eau et robuste, il permet aussi de concevoir des d'agencements intéressants.

El metal es un material innovador que ha ganado gran protagonismo en el diseño moderno. Además de su gran resistencia e impermeabilidad, este elemento ofrece muchas posibilidades de obtener interesantes creaciones.

Il metallo è un materiale innovativo che ha aumentato la sua importanza proprio grazie ai design moderni. Oltre alla sua robustezza e resistenza all'acqua, il metallo consente di realizzare delle creazioni interessanti.

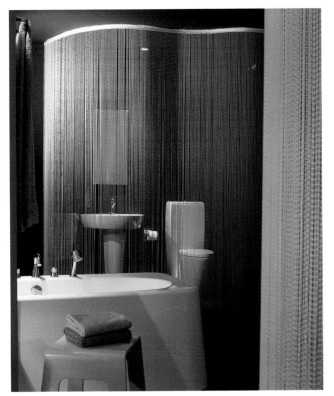

Design by Augusto Le Monnier
Interior design by Lorna Agustí, Natalia G. Novelles
Photo © Nuria Fuentes

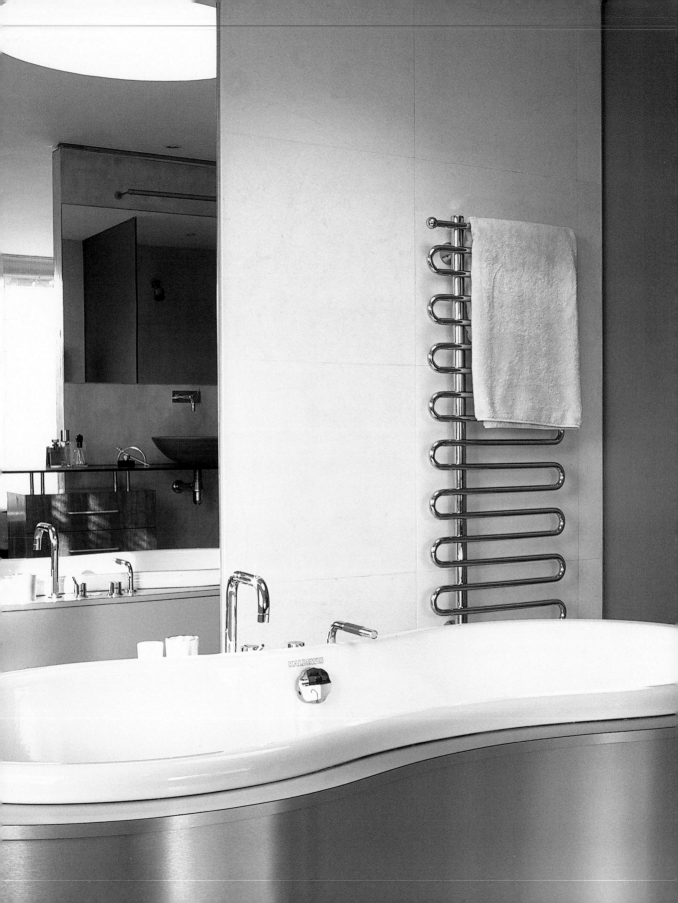

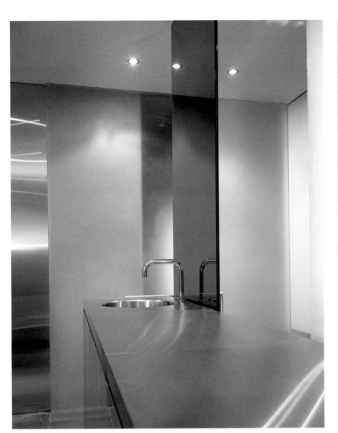

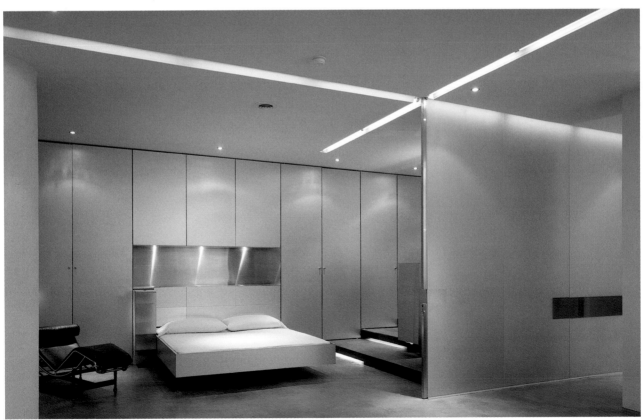

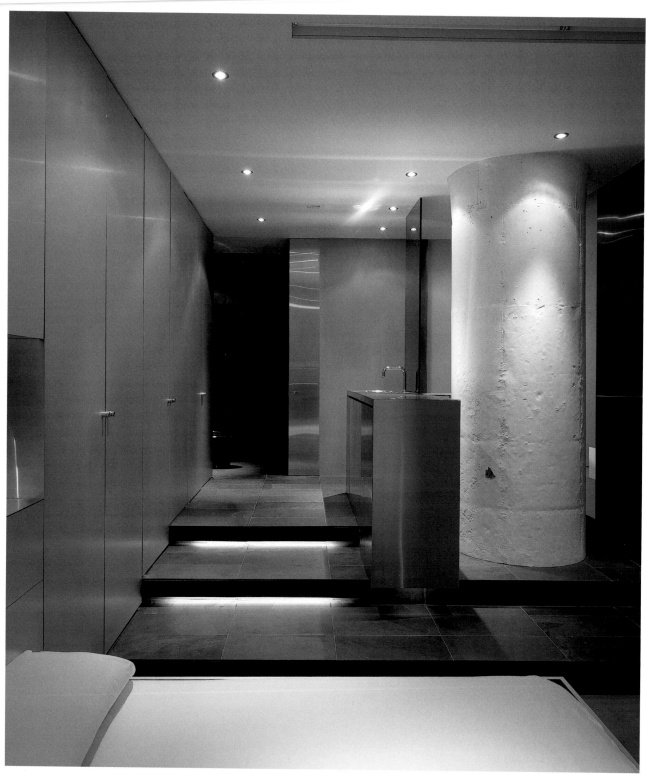

Both pages
Design by Johnson Chou
Photo © Volker Seding Photography

Both pages
Design by Grollmitz-Zappe
Photo © Kirsti Kriegel

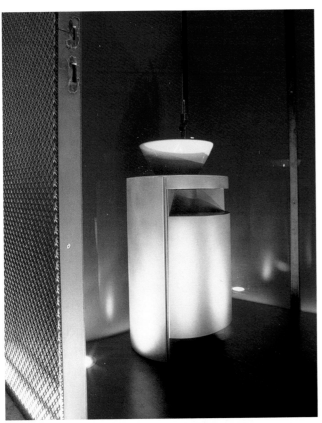

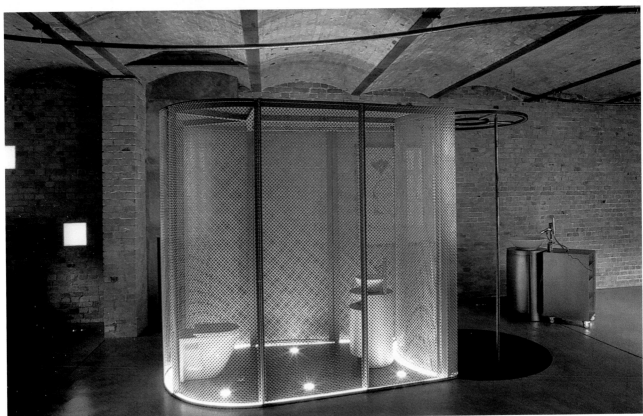

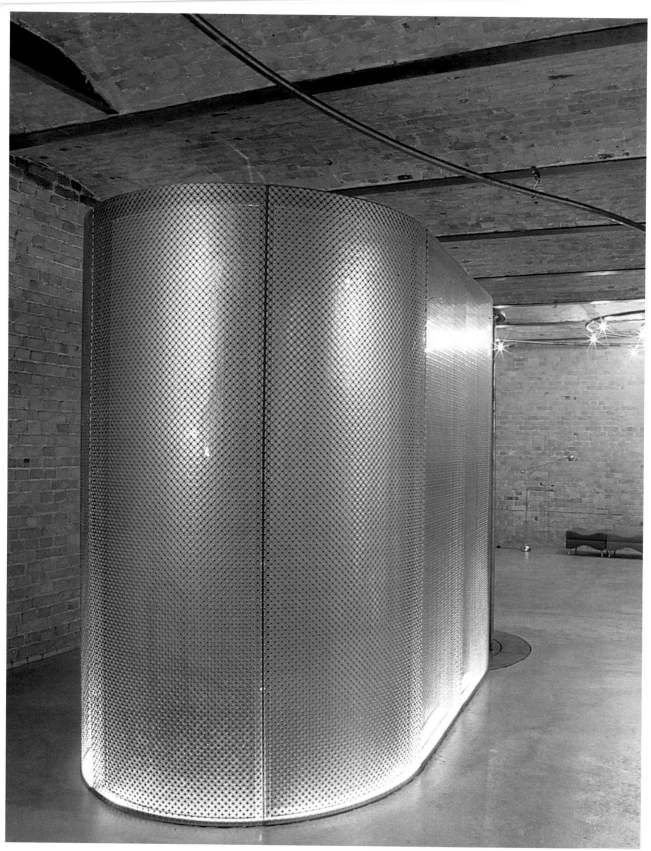

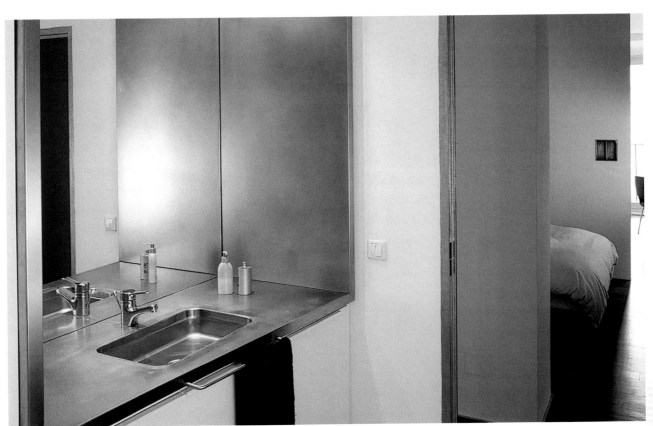

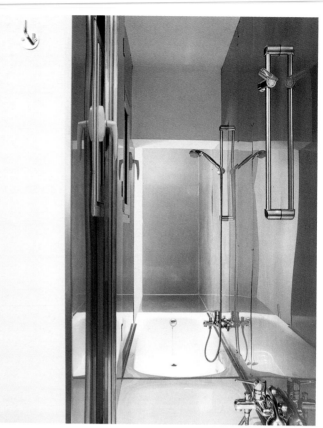

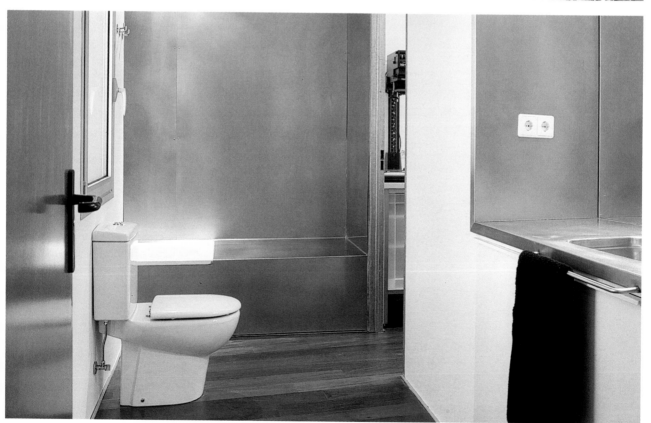

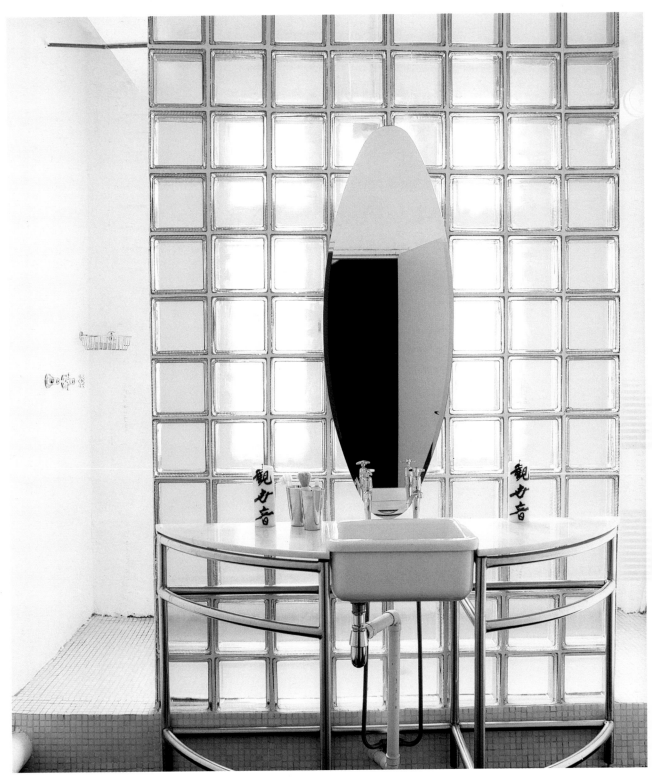

Design by Craig Port
Photo © Ken Hayden/Red Cover

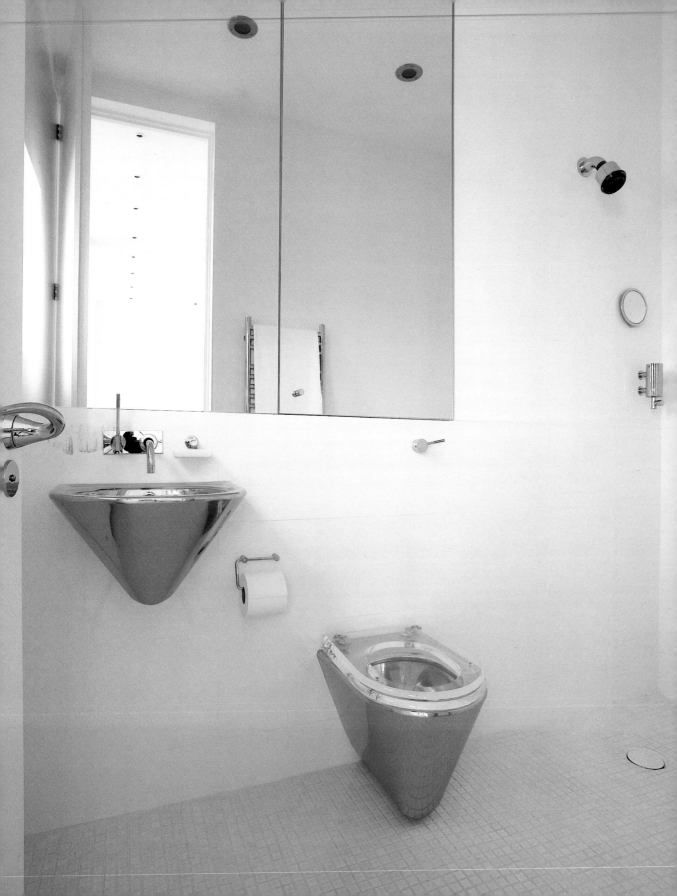

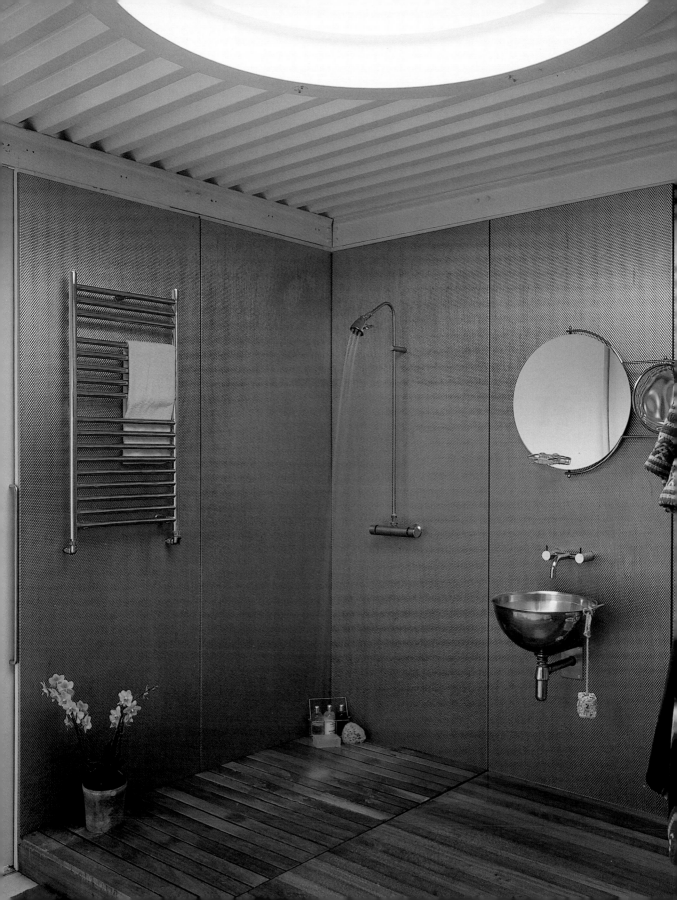

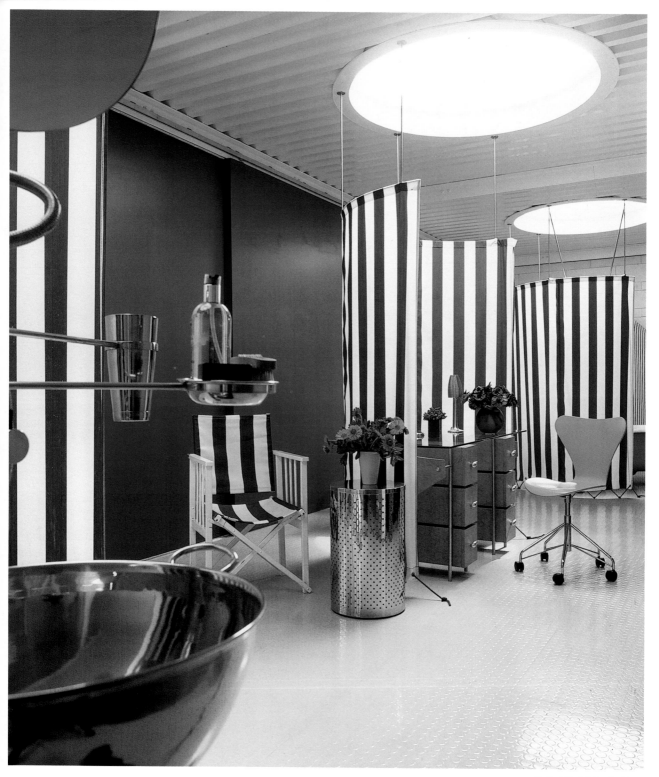

Design by Paula Pryke

Glass

Both pages
Design by Desai/Chia Studio
Photo © Joshua McHugh

Glass is a highly versatile material. Being water resistant, tinted glass is particularly suitable as a screening element or for making a bathroom seem lighter.

Glas ist ein sehr vielseitig verwendbares Material. Aufgrund seiner Resistenz gegen Wasser eignet sich getöntes Glas besonders für die Verwendung als Sichtschutz oder um Badezimmer optisch aufzuhellen.

Le verre est un matériau d'utilisation polyvalente. Très résistant à l'eau, le verre teinté est particulièrement indiqué comme écran visuel ou pour illuminer la salle de bain.

El cristal es un material muy versátil. Gracias a su gran resistencia al agua, el vidrio tintado resulta especialmente adecuado para hacer paneles de separación que protejan ciertas zonas de la vista o para lograr el efecto óptico de claridad en un cuarto de baño oscuro.

Il vetro è un materiale utilizzabile in modo molto versatile. Grazie alla sua resistenza all'acqua, il vetro colorato si presta particolarmente bene come schermo alla vista, oppure per rendere il bagno più luminoso.

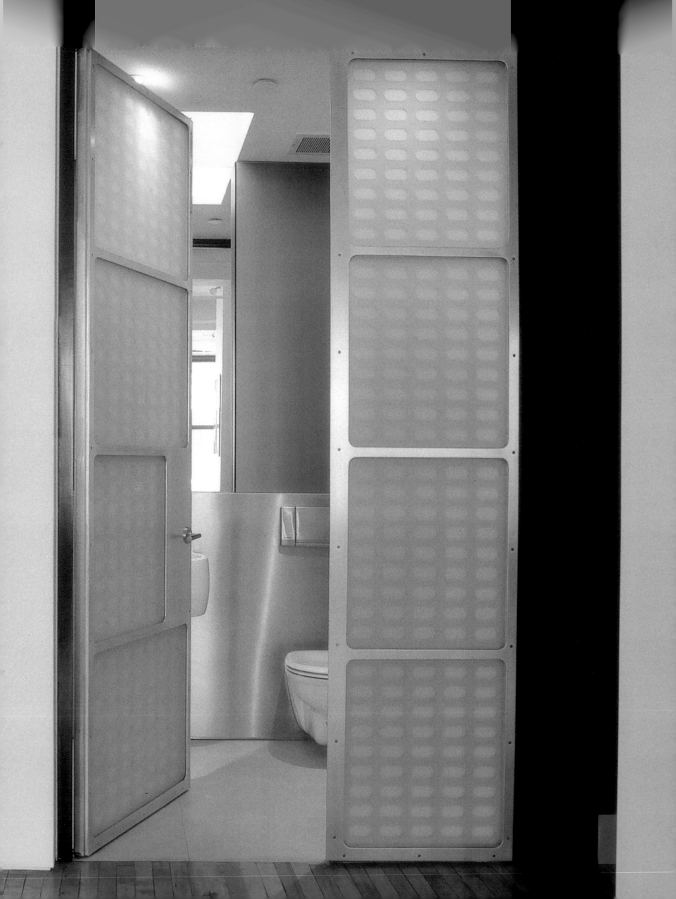

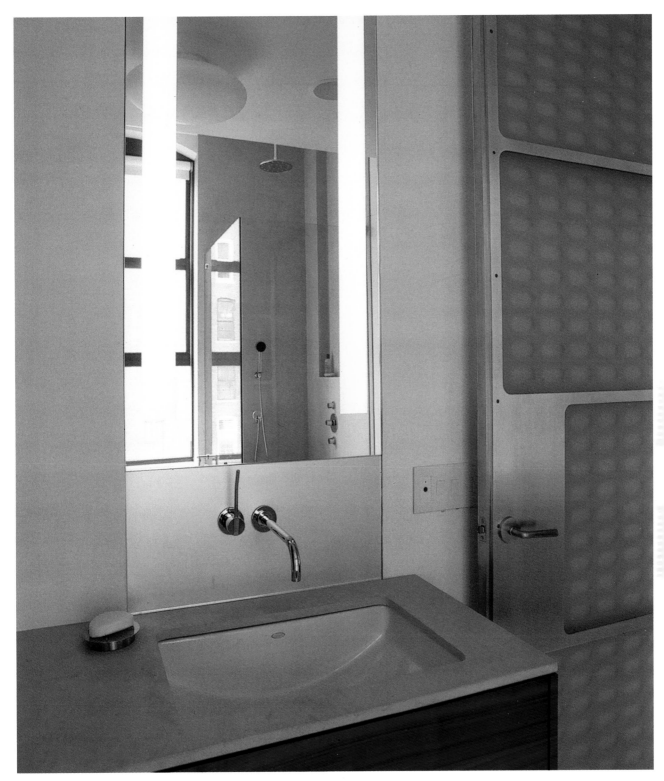

Design by Desai/Chia Studio
Photo © Joshua McHugh

Design by AVI Architekten
Photo © Michael Heinrich

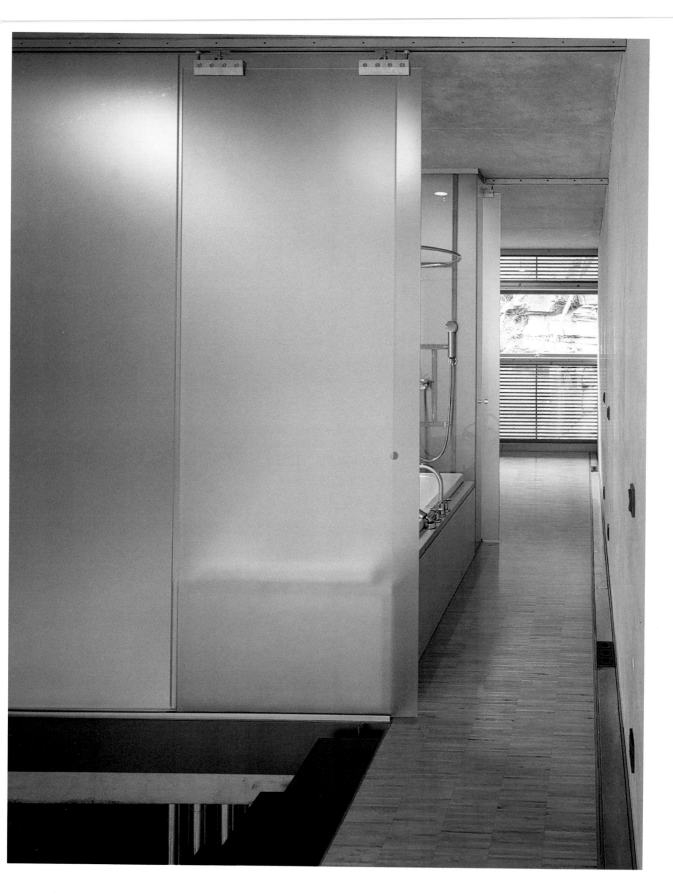

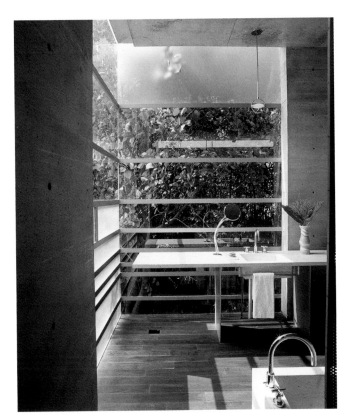

Both photos
Design by Alberto Kalach
Photo © Undine Pröhl

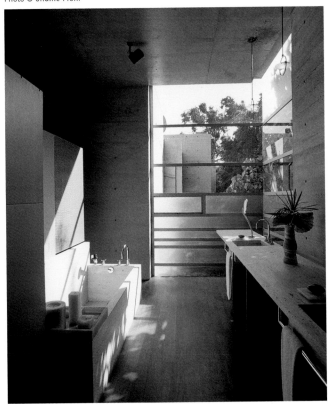

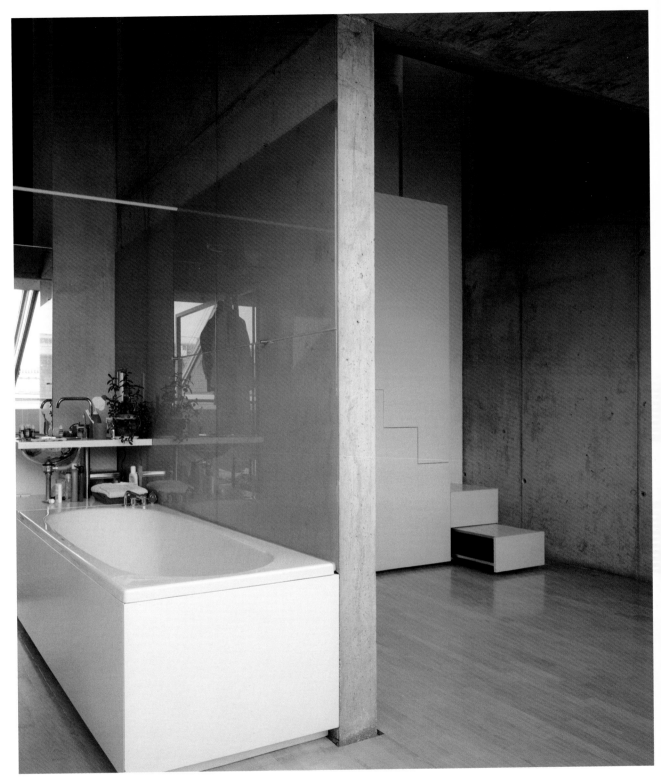

Design by Lichtblau.Wagner Architekten
Photo © Bruno Klomfar

Photo © Jordi Sarrà

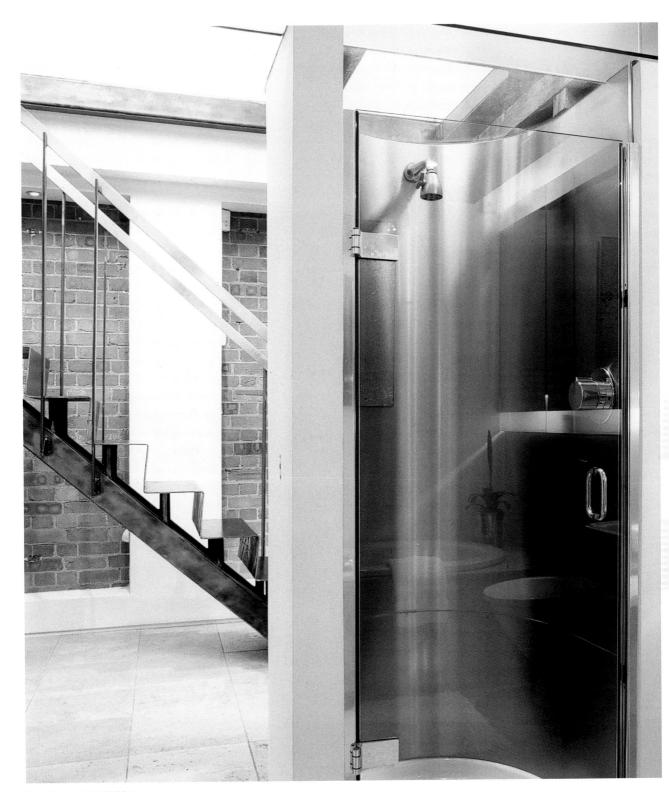

Design by Rachline Hanon

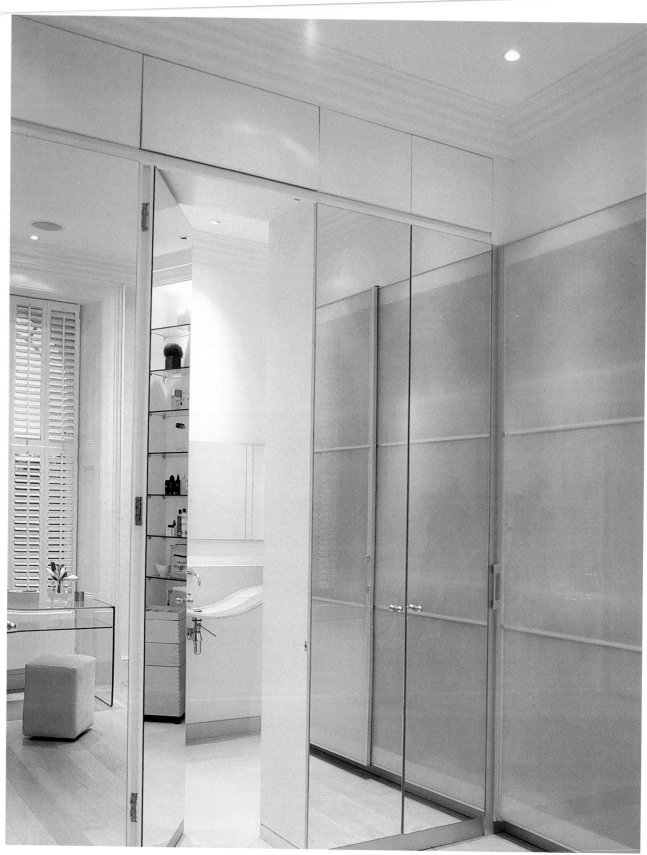

Wood

Design by Didier Gomez
Photo © Chris Tubbs/Red Cover

Wood is a versatile material with the capacity to create a warm and natural atmosphere in any room. All non-tropical woods must be treated to make them resistant to the water in the bathroom.

Holz ist ein vielfach verwendetes Material, das jedem Raum eine warme und natürliche Ausstrahlung verleiht. Abgesehen von Tropenhölzern sollte die Oberfläche jedoch gegen die Feuchtigkeit im Bad behandelt werden.

Le bois est un matériau polyvalent, qui, dans une pièce, crée une atmosphère chaleureuse. A l'exception des bois tropicaux, il faut traiter la surface du bois contre l'humidité inhérente à la salle de bains.

La madera es un material usado de muy diversas formas que dota cualquier espacio de una atmósfera cálida y natural. Con excepción de las variedades tropicales, la madera debe ser tratada contra la humedad del baño.

Il legno è un materiale ampiamente adoperato che conferisce ad ogni ambiente un carattere caldo e naturale. Tuttavia, le superfici in legno, con esclusione di quelle in legno tropicale, dovrebbero essere trattate contro l'umidità presente nel bagno.

Design by Annie Stevens
Photo © Jake Fitzjones/Red Cover

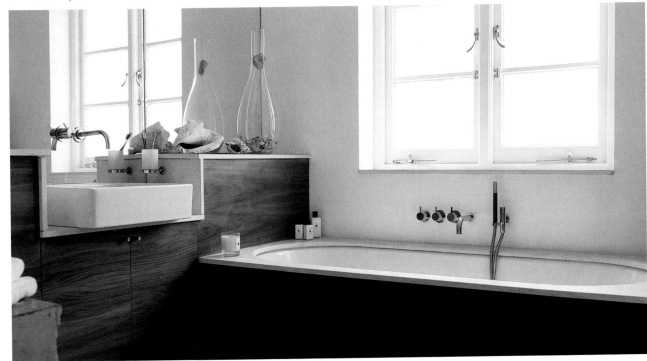

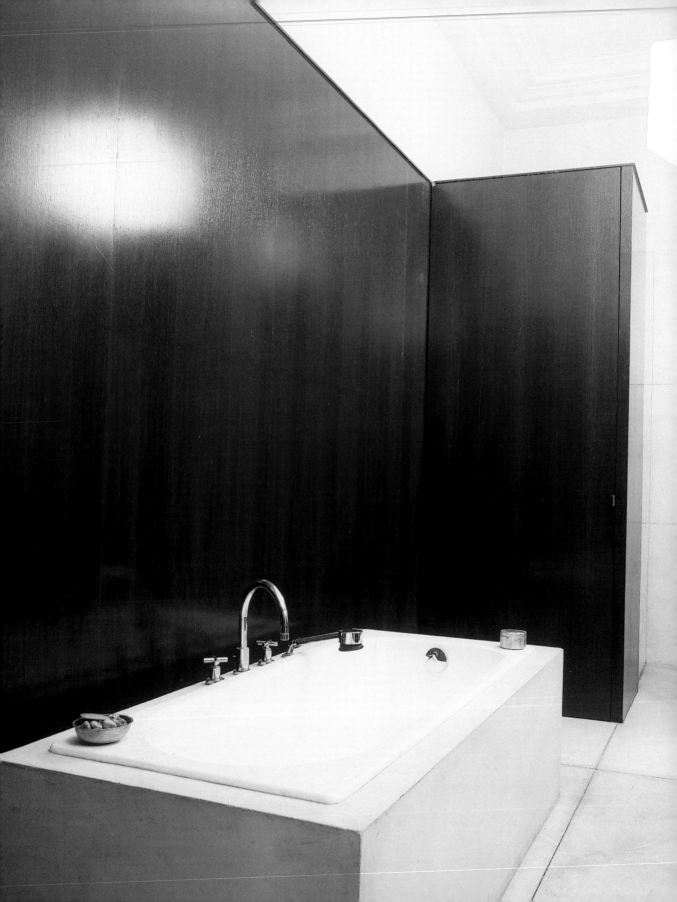

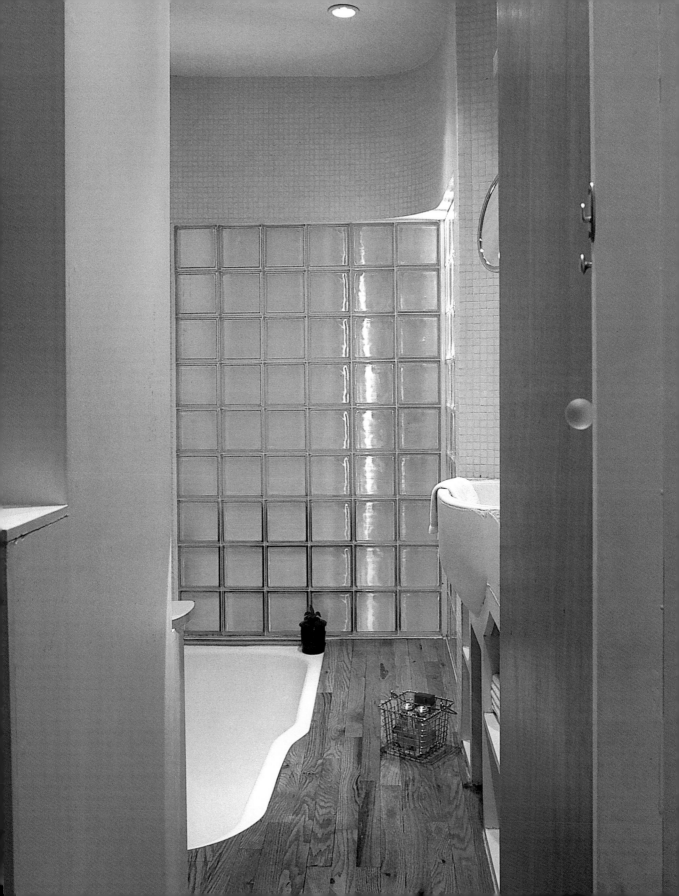

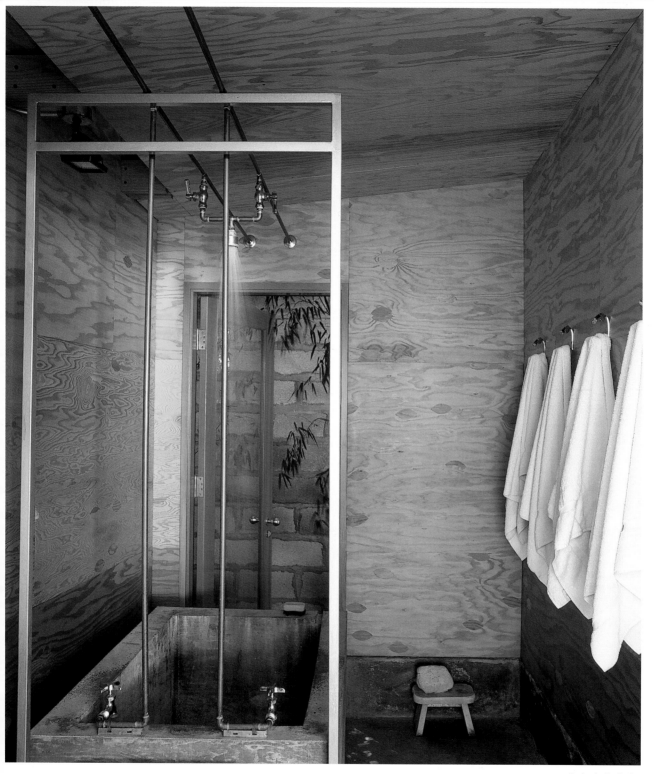

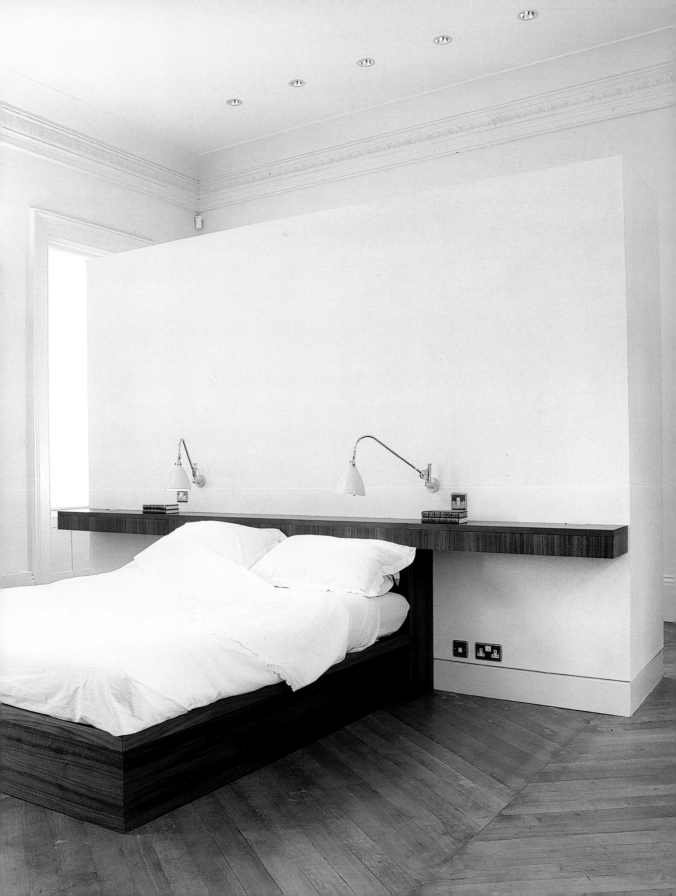

Both pages
Design by Hugh Broughton
Photo © Carlos Domínguez

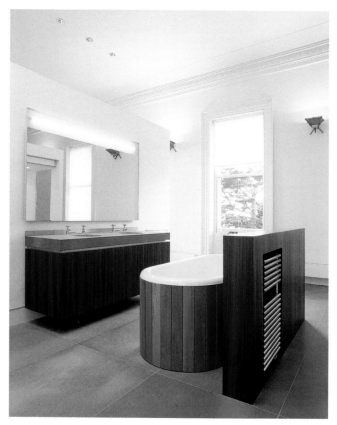

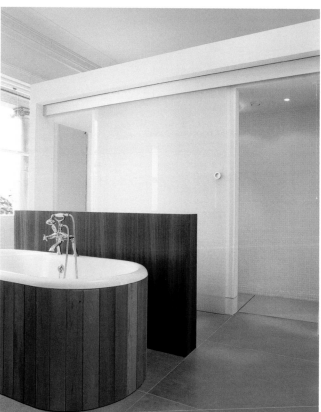

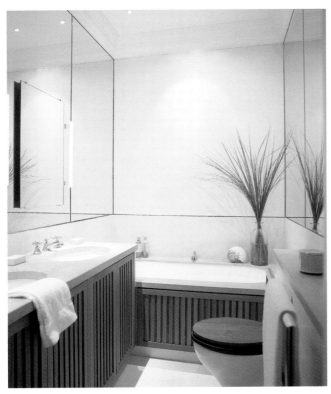

Photo © Ken Hayden/Red Cover

Design by Legorreta Architects
Photo © Undine Pröhl

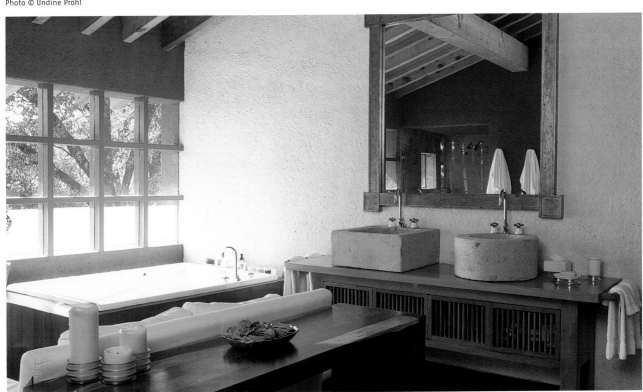

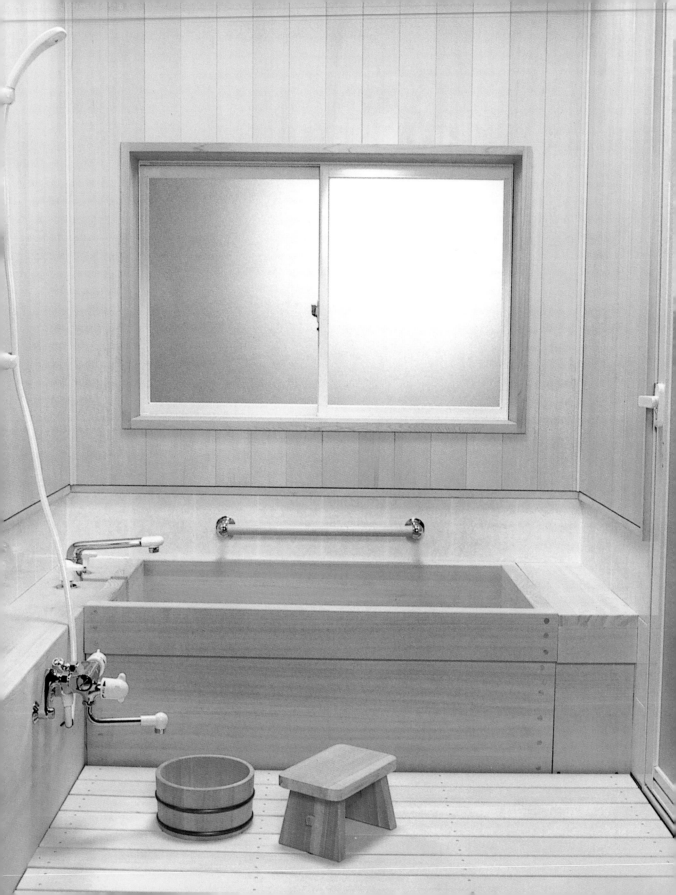

Design by Michael Carapetian
Photo © Andrea Martiradonna

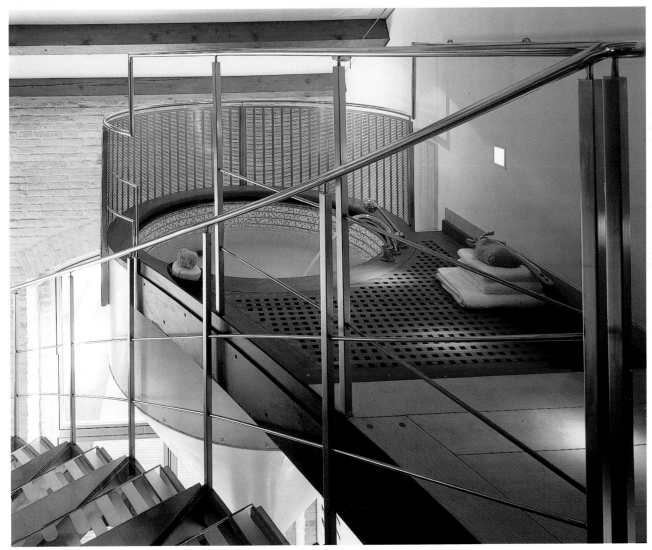

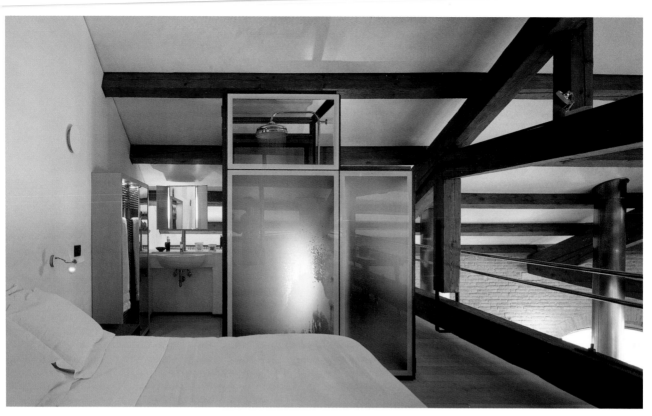

Both photos
Design by Michael Carapetian
Photo © Andrea Martiradonna

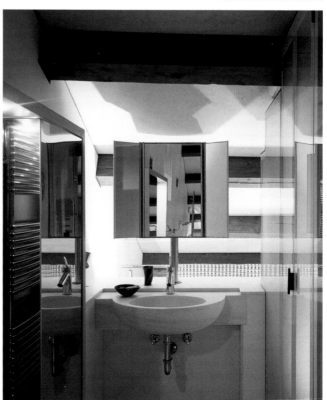

Marble and ceramic

The water and steam resistance of marble and ceramic makes these materials highly suitable for use in bathrooms. Marble also creates a particularly elegant and sophisticated atmosphere.

Marmor und Keramik sind unempfindlich gegenüber Wasser und Dampf und daher besonders für den Einsatz im Badezimmer geeignet. Marmor vermittelt dabei einen besonders eleganten und anspruchsvollen Charakter.

Le marbre et la céramique, insensibles à l'eau et à la vapeur, sont idéals pour la salle de bains. Le marbre est particulièrement élégant et noble.

El mármol y la cerámica son impermeables al agua y al vapor, y por ello resultan especialmente indicados para el cuarto de baño. El mármol tiene un carácter especialmente noble y elegante.

Grazie alla loro resistenza all'acqua ed al vapore, il marmo e la ceramica sono materiali particolarmente adatti per essere impiegati nel bagno. Sopratutto il marmo trasmette una sensazione elegante ed esclusiva.

Design by Karlos Bayón
Photo © Nuria Fuentes

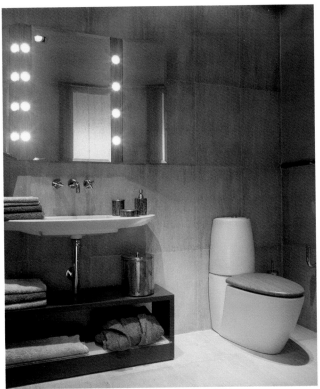

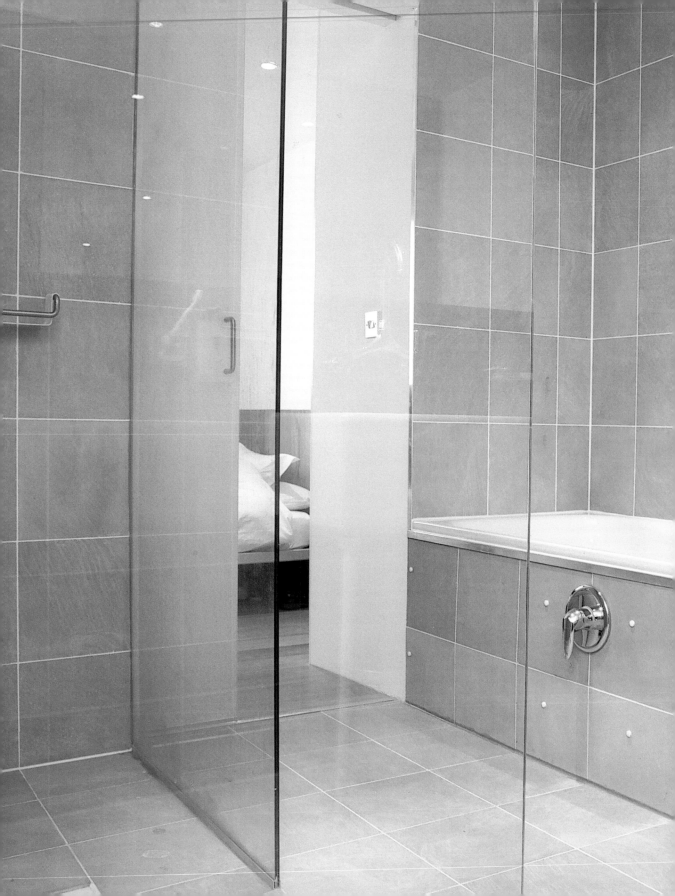

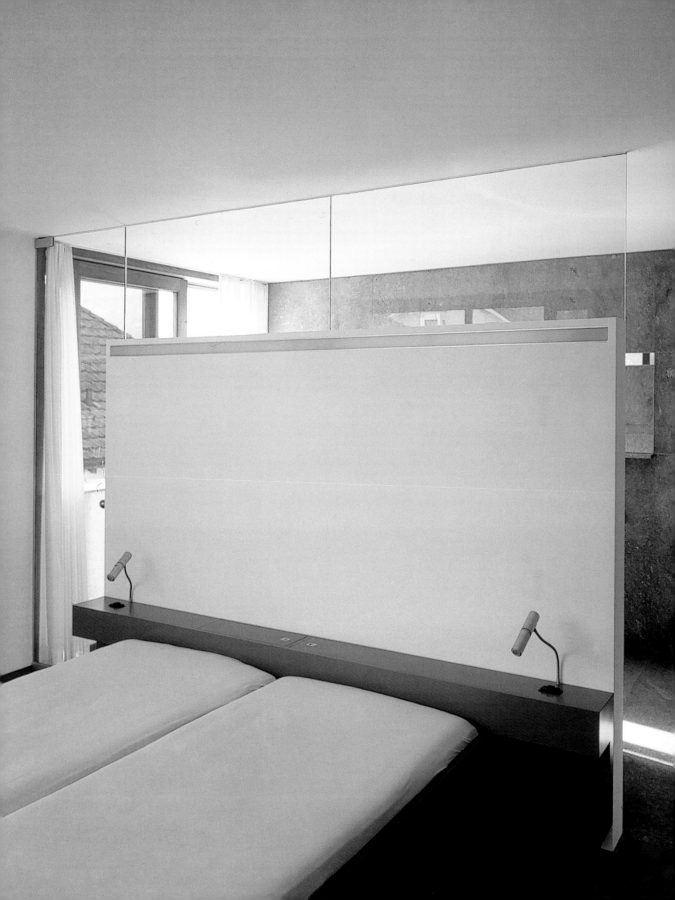

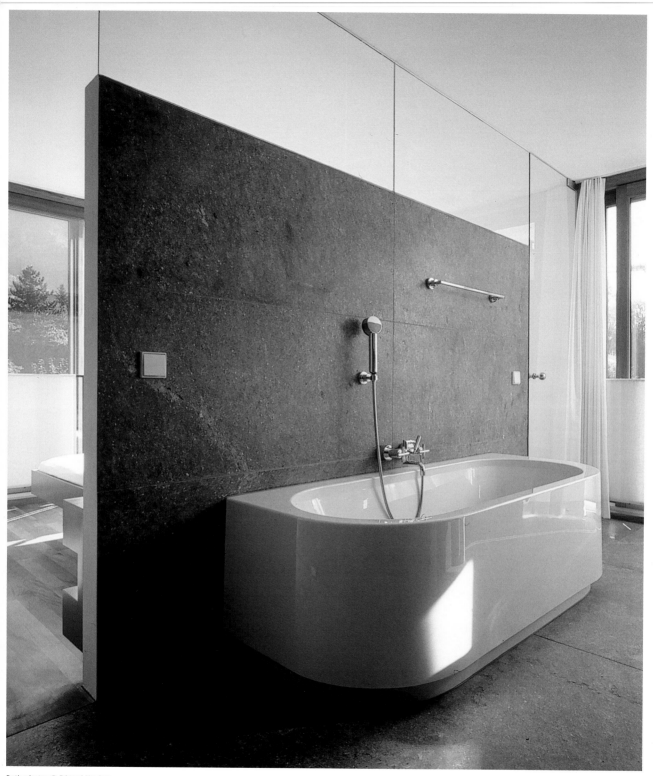

Both photos © Eduard Hueber

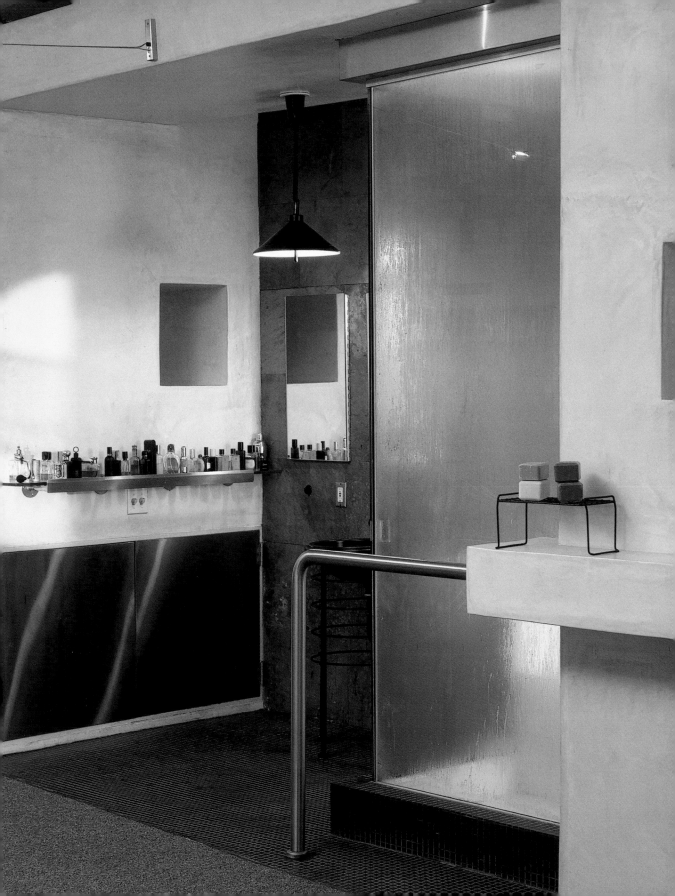

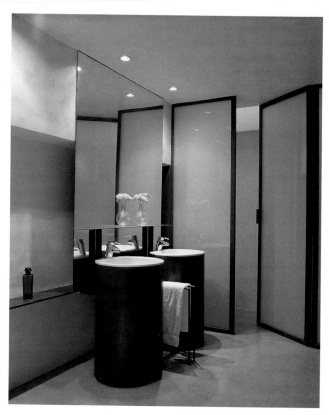

Both photos
Design by Dorotea Oliva
Photo © Eugeni Pons

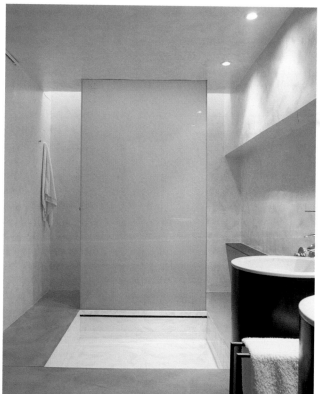

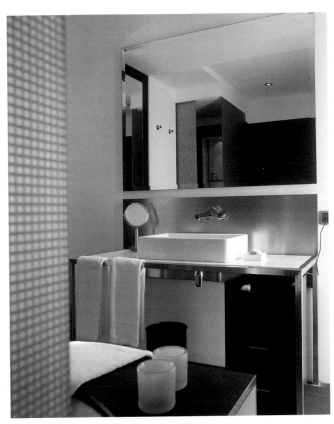

Photos © Nuria Fuentes

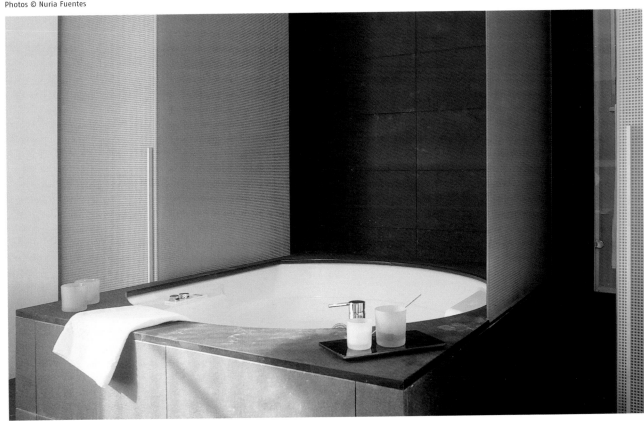

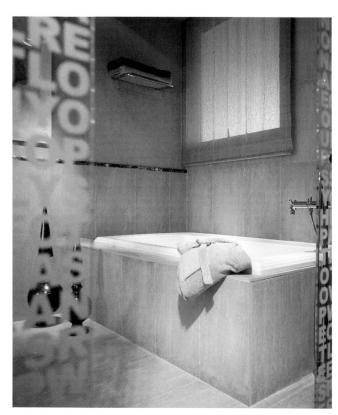

Both photos
Design by Karlos Bayón
Photos © Nuria Fuentes

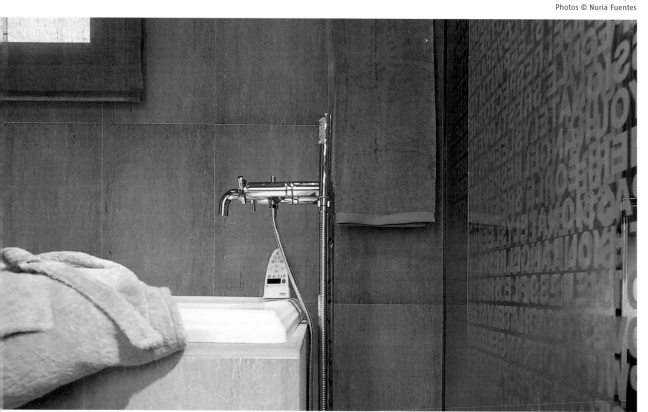

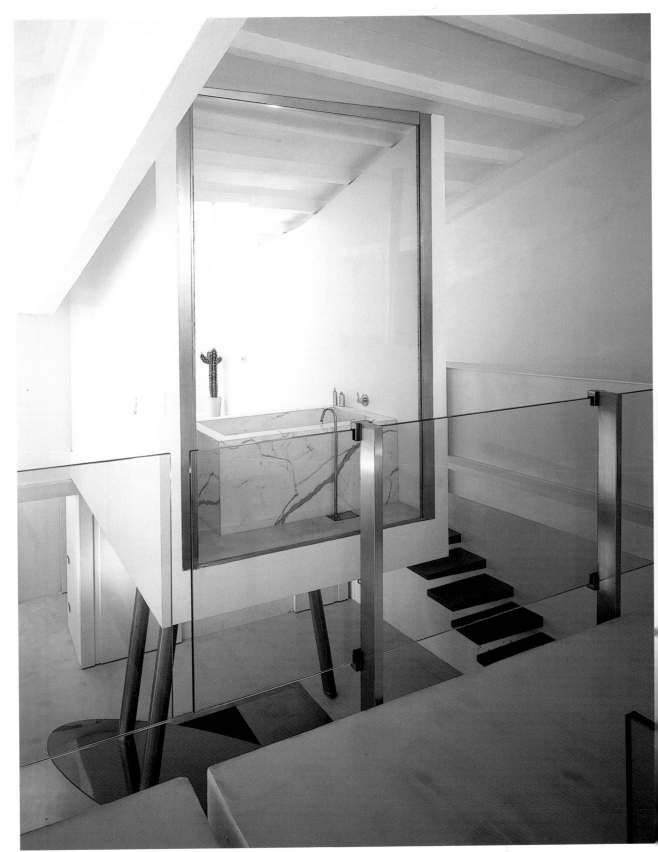

Both pages
Design by Attilio Stocchi
Photo © Andrea Martiradonna

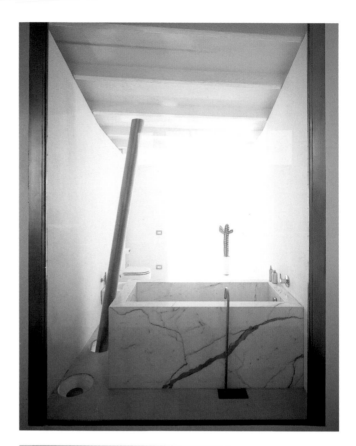

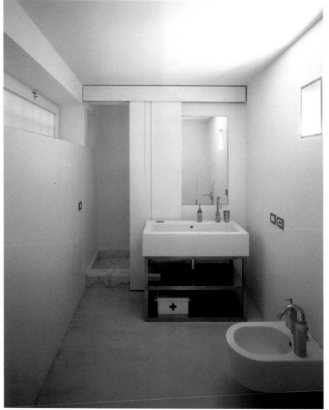

Both pages
Stylism by Silvia Rademakers, Virginia Palleres
Photos © José Luis Hausmann

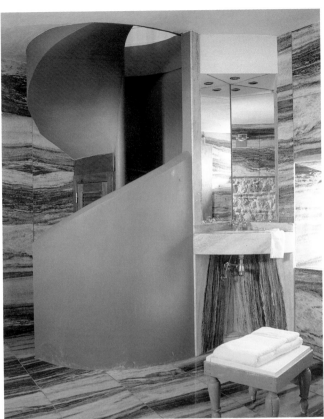

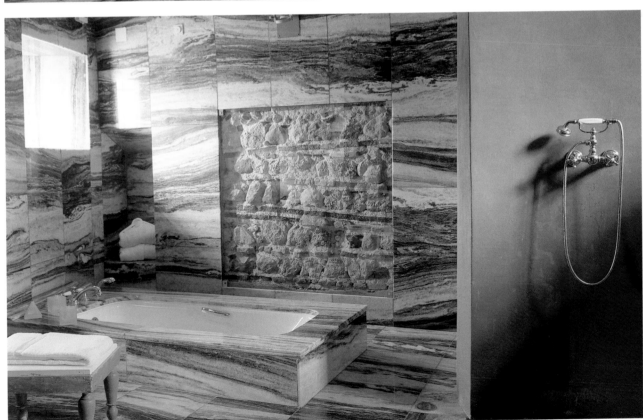

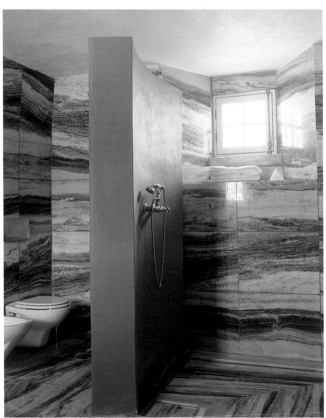

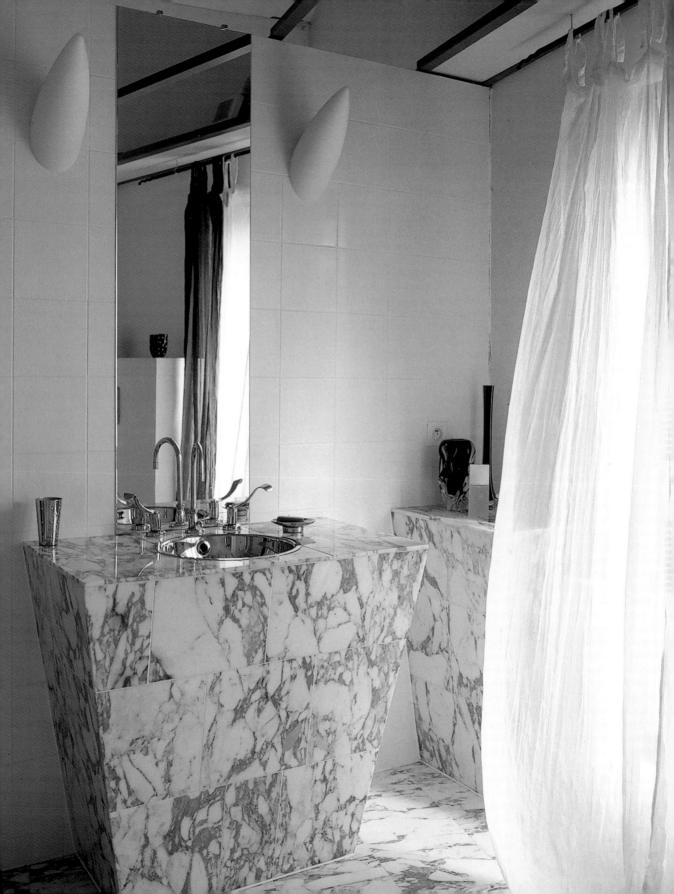

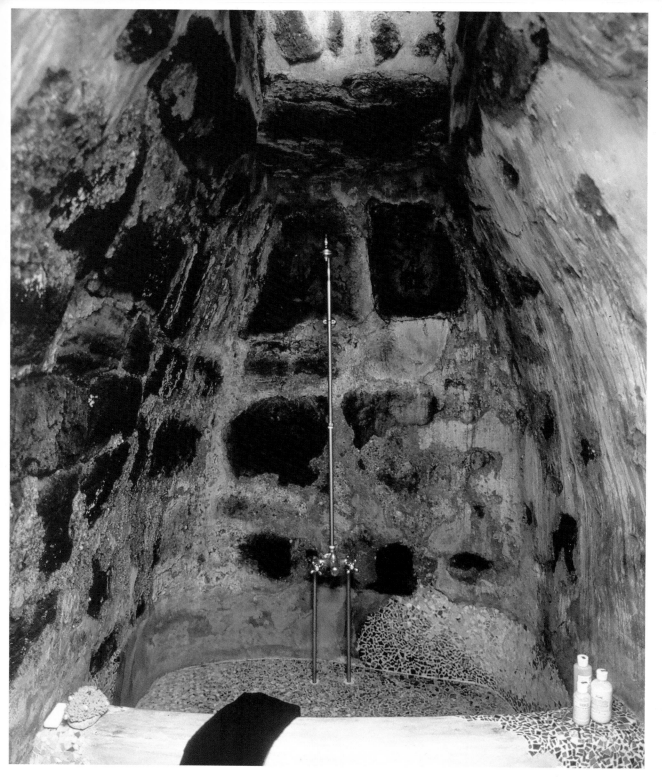

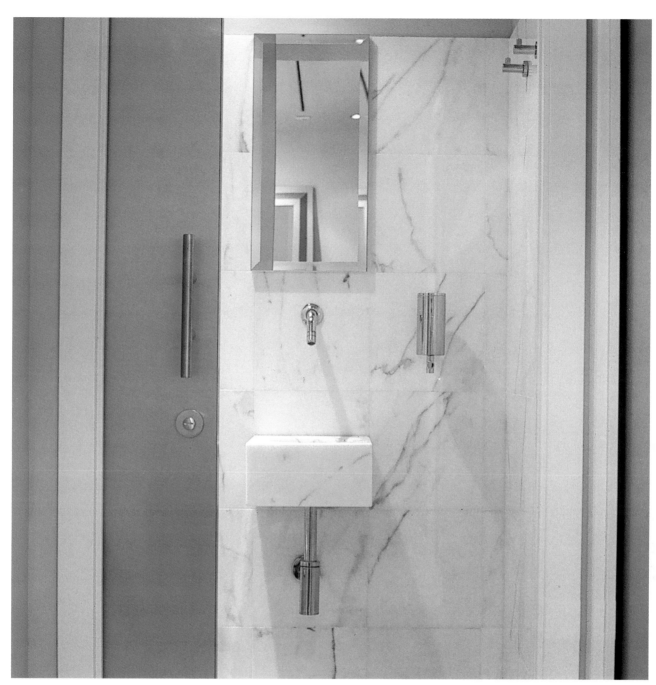

Both pages
Design by Chris Redfern, Christina Di Carlo
Photo © Santi Caleca

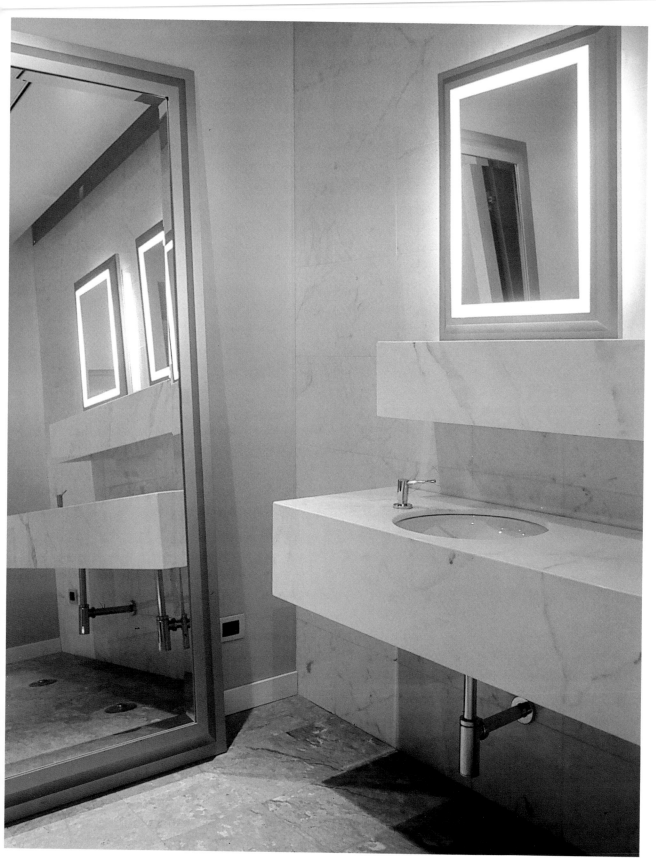

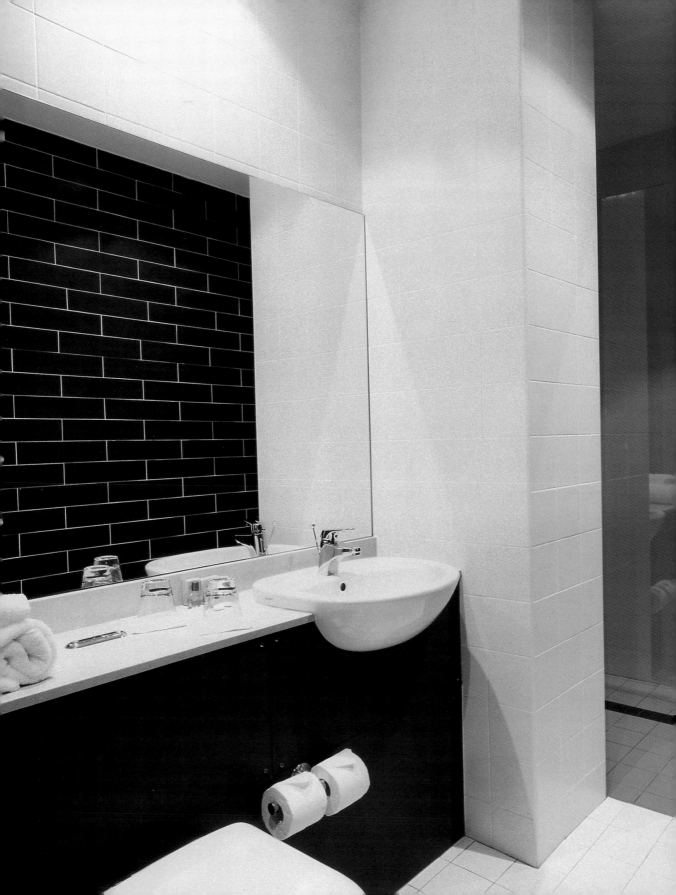

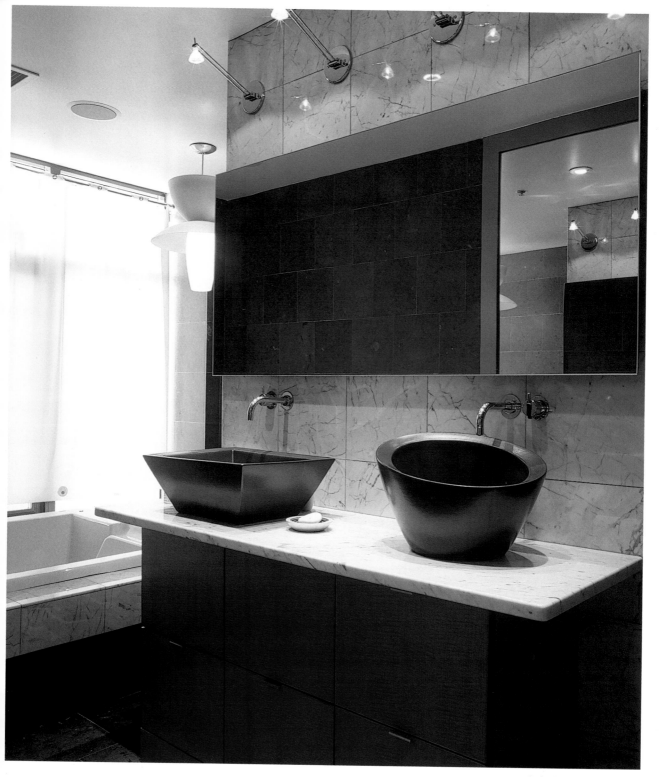

Mosaic tiles

Both pages
Design by Stéphane Plassier
Stylism by Silvia Rademakers, Virginia Palleres
Photos © José Luis Hausmann

Mosaics are composed of numerous small ceramic or glass tiles that are optimal for use in areas that are frequently exposed to water. They are available in a wide range of colors and sizes.

Mosaike bestehen aus einer Vielzahl von kleinen Keramik- oder Glasteilchen, die optimal für Bereiche sind, die oft mit Wasser in Berührung kommen. Sie werden in vielfältigen Farben und Größen hergestellt.

Les mosaïques sont constituées d'une grande quantité de petits carreaux de céramique ou de verre, idéals pour les surfaces en contact avec l'eau. Ils sont de différentes tailles et de diverses couleurs.

Las baldosas de mosaico están hechas de infinidad de pequeñas teselas de cerámica o cristal, y resultan ideales para zonas en frecuente contacto con el agua. Se fabrican en una gran variedad de colores y materiales.

I mosaici sono composti da un gran numero di piccole tesserine in ceramica od in vetro; si prestano in modo ottimale per tutte le zone che sono frequentemente a contatto con l'acqua. Vengono prodotti in colori e dimensioni diverse.

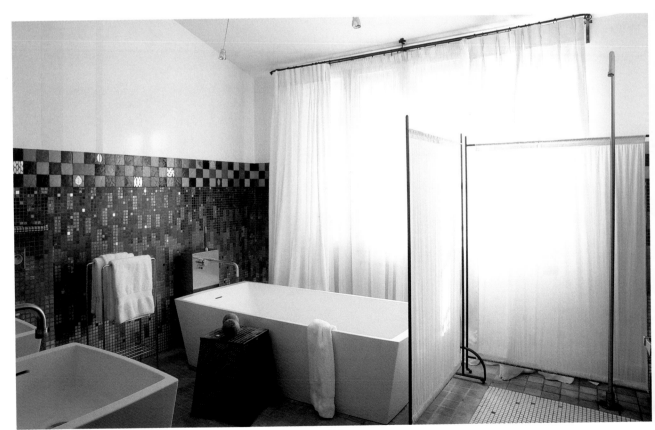

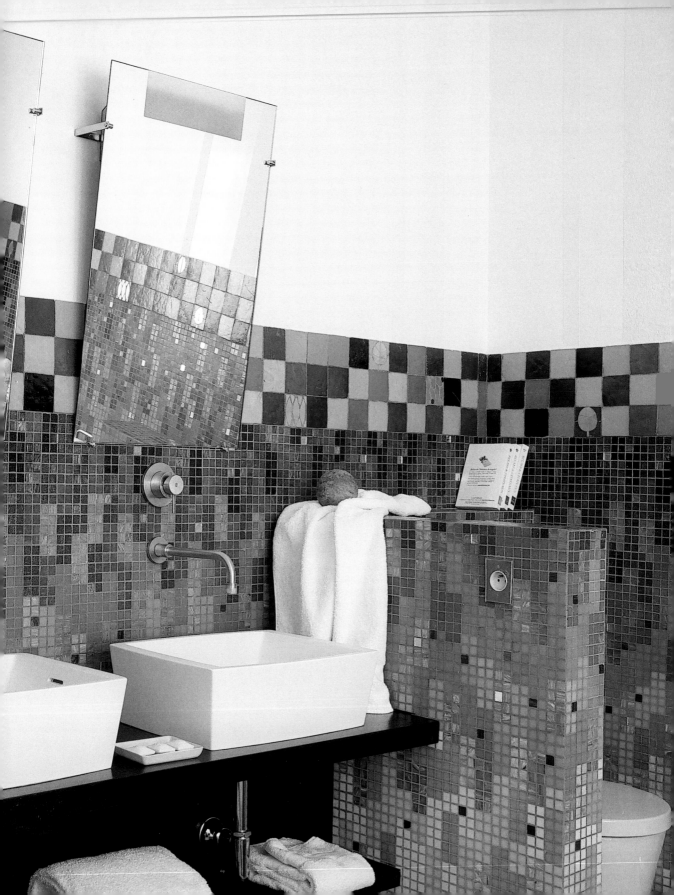

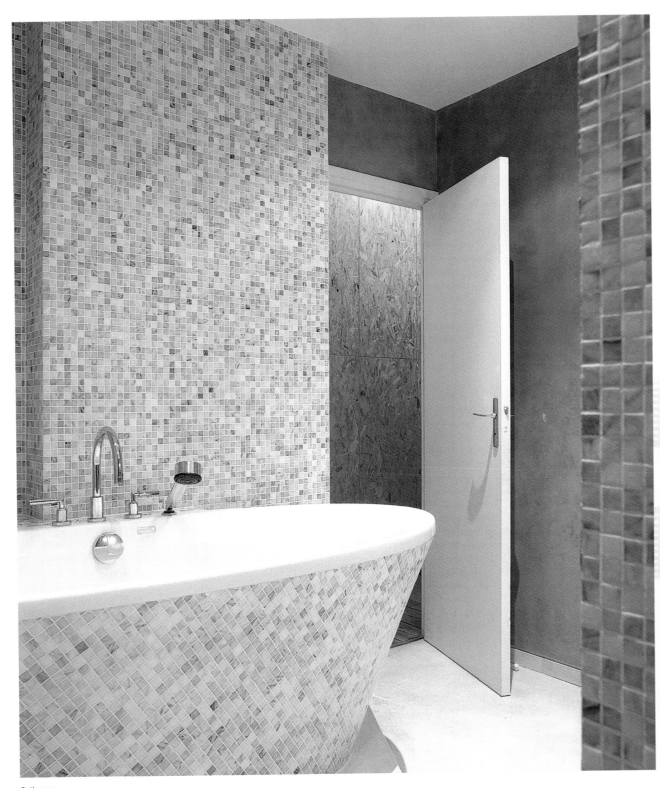

Both pages
Design by Odile Veillon
Photo © Hervé Abbadie

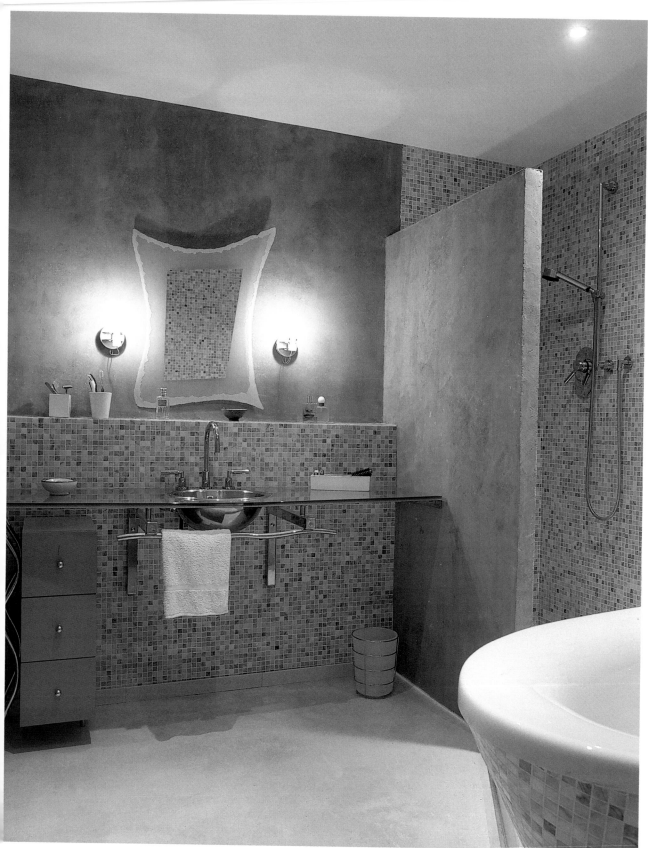

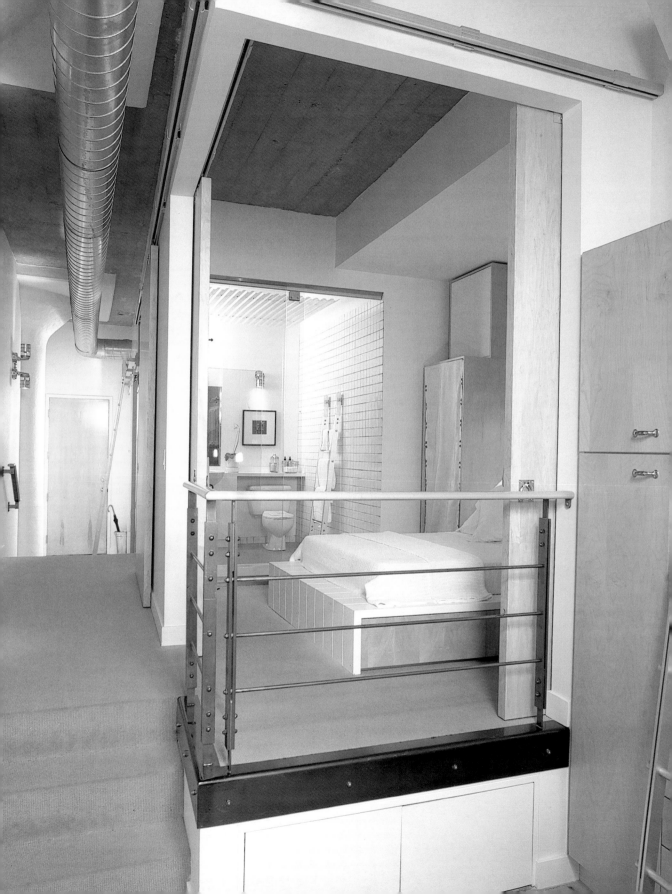

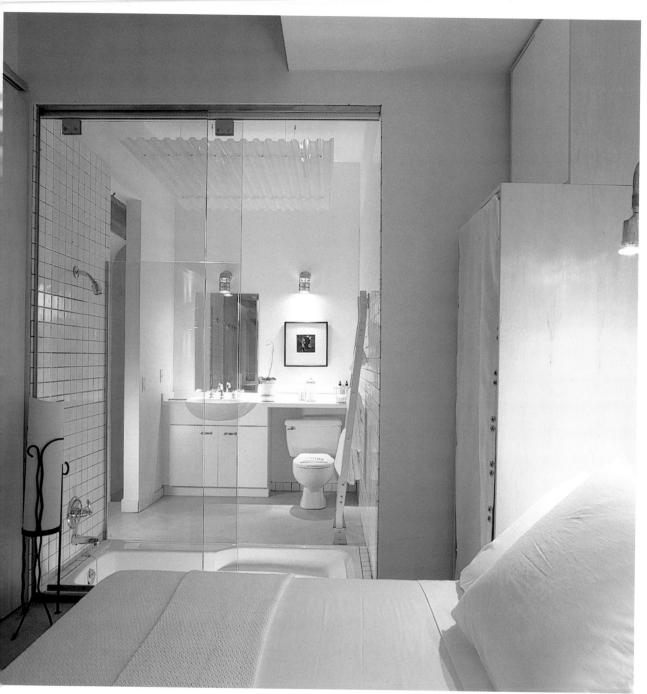

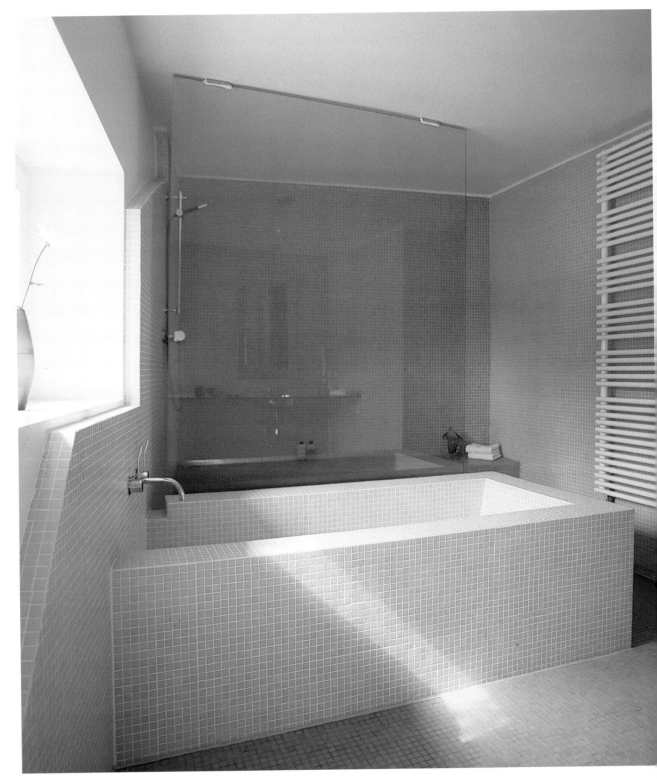

Photo © Winfried Heinze/Red Cover

Photo © James Mitchell/Red Cover

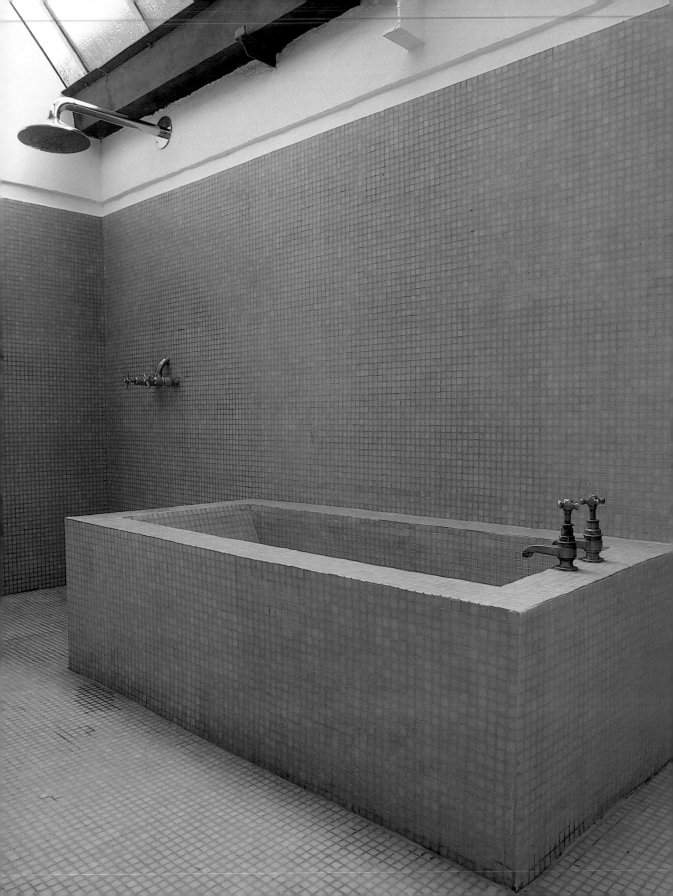

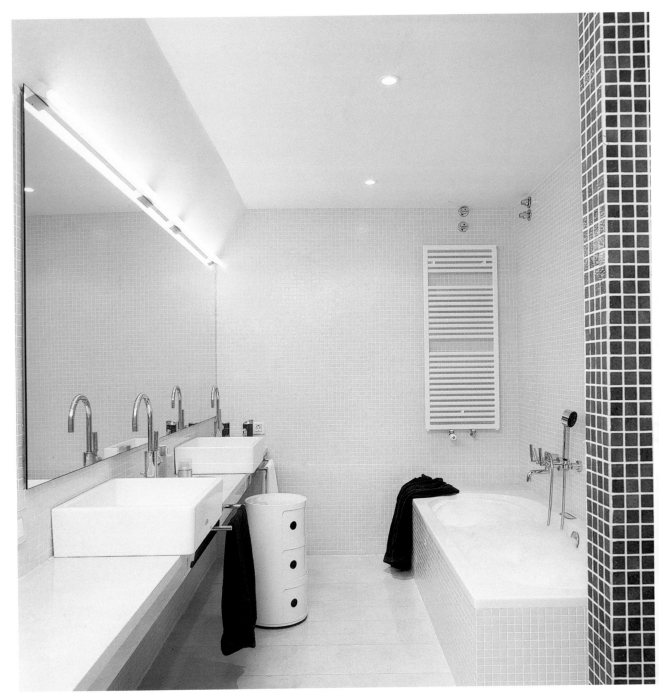

Photo © José Luis Hausmann

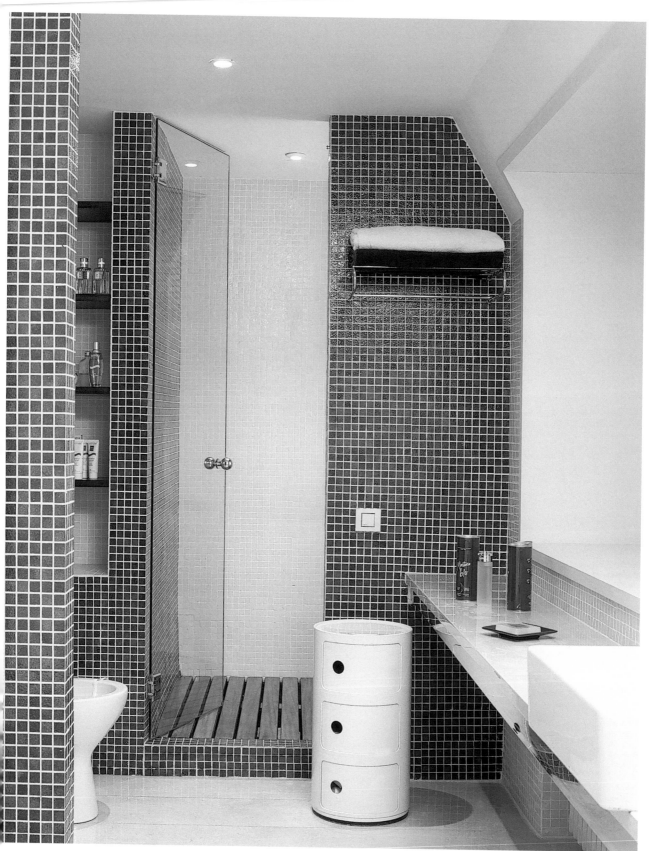

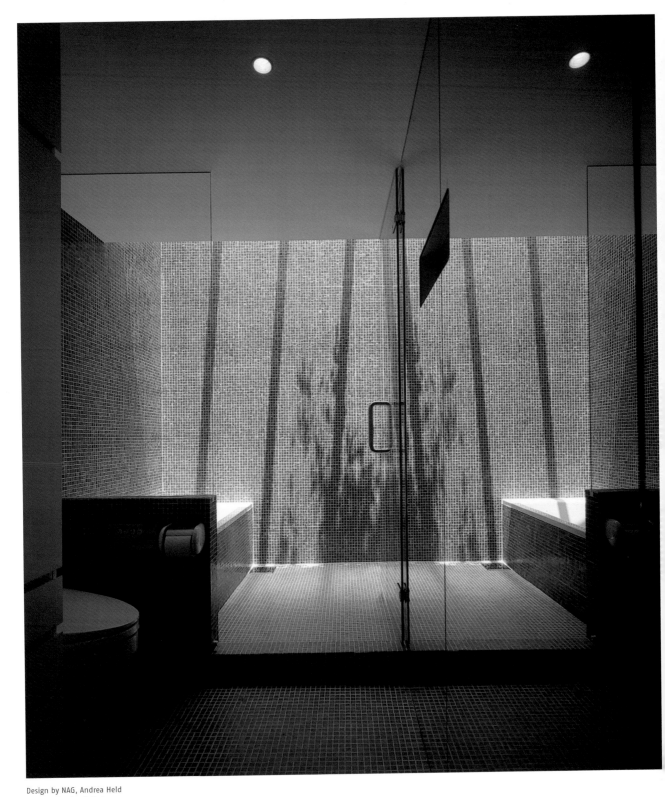

Design by NAG, Andrea Held
Photo © Nacása & Partners

Design by Jonathan Clark
Photo © Nick Hufton/View

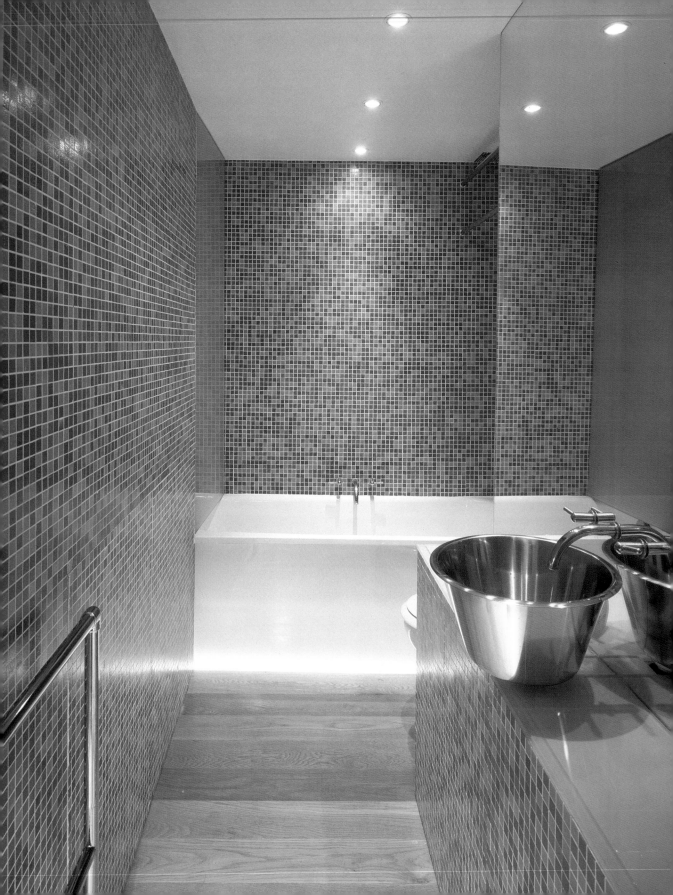

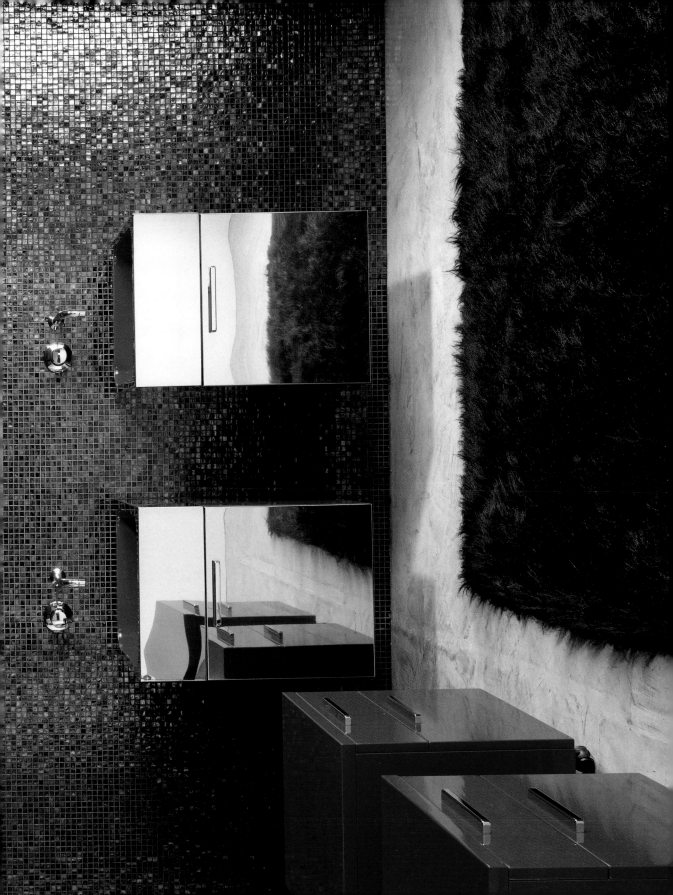

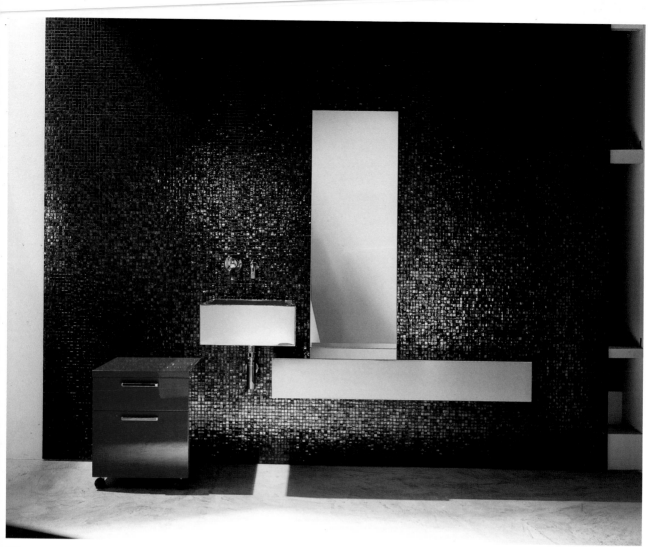

Both pages
Design by Falper
Photo © Maurizio Marcato

Design by Oishi Kazuhiku Architect Atelier
Photo © Kouji Okamoto

Design by Makoto Tanaka
Photo © Makoto Tanaka

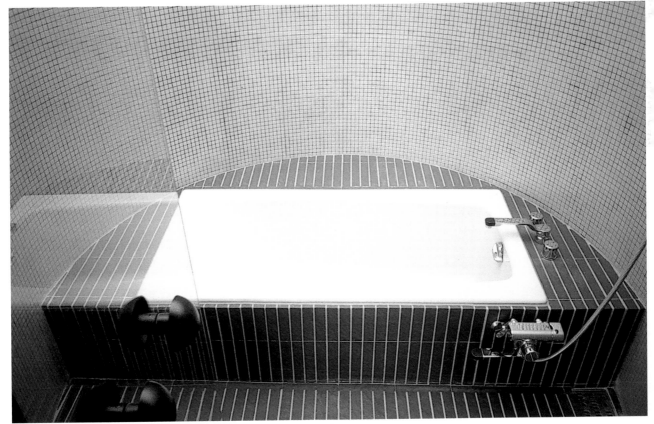

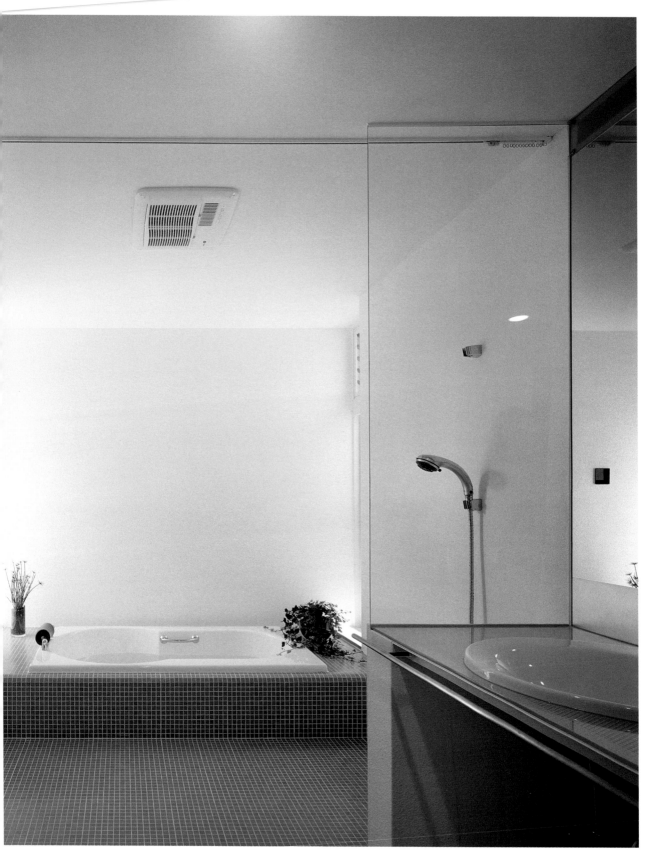

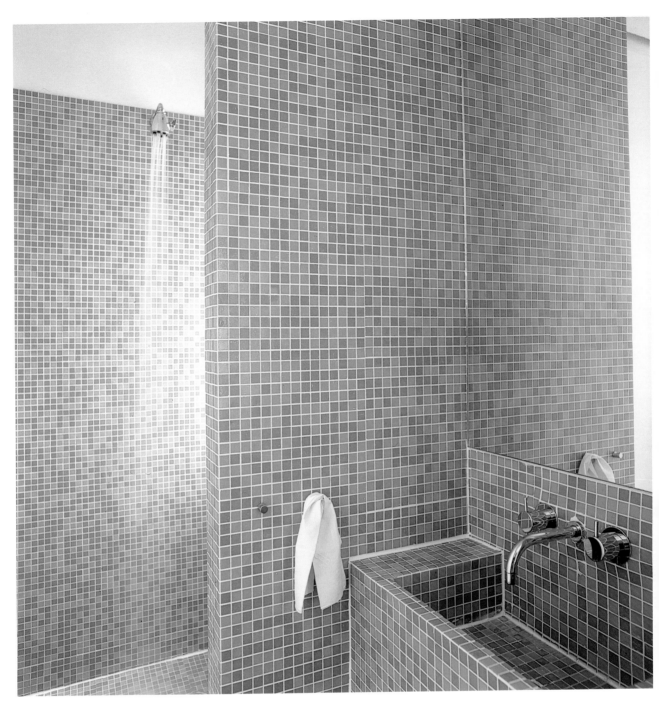

Design by Jonathan Clark
Photo © Jan Baldwin/Narratives

Design by Jeremy Wolveridge Architect Pty Ltd.
Photo © Shania Shegedyn

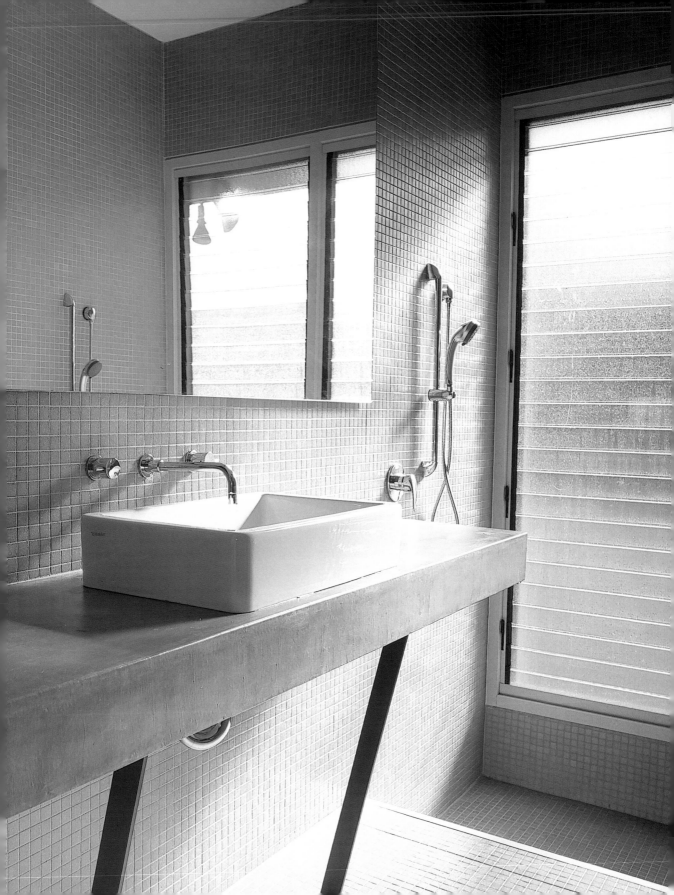

Cement

Modern designs have made cement a popular material for surface coverings and for elements such as bathtubs. This material allows for the creation of individualized designs that make old-fashioned bathrooms look modern.

Zement als Material für Verkleidung und Elemente, wie zum Beispiel Wannen, wurde durch moderne Designs populär. Es ermöglicht eine individuelle Verarbeitung und kann rustikalen Bädern ein modernes Erscheinungsbild geben.

Le ciment comme matériau pour éléments et revêtement de baignoires est devenu populaire grâce au design moderne. Il permet des conceptions individuelles et apporte une touche de modernisme à une salle de bains rustique.

El cemento se ha hecho popular gracias al diseño moderno para el revestimiento o para construir ciertos elementos como, por ejemplo, bañeras. Y es que este material posibilita una elaboración individual y puede dar a los cuartos de baño rústicos una apariencia moderna.

Il cemento come materiale per rivestimento e per elementi, come ad esempio le vasche da bagno, è diventato di moda, grazie ai design moderni. Consente una lavorazione individuale ed è in grado di conferire ai bagni rustici un'impronta moderna.

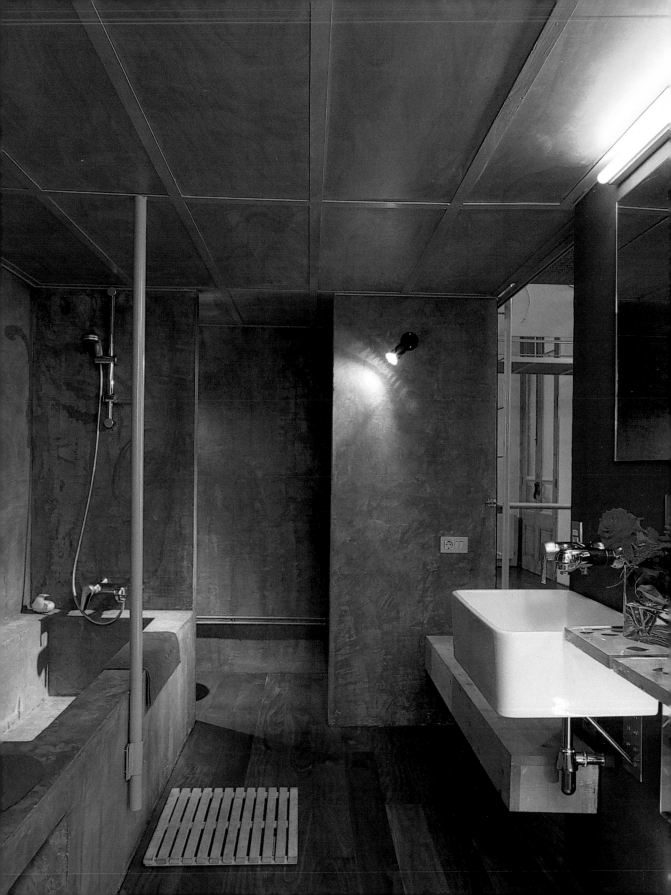

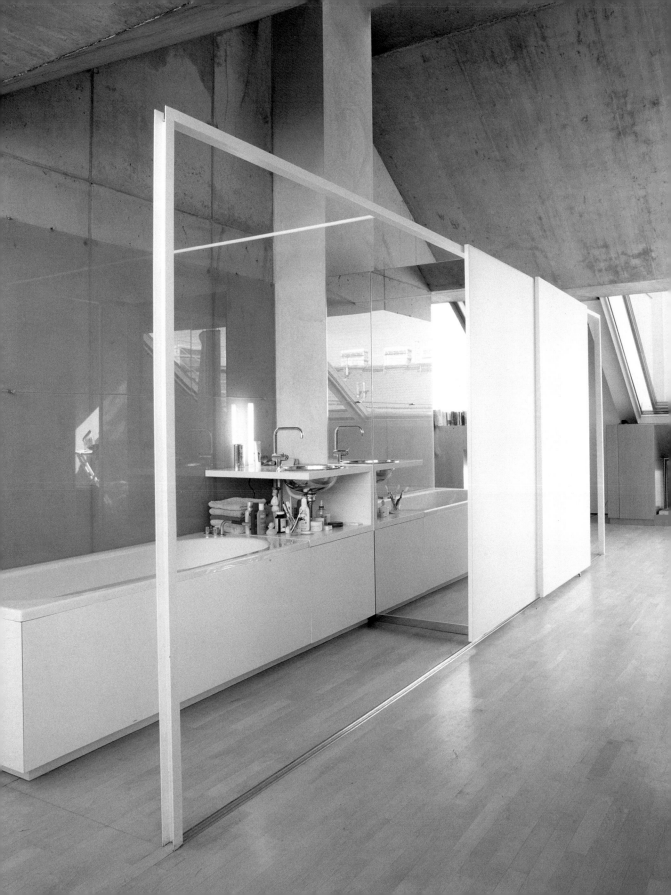

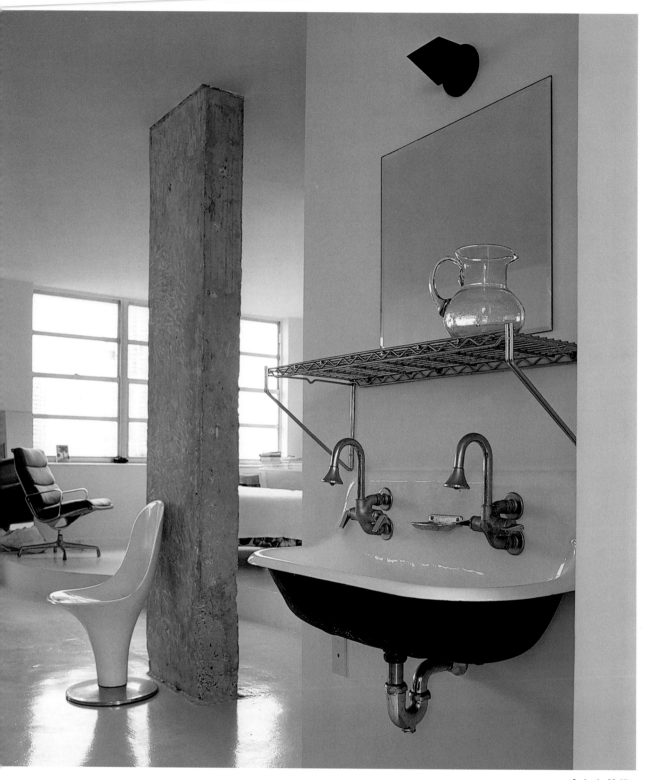

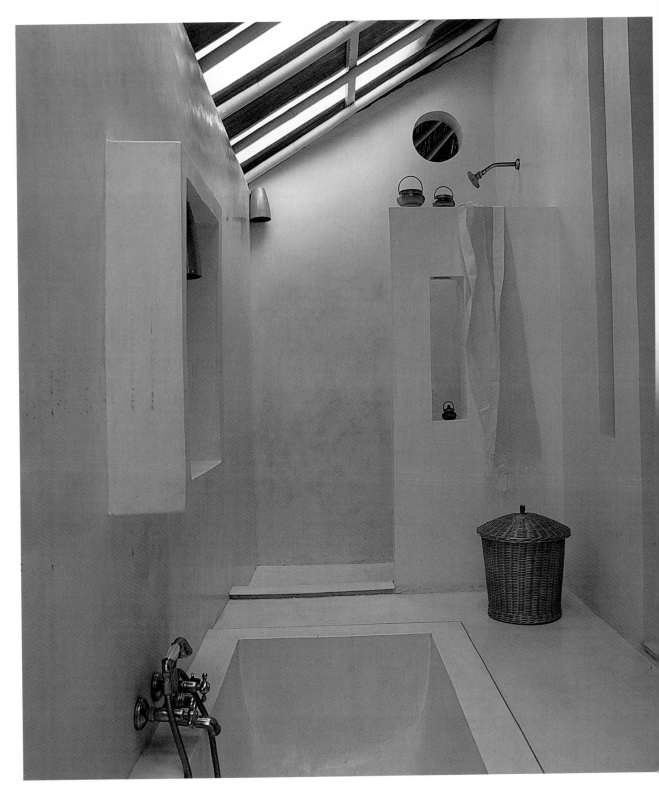

Photo © Reto Guntli/Red Cover

194

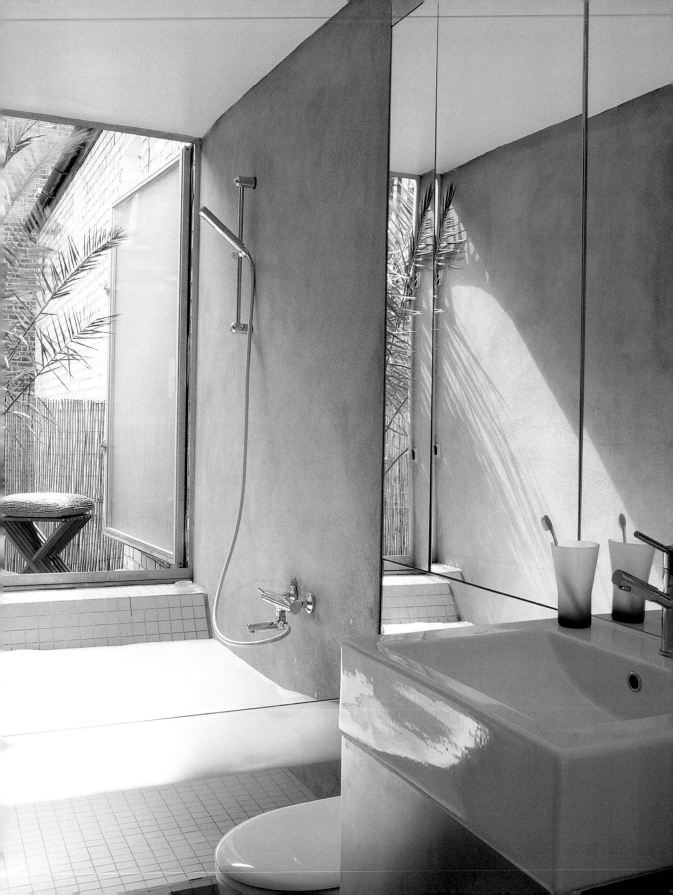

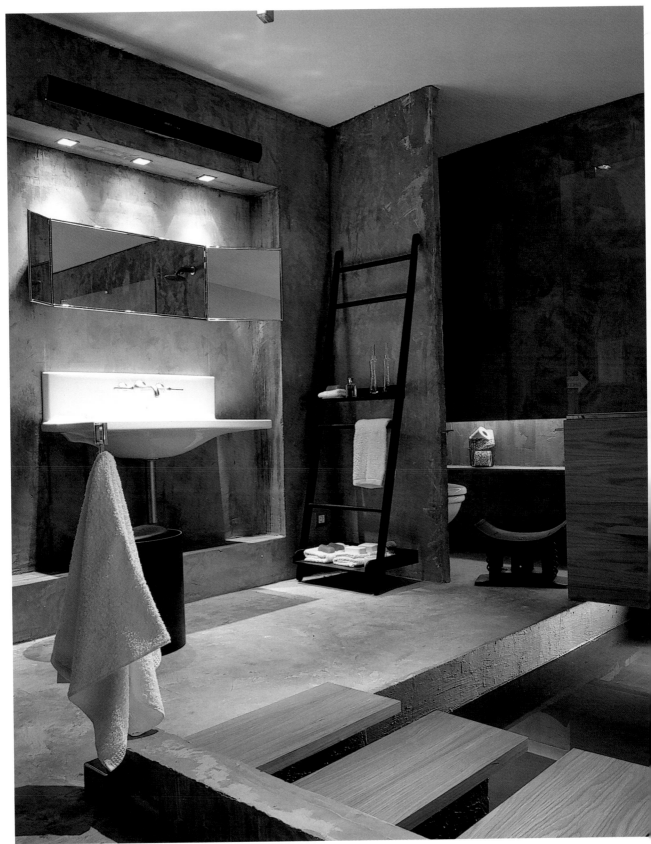

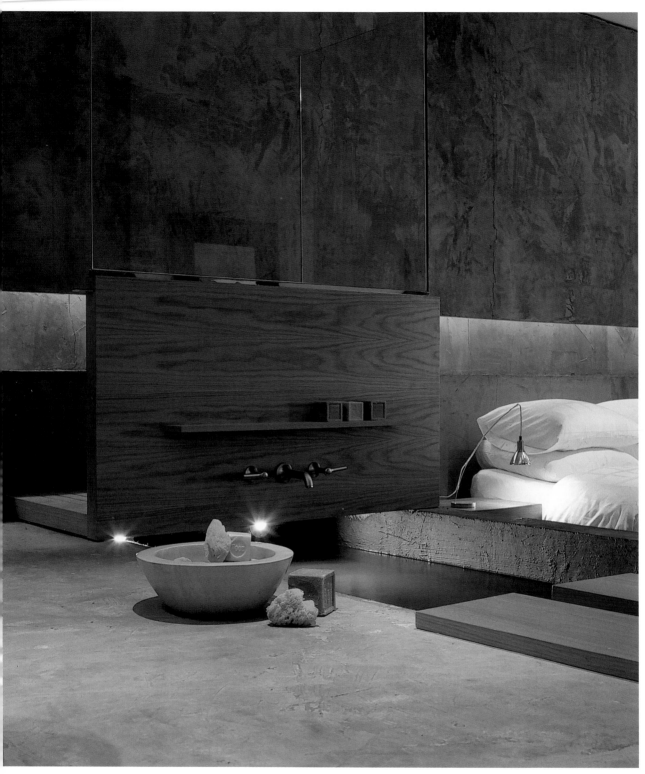

Both pages
Photos © José Luis Hausmann

197

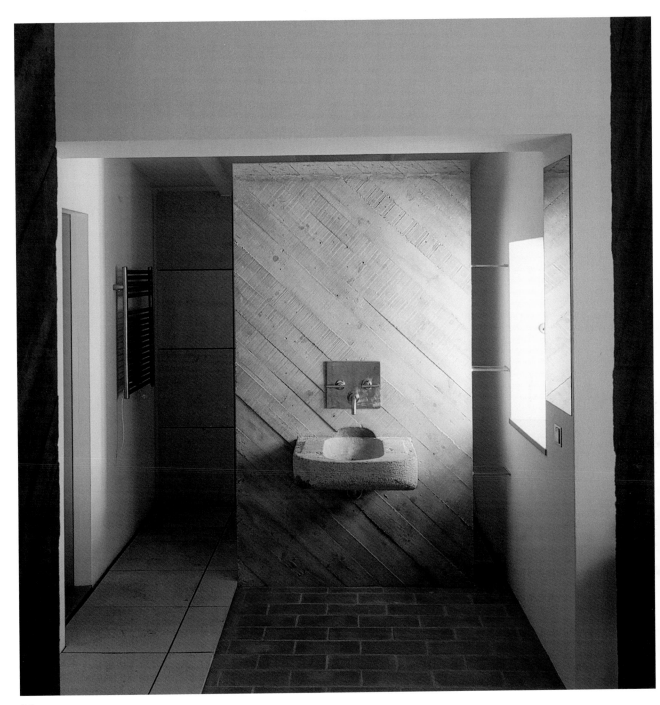

Both pages
Photo © Georges Fessy

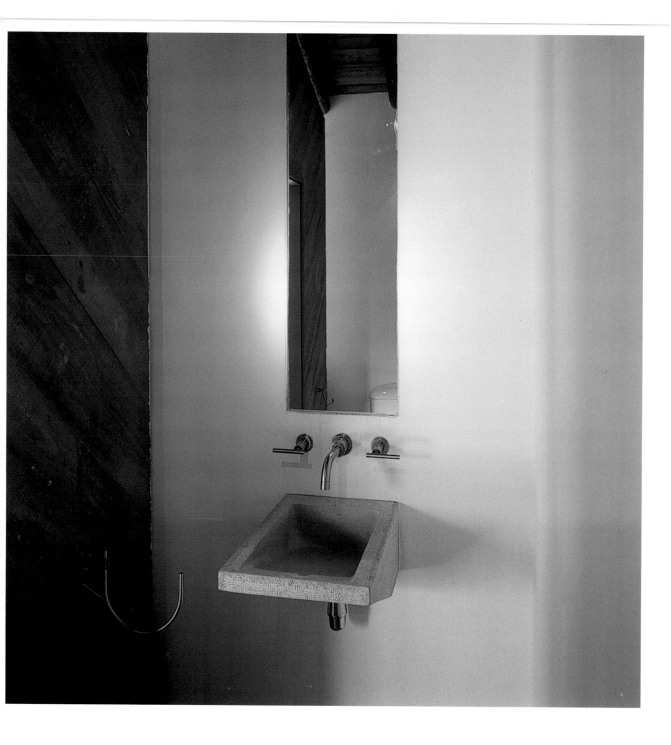

Both pages
Design by Stéphan Bourgeois
Photo © Pere Planells

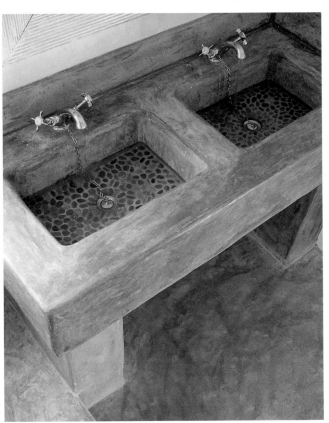

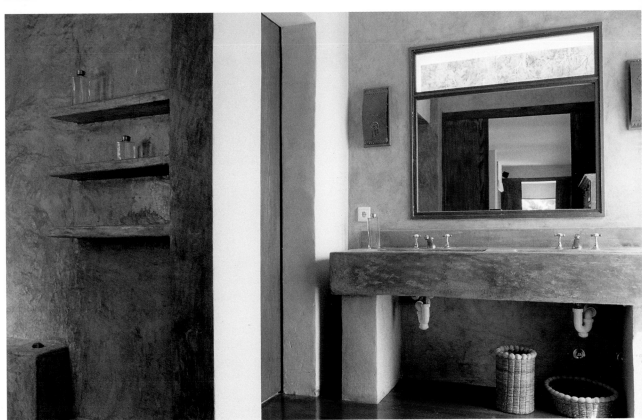

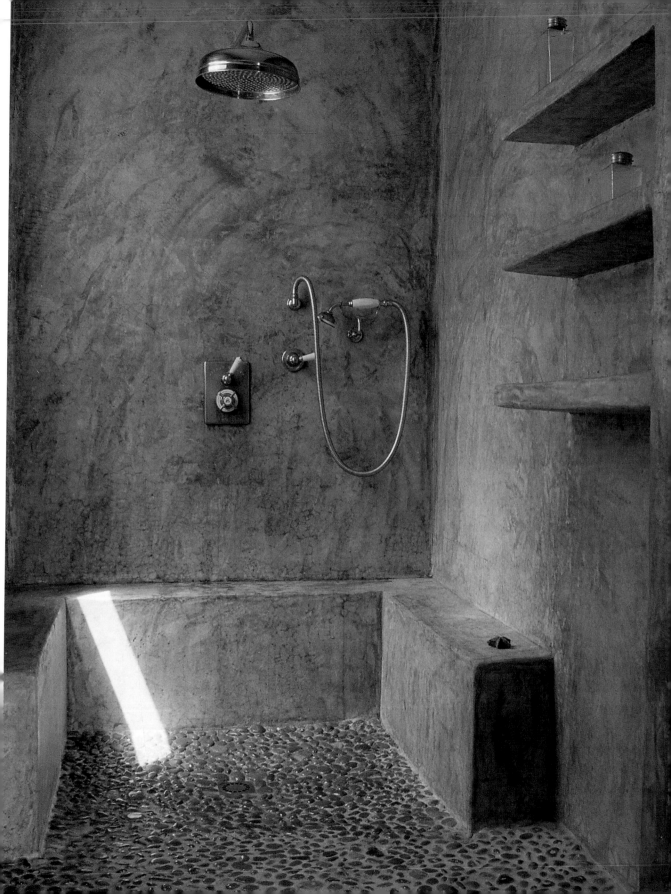

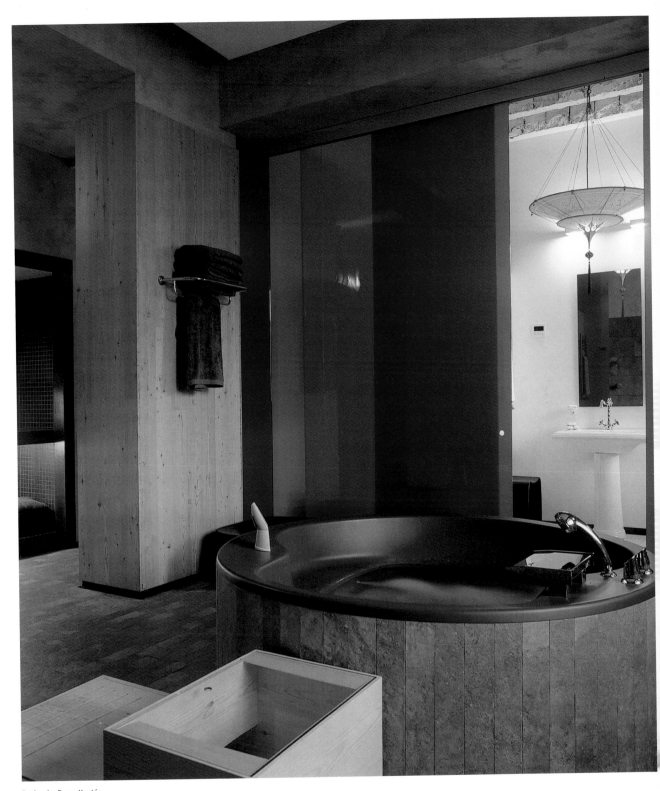

Design by Reyes Ventós
Photo © Nuria Fuentes

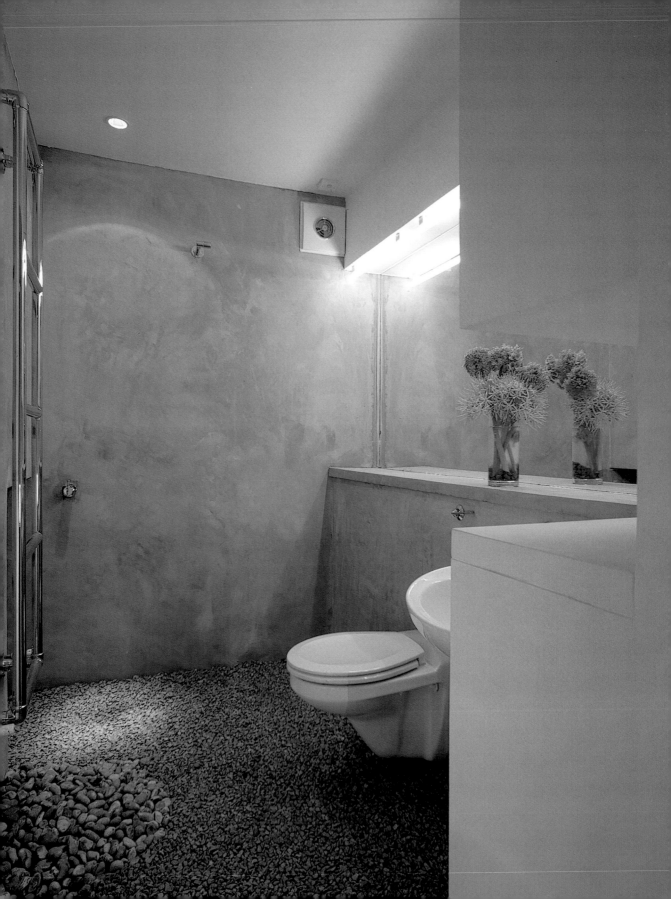

Color >>>>>>>>>>>

The selection of surface area and wall colors constitutes the first step in determining the style in which a bathroom will be designed. Although this dimension of bathroom decor is highly subjective, visual effects are in fact achieved through the use of certain well known principles. For example, a lack of space can be offset by selecting appropriate colors, since the various colors in the spectrum respond differently to natural light.

The fact that light colors make a room look larger renders them particularly suitable for smaller bathrooms. Conversely, dark colors make a room look smaller. Such colors are particularly effective in larger bathrooms where a warmer atmosphere or greater contrast is desired.

Colors also affect our moods. Cool colors are calming and thus enable us to rest and relax. Neutral colors such as white, beige and pastels are associated with cleanliness and hygiene and thus are highly suitable for the ambience of a bathroom. Warm and intense colors are associated with liveliness and should therefore be avoided in rooms that are designed for relaxation.

However, there are no hard and fast rules that preclude the use either of any particular color combination or warmer tones for a bathroom. Nowadays, colors can be manufactured in very fine tonal gradations, which means that warm colors can be transformed into pastel tones by simply making them less intense.

Inasmuch as the main purpose of decorating a bathroom is to ensure that it is realized in keeping with the users' tastes and requirements, bathroom colors should be selected in accordance with the user's propensities. In so doing, a wide range of color combinations can be used. If the focus of the bathroom decor is to be its furnishings and fixtures, neutral background colors are preferable.

> The selection of surface area and wall colors constitutes the first step in determining the style in which a bathroom will be designed.

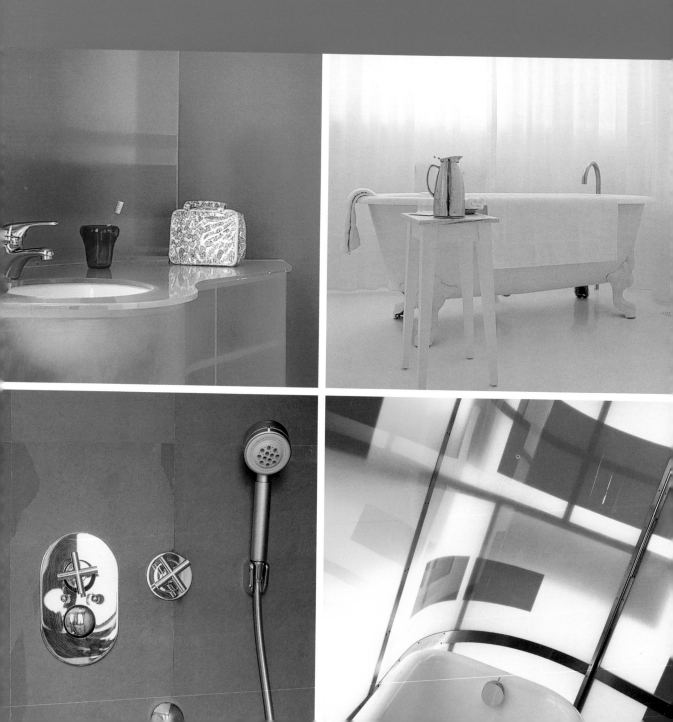

Farben

Die Wahl der Wandfarbe und der Verkleidung ist der erste Schritt zur Bestimmung der Stilrichtung, die ein Badezimmer erhalten soll. Dieser Aspekt der Dekoration wird zwar sehr subjektiv empfunden, visuelle Effekte beruhen jedoch auf bekannten Prinzipien. So lassen sich Platzprobleme durch die entsprechende Farbwahl lösen, denn unterschiedliche Farben reagieren unterschiedlich auf das natürliche Licht.

Helle und leuchtende Farben vergrößern den Raum optisch und sind dadurch besonders für kleine Bäder geeignet. Umgekehrt verkleinern dunkle Farben die Größe eines Raumes. Sie sind besonders wirkungsvoll in größeren Badezimmern, für die man sich eine intimere Atmosphäre oder stärkere Kontraste wünscht.

Farben beeinflussen auch unsere Stimmung. Kalte Farben vermitteln ein Gefühl von Ruhe und erleichtern so die Entspannung und Erholung. Neutrale Farben wie Weiß, Beige und Pastelltöne vermitteln ein Gefühl von Hygiene und Sauberkeit und passen daher sehr gut zur Atmosphäre eines Badezimmers. Warme, intensive Farben vermitteln ein Gefühl von Vitalität. Daher werden sie normalerweise nicht für Räume empfohlen, in denen man Entspannung sucht.

Trotzdem gibt es keine Regeln, welche die Verwendung verschiedenartiger Farbkombinationen verbieten oder einen daran hindern würden, wärmere Töne für das Badezimmer zu wählen. Farbtöne können heute in feinsten Abstufungen hergestellt werden, und sogar eine Farbe, die eher als warm empfunden wird, kann durch Abschwächung in einen Pastellton verwandelt werden.

Da das Ziel der Dekoration in erster Linie darin besteht, einen Raum nach dem Geschmack und den Bedürfnissen des Benutzers zu entwerfen, sollten die Farben nach dessen subjektivem Empfinden ausgewählt werden. Eine Vielzahl von Kombinationen ist möglich. Möchte man das Mobiliar und die sanitären Einrichtungen in den Vordergrund stellen, sollte der Farbhintergrund neutral gehalten werden.

Domani by Sieger Design for Dornbracht

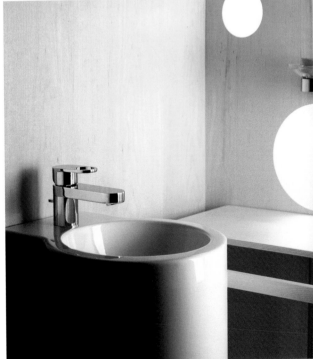

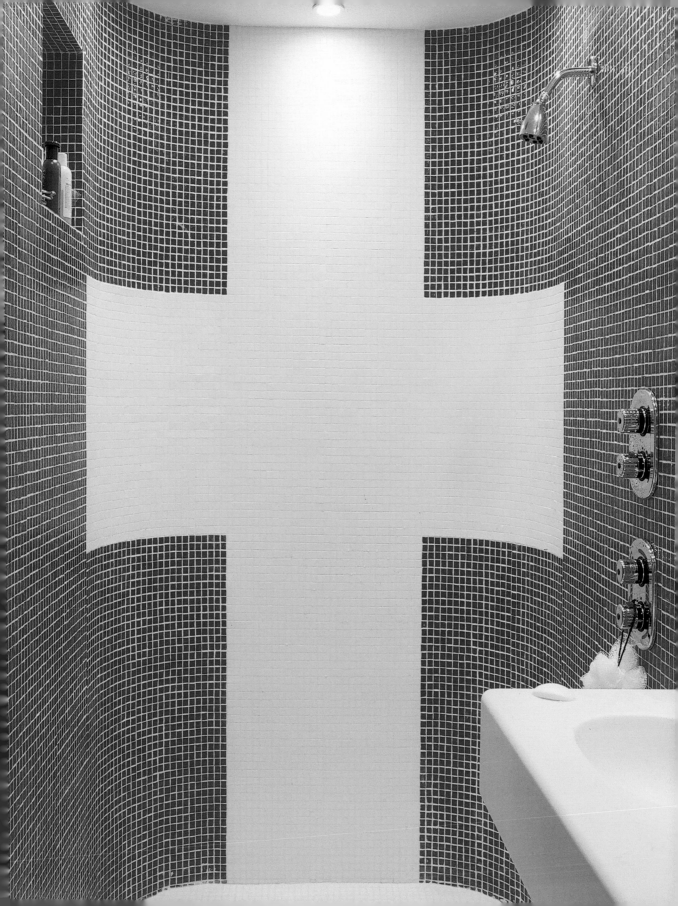

La couleur

Le choix de la couleur des murs et du revêtement est la première étape qui détermine le style de la salle de bains. Cet aspect de la décoration est certes très subjectif, toutefois les effets visuels reposent sur des principes acquis. Les problèmes de place peuvent se résoudre en choisissant une couleur adéquate. En effet, les différentes couleurs réagissent aussi différemment à la lumière naturelle.

Les couleurs claires et brillantes donnent l'illusion d'agrandir la pièce et sont donc particulièrement indiquées pour les petits espaces. A l'inverse, les couleurs foncées réduisent la taille d'une pièce. Elles font beaucoup d'effet dans les grandes salles de bains où l'on désire créer une atmosphère intime ou davantage de contrastes.

Les couleurs ont aussi une influence sur notre humeur. Les couleurs froides transmettent un sentiment de calme et favorisent la détente et le repos. Les couleurs neutres à l'instar du blanc, du beige et des tons pastel créent la sensation d'hygiène et de propreté et conviennent parfaitement à l'univers d'une salle de bains. Des couleurs chaudes et intenses sont vivifiantes. Elles ne sont donc pas recommandées pour les pièces où l'on recherche la détente.

Mais finalement, il n'y a pas de règles interdisant de combiner les couleurs ensemble où de choisir des tons chauds pour la salle de bains. De nos jours, la palette de couleurs se décline dans des nuances très subtiles, et même une couleur, considérée autrefois comme un ton chaud, peut être atténuée et transformée en un ton pastel.

Le but premier de la décoration étant de concevoir un espace en harmonie avec les goûts et les besoins du client, le choix de couleurs sera fait en fonction de ses critères subjectifs personnels. Il y a une myriade de combinaisons possibles. Si l'on veut faire ressortir le mobilier et l'équipement sanitaire, la couleur de fond devra rester neutre.

Design by Rapsel

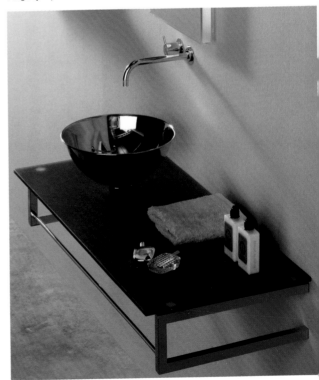

208

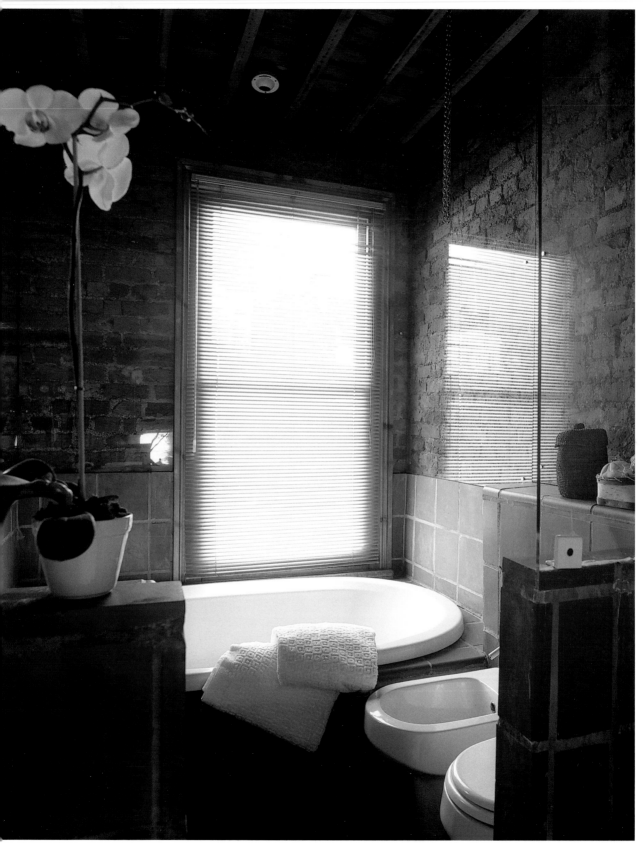

El color

La elección del color de las paredes y los revestimientos del cuarto de baño es el primer paso para determinar el estilo que ha de dominar la pieza. Si bien ese aspecto de la decoración es algo muy subjetivo, los efectos ópticos de los colores se basan en principios de sobra conocidos. Así, los problemas de espacio se pueden mitigar con la elección de la tonalidad adecuada, ya que los diferentes colores reaccionan de forma diferente a la luz natural.

Los tonos claros y brillantes producen el efecto óptico de agrandar una pieza y son por ello especialmente indicados para los cuartos de baño reducidos. Por el contrario, un color oscuro hace parecer más pequeñas las dimensiones de un espacio. Los tonos intensos resultan efectistas en piezas grandes en las que se busca crear una atmósfera íntima o un mayor contraste.

Los colores pueden cambiar nuestro estado de ánimo. Los tonos fríos transmiten un sentimiento de tranquilidad y facilitan la relajación y el descanso. Las tonalidades neutras como el blanco, el beige y los colores pastel dan la sensación de higiene y limpieza, y resultan muy adecuadas para la atmósfera de un cuarto de baño. Finalmente, los colores cálidos e intensos dan sensación de vitalidad. Por eso no suelen escogerse para la decoración de habitaciones en las que se busca la relajación.

De todas formas, no existen reglas estrictas que prohíban el uso de combinaciones cromáticas originales o de tonos cálidos para el cuarto de baño. Hoy en día, el mercado ofrece una amplísima gama cromática de pintura e incluso un color que en principio se considera cálido puede ser matizado hasta que se convierte en un tono pastel.

El primer objetivo de la decoración es diseñar el espacio según el gusto y las necesidades de sus usuarios; por tanto, los colores deben elegirse teniendo en cuenta su percepción subjetiva. Así es posible lograr una gran variedad de combinaciones. Por ejemplo, si lo que desea es destacar el mobiliario y las instalaciones sanitarias, es recomendable un color de fondo neutro.

Meta by Sieger Design for Dornbracht

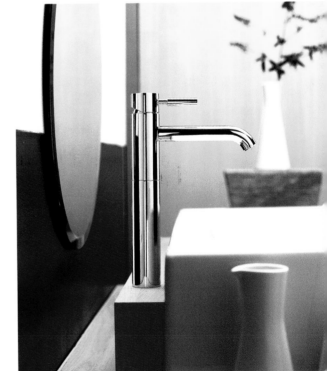

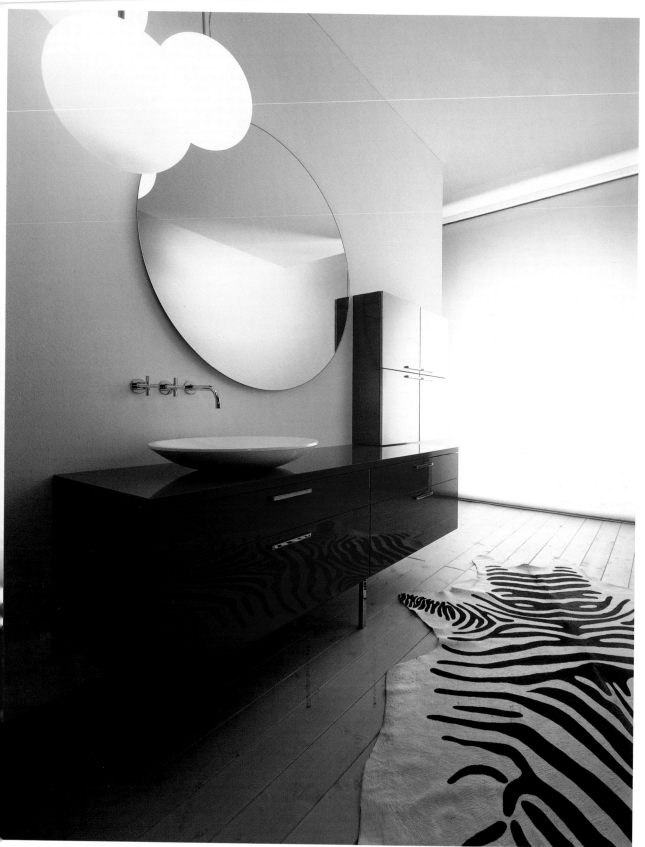

La colori

La scelta del colore della parete e del rivestimento è il primo passo verso la decisione dello stile che il bagno dovrà assumere. Nonostante questo aspetto relativo alla decorazione venga percepito in modo molto soggettivo, gli effetti visivi si basano su principi noti. Cosi i problemi di spazio potranno essere risolti con una scelta dei colori idonea, visto che i colori diversi reagiscono diversamente alla luce naturale.

I colori chiari e luminosi fanno sembrare più ampio lo spazio; per questo motivo sono particolarmente adatti ai bagni piccoli. Viceversa, i colori scuri tendono a rimpicciolire le dimensioni di un ambiente. Esercitano un effetto particolare nei bagni spaziosi in cui si desidera ottenere un atmosfera più intima o dei contrasti più forti.

I colori influenzano anche il nostro stato d'animo. I colori freddi trasmettono la sensazione di tranquillità e favoriscono così il rilassamento e la ricreazione. I colori neutri come bianco, beige e le tonalità pastello invece, trasmettono una sensazione di igiene e di pulito; per questo motivo si abbinano bene all'atmosfera generale di un bagno. I colori caldi ed intensi trasmettono una sensazione di vitalità. Per questo motivo solitamente non vengono consigliati per ambienti in cui si cerca di favorire il rilassamento.

Tuttavia non vi sono delle regole precise che vietano l'utilizzo di abbinamenti di colori diversi o che impediscano di scegliere per il bagno delle tonalità più calde. Oggigiorno si producono tutte le tonalità di colori nella più differenziata gradazione, ed attenuandolo, si riesce perfino a trasformare un colore che viene percepito piuttosto caldo, in una tonalità pastello.

Poiché lo scopo della decorazione consiste innanzitutto nell'obiettivo di progettare un ambiente secondo il gusto e le necessità dell'utente, i colori dovranno essere scelti secondo le sue percezioni soggettive. Si offre comunque una grande varietà di combinazioni. Qualora si volesse mettere in primo piano l'arredamento del bagno, sia i mobili che i sanitari, i colori del sottofondo dovranno essere tenuti neutri.

Tara by Sieger Design for Dornbracht

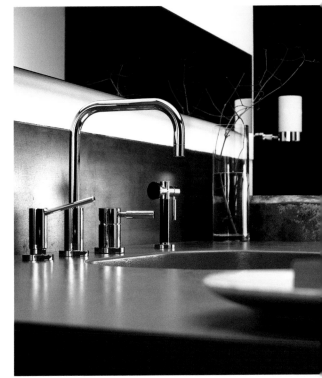

Tara by Sieger Design for Dornbracht

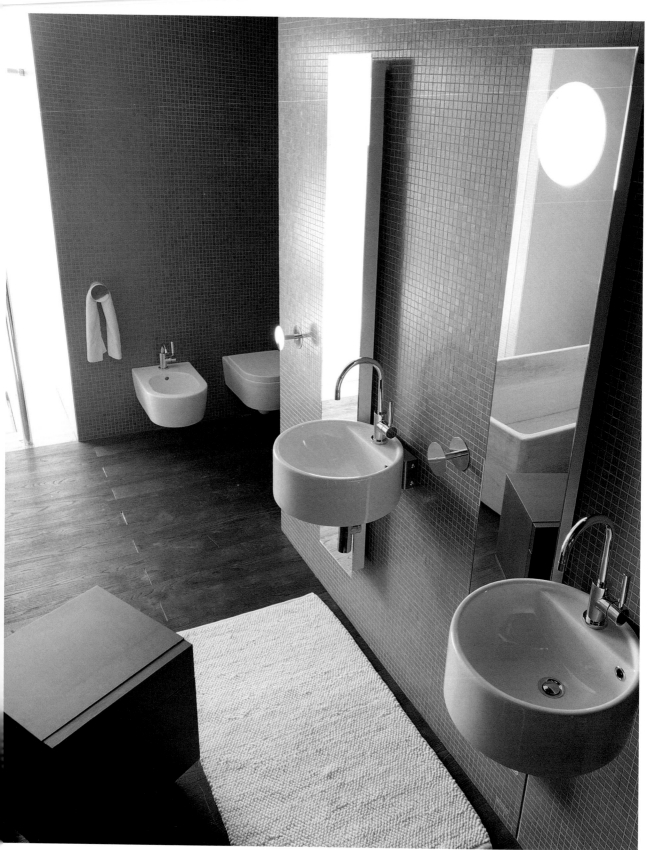

White

Design by Kenji Hashimoto
Photo © Nacása & Partners Inc.

Because it is neutral, white goes well with other colors. It also lends rooms a clean and hygienic feeling. White is particularly suitable for small bathrooms because it makes them look larger.

Weiß, eine neutrale Farbe, ist sehr gut mit anderen Farben kombinierbar. Zudem vermittelt es ein Gefühl von Hygiene und Sauberkeit. Weiß ist besonders für kleine Bäder geeignet, da es den Raum optisch vergrößert.

Le blanc est une couleur neutre facile à combiner avec une autre. En plus, elle diffuse la sensation d'hygiène et de propreté. Le blanc convient particulièrement bien aux petites salles de bains car il donne l'illusion d'agrandir la pièce.

El blanco es un color neutro que combina muy bien con todas las tonalidades. Además proporciona una sensación de higiene y limpieza. Es especialmente adecuado para cuartos de baño pequeños, ya que provoca un efecto óptico de ampliar el espacio.

Il bianco, essendo un colore neutro, si abbina benissimo a tutti gli altri colori. Trasmette inoltre una sensazione di igiene e di pulizia. Il bianco, con il suo effetto ottico ingrandente, si presta particolarmente bene per i bagni più piccoli.

Design by Takaharu and Yui Tezuka Architects + Masahiro Ikeda
Photo © Katsuhisa Kida

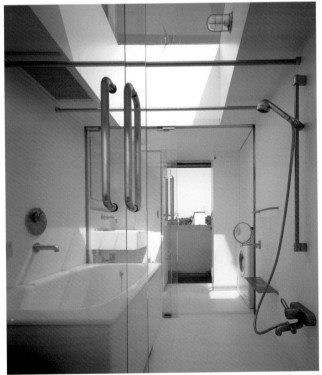

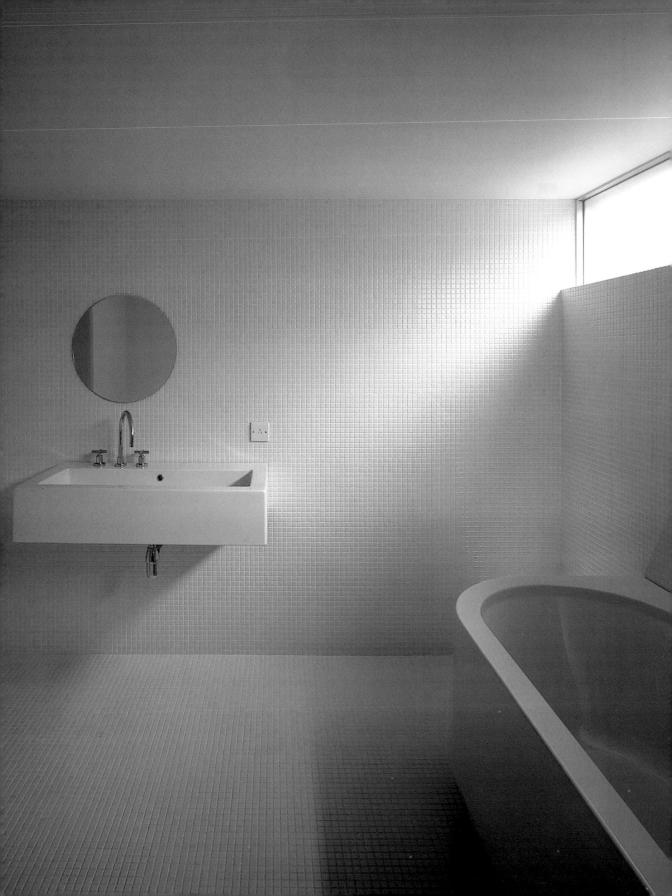

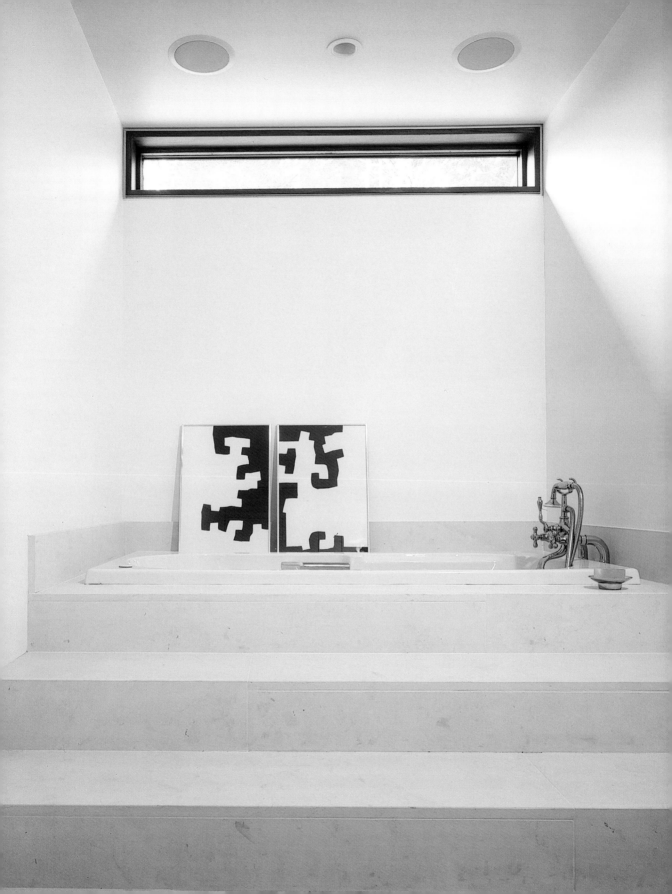

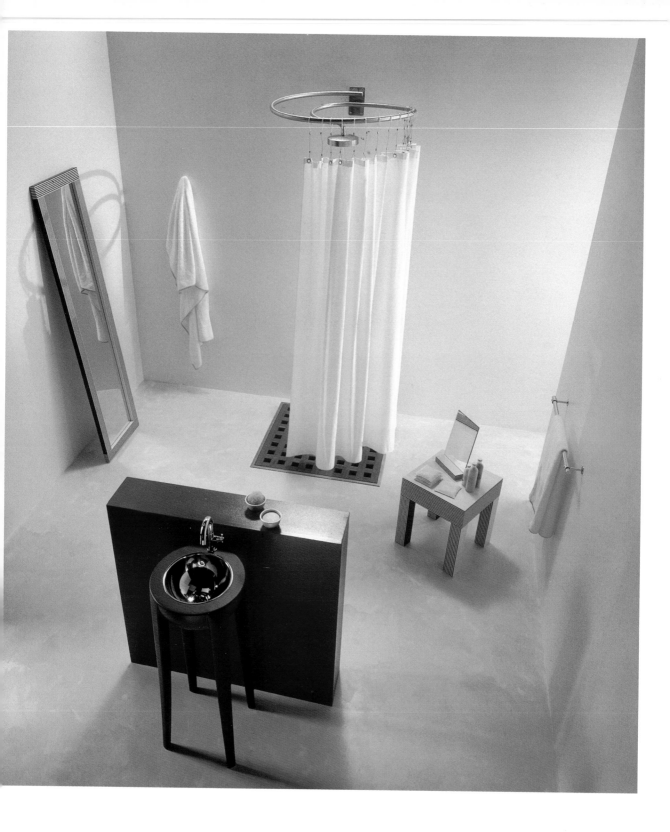

Design by Marisa García & Álex Baeza
Photo © José Luis Hausmann

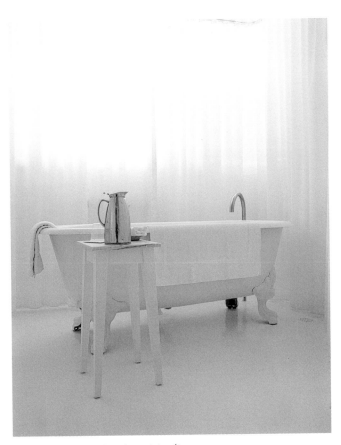

Design by PMG Architects, Peter Grumpel, Jury Álvarez
Interior design by Philippe Starck
Photo © Pep Escoda

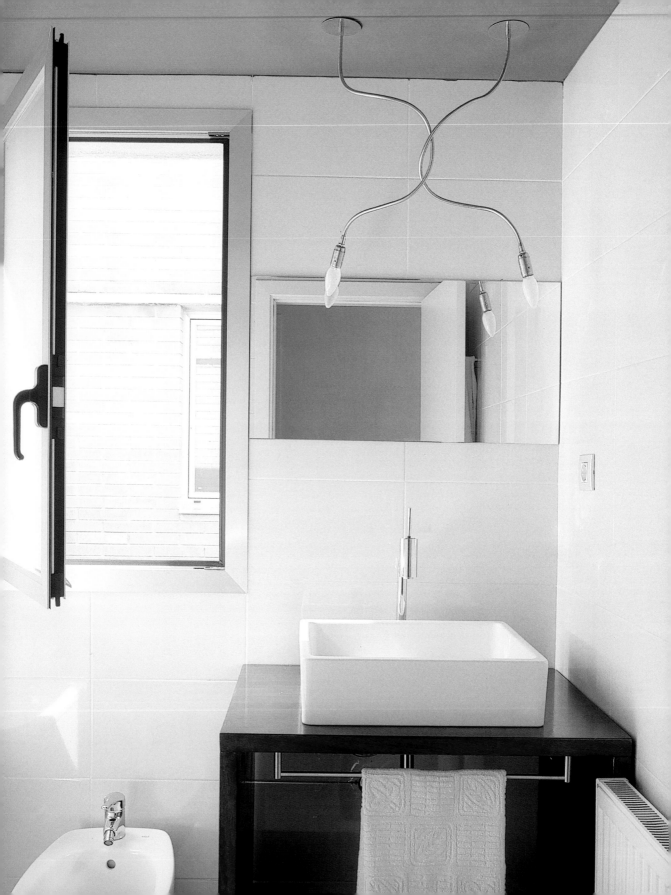

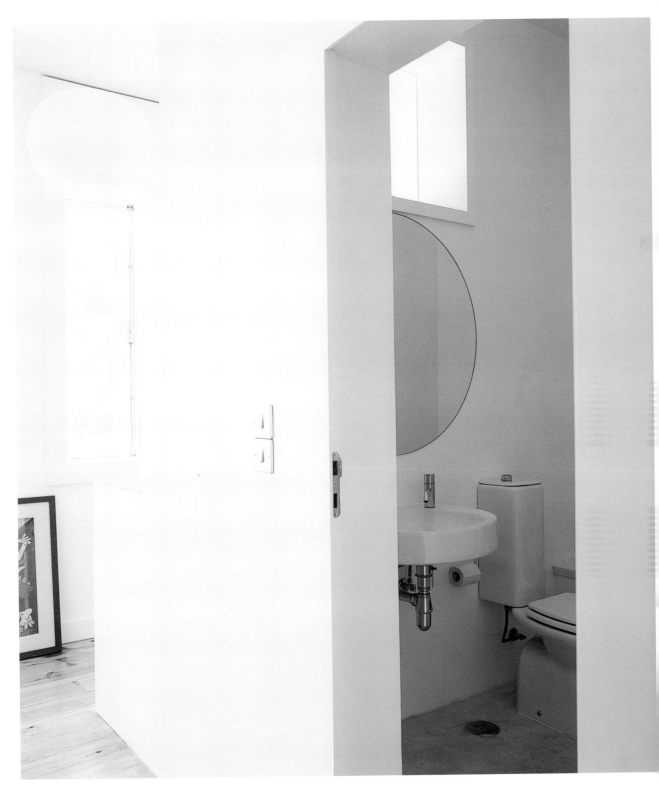

Design by Inês Lobo
Photo © Sergio Mah

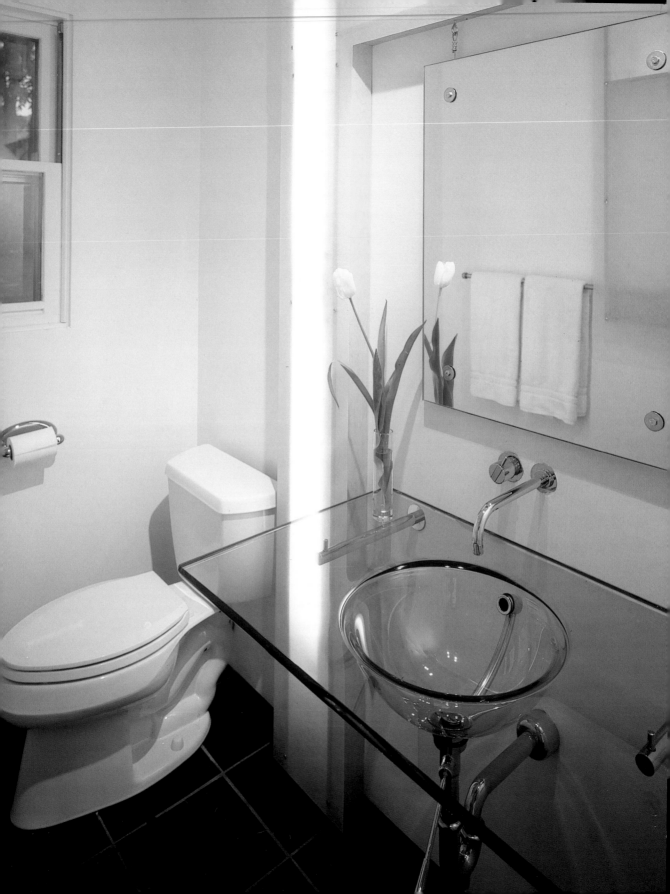

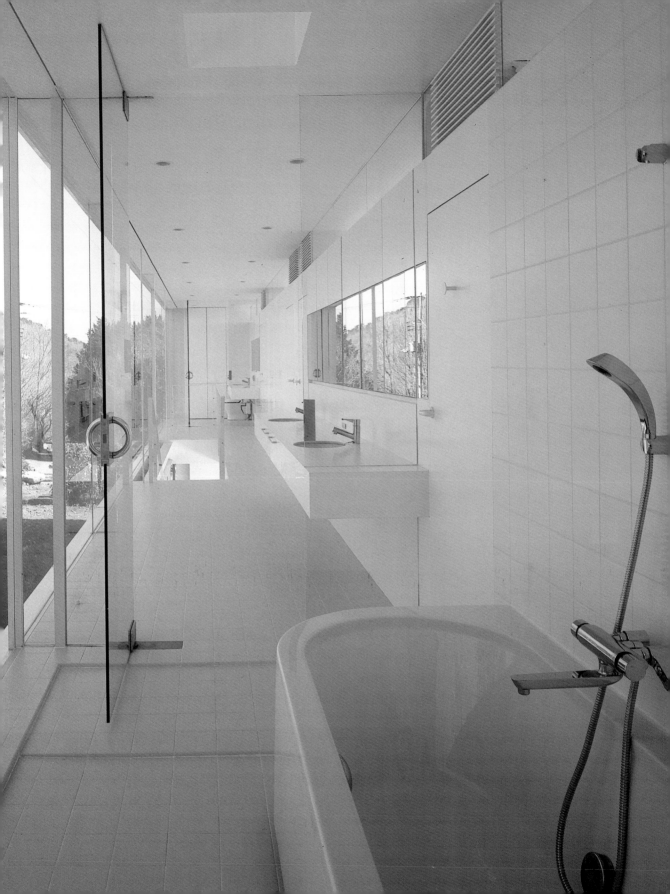

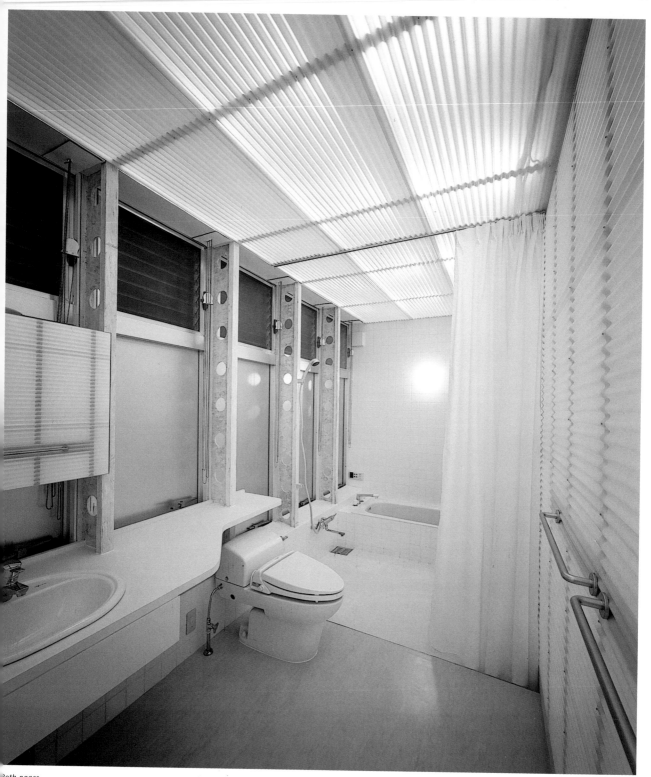

Both pages
Design by Shigeru Ban Architects
Photo © Hiroyuki Hirai

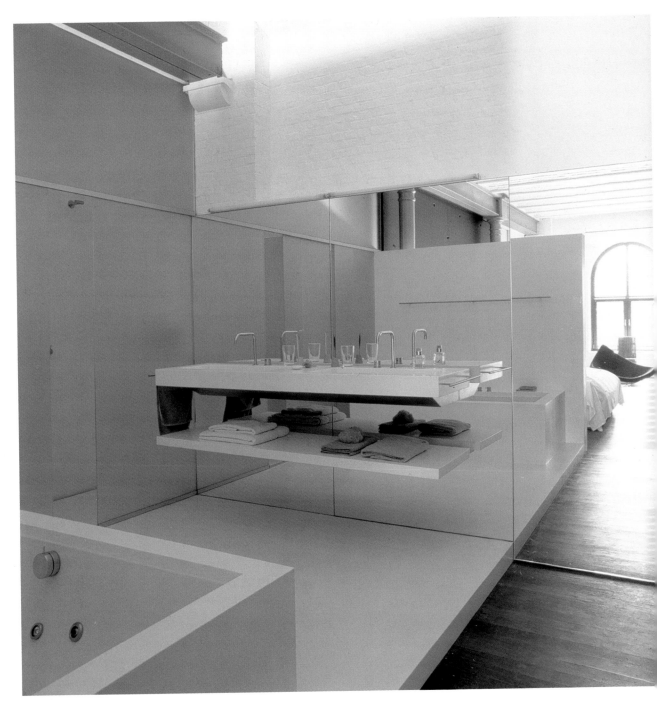

Both pages
Design by Jo Crepain Architects
Photo © Jan Verlinde, Ludo Noël

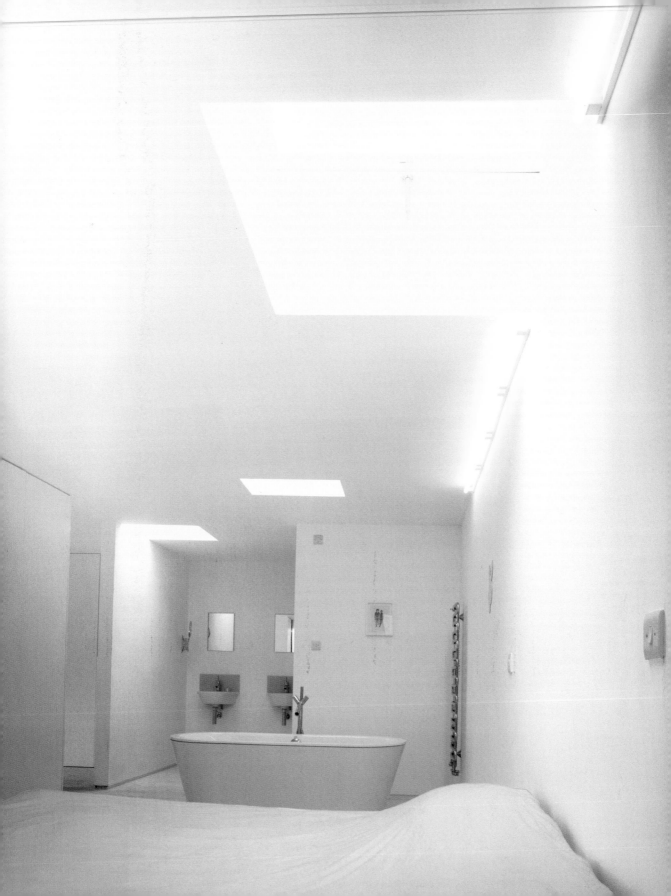

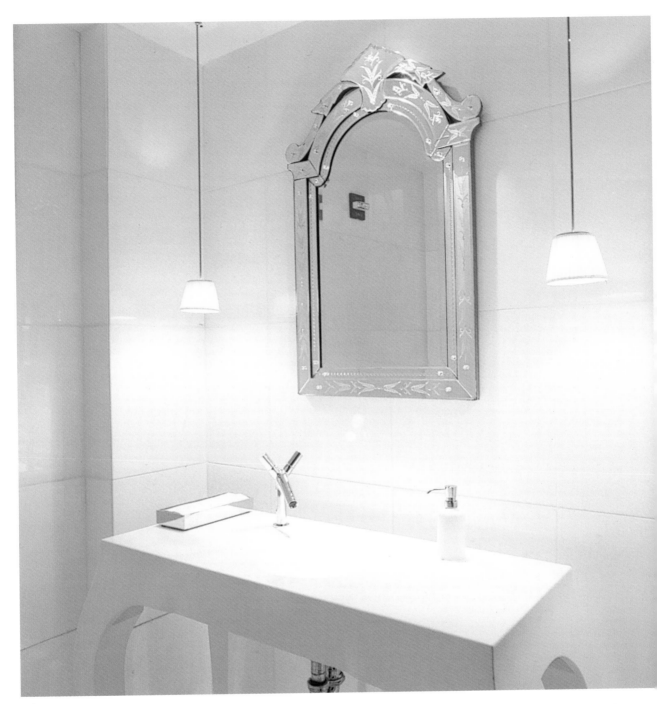

Both pages
Design by Philippe Starck
Photo © Jordi Miralles

226

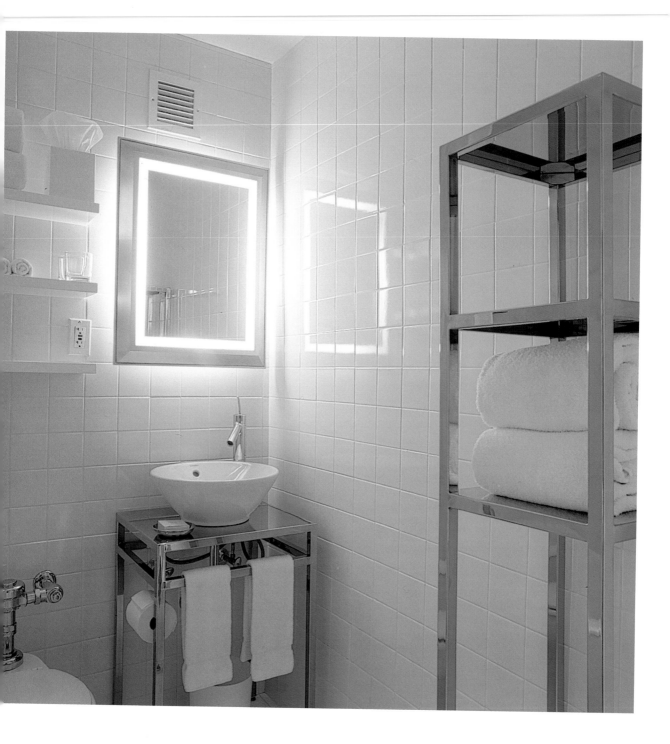

Design by Takaharu and Yui Tezuka Architects
Photo © Katsuhisa Kida

Design by Blockarchitecture
Photo © Leon Chew

Design by Farnan Findlay Architects
Photo © Brett Boardman

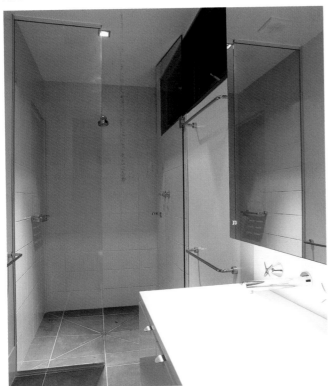

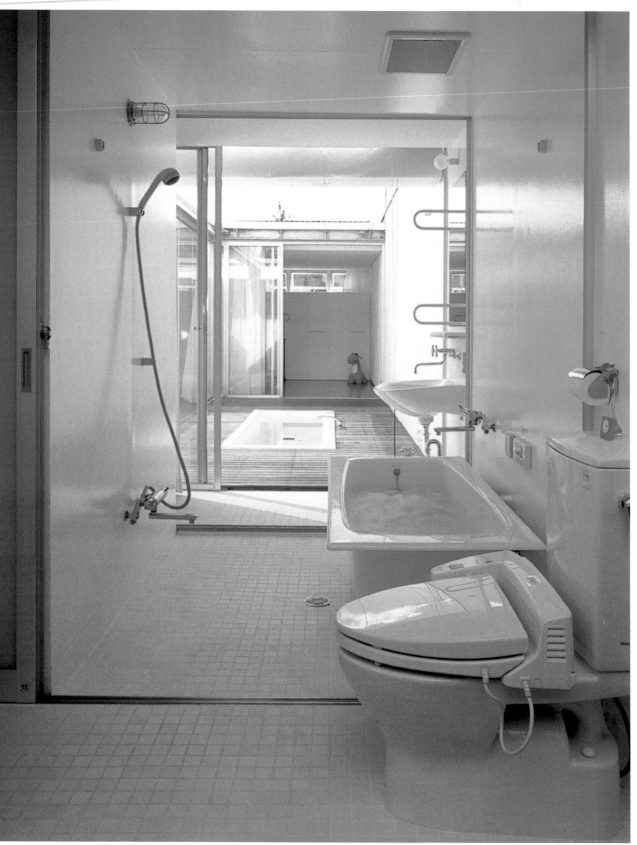

Both pages
Design by PMG Architects, Peter Grumpel, Jury Álvarez
Photo © Pep Escoda

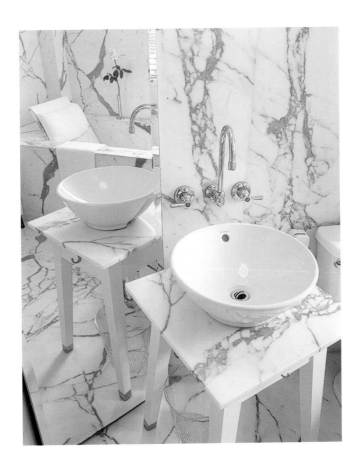

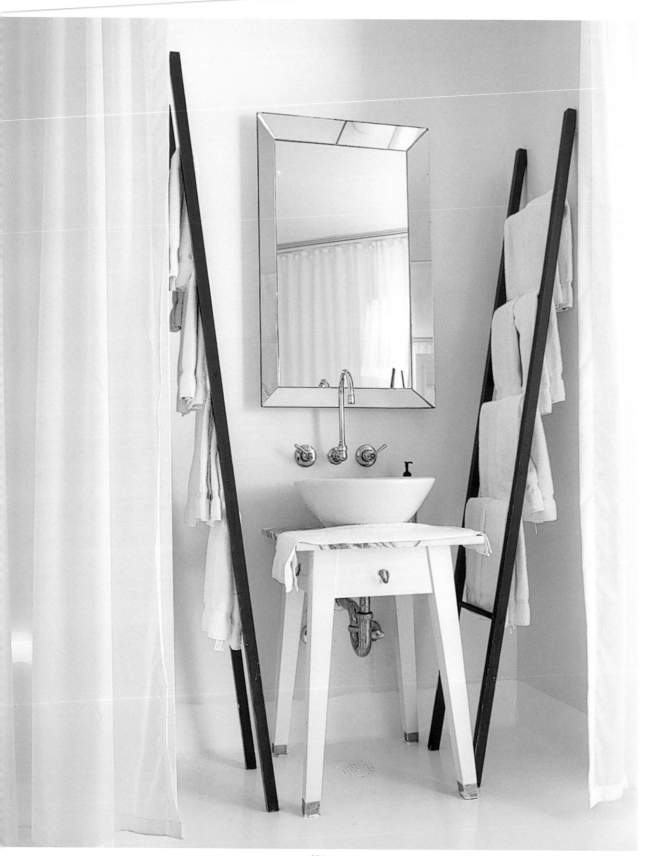

Design by Kim Pooley
Photo © Carlos Domínguez

Red

Since red is associated with vitality, energy and warmth, it should not be used in rooms that are designed for relaxation. However, red can add a great deal of contrast to monochromatic bathrooms.

Rot vermittelt ein Gefühl von Vitalität, Energie und Wärme. Daher wird diese Farbe normalerweise nicht für Räume empfohlen, in denen man Entspannung sucht. Es kann jedoch monotone Bäder kontrastreich aufladen.

Le rouge transmet une sensation de vitalité, d'énergie et de chaleur. C'est pourquoi cette couleur n'est, en général, pas conseillée dans une pièce où l'on cherche à se détendre. Mais elle peut donner du piment à une salle de bains monotone.

El rojo transmite vitalidad, energía y calor. Por ello no acostumbra a elegirse para decorar habitaciones destinadas a la relajación. Sin embargo, también puede servir para animar y dar un poco de contraste a un cuarto de baño monótono.

Il rosso trasmette una sensazione di vitalità, di energia e di calore. Per questo motivo viene normalmente sconsigliato per gli ambienti in cui si cerca di favorire il rilassamento. Tuttavia, il rosso è in grado di arricchire i contrasti nei bagni monotoni.

Photo © Tom Scott/Red Cover

Design by Kim Pooley
Photo © Carlos Domínguez

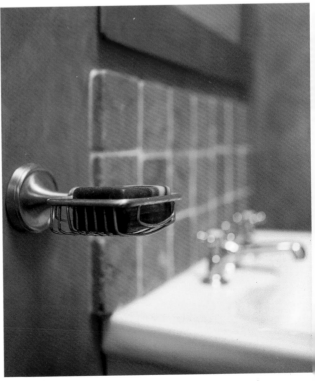

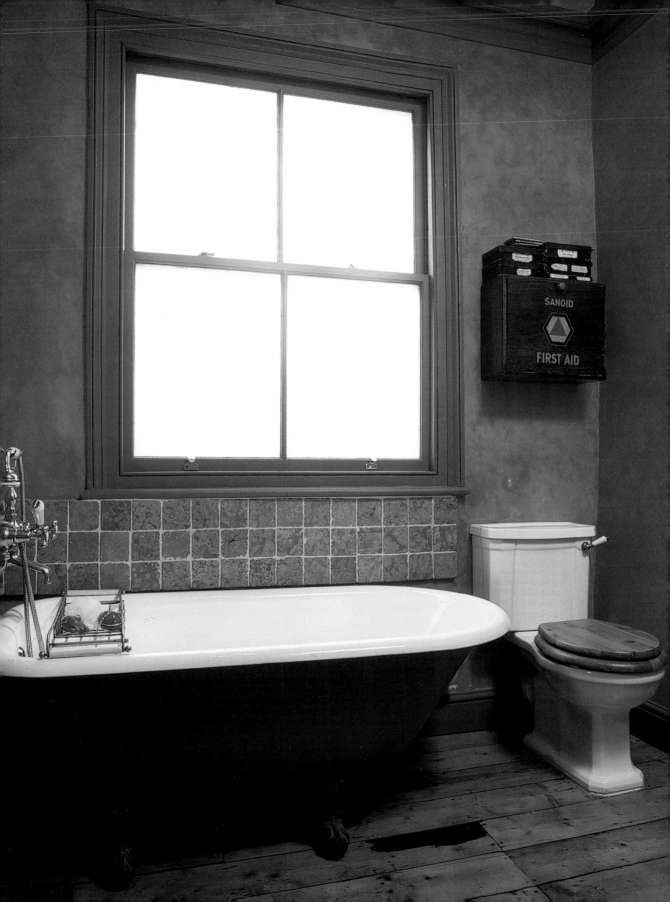

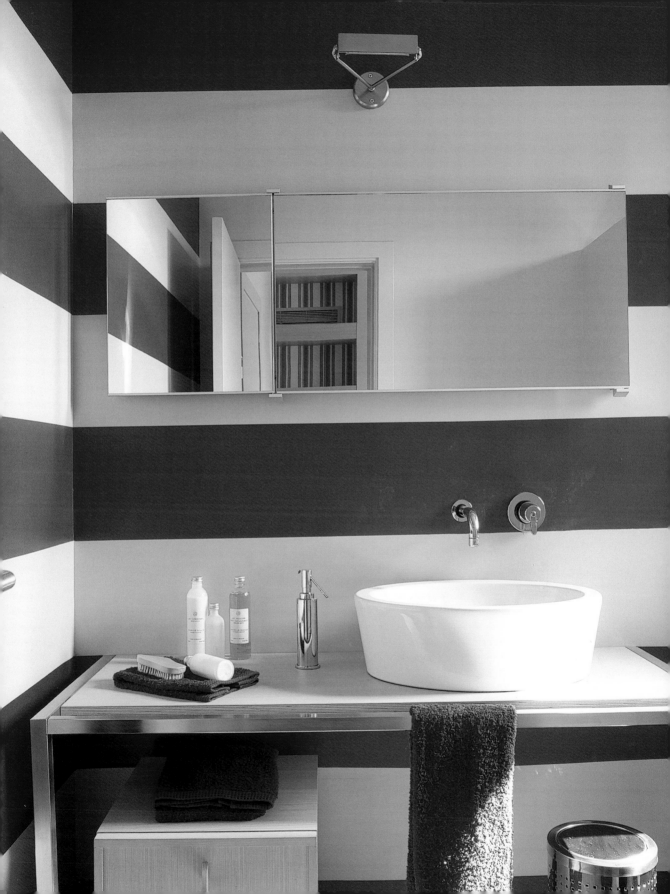

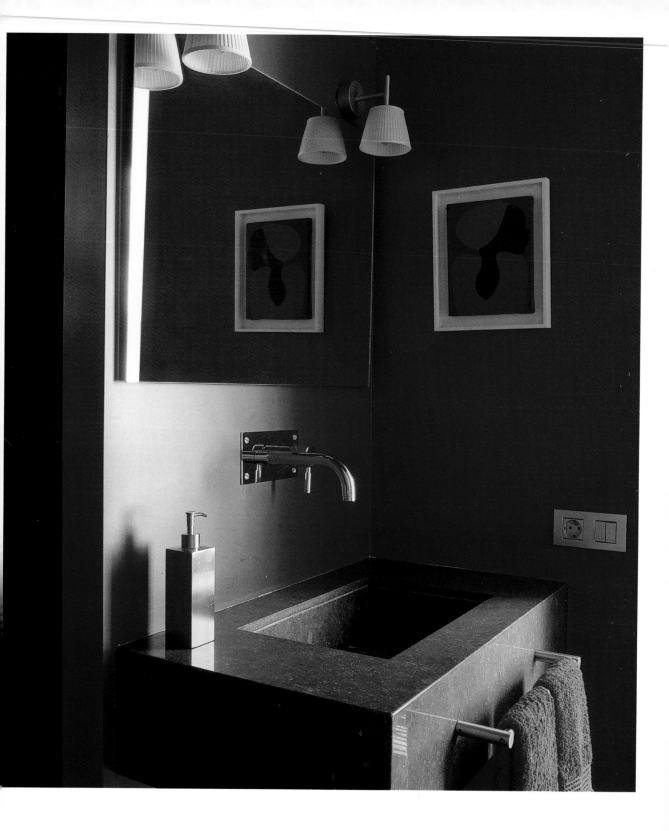

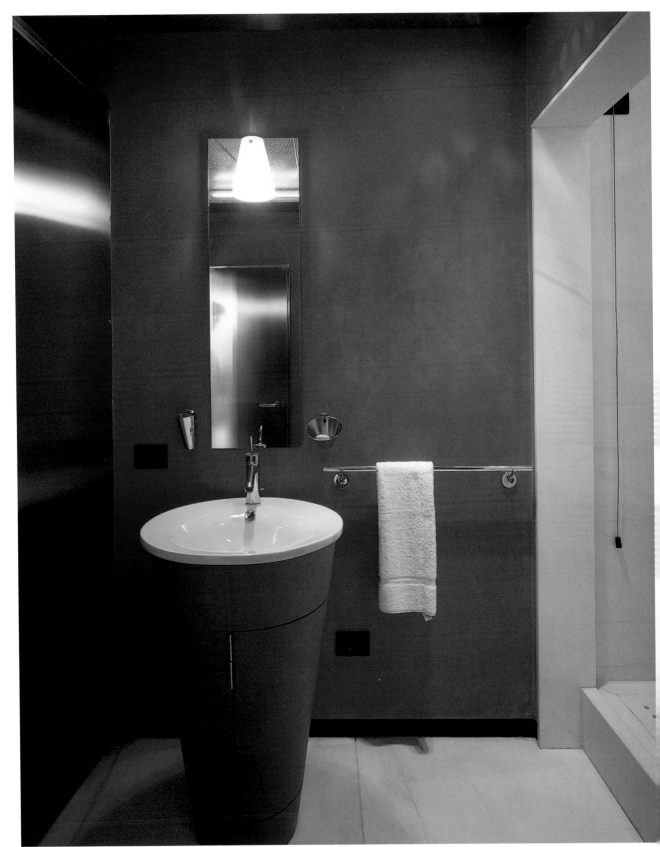

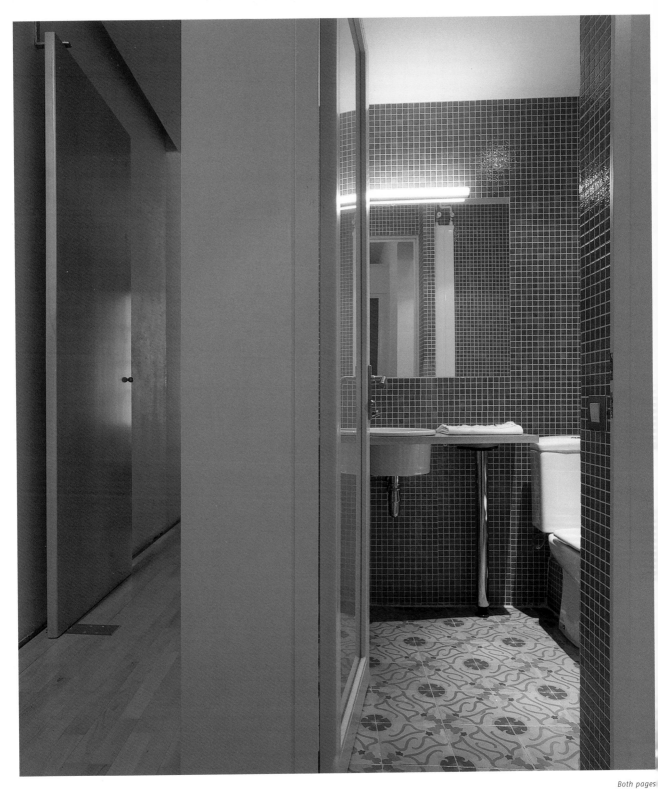

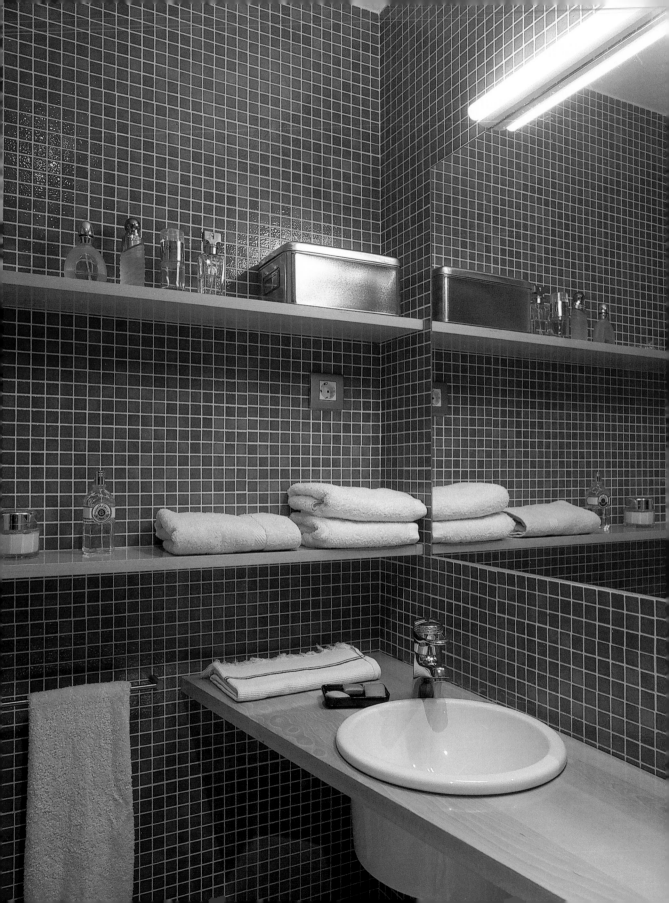

Both pages
Design by Holger Kleine
Photo © Alexander von Reiswitz/Frank Seehausen

Green

Both pages
Design by Jennifer Randall & Associates
Photo © Werner Huthmacher

Green is a color that is available in a plethora of shades. Light tones add a luminous and youthful feeling to a room whereas darker tones make the atmosphere of a room more sophisticated and serious. Green goes well with red and blue tones.

Grün ist eine Farbe, die über eine Vielzahl von Schattierungen verfügt. Helle Töne wirken leicht und jugendlich, dunkle Töne vermitteln Reife und Seriosität. Grün kann sehr gut mit Rot- und Blautönen kombiniert werden.

Le vert est une couleur qui se décline en une infinité de nuances. Les tons clairs font jeune et tonique, les tons foncés procurent sagesse et sérieux. Le vert se marie facilement avec les tons bleus et rouges.

El verde es un color que ofrece muchos matices. Los tonos claros resultan ligeros y juveniles; los oscuros, por el contrario, transmiten una sensación de madurez y seriedad. El verde puede combinarse perfectamente con tonalidades rojas y azules.

Il verde è un colore ricco di numerosissime tonalità. Mentre i toni chiari appaiano leggeri e giovanili, quelli scuri trasmettono una sensazione di maturità e di serietà. Il verde si riesce a combinare molto bene con tante tonalità di rosso e di blu.

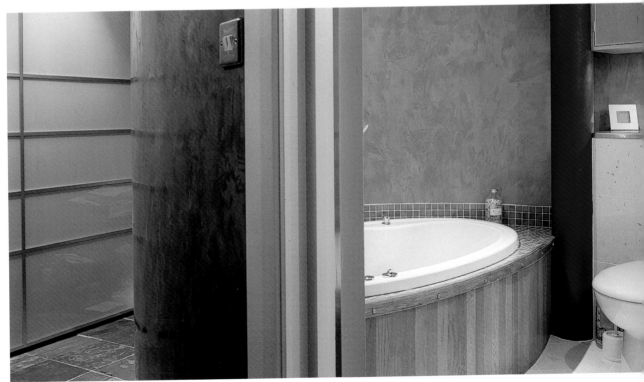

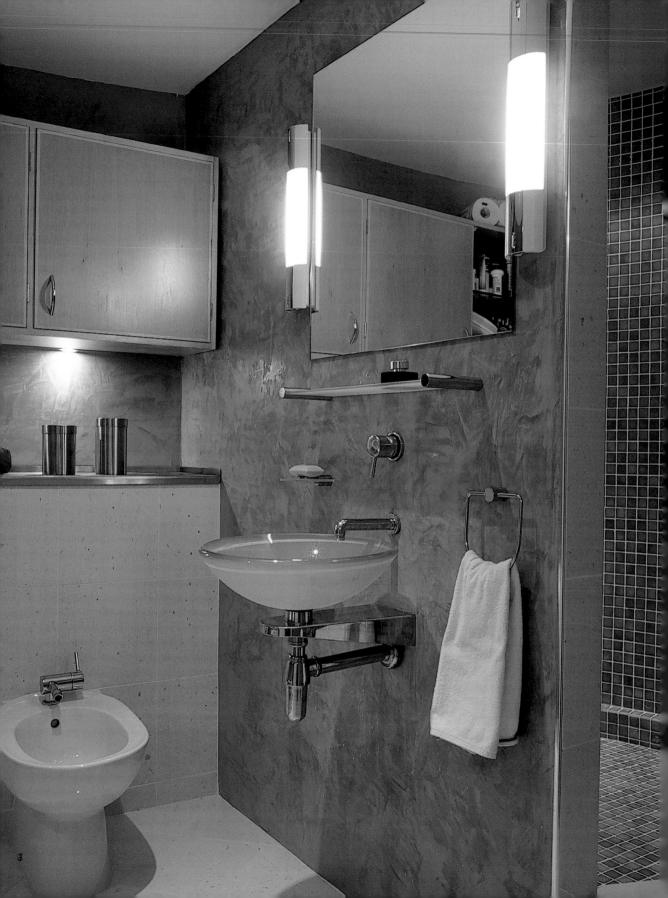

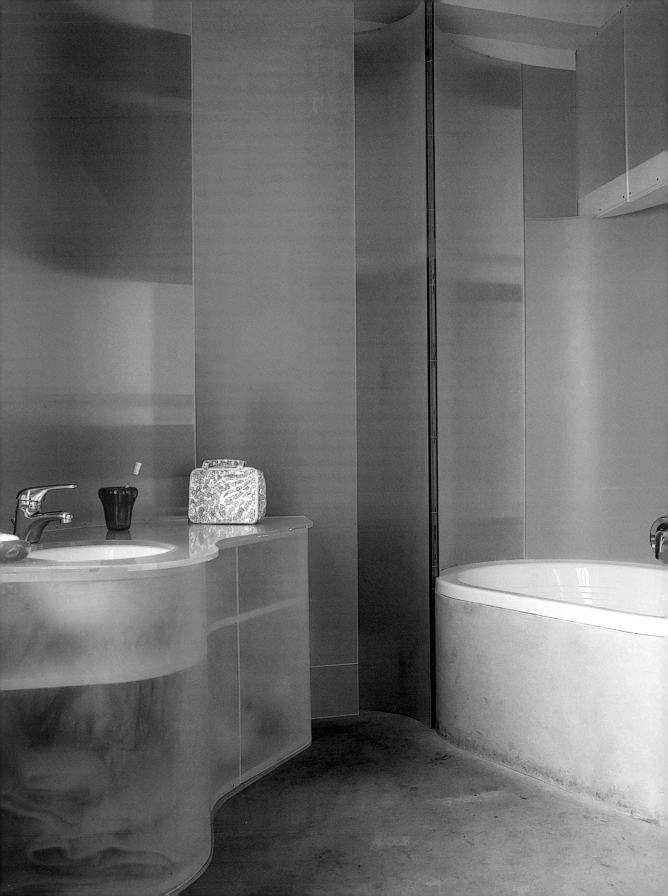

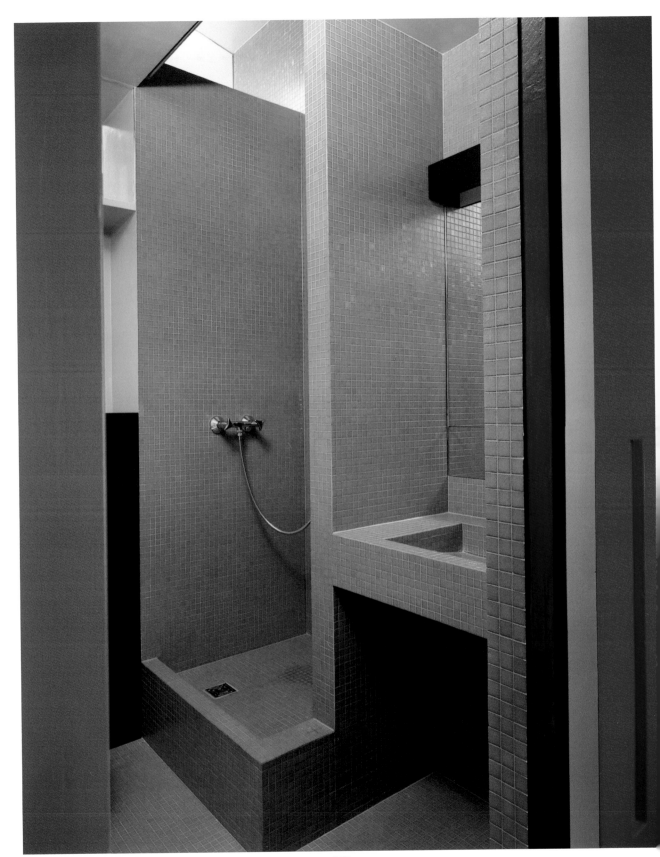

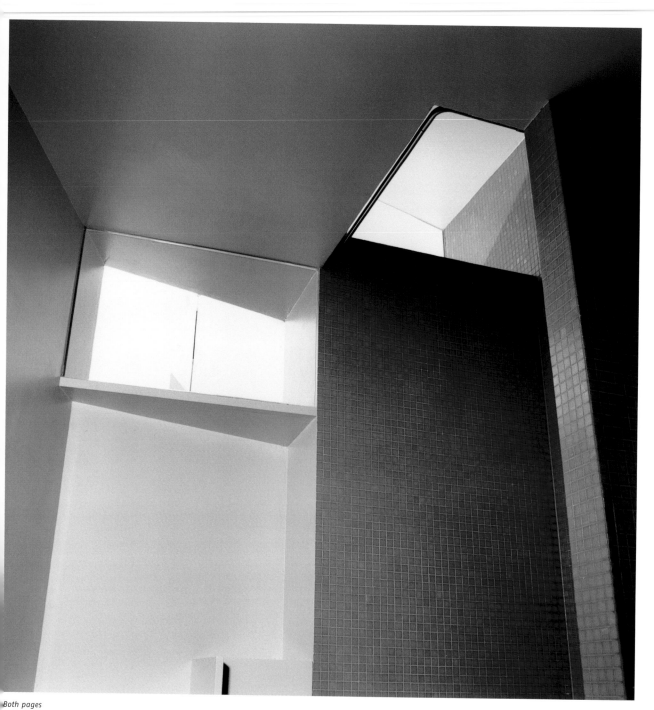

Both pages
Design by Holger Kleine
Photo © Alexander von Reiswitz, Frank Seehausen

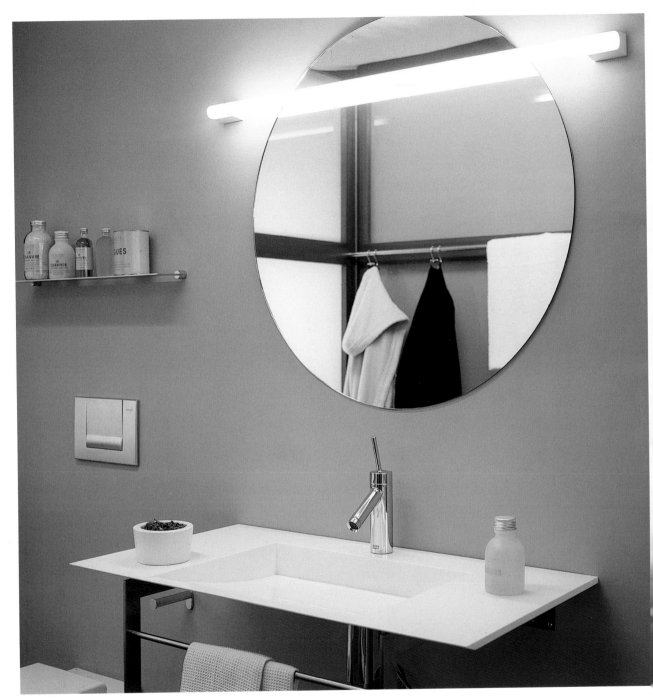

Design by Nancy Robbins, Lluís Victori
Photo © José Luis Hausmann

Design by Holger Kleine
Photo © Werner Huthmache

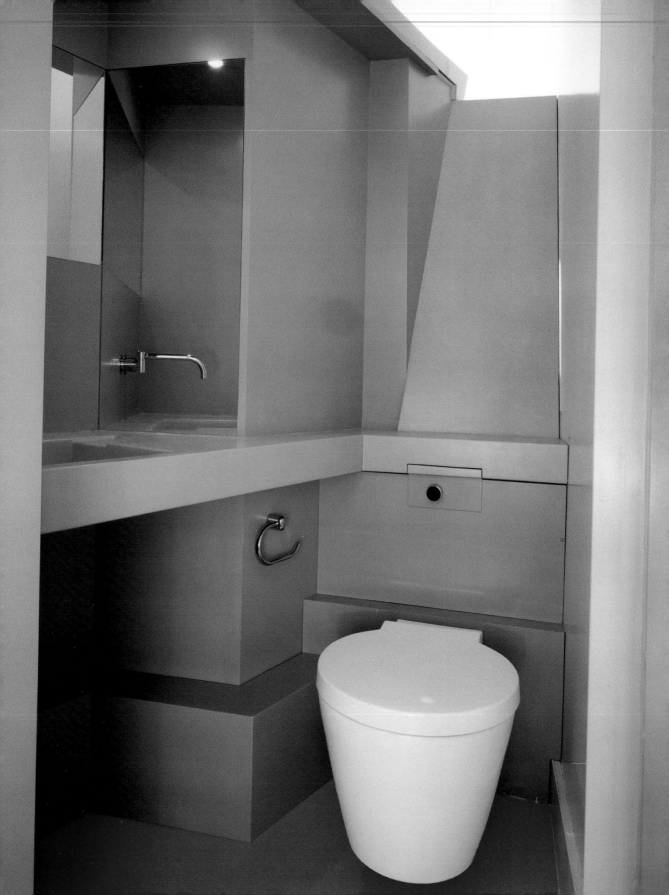

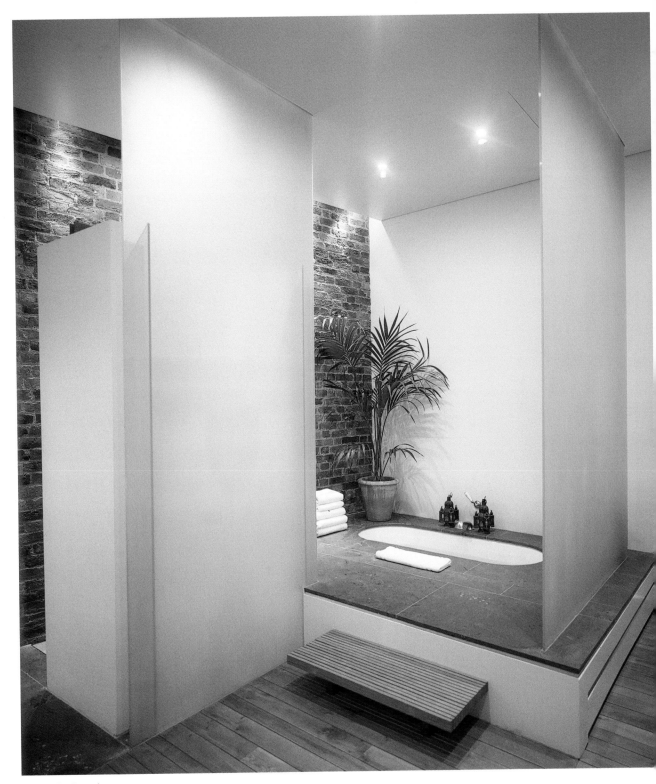

Design by Tara Bernerd
Photo © Andreas von Einsiedel/Red Cover

Design by Peter Osbourn
Photo © Andrew Twort/Red Cover

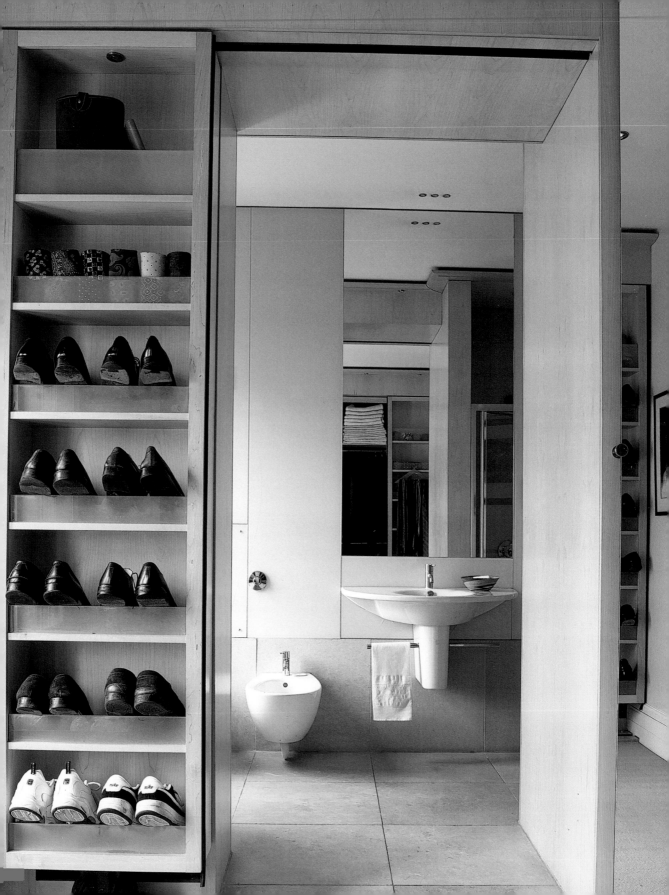

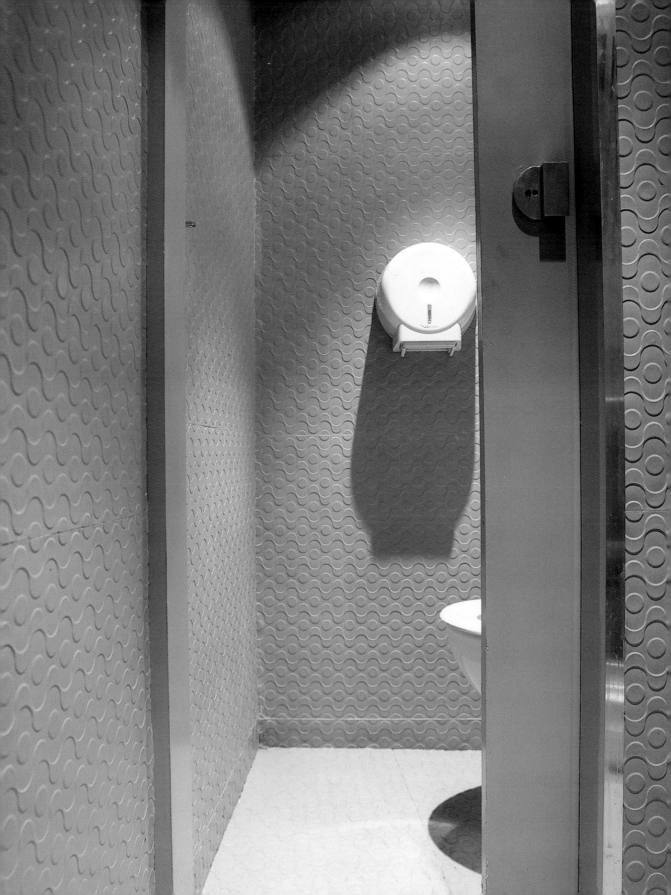

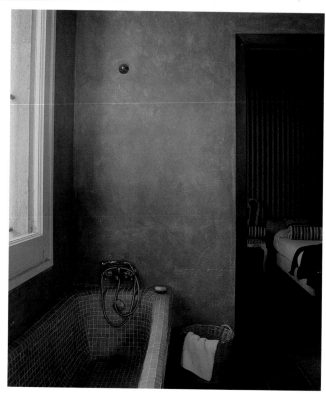

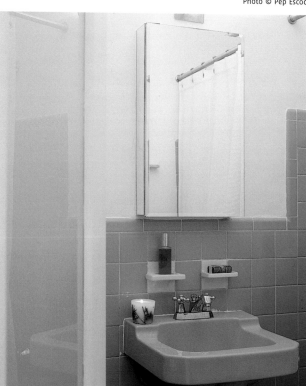

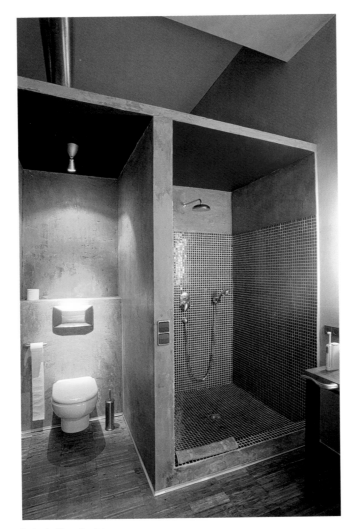

Design by Simon Conder
Photo © Maite Gallardo

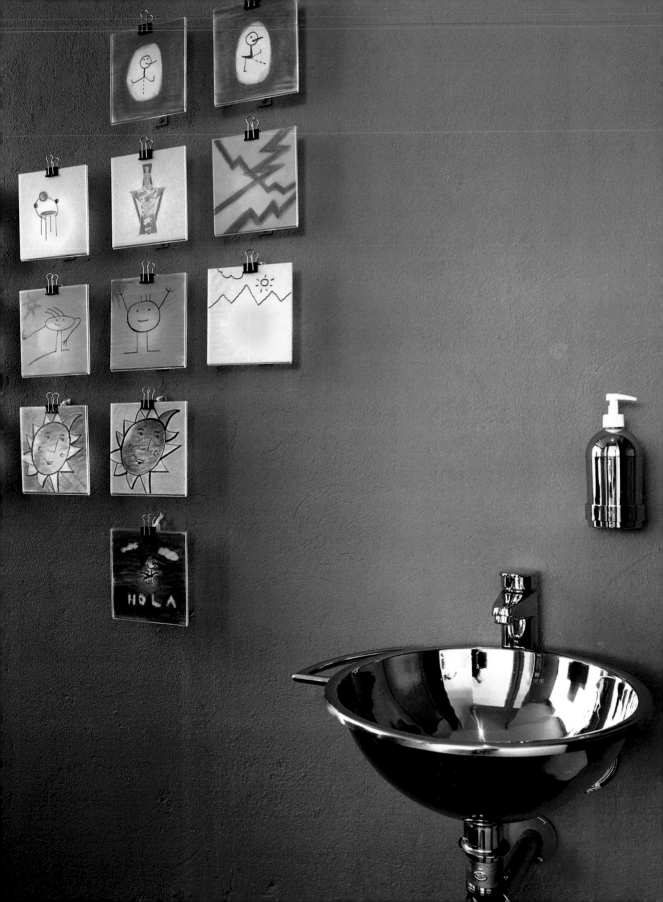

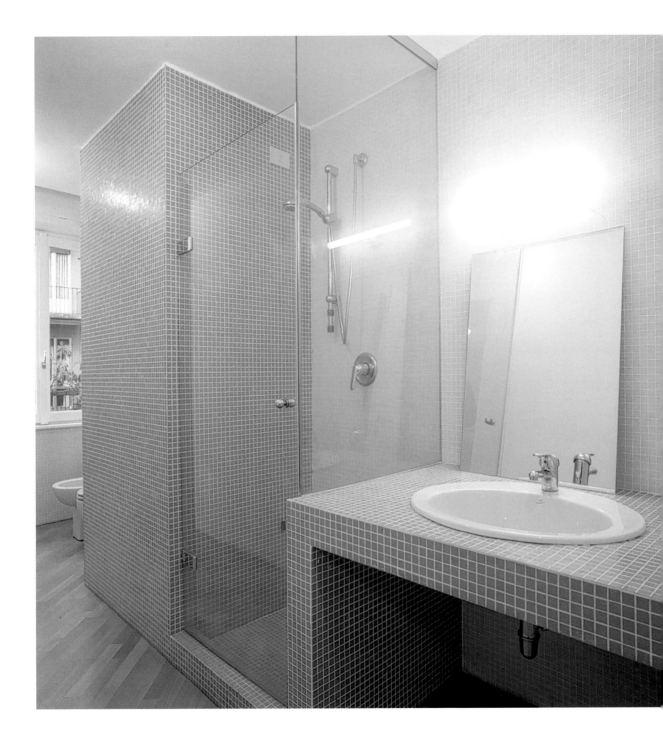

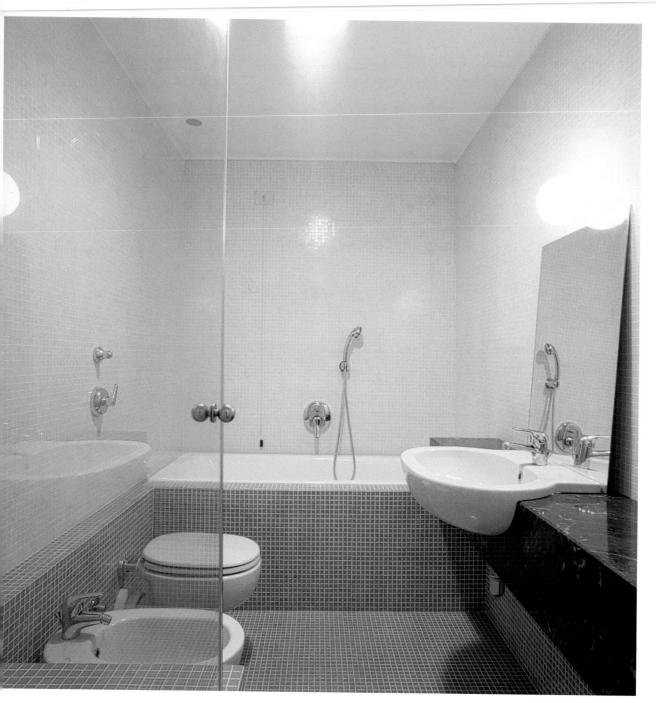

Blue

Blue is associated with water, freshness and cleanliness. It goes very well with white and it is therefore not surprising that blue (along with white) is one of the most commonly used bathroom colors.

Mit Blau assoziiert man Wasser, Frische und Sauberkeit. Es ist sehr gut mit Weiß kombinierbar und so erstaunt es nicht, dass Blau, neben Weiß, eine der am häufigsten für Badezimmer verwendeten Farben ist.

Avec le bleu, on associe l'eau, la fraîcheur et la propreté. Il se marie très bien avec le blanc. Il n'est donc pas étonnant que le bleu soit la couleur la plus utilisée dans les salles de bains, après le blanc.

El color azul se asocia con el agua, el frescor y la limpieza. Se complementa muy bien con el blanco, por eso no sorprende que el azul (junto con el blanco) sea uno de los colores más utilizados en los cuartos de baño.

Con il blu si associa l'acqua, freschezza e pulizia. Si abbina molto bene al bianco e non c'è da stupirsi che il blu (giunto con il blanco) sia uno dei colori più frequentemente scelti per i bagni.

Photos © Jordi Sarrà

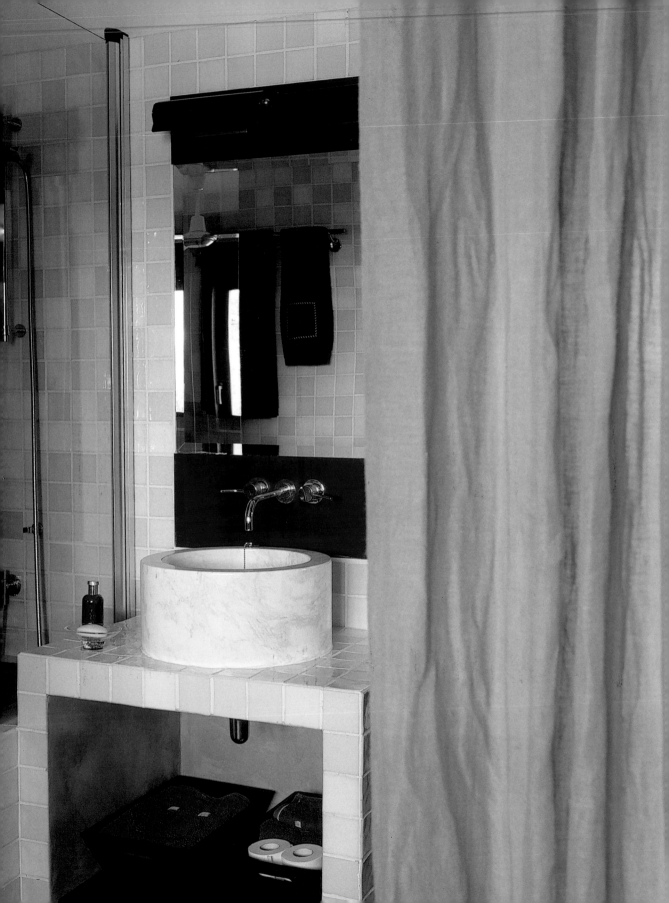

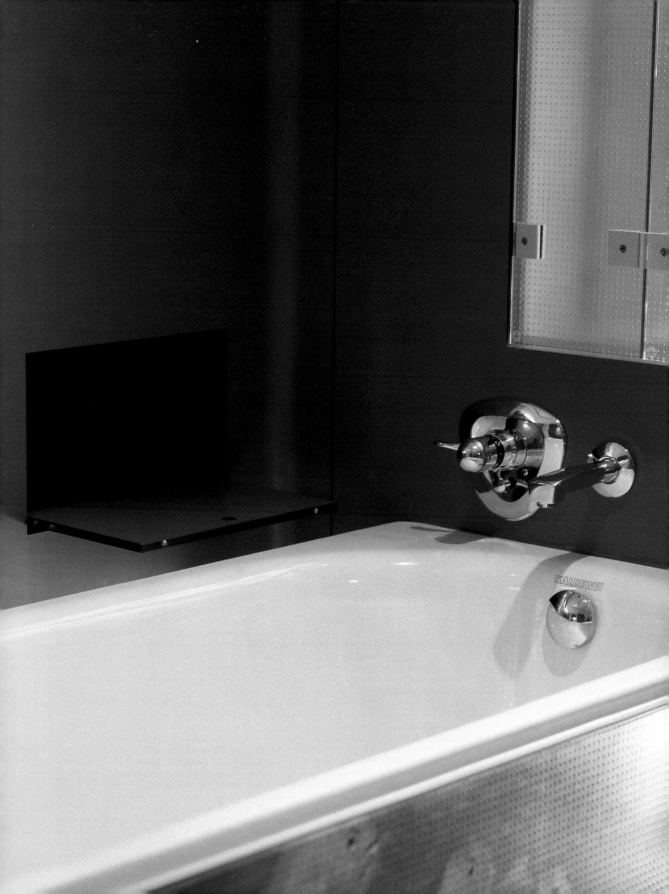

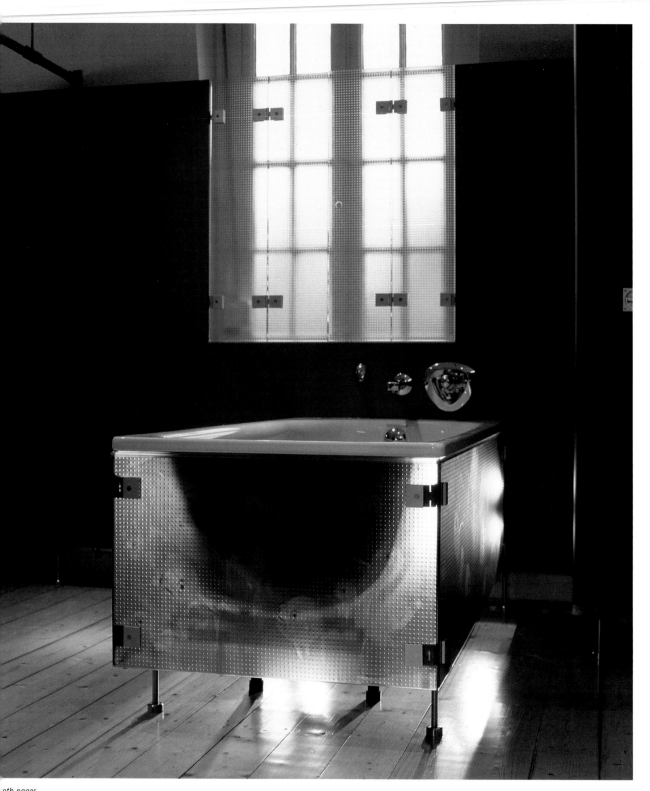

oth pages
esign by Kalhöfer–Korschildgen
hoto © Jörg Hempel

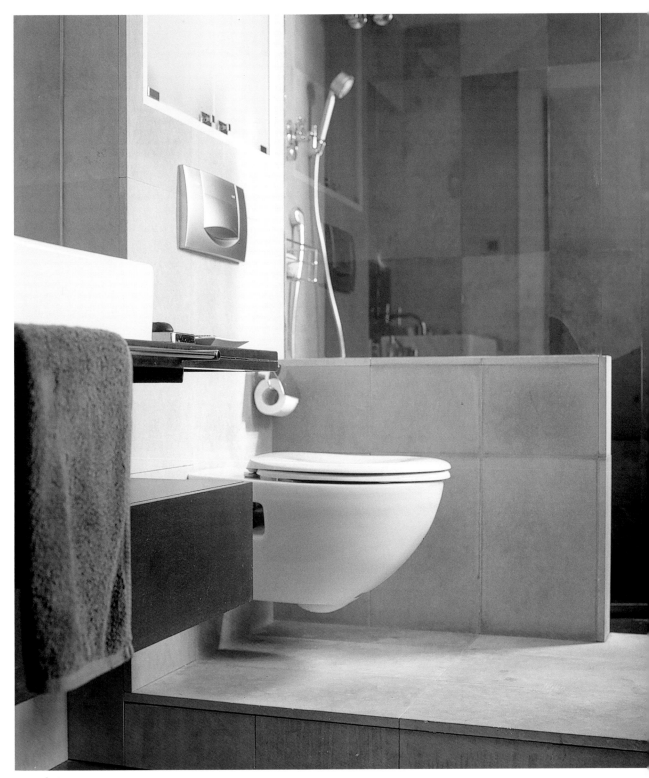

Photo © José Luis Hausmann

Photo © José Luis Hausman

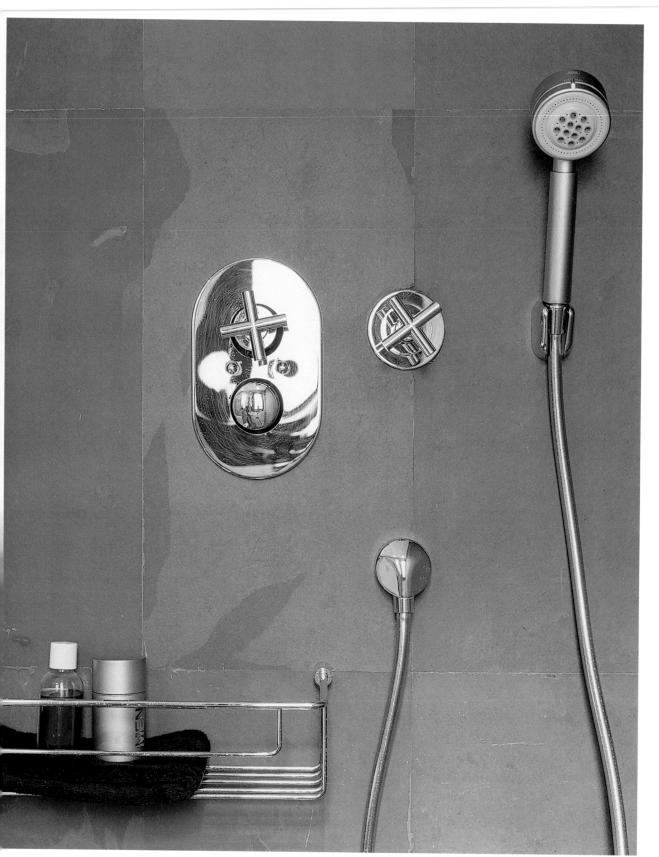

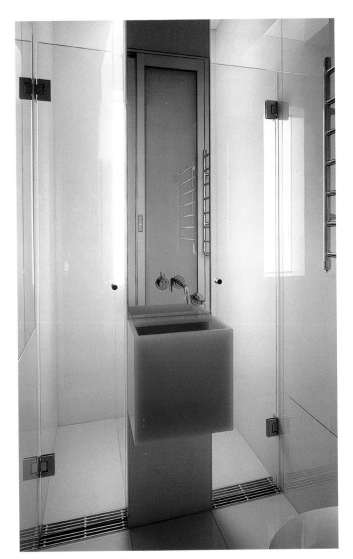

Design by Stephen Varady Architecture
Photo © Richard Glover

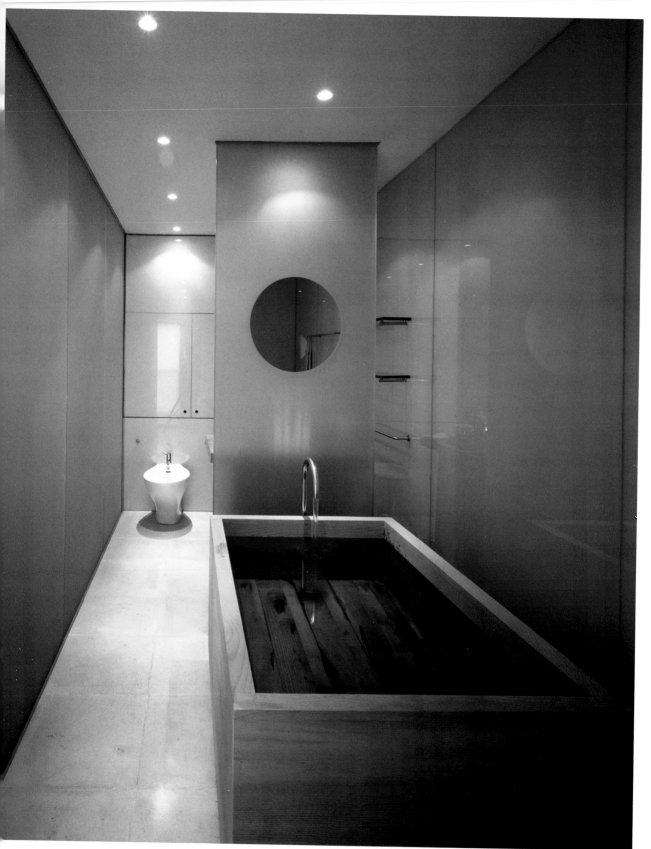

Lavender

Lavender has traditionally been an ecclesiastic color that was reserved for use in royal palaces. It is a color that tends to stand out and is therefore rarely used on large interior surfaces.

Traditionell war Violett eine religiöse Farbe, die vor allem den Königshäusern vorbehalten war. Es hat einen dominanten Charakter und wird daher selten großflächig in der Gestaltung von Innenräumen verwendet.

Traditionnellement, le violet était la couleur de la religion et l'apanage exclusif des maisons royales. Couleur dominante, elle est de ce fait, dans la conception d'espaces intérieurs, rarement utilisée pour les grandes surfaces.

Tradicionalmente, el violeta era un color religioso reservado a las casa reales. Tiene un carácter dominante y por ello se suele usar con moderación en la decoración de interiores.

Tradizionalmente, il viola è stato considerato un colore religioso, riservato sopratutto alle case reali. Avendo un carattere molto dominante, il viola viene adoperato raramente per arredare grandi superfici interne.

Both pages
Photo © Jordi Sarrà

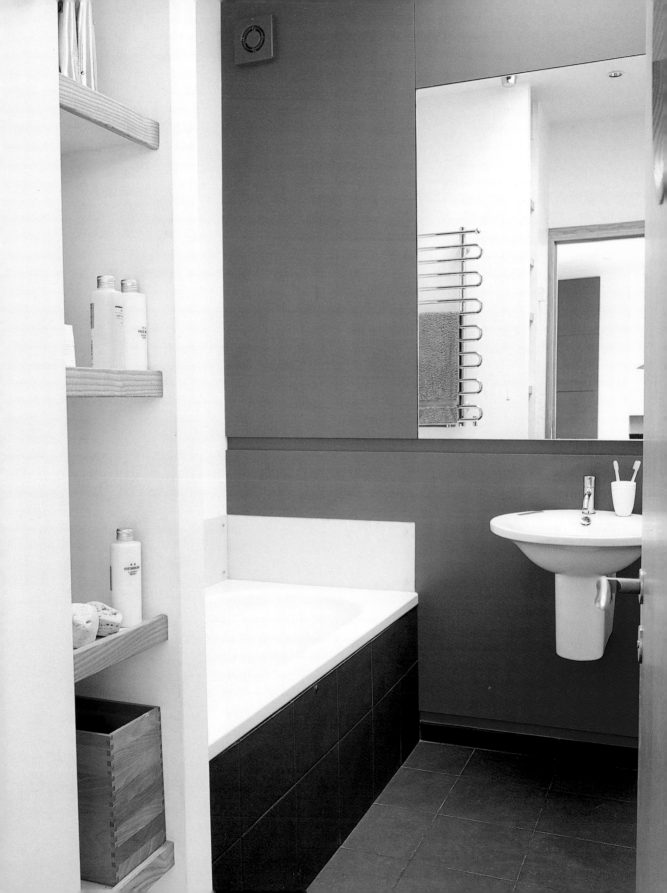

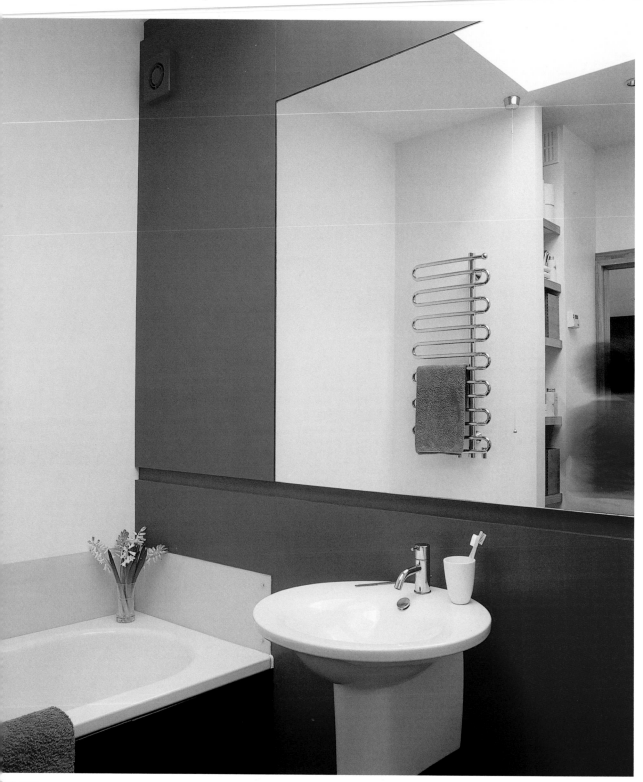

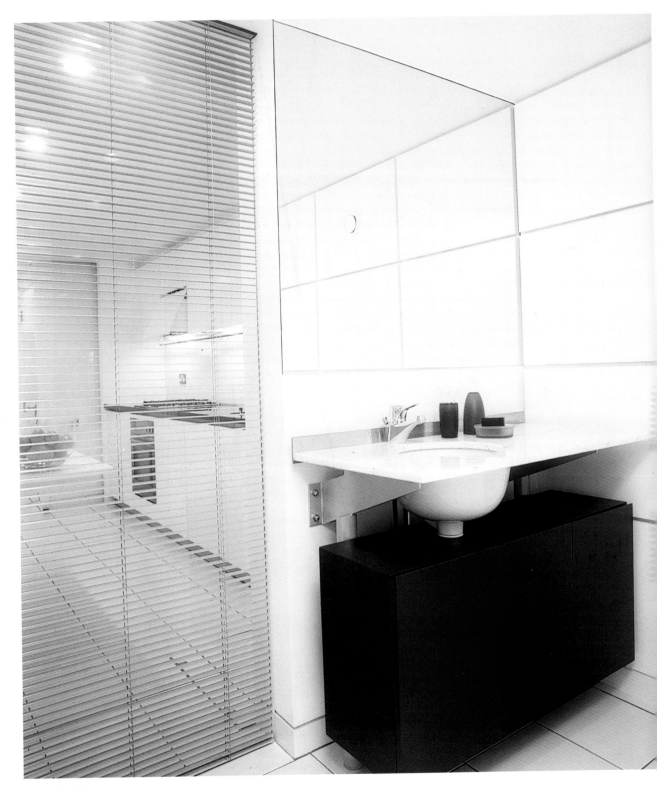

Design by Hugh Broughton
Photo © Carlos Domínguez

Design by Nobuyuki Furuy
Photo © Mitsuo Matsuok

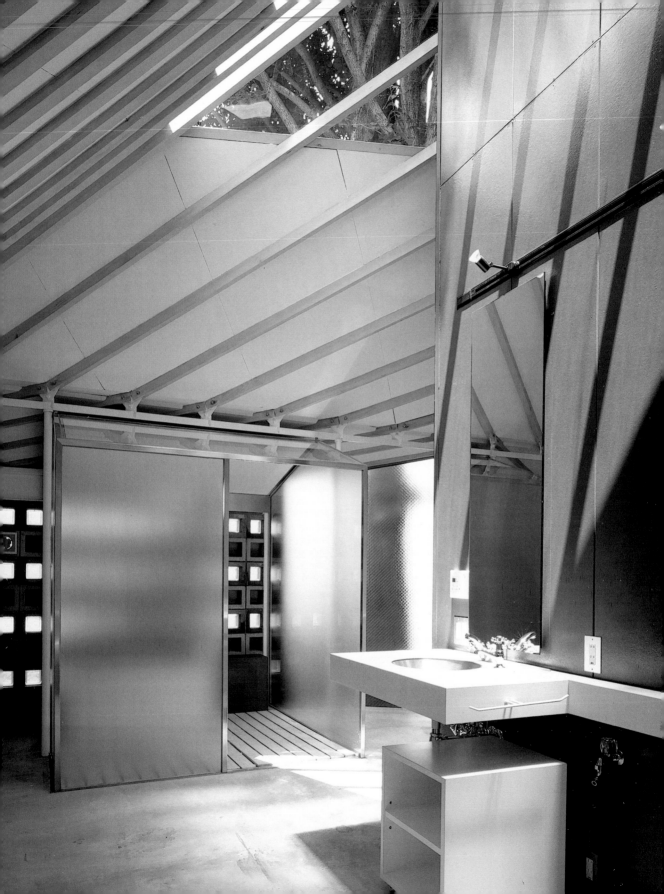

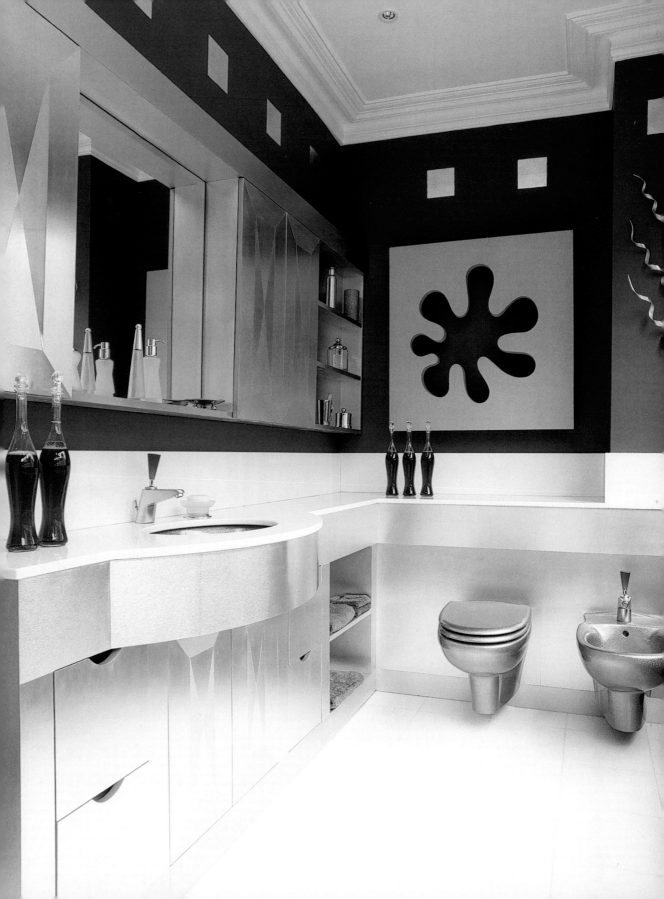

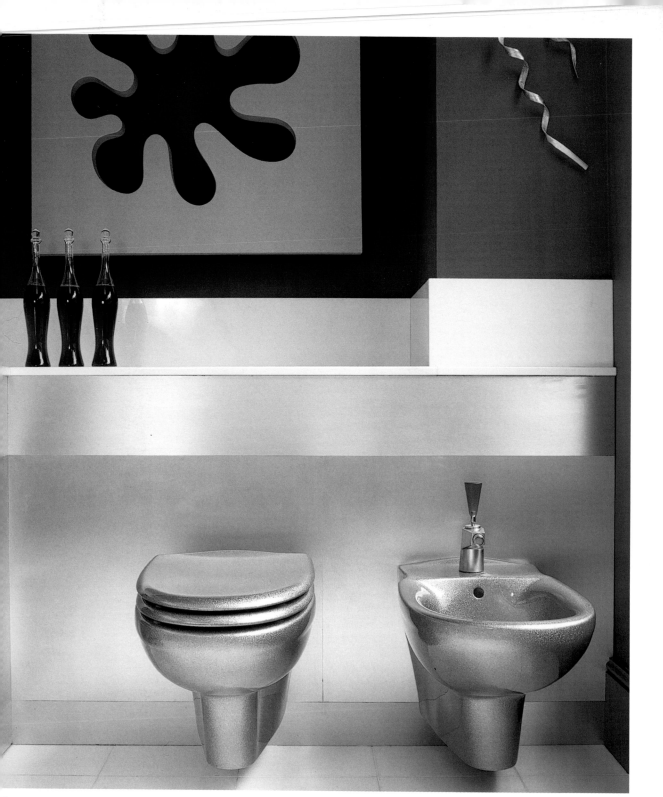

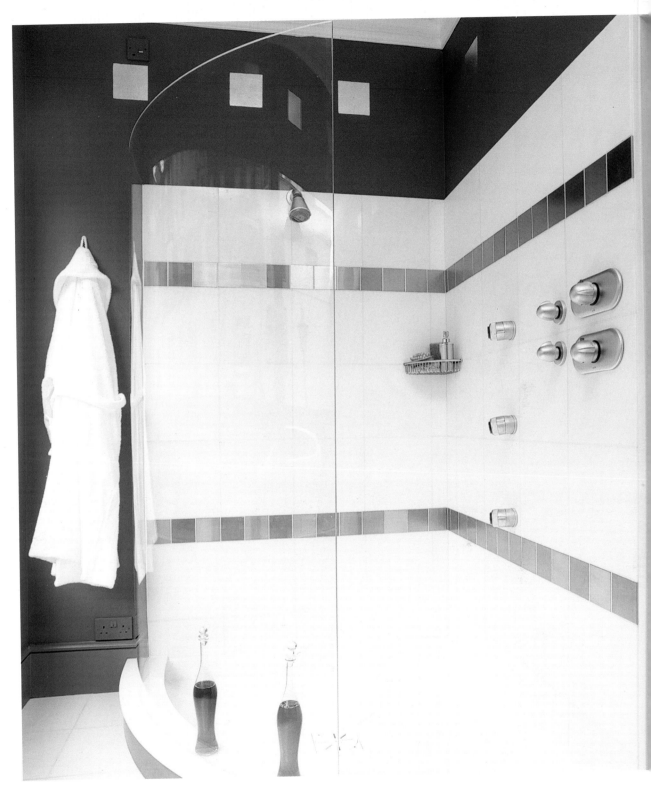

Design by Pipe Dreams
Photo © Carlos Domínguez

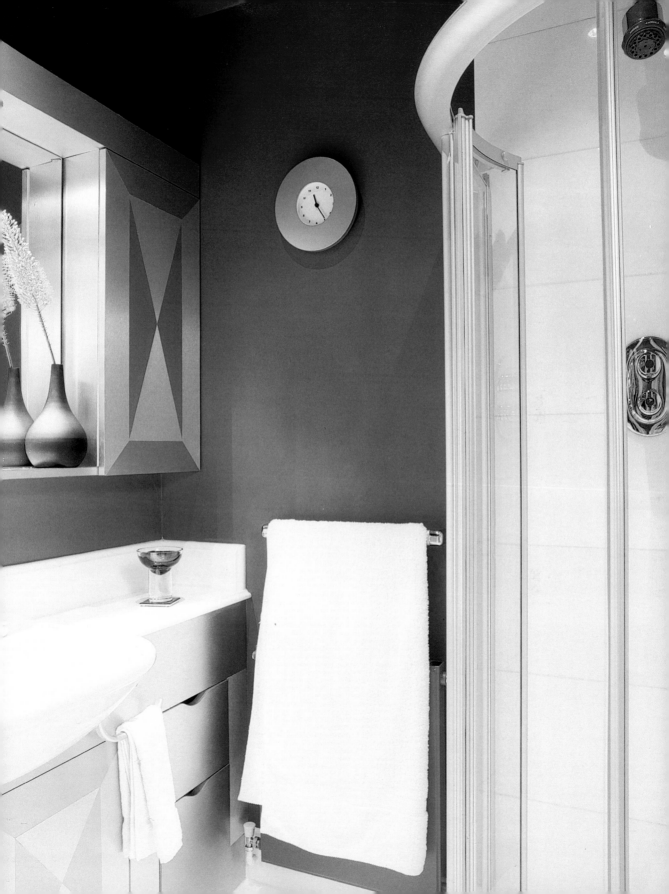

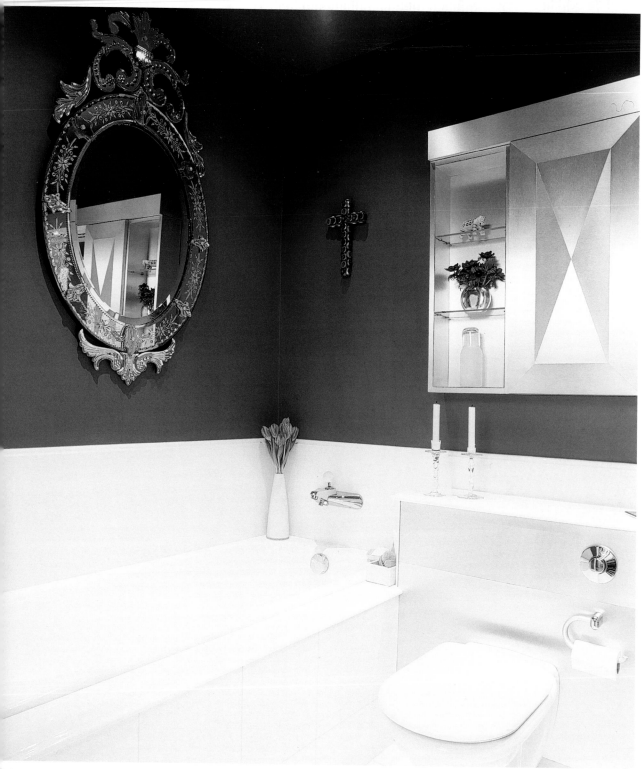

Brown

Brown, like green, is a color that occurs frequently in nature and because of its versatility can be put to countless decorative purposes. It is mainly used to create a warm and relaxed atmosphere.

Braun ist, wie Grün, eine Farbe der Natur und ermöglicht aufgrund seiner Vielfältigkeit unbegrenzte Möglichkeiten bei der Dekoration. Es wird vor allem verwendet, um ein warmes und entspanntes Ambiente zu schaffen.

Le brun, à l'instar du vert, est une couleur issue de la nature et offre une infinité de possibilités dans la décoration intérieure. Il est surtout utilisé pour créer une ambiance chaleureuse et décontractée.

El marrón, como el verde, es un color natural que gracias a su riqueza de matices ofrece ilimitadas posibilidades de decoración. Se usa sobre todo para crear ambientes cálidos y relajados.

Il marrone, come anche il verde, è un colore della natura; grazie alle sue tonalità molteplici, esso offre per scopi decorativi delle possibilità illimitate. Viene adoperato sopratutto per creare degli ambienti caldi e distensivi.

Design by Lizarriturry Tuneu Arquitectures
Stylism by Silvia Rademakers, Virginia Palleres
Photos © José Luis Hausmann

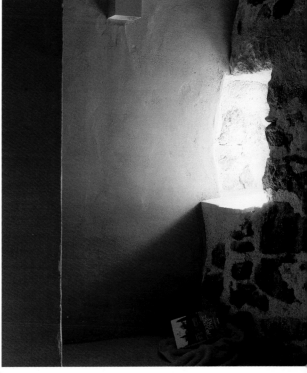

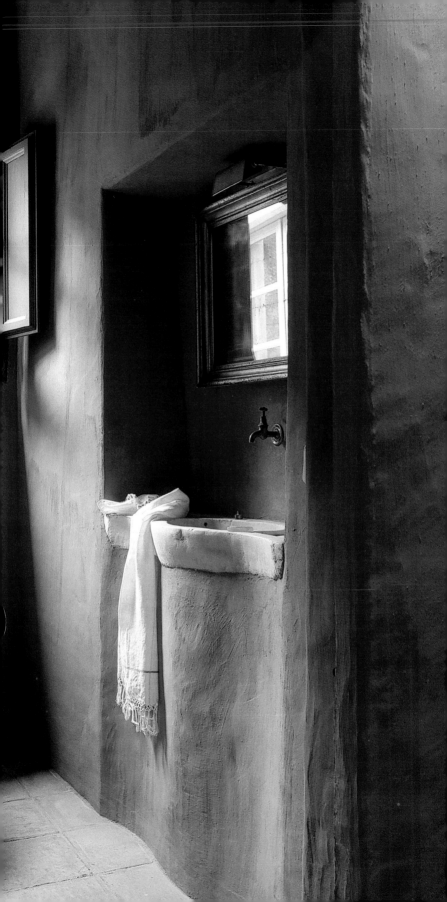

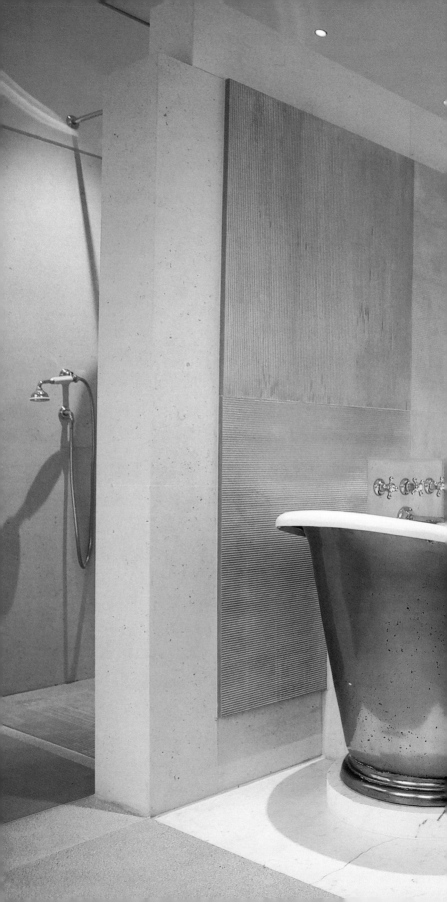

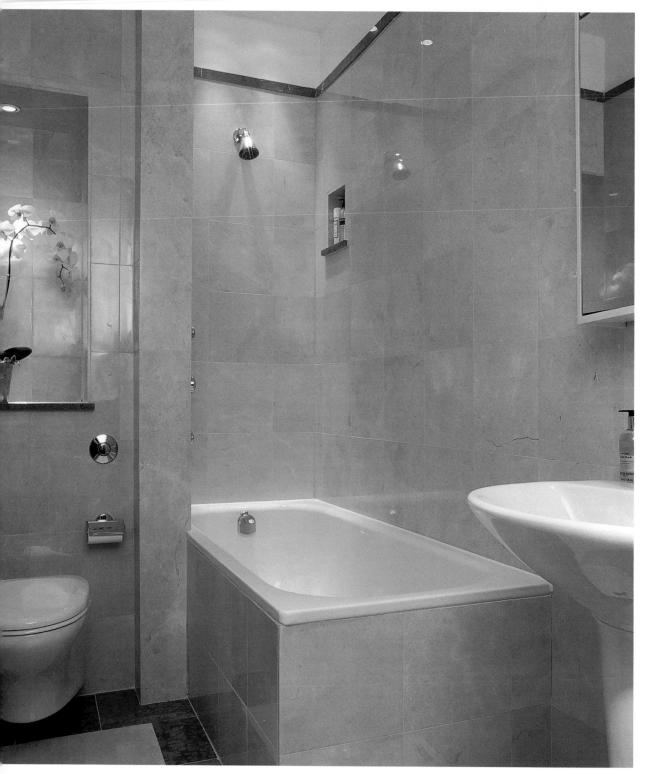

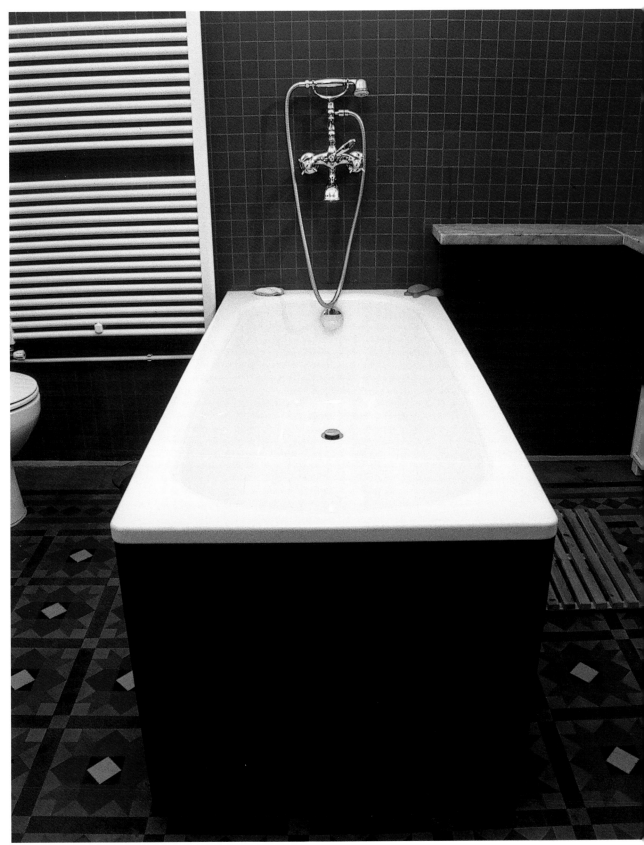

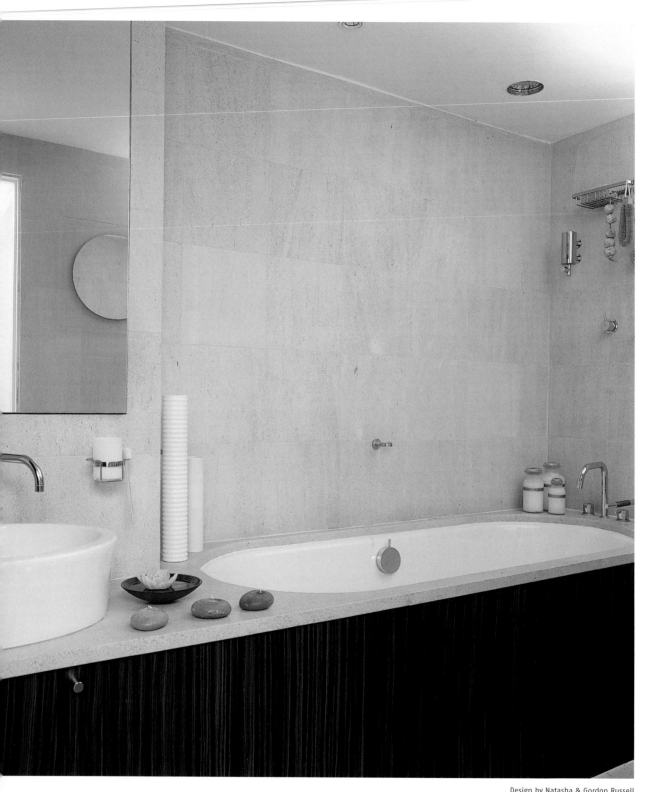

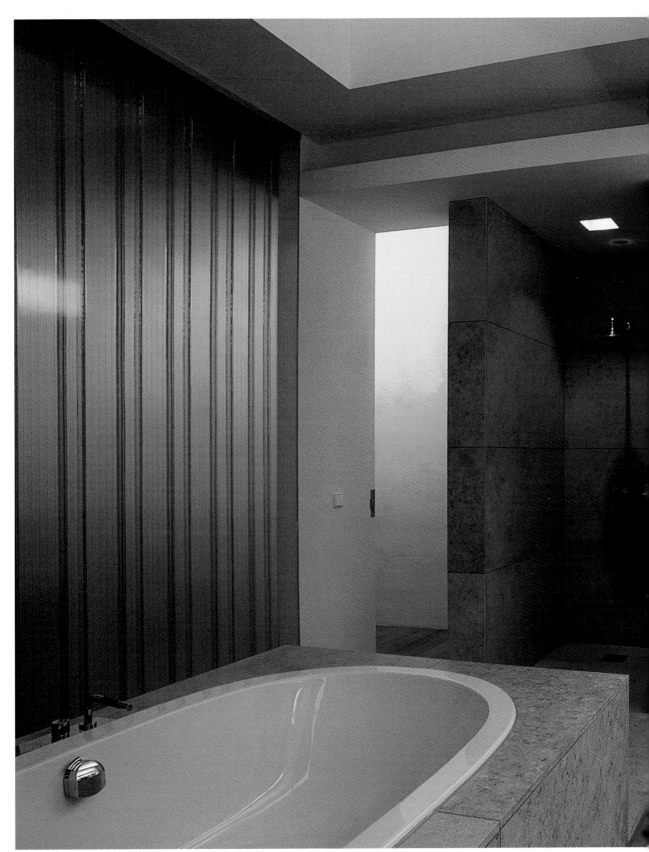

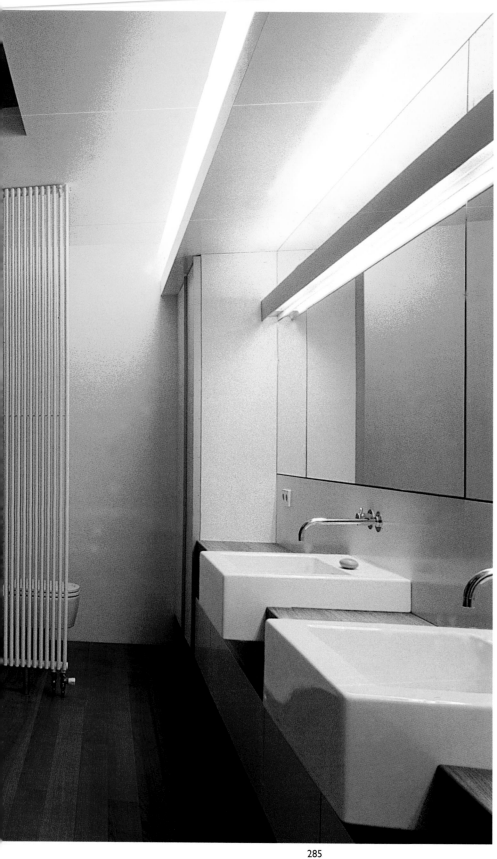

Design by Lynx Architecture
Photo © Andreas J. Focke

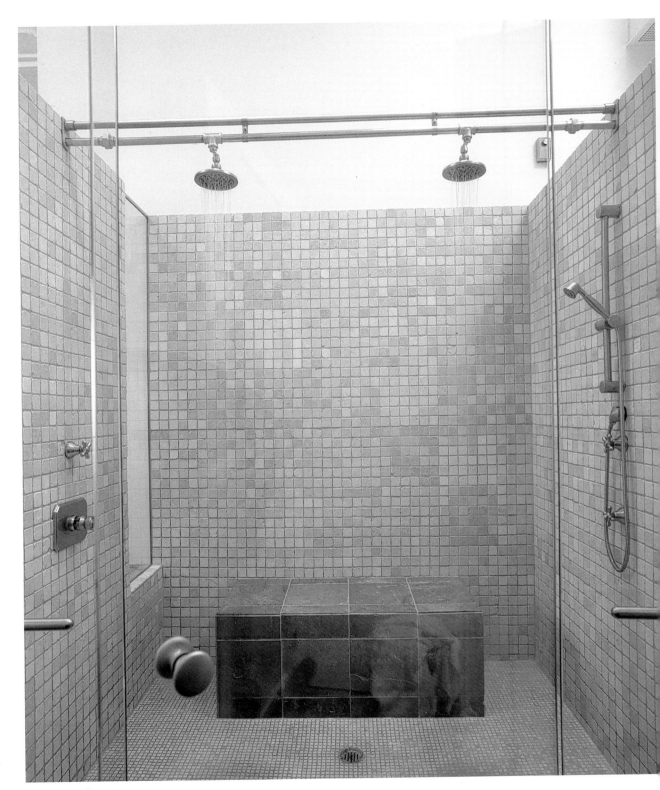

Design by Cecconi Simone Inc.
Photo © Joy von Tiedemann

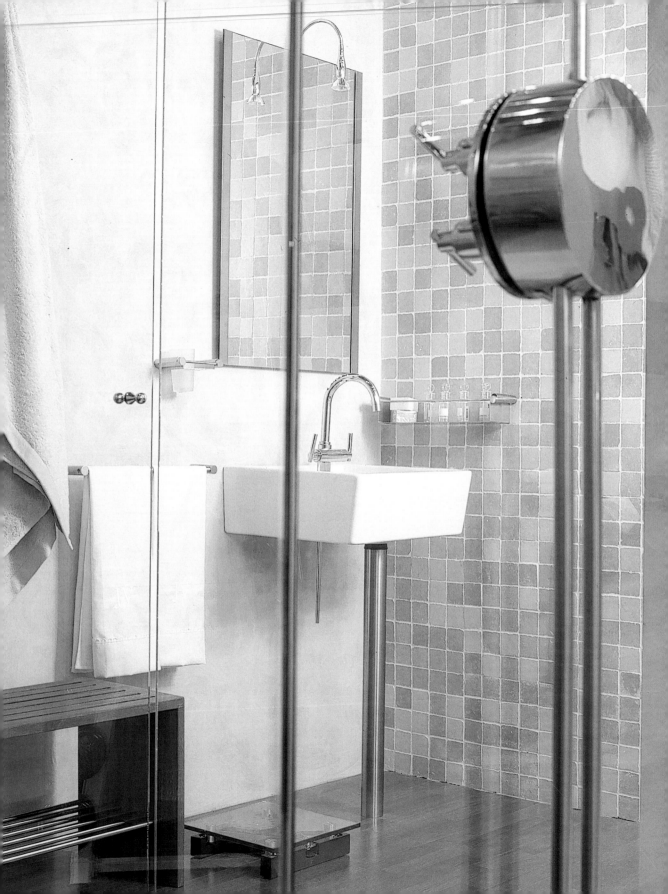

Black

Black goes extremely well with white, yellow and other clear colors. It is particularly effective in larger bathrooms where a warmer atmosphere or greater contrast is desired.

Schwarz ist eine Farbe, die sehr gut mit Weiß, Gelb und anderen klaren Farben kombiniert werden kann. Es ist besonders wirkungsvoll in größeren Badezimmern, für die man sich eine intimere Atmosphäre oder stärkere Kontraste wünscht.

Le noir est une couleur très facile à combiner avec le blanc, le jaune et autres couleurs claires. Elle fait beaucoup d'effet dans les grandes pièces où l'on souhaite créer une atmosphère plus intime ou un effet de contraste.

El negro es un color que combina muy bien con el blanco, el amarillo y otros tonos claros. Resulta especialmente efectista en cuartos de baño de grandes dimensiones en los que se desea lograr una atmósfera de carácter íntimo o rica en contrastes.

Il nero è un colore che si abbina molto bene al bianco, al giallo ed ad altri colori brillanti. È di grande effetto soprattutto in bagni spaziosi in cui si desidera creare un atmosfera più intima o dei contrasti più forti.

Photo © José Luis Hausmann

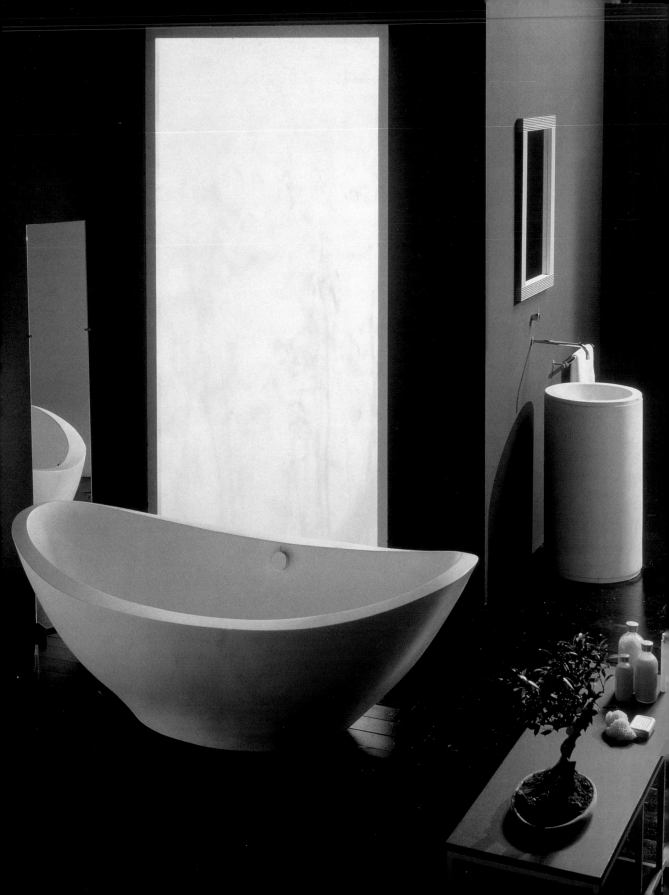

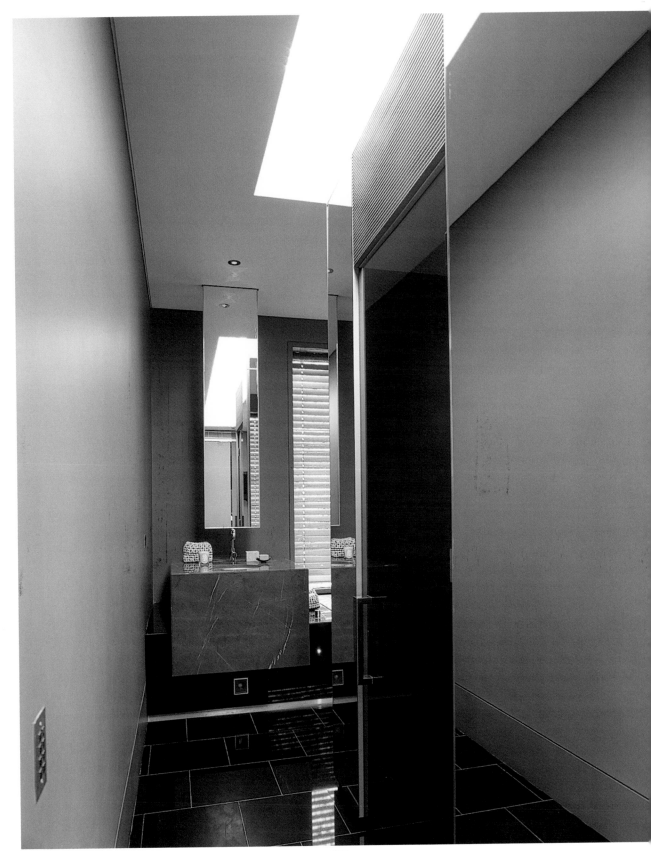

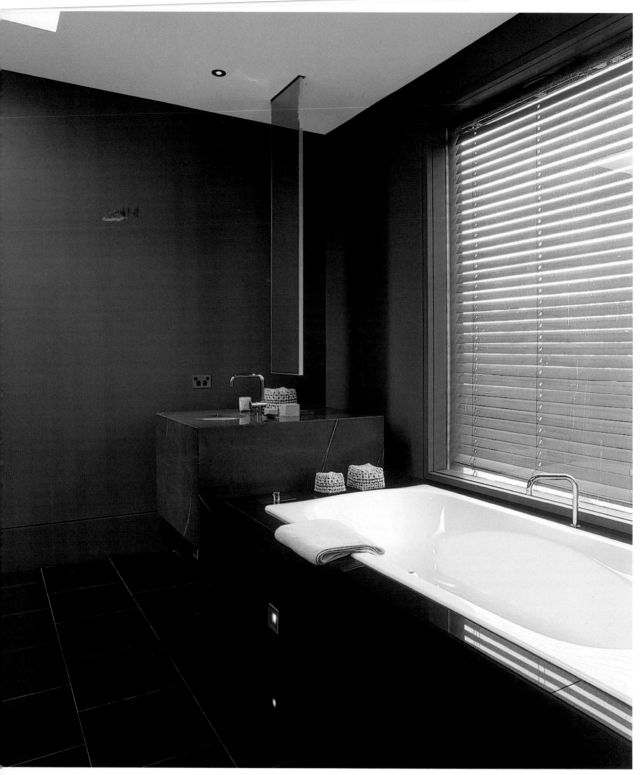

oth pages
esign by Burley Katon Halliday
noto © Sharrin Rees

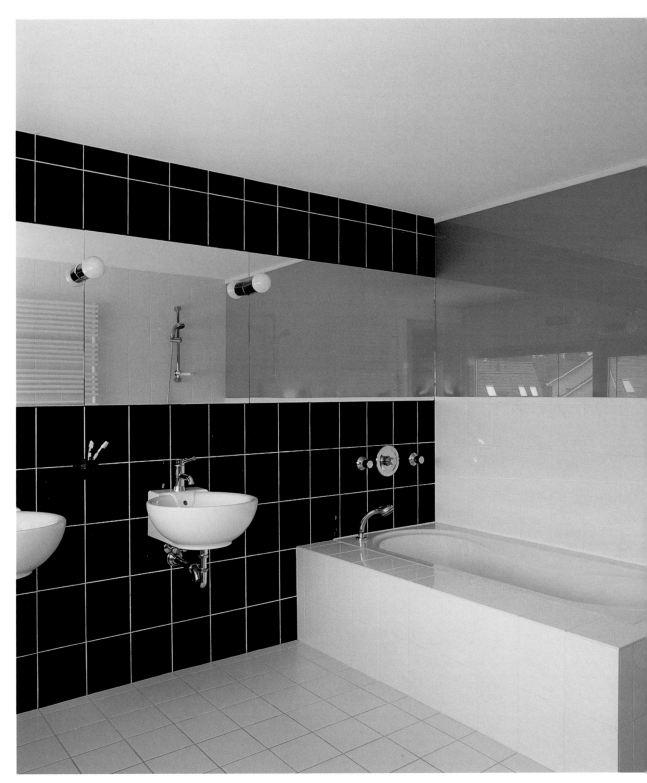

Design by Dirk Jan Postel
Photo © Jordi Miralles

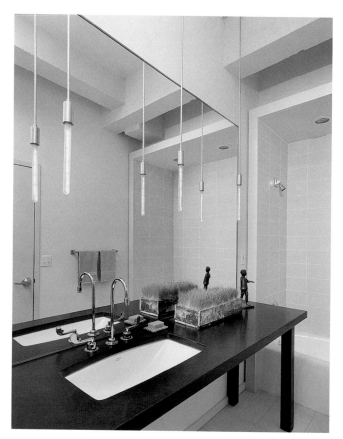

Design by Chroma AD
Photo © David M. Joseph

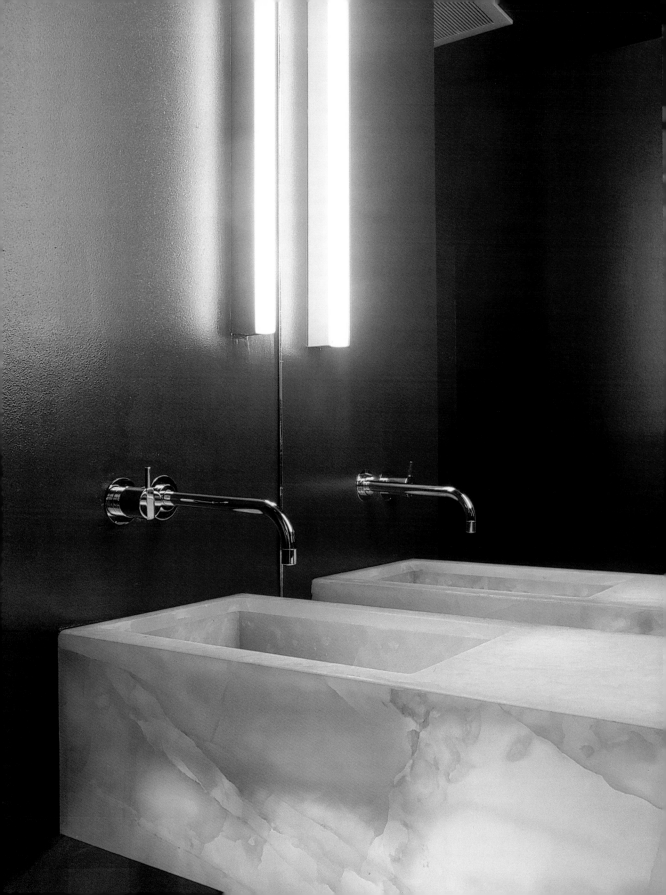

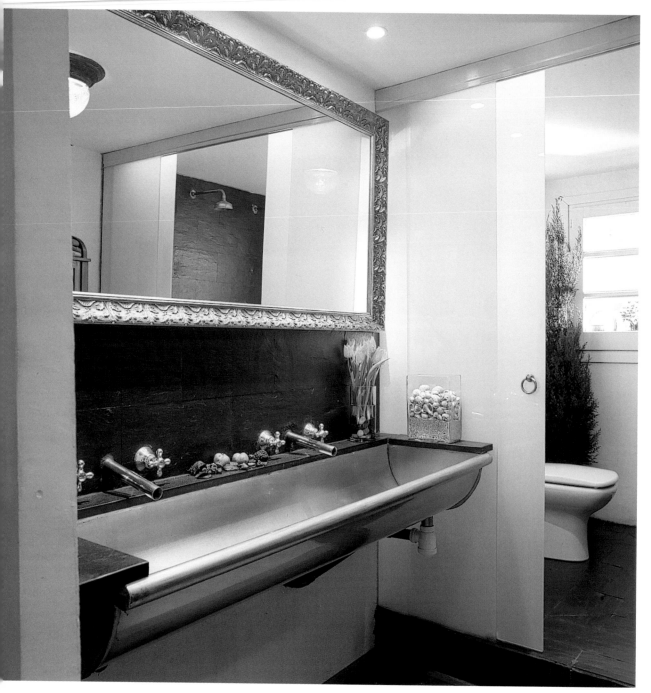

Photo © José Luis Hausmann

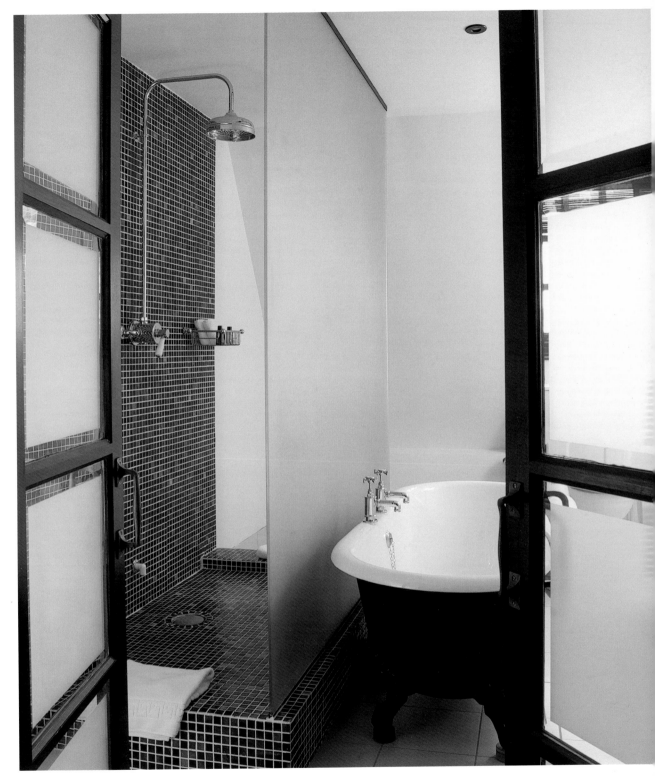

Design by Guillermo Aria

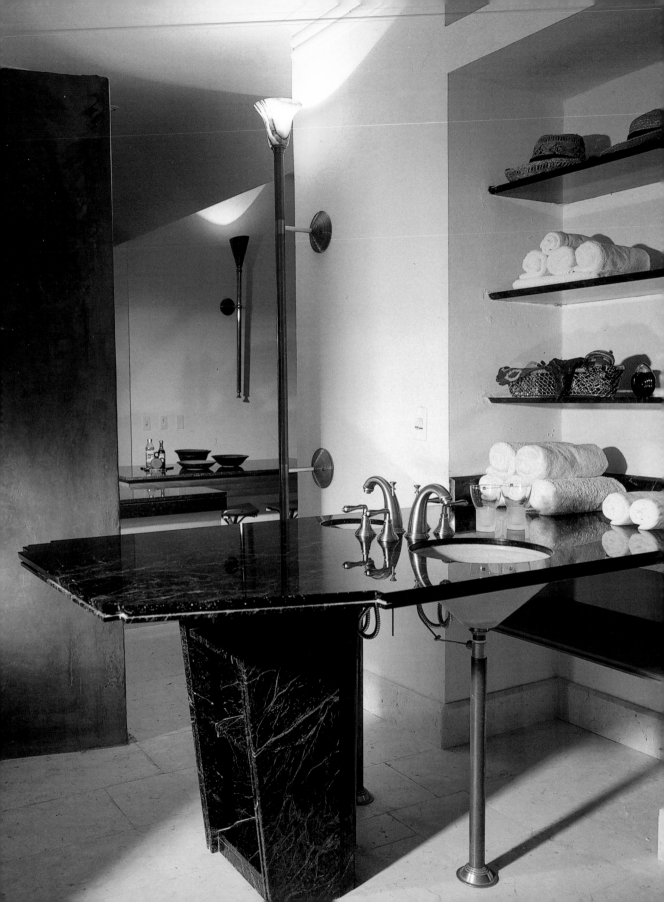

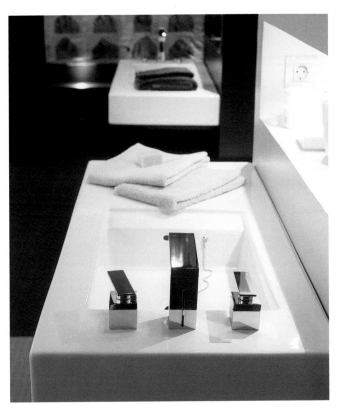

Design by Augusto Le Monnier
Interior design by Lorna Agustí, Natalia G. Novelles
Photos © Nuria Fuentes

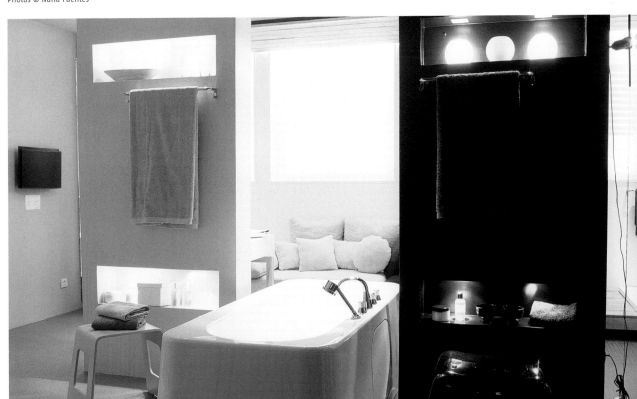

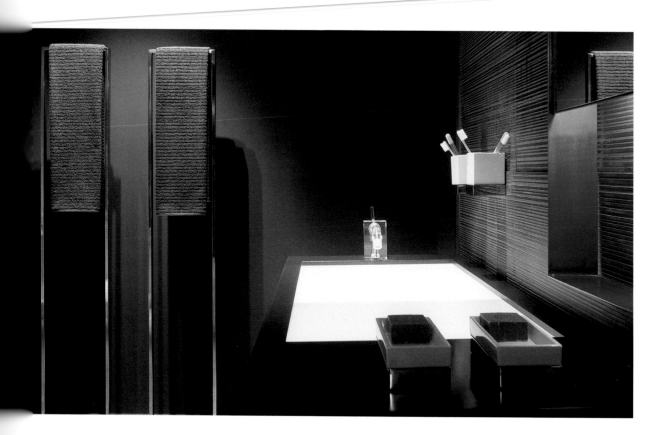

Design by Trentino
Photos © Nuria Fuentes

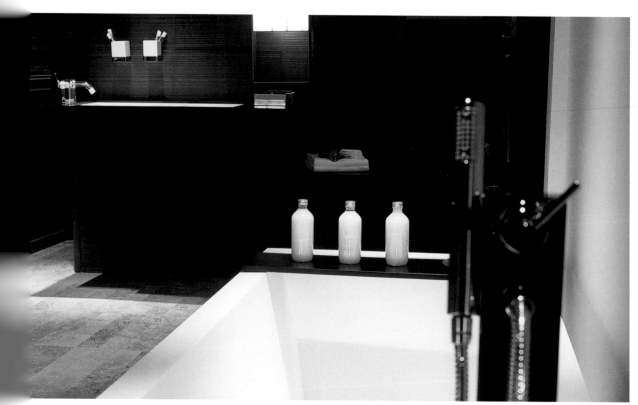

Light >>>>>>>>>>

Natural light is without a doubt the optimal solution for bathrooms because it does not distort colors, and makes shaving and makeup application much easier. It is therefore advisable to avoid opaque windows and the use of curtains or blinds because they prevent natural light from entering the room. Instead, lightweight fabrics and transparent glass should be selected so as to achieve a warm atmosphere.

Bathrooms with relatively good natural light should also be equipped with adequate artificial lighting since such rooms are also used after sundown. Bathrooms should have even and warm lighting, and this can be achieved through the use of recessed overhead halogen lights which create white light that is very similar to daylight.

In addition to this general lighting, care should be taken to ensure that the area around the sink is well illuminated. Placing two lights at the upper corners or on either side of the bathroom mirror creates even lighting that enables the user to see their face clearly. A row of lights can also be installed along the top edge of the mirror. However, care should be taken to ensure that no light is reflected in the mirror as this would create distracting glare and reflections. Hanging lamps and bare light bulbs should be avoided for reasons of safety.

Bathtubs and showers usually do not require separate lighting since the bathroom's general illumination provides sufficient coverage for these areas. Windowless bathrooms can be outfitted with light boxes in which the light source is mounted behind an acrylic glass plate.

> Natural light is without a doubt the optimal solution for bathrooms because it does not distort colors, which makes shaving and makeup application much easier.

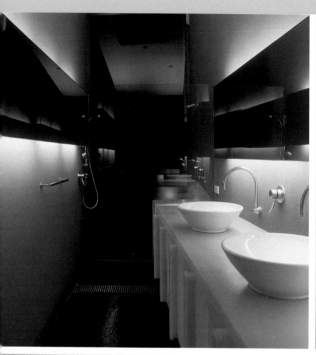

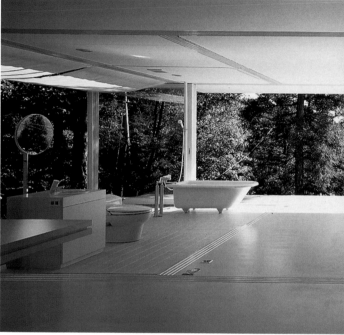

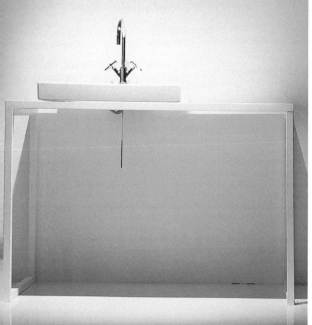

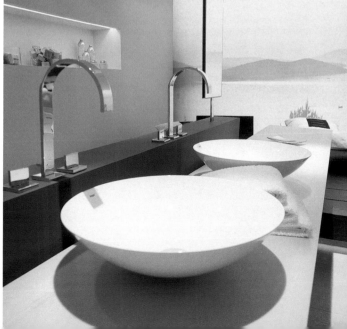

Beleuchtung

Natürliches Licht ist ohne Zweifel die günstigste Beleuchtung für ein Badezimmer, weil es die Farben nicht verfälscht und Tätigkeiten wie das Rasieren oder Schminken erleichtert. Daher sollte bei Bädern mit Fenstern auf Gardinen, Jalousien oder lichtundurchlässiges Fensterglas verzichtet werden, weil sie den natürlichen Lichteinfall von außen beeinträchtigen. Empfehlenswert, auch um die Intimsphäre zu bewahren, sind hingegen dünne Stoffe und lichtdurchlässiges Glas.

Auch in hellen Räumen sollte auf eine ausreichende künstliche Beleuchtung geachtet werden, denn deren Benutzung ist nach dem Verschwinden des Tageslichts in jedem Fall notwendig. Im Badezimmer wird eine gleichmäßige, warme Beleuchtung benötigt. Dies wird zum Beispiel durch verschiedene, in die Decke eingelassene Halogenlampen erreicht, die ein weißes, dem Tageslicht sehr ähnliches Licht erzeugen.

Zusätzlich zu dieser allgemeinen Raumbeleuchtung bedarf der Bereich des Toilettentisches besonderer Aufmerksamkeit. Zwei Leuchten, die an den zwei oberen Enden des Spiegels oder an seinen Seiten installiert sind, erzeugen eine passende Beleuchtung und lassen das Gesicht des Betrachters in einem homogenen Licht erscheinen. Es ist auch möglich, die Lampen in einer Reihe über dem Spiegel anzuordnen. Allerdings sollte man hier darauf achten, dass das Licht nicht im Spiegel reflektiert wird, um blendende und störende Lichtspiegelungen zu vermeiden. Aus Sicherheitsgründen ist von Hängelampen und ungeschützten Glühbirnen abzuraten.

In der Nasszone, das heißt im Bereich der Badewanne oder der Dusche, ist eine Beleuchtung normalerweise nicht notwendig, da die allgemeine Lichtquelle auch diesen Bereich ausreichend abdeckt. Fensterlose Badezimmer können zusätzlich mit Leuchtkästen gestaltet werden, wobei die Lichtquelle hinter einer Acrylglasplatte montiert wird.

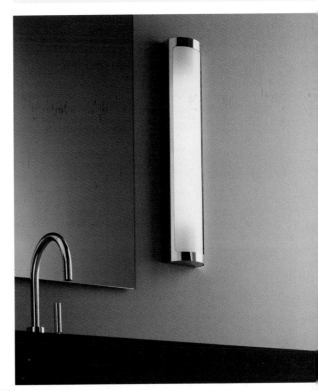

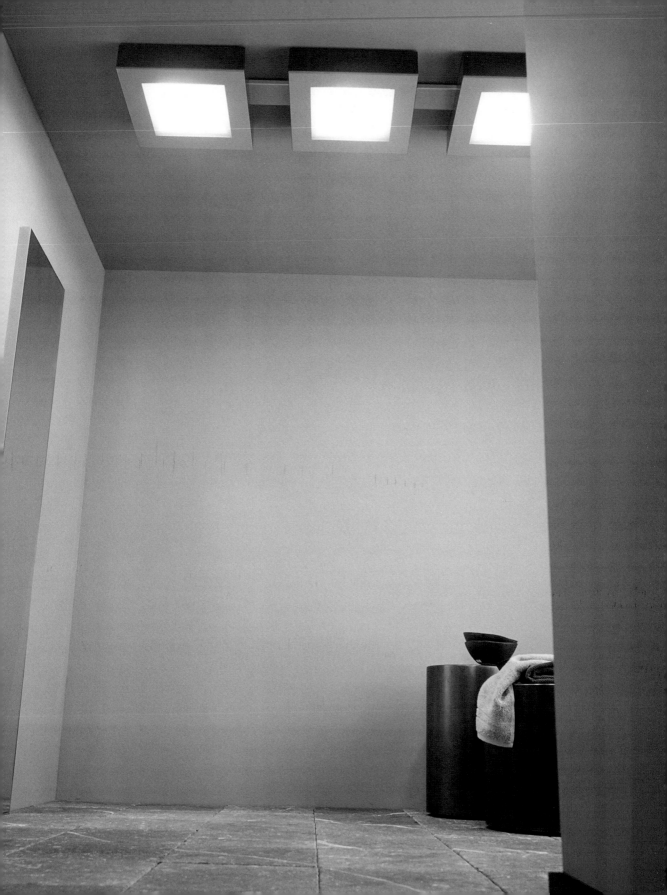

L'éclairage

Dans une salle de bains, la lumière naturelle est le meilleur éclairage qui soit, car elle ne modifie pas les couleurs, facilitant ainsi le rasage ou le maquillage. Par conséquent, si une salle de bains dispose de fenêtres, il vaut mieux éviter rideaux, stores ou vitres opaques car ils empêchent la lumière extérieure d'entrer. Les tissus fins et le verre translucide sont idéaux et permettent aussi de préserver la sphère intime.

Les pièces claires nécessitent aussi une source d'éclairage artificielle suffisante surtout lorsque la lumière du jour décline. L'éclairage d'une salle de bains doit être chaleureux et homogène. Des lampes halogènes installées dans le plafond diffusent une lumière blanche qui se rapproche de la lumière du jour.

En dehors de l'éclairage général, la zone du plan de toilette mérite une attention particulière. Avec deux sources d'éclairage placées au-dessus ou des deux côtés du miroir, on obtient une lumière homogène bien adaptée au visage. Il et aussi possible d'installer une rangée de lampes au-dessus du miroir, tout en prenant soin d'éviter les reflets aveuglants désagréables. Pour des raisons de sécurité, les lampes suspendues ou les ampoules sans protection sont contre indiquées.

Il est rarement nécessaire de prévoir un éclairage d'appoint dans la partie réservée à la baignoire ou à la douche, la lumière de la salle de bains étant en général suffisante pour éclairer cette zone. Dans les salles de bains sans fenêtres, on ajoute des coffrets lumineux, dotés d'une protection en acrylique.

> > >

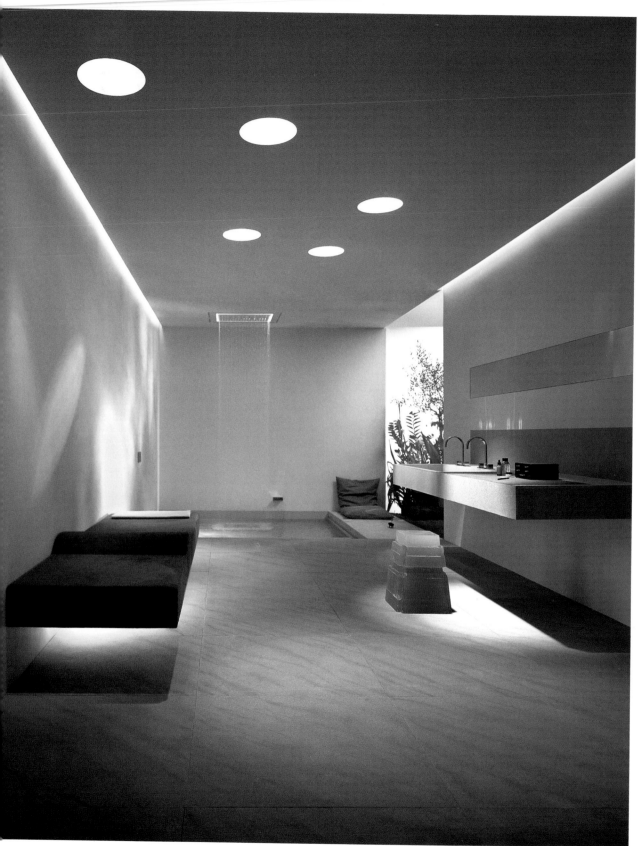

La iluminación

La luz natural es, sin duda alguna, la mejor para el cuarto de baño porque no falsea los colores y facilita la tarea de afeitarse o maquillarse. Por eso no es recomendable instalar persianas, cortinas o cristales que impidan la entrada de la claridad exterior en los baños con ventanas. Asimismo son recomendables, también para mantener una atmósfera íntima, los tejidos finos y los cristales translúcidos.

Pero incluso en las estancias más luminosas hay que procurar una luz artificial suficiente porque se hace necesaria cuando oscurece. En el baño hay que tener una iluminación uniforme y cálida. Ello se consigue, por ejemplo, con la instalación en el techo de lámparas halógenas empotradas que irradien luz blanca similar a la natural.

Además de la iluminación general, la zona del tocador reclama una fuente de luz específica. Dos lámparas colocadas en los márgenes superiores o en los laterales del espejo proporcionarán la claridad adecuada y homogénea a la persona que lo usa. Otra solución es situar una hilera de lámparas sobre el espejo, pero teniendo siempre en cuenta que la luz no se refleje y evitar así molestos deslumbramientos. Por razones de seguridad no es recomendable usar lámparas de suspensión ni bombillas sin la debida protección.

En la zona húmeda, es decir donde se encuentran la bañera o la ducha, no suele hacer falta ninguna iluminación especial, ya que las halógenas son suficientes. En los baños sin ventanas se pueden instalar cajas de luz adicionales hechas con paneles de cristal acrílico.

> > >

Design by Engelen & Moore
Photo © Ross Honeysett

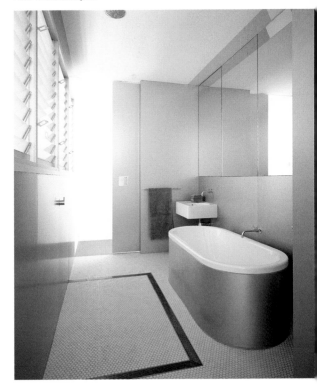

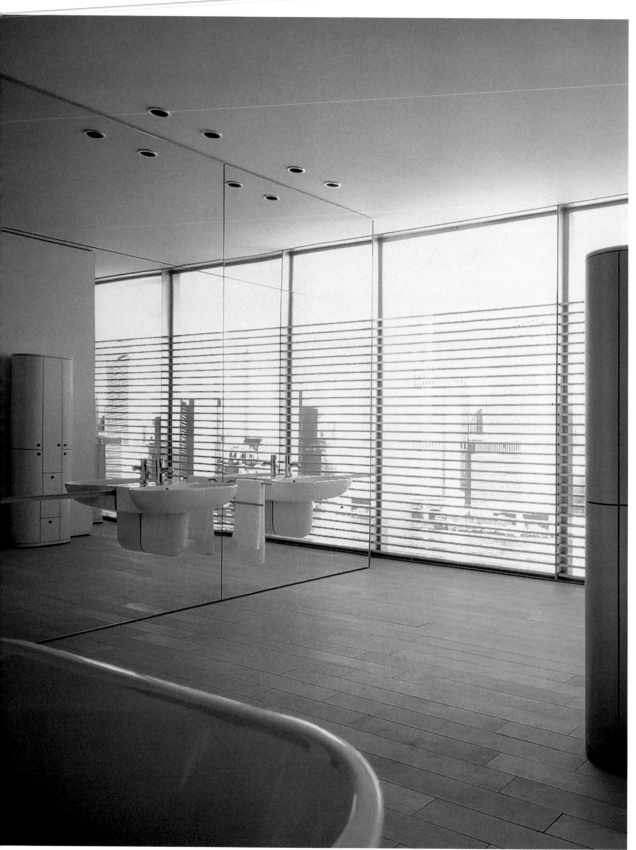

L'illuminazione

Both pages
Design by Duravit

La luce naturale costituisce indubbiamente l'illuminazione del bagno più opportuna perché non falsifica i colori, facilitando così attività quali farsi la barba o truccarsi. Per questo motivo, in caso di bagni con finestre, si dovrà rinunciare a tende, veneziane od a vetrate con vetri a tenuta di luce perché comprometterebbero l'incidenza naturale della luce proveniente dal di fuori. Onde rispettare la sfera intima si consigliano anche tessuti leggeri e vetrate trasparenti alla luce.

Anche in ambienti luminosi si dovrà prevedere una sufficiente illuminazione artificiale, visto che servirà comunque allo scemare della luce del giorno. Nel bagno ci vuole un'illuminazione costante e calda, realizzabile ad esempio con diverse lampade ad alogeni incassate nel soffitto che producono una luce bianca, molto simile alla luce del giorno.

Oltre a questa illuminazione generale dell'ambiente, è la zona del tavolino di toilette a richiedere particolare attenzione. Due luci, montate o sulle due estremità superiori dello specchio o lungo i suoi lati, producono una illuminazione idonea e fanno in modo che il viso dell'osservatore appaia in una luce omogenea. È altresì possibile sistemare le lampade in una fila sopra lo specchio. Tuttavia, in tal caso si dovrà stare attenti affinché la luce non venga riflessa dallo specchio, per evitare dei riflessi di luce accecanti e fastidiosi. Per motivi di sicurezza si sconsigliano delle lampade appese o lampadine non protette.

Nella zona cosiddetta "umida", e cioè nella zona della vasca o della doccia, normalmente non serve un'illuminazione apposita perché la fonte di luce generale solitamente provvede per una sufficiente illuminazione, anche di questa zona. I bagni senza finestre potranno essere addizionalmente corredati di scatole luminose. In tal caso, la fonte di luce dovrà essere montata dietro una lastra in vetro acrilico.

> > >

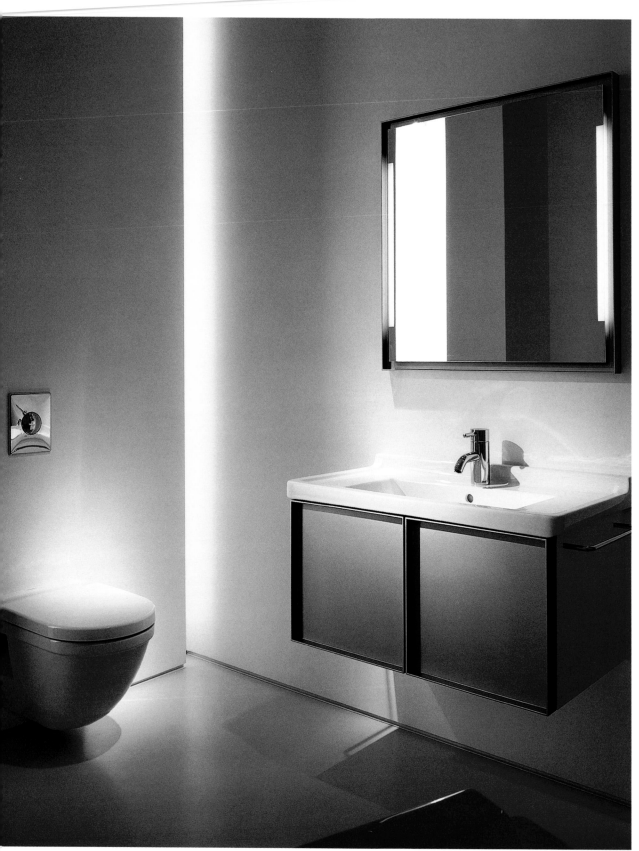

Natural light

Design by Allen Jack + Cottier Architects
Interior design by Tim Allison & Associates
Photo © Richard Glover

Natural light is the optimal light source during shaving or when makeup is applied because it makes natural colors optimally visible. Bathrooms with relatively good natural light should also be equipped with sufficient artificial lighting.

Natürliches Licht ist die günstigste Beleuchtung, da es die natürlichen Farben nicht verfälscht und das Rasieren oder Schminken erleichtert. Aber auch in hellen Räumen sollte auf eine zusätzliche künstliche Beleuchtung geachtet werden.

La lumière naturelle est de toute évidence le meilleur éclairage pour le rasage et le maquillage parce que il ne désnature les couleurs. Même si les pièces sont claires, il est essentiel d'ajouter une source d'éclairage artificielle.

La luz natural es la mejor para afeitarse o maquillarse ya que no falsea los colores. Sin embargo, la iluminación artificial es también importante incluso en los espacios más claros.

La luce naturale costituisce l'illuminazione più favorevole, visto che i colori naturali facilitano operazioni quali farsi la barba o truccarsi. Ma anche in ambienti luminosi si dovrà prevedere un'illuminazione artificiale aggiuntiva.

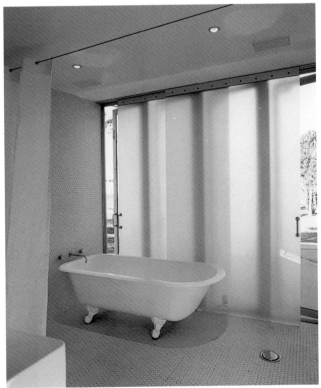

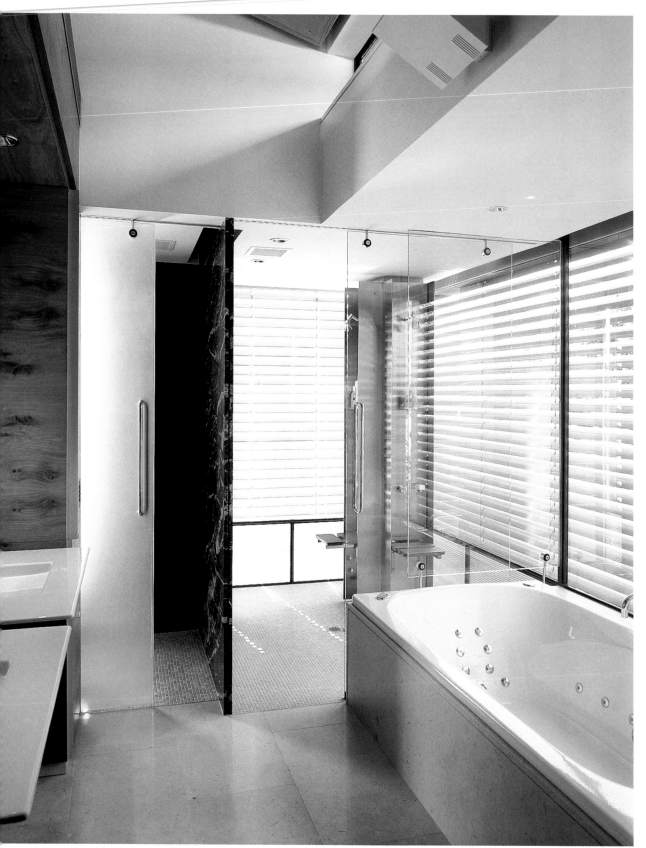

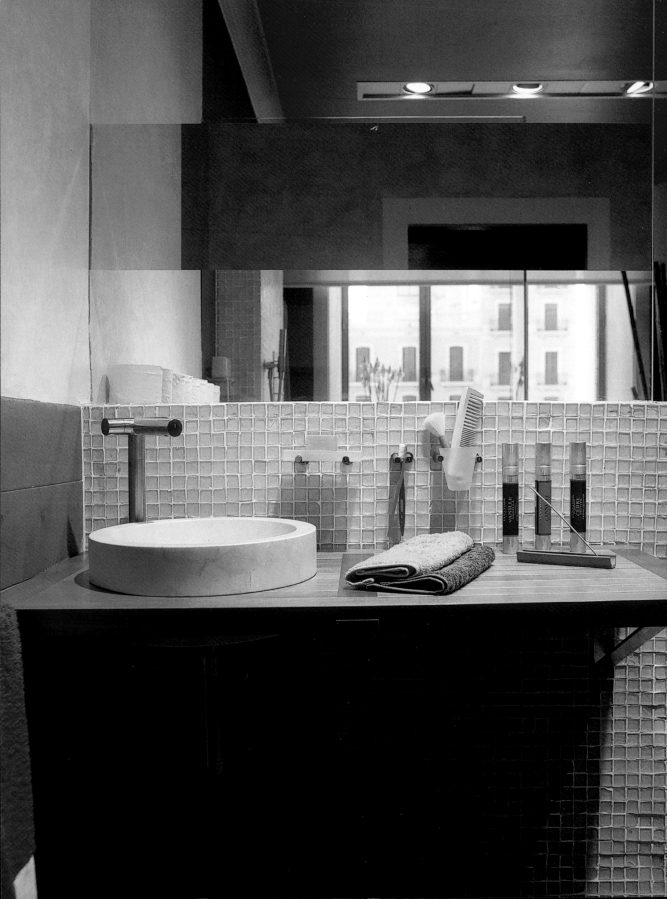

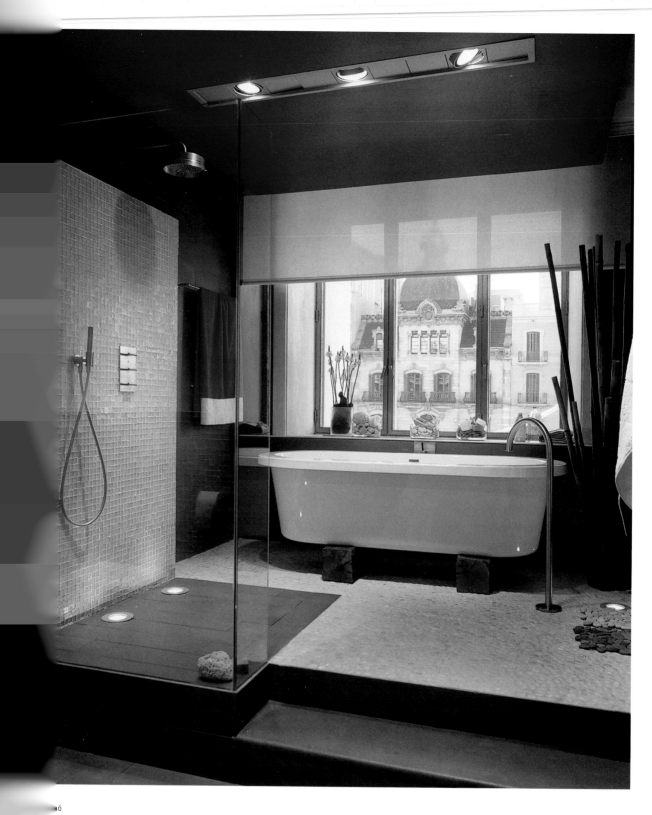

ó
entes

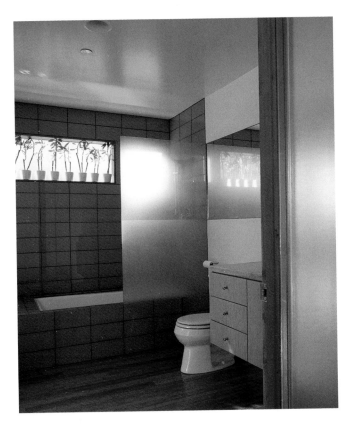

Design by O'Herlihy Architects
Photos © Undine Pröhl

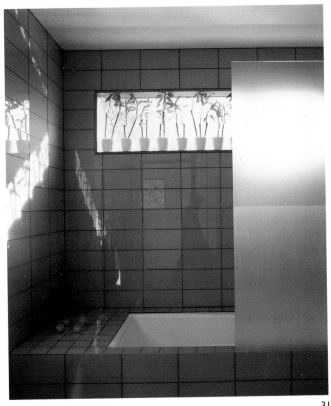

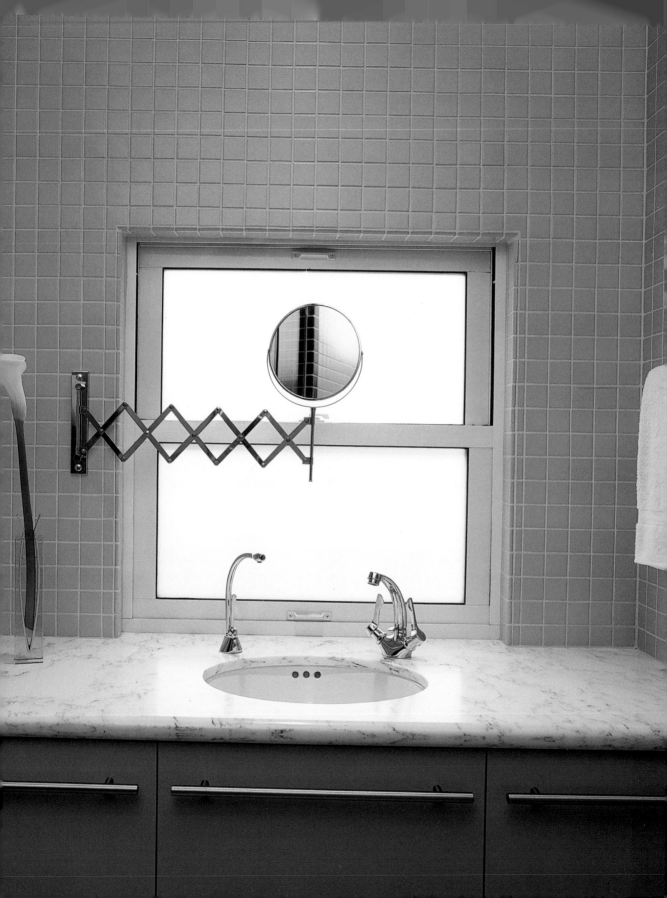

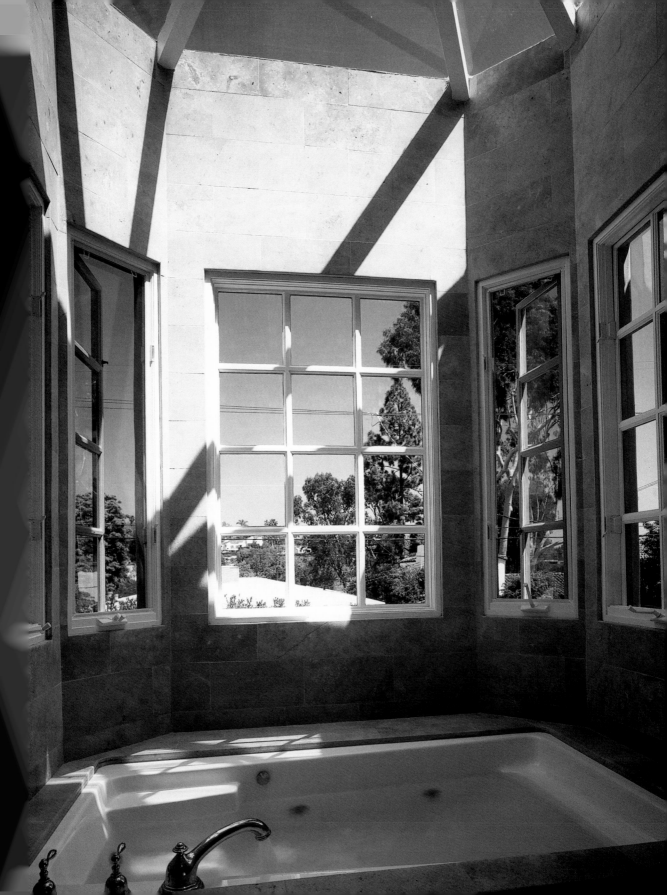

Both photos
Design by UdA/Walter Camagna, Massimiliano Camoletto, Andrea Marcante
Photo © Emilio Conti

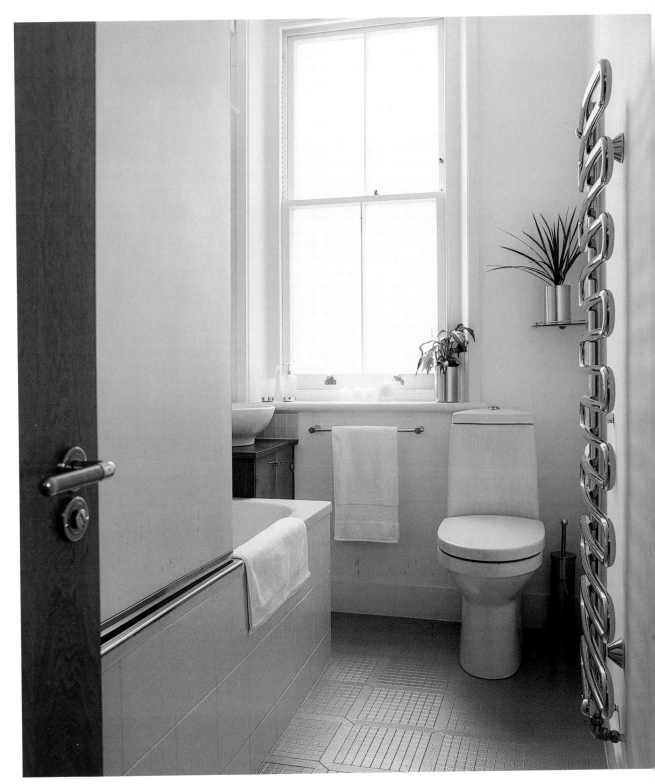

Photo © Jake Fitzjones/Red Cover

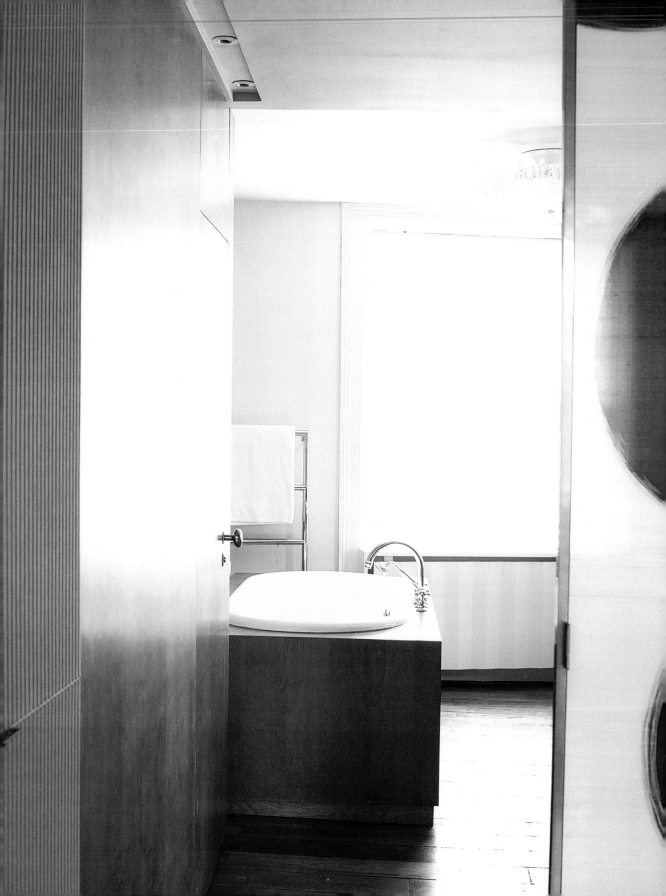

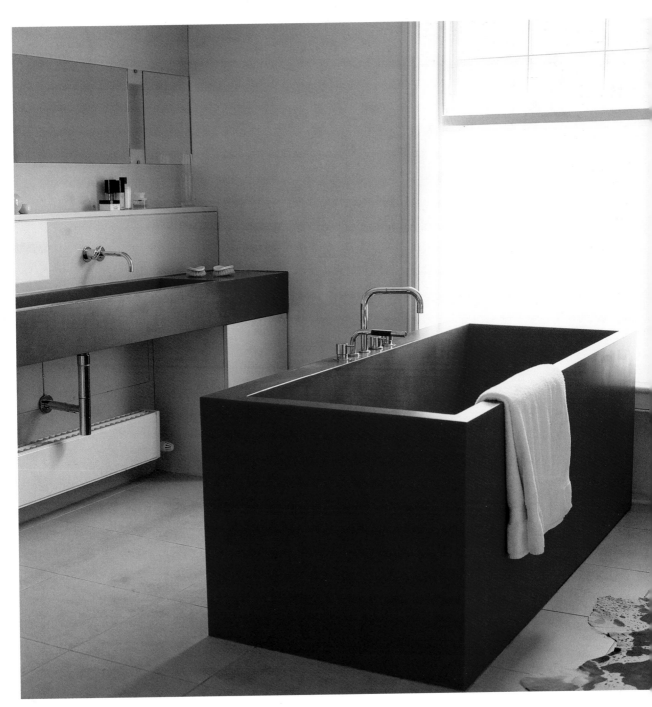

Design by Fred Collins
Photo © Verity Welstead/Red Cover

Both photos
Design by MINIM Architects
Photo © Nuria Fuentes

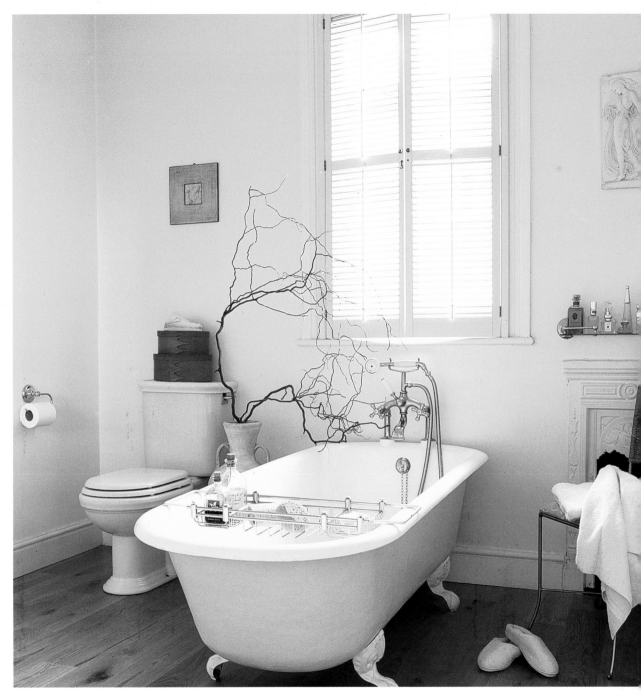

Both photos © Jake Fitzjones/Red Cover

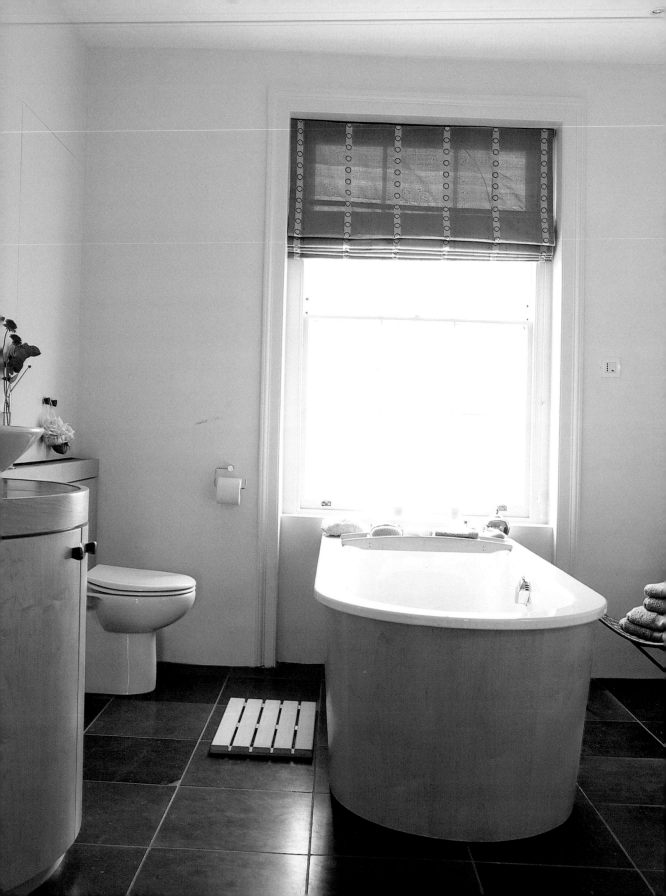

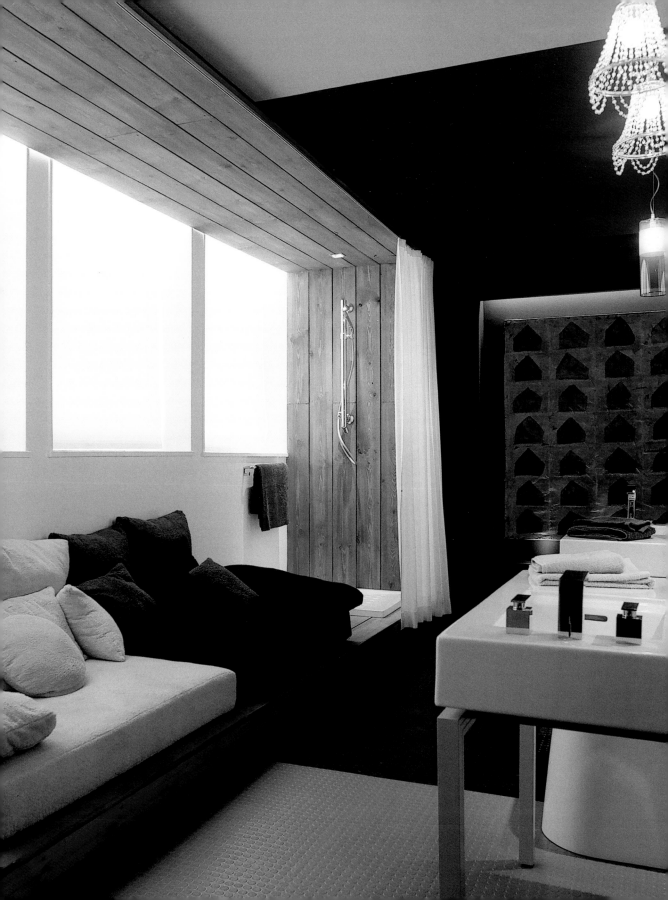

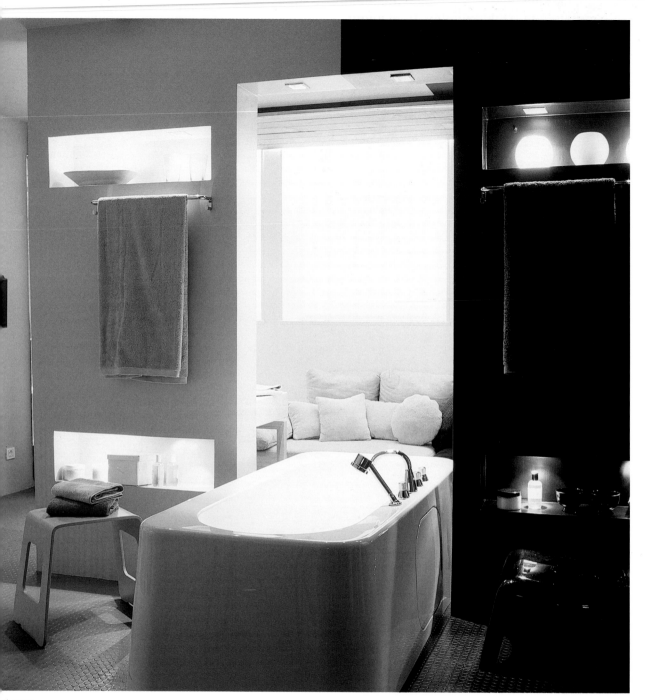

th pages
sign by Augusto Le Monnier
terior design by Lorna Agustí, Natalia G. Novelles
oto © Nuria Fuentes

Both pag
Design by Shigeru Ba
Photo © Hiroyuki Hi

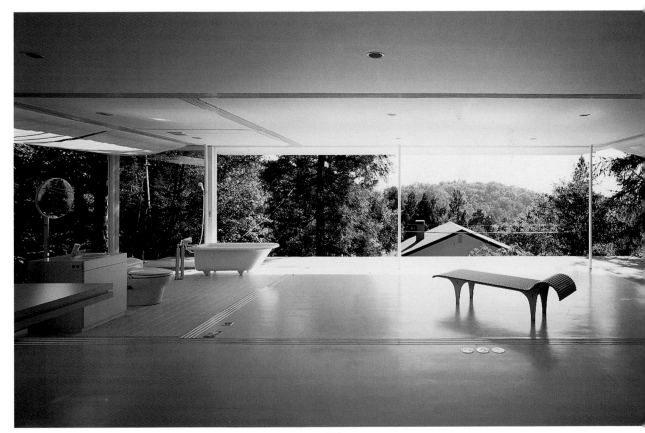

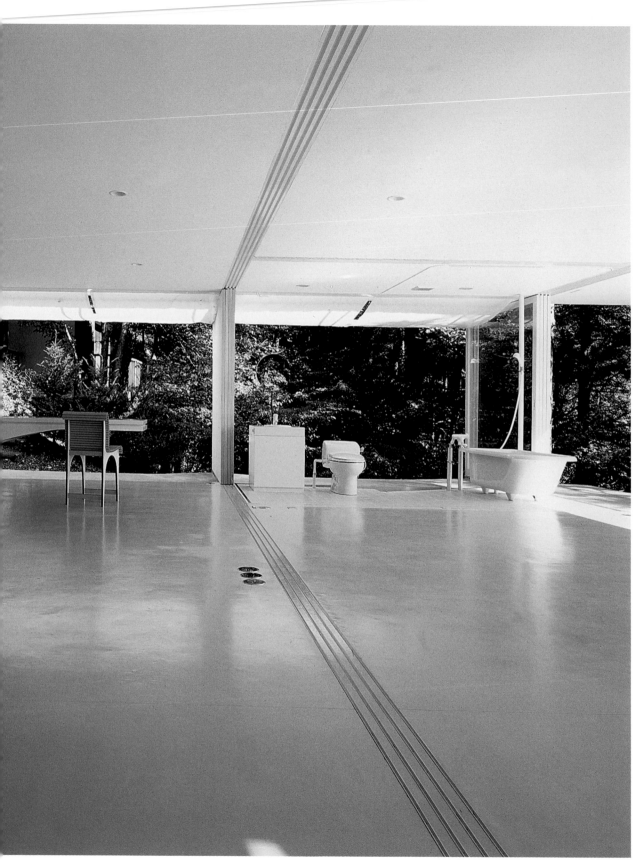

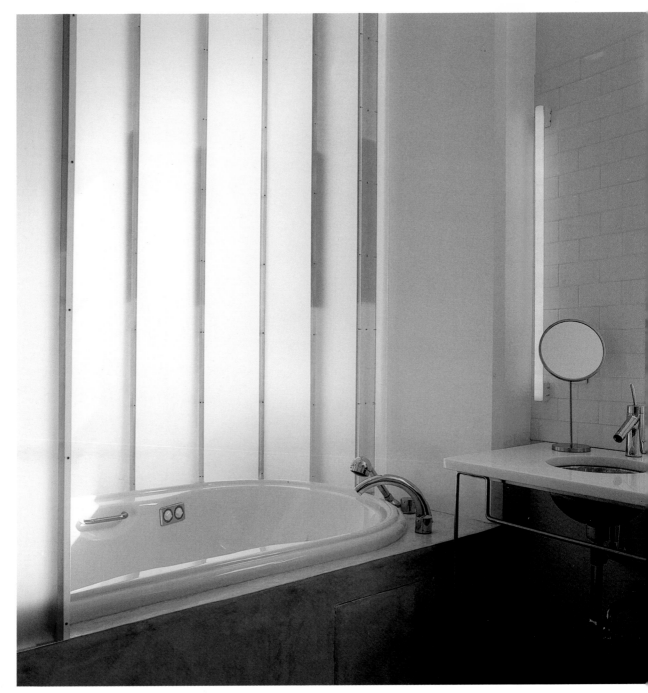

Both photos © Jordi Miralles

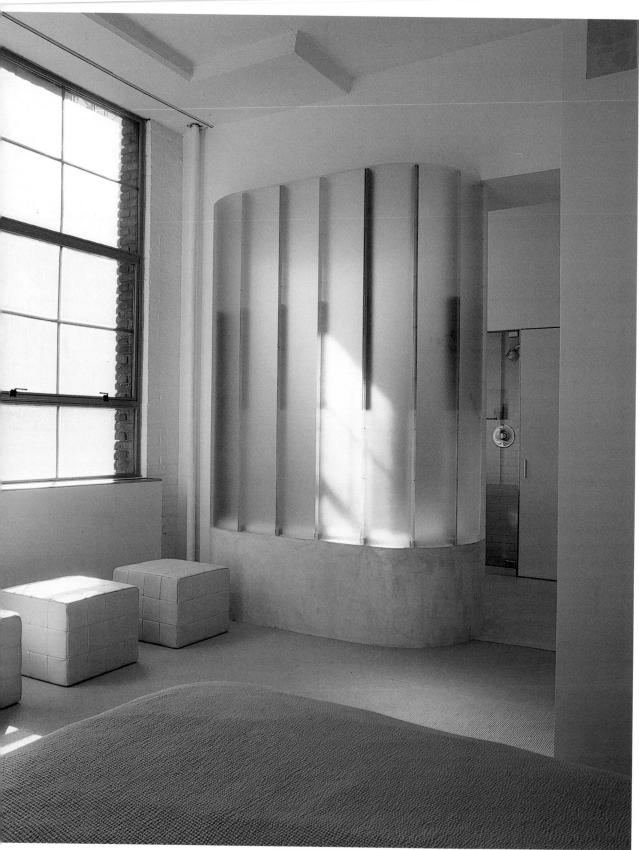

Artificial light

Design by A. Prin
Photo © Nuria Fuent

Recessed halogen ceiling spotlights are the optimal solution for general bathroom illumination. However, lights should also be installed over the bathroom mirror or on either side of it.

Das helle Licht von Halogenstrahlern, die in der Decke eingelassen sind, ist bestens für eine allgemeine Beleuchtung geeignet. Dennoch sollte eine Ausleuchtung über oder zu beiden Seiten des Spiegels vorhanden sein.

La lumière claire, diffusée par les lampes halogènes installées dans le plafond, est parfaite pour un éclairage général. Il est toutefois conseillé d'ajouter un éclairage frontal ou latéral autour du miroir.

Las lámparas halógenas empotradas en el techo son el mejor medio para lograr una iluminación general. Sin embargo, siempre debe haber una fuente de luz indirecta, bien sobre el espejo, bien en sus laterales.

La luce chiara di faretti alogeni incassati nel soffitto è perfettamente adatta come illuminazione generale. Tuttavia si dovrà prevedere un'ulteriore illuminazione, da montare o sopra o ad entrambi i lati dello specchio.

Design by Stephen Varady, Russell Pell
Photo © Stephen Varady, Russell Pell

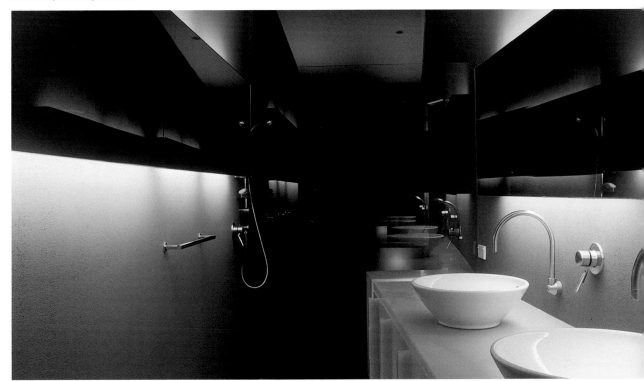

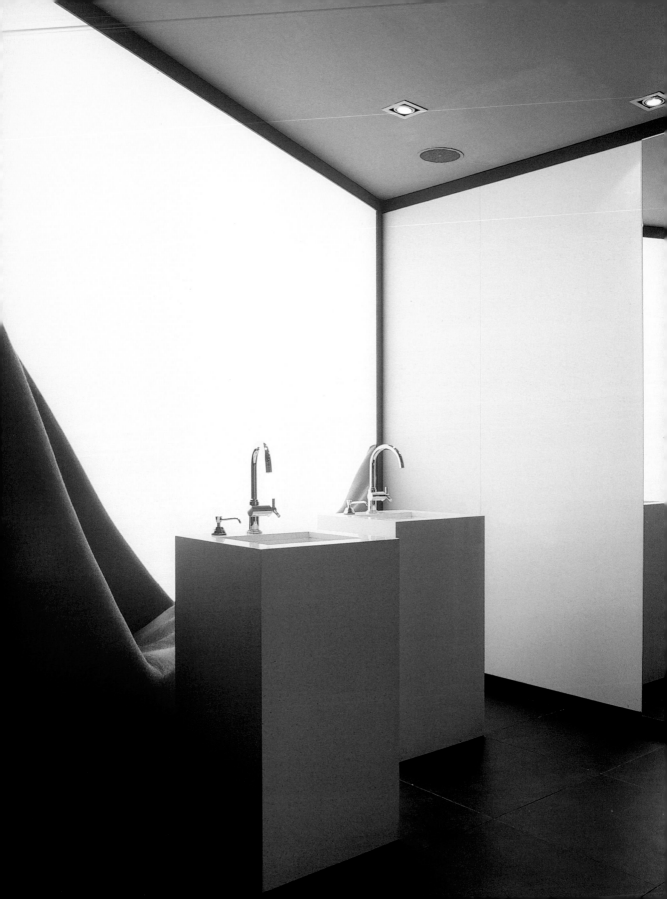

Both pag
Design by Glòria Duran Torrell
Photo © Nuria Fuent

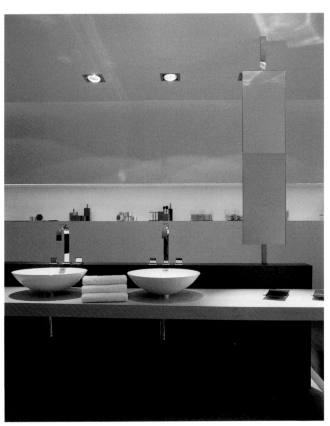

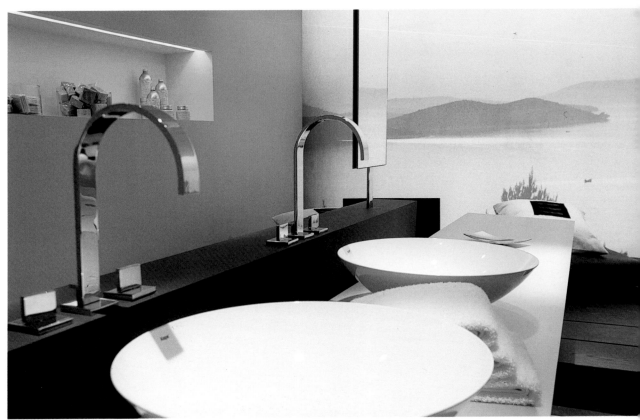

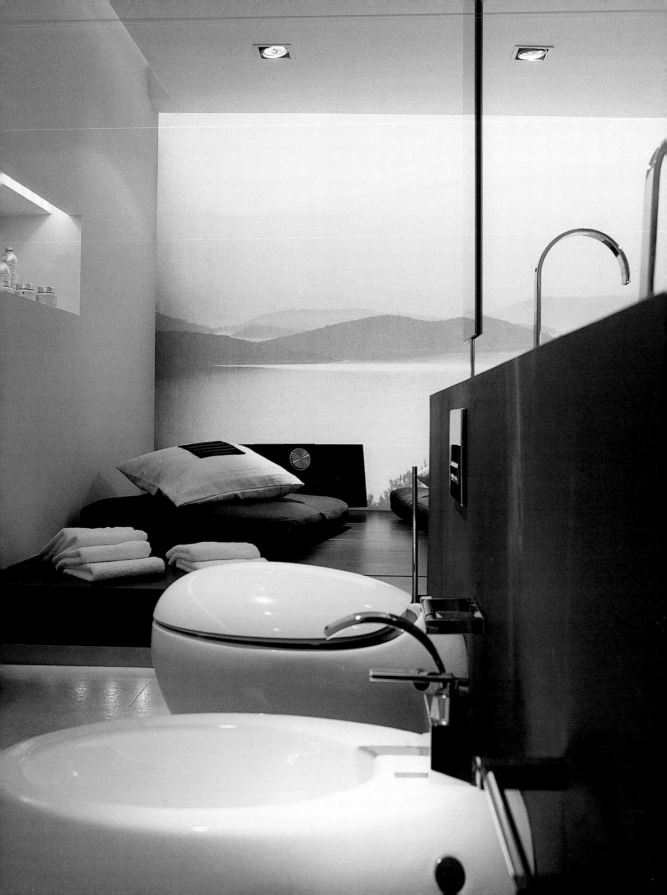

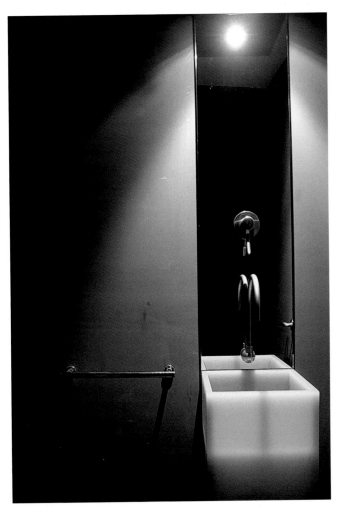

Both pages
Design by Stephen Varady, Russell Pell
Photo © Stephen Varady, Russell Pell

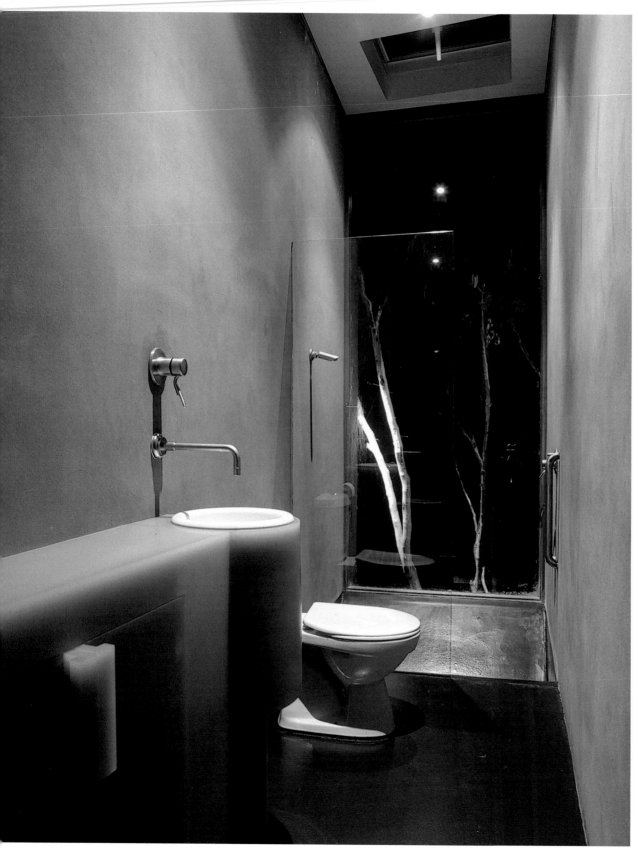

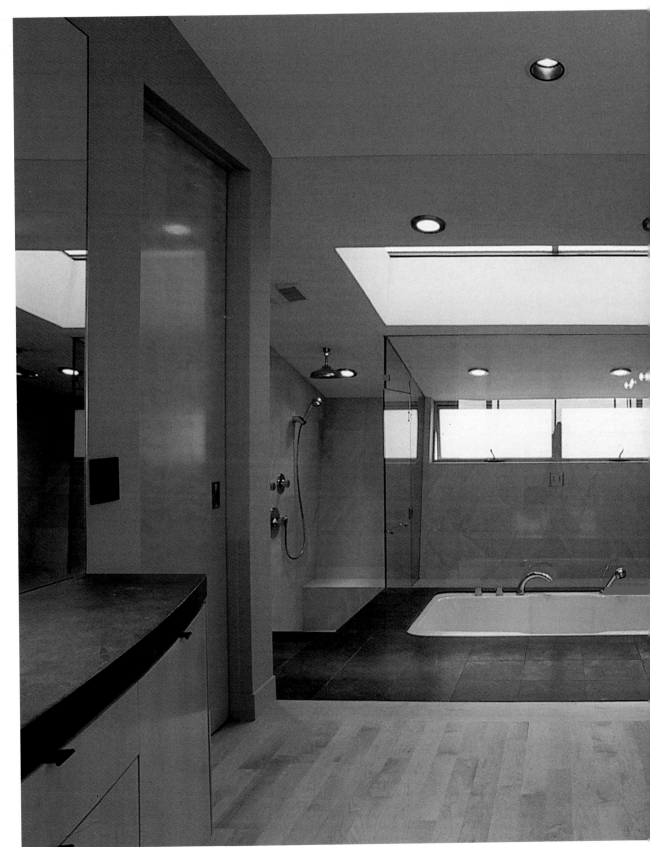

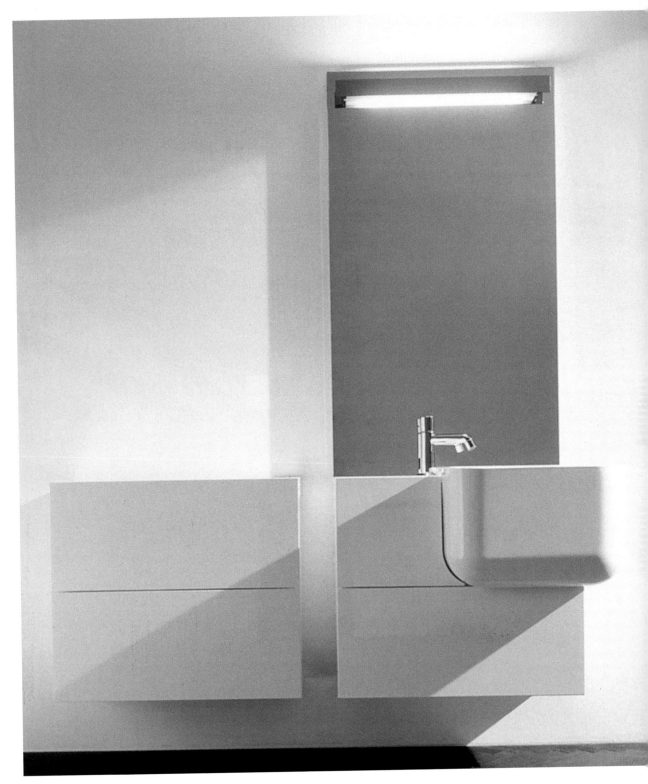

Both pages
Design by Falper

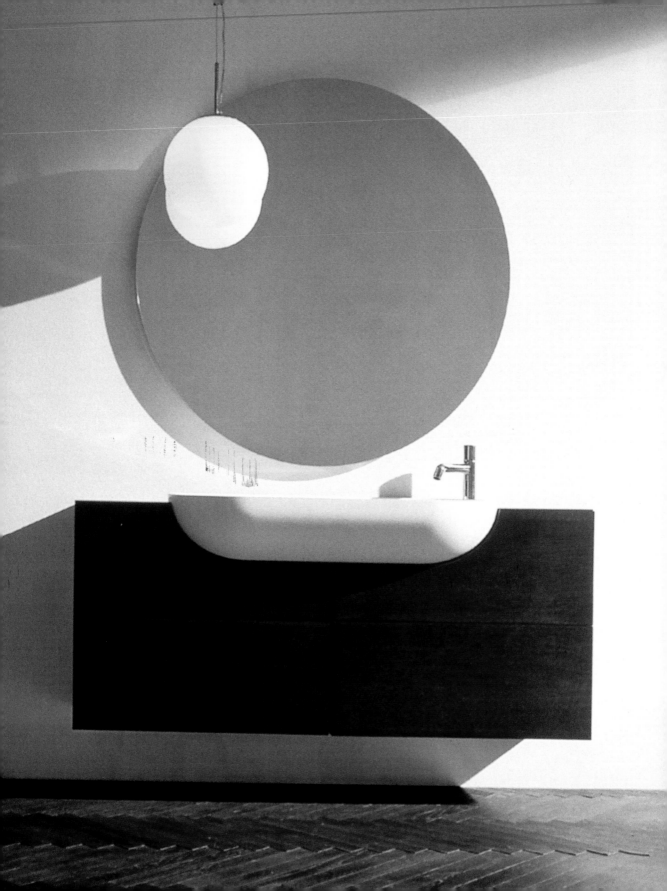

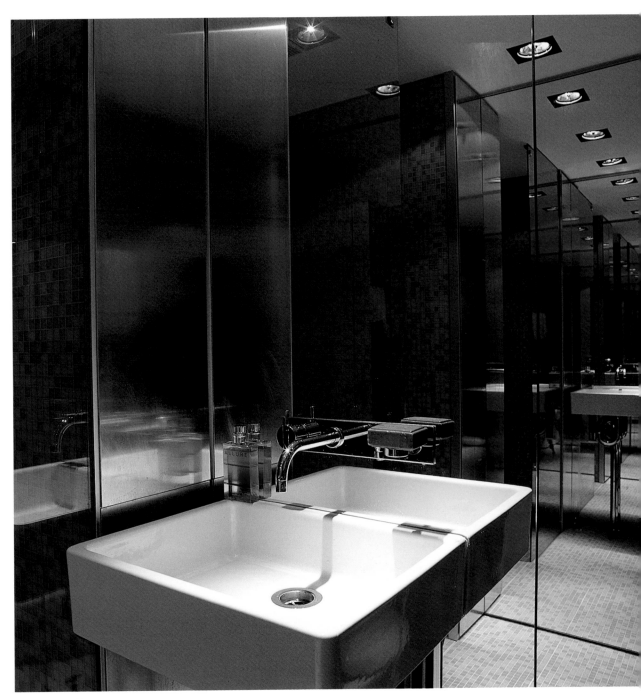

Design by PTW Architects
Photo © Sharrin Rees

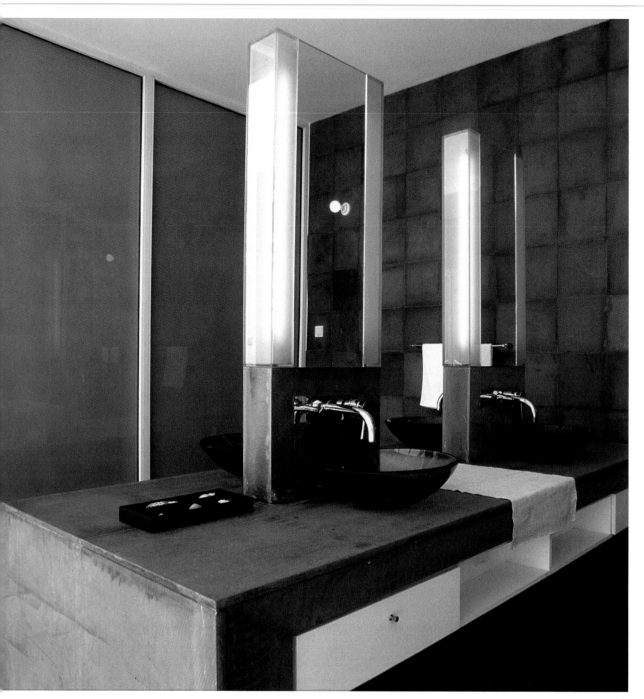

Design by Kanika R'kul/Leigh & Orange Ltd.
Photo © Satoshi Asakawa

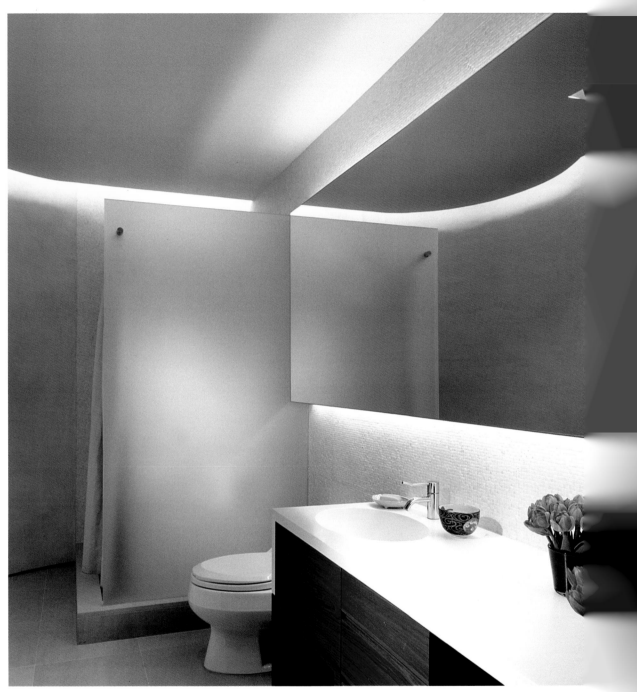

Both pages
Design by Janson Goldstein
Photo © Paul Warchol

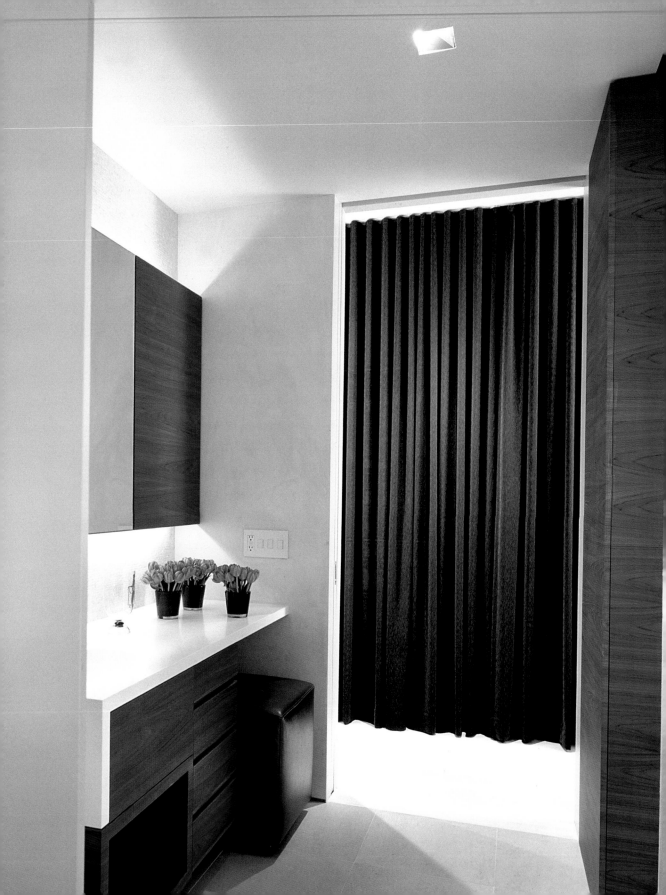

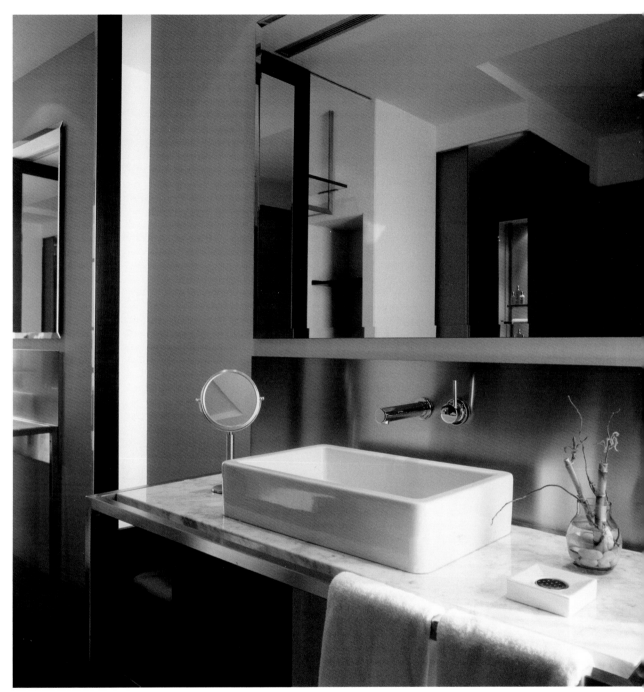

Both pages
Design by GCA Arquitectes Associats
Photo © Jordi Miralles

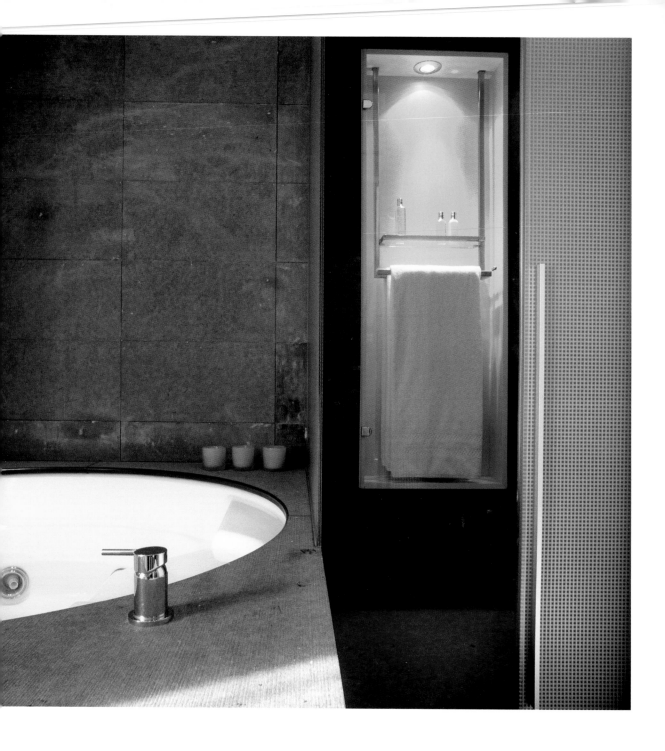

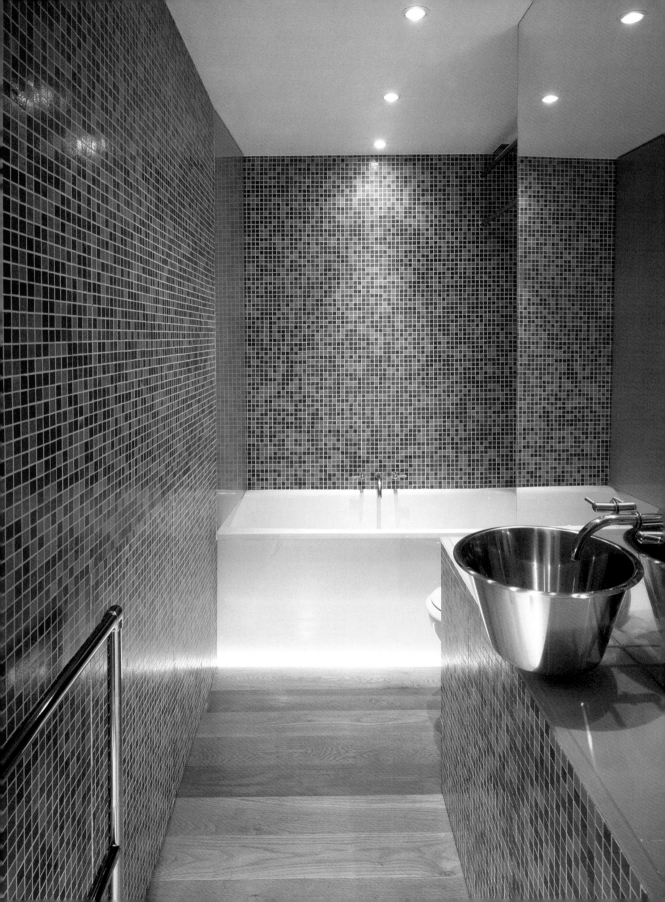

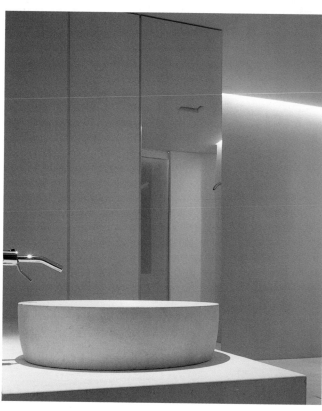

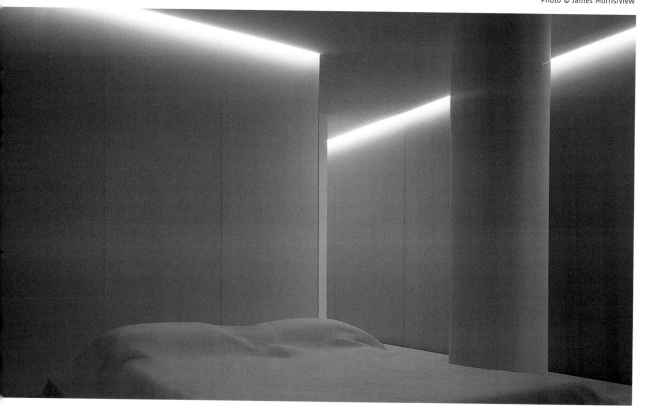

Distribution >>>>>

The bathroom (like the kitchen) is a room that requires extensive and careful planning because once the plumbing has been installed, it is extremely difficult to effect any changes in the configuration of the room. It is wise to assess every aspect of the available space before beginning work on a bathroom. This includes determining where the entrance is to be, where the drain pipes are to be placed, how the available light can used to best advantage and the amount of ventilation available.

In conducting this assessment, individual users' needs should also be taken into account, e.g. the number of baths and/or showers that will be taken, the amount of storage or counter space required, and even how extensively the sink counter will be used.

Although nowadays bathrooms are regarded as spaces that can be used by all members of the household concurrently, the room should still provide individual users with privacy. This is one of the reasons why the configuration of the space and the separations between its various functional areas should allow for concurrent usage by more than one person.

The three main areas of a bathroom are the sink, the shower/bath and the toilet. These areas can be separated by doors, half-walls, full walls, or by clearly differentiating the various areas so that they are separate from each other.

The manner in which the space is configured is also determined by the size of the room. Smaller bathrooms should have showers rather than bathtubs, as well as a wall-mounted toilet, and a bidet should be dispensed with. By the same token, a small built-in sink takes up less space than a sink with feet or a pedestal. The use of light materials, simple lines and a well structured floor plan can make a bathroom look larger than it actually is.

> The bathroom is a room that requires extensive and careful planning because once the plumbing has been installed, it is extremely difficult to effect any changes in the configuration of the room.

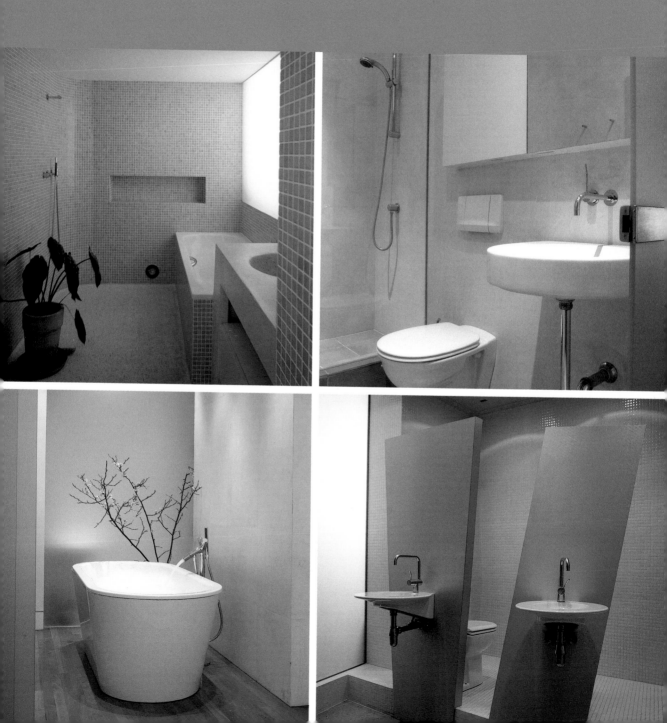

Die Badaufteilung

Das Badezimmer ist wie auch die Küche ein Raum, der eine intensive Planung erfordert, weil nach dem Installieren der Leitungen und Abflussrohre eine Neuaufteilung sehr schwierig wird. Es ist empfehlenswert, vor Beginn der Arbeiten, den verfügbaren Platz bis ins Detail zu analysieren: Wo befindet sich der Eingang, wie ist die Lage der Abwasserleitungen, wie kann man das vorhandene Licht am besten nutzen, über welche Lüftungen verfügt man.

Dabei sollten die Prioritäten des einzelnen Benutzers in Betracht gezogen werden. Wichtig ist zu analysieren, ob oft gebadet wird, ob viel Aufbewahrungsraum oder Lagerplatz benötigt wird, ja selbst wie häufig der Toilettentisch benutzt werden wird.

Obwohl das Badezimmer heutzutage als offener Raum begriffen wird, den die ganze Familie gleichzeitig nutzen kann, verlangt er doch auch immer noch einen hohen Grad an Intimität für den Einzelnen. Das ist einer der Gründe, warum die Raumaufteilung Trennungen zwischen den Funktionsbereichen vorsehen sollte, welche die gleichzeitige Benutzung durch mehrere Personen möglich machen.

Die drei grundlegenden Bereiche des Badezimmers sind der Toilettentisch, die Nasszone und der Sanitärbereich. Die verschiedenen Zonen können durch Türen, halbhohe Mauern, Trennwände oder einfach durch eine klar differenzierte Aufteilung als unabhängige Bereiche gekennzeichnet werden.

Abhängig ist diese Aufteilung auch vom verfügbaren Platz. Bei kleinen Räumen ist die Installation einer Dusche der einer Badewanne vorzuziehen, genauso wie es hier sinnvoll ist, auf das Bidet zu verzichten und ein Wand-WC zu wählen. Ein kleines eingebautes Waschbecken ist weniger voluminös als eine Waschgelegenheit mit Fuß oder Sockel. Die Auswahl von leichten Materialien, Einfachheit in der Linienführung und eine geordnete Gliederung lassen den Raum ebenfalls optisch größer erscheinen.

Both pages
Design by Anne Bugagnani, Diego Fortunato
Photo © Eugeni Pons

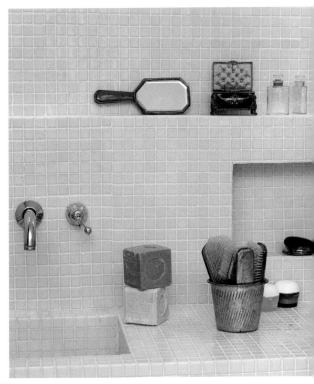

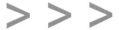

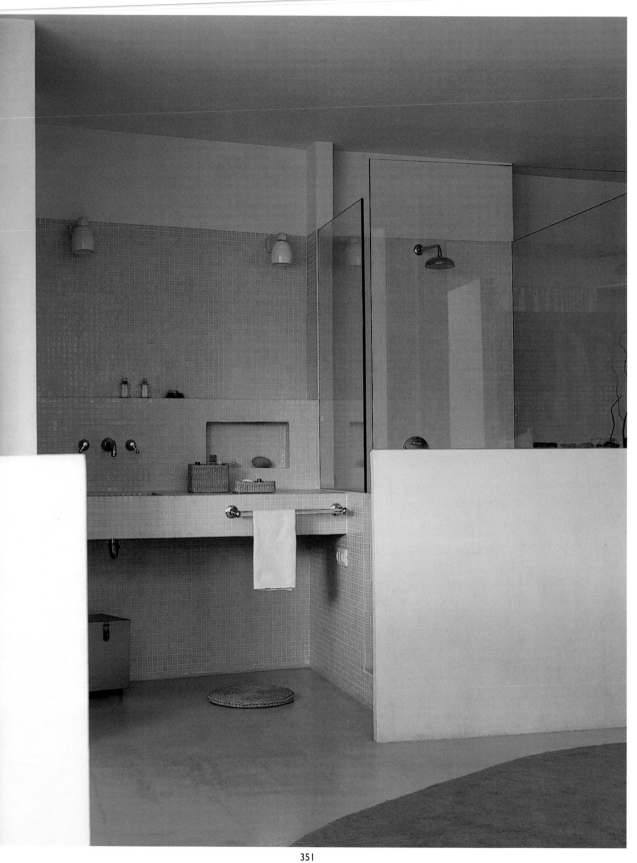

Distribution de la salle de bains

Avec la cuisine, la salle de bains est une pièce qui nécessite une planification très soignée, car après l'installation des conduites et des tuyaux, il est difficile d'en modifier la distribution. Avant le début des travaux, il est conseillé d'analyser en détails la place disponible : où se trouve l'entrée, où sont disposées les conduites d'évacuation des eaux usées, comment tirer parti au maximum de l'éclairage existant, de quels moyens d'aération dispose-t-on?

Il faut aussi prendre en considération les priorités de l'utilisateur. Il est essentiel de connaître la quantité habituelle de bains, les besoins en rangement et en place et même la fréquence d'utilisation des lavabos.

Et si aujourd'hui, la salle de bains est un lieu de vie ouvert que toute la famille peut utiliser en même temps, l'intimité individuelle compte encore beaucoup. C'est pourquoi, il est important de prévoir, dans la segmentation de l'espace, les séparations à intégrer selon les différentes fonctions et leur utilisation commune.

Les trois espaces de base d'une salle de bains sont le plan de toilette, la zone de douche et bain et les sanitaires. Ces différentes zones peuvent être séparées par des portes, des murs à mi-hauteur, des cloisons ou tout simplement à l'aide d'une répartition claire en zones indépendantes les unes des autres.

Cette distribution dépend aussi de la place disponible. Dans les petites pièces, il est préférable d'installer une douche plutôt qu'une baignoire. De même, il est judicieux de renoncer au bidet au profit d'un WC suspendu. Un petit lavabo encastré prend moins de place qu'un grand lavabo sur colonne. Le choix de matériaux léger, des lignes simples et une répartition bien structurée permettent d'agrandir la pièce sur le plan optique.

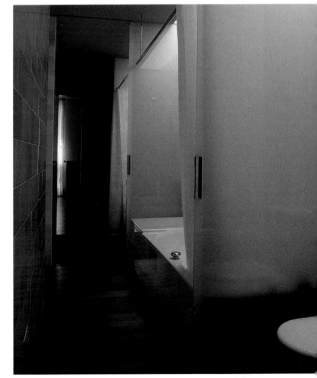

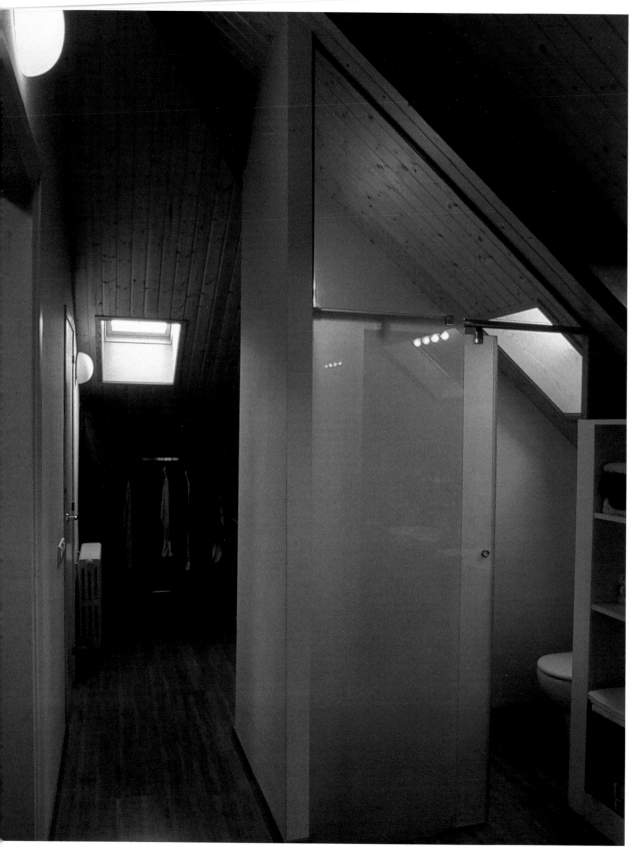

La distribución del cuarto de baño

El baño es, junto con la cocina, la pieza que necesita una planificación más exhaustiva, porque una vez instalados, los desagües y cañerías son difíciles de modificar. Se recomienda analizar el espacio disponible hasta el último detalle desde el principio: dónde se encuentra la entrada, cómo están situados los desagües, cómo se puede aprovechar mejor la luz, de qué ventilaciones se dispone.

Asimismo, es importante tener en cuenta las prioridades personales del usuario. Es fundamental saber si se baña a menudo, si necesita mucho espacio para colocar sus cosas o con qué frecuencia va a usar el tocador.

Aunque el baño se concibe hoy en día como un espacio abierto que toda la familia pueda usar al mismo tiempo, requiere un alto grado de intimidad. Así, en el momento de decidir la distribución espacial hay que procurar crear separaciones entre diferentes sectores funcionales que posibiliten el uso simultáneo del cuarto del baño por varias personas.

Las zonas básicas del cuarto de baño son el tocador, la zona húmeda y la del sanitario. Las tres pueden separarse entre sí por puertas, tabiques o mamparas, o simplemente quedar delimitadas como espacios independientes por medio de una marcada distribución.

La planificación del baño depende, además, del espacio disponible. En las piezas de dimensiones reducidas es más recomendable instalar una ducha que una bañera; conviene renunciar al bidé e instalar un inodoro suspendido. Asimismo, un lavabo de pared será siempre menos voluminoso que otros con pie o pedestal. La elección de materiales ligeros, la sencillez de líneas y una distribución clara también contribuyen a proporcionar sensación de amplitud.

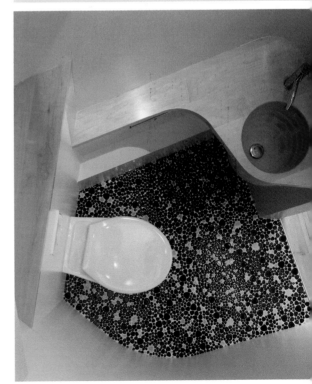

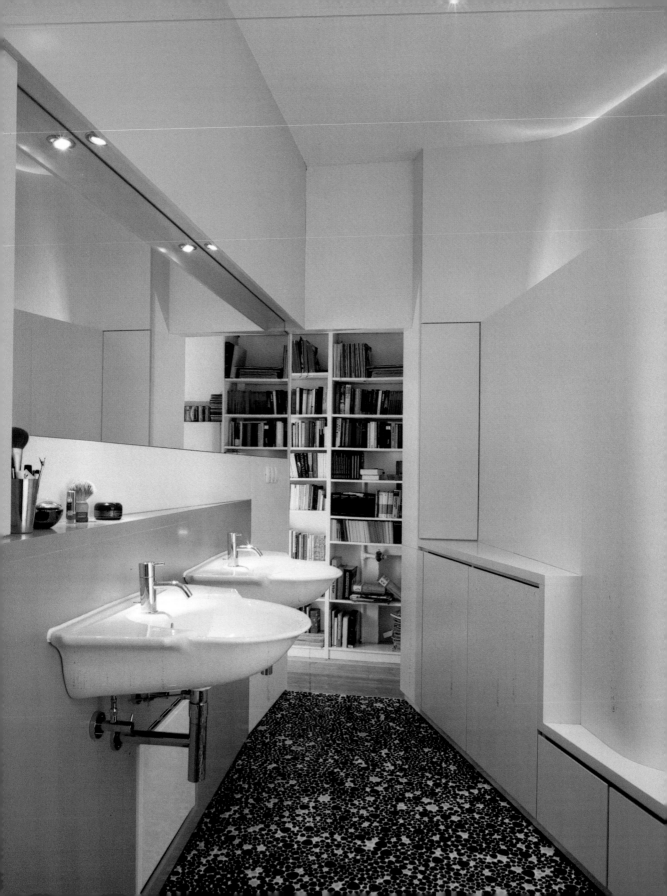

La distribuzione logistica del bagno

Both pages
Design by Huber David Ambrosius
Photo © Miquel Tres

Oltre la cucina, il bagno costituisce un ambiente che richiede una pianificazione intensiva, visto che sarebbe molto complicato provvedere ad una nuova distribuzione logistica, dopo l'installazione dei tubi e delle tubature di scarico. Prima di iniziare i lavori è consigliabile analizzare lo spazio disponibile fino al più piccolo dettaglio: dove si trova l'ingresso, come è la posizione delle tubature di scarico, come si potrà sfruttare meglio la luce esistente, su quali sistemi di aerazione si potrà contare.

Per tutto ciò si dovranno prendere in considerazione le priorità del singolo utente. È importante analizzare se si fa il bagno molto spesso, se serve molto spazio per stivare o custodire oggetti e perfino quanto spesso si prevede di utilizzare il tavolino da toilette. Nonostante il bagno oggigiorno venga inteso come un ambiente aperto che possa essere utilizzato da tutta la famiglia contemporaneamente, tuttavia esso richiede sempre un alto grado di intimità per la singola persona. Questo è uno dei motivi per cui per la suddivisione dello spazio si dovrebbero prevedere delle separazioni tra le singole zone funzionali che consentono a più persone di utilizzare il bagno contemporaneamente.

Le tre zone fondamentali del bagno sono il tavolino da toilette, la zona bagni e la zona sanitari. Le singole zone potranno essere segnalate come zone indipendenti, mediante porte, muretti divisori, pareti separatorie o semplicemente mediante una suddivisione chiara e differenziata.

Questa suddivisione è anche subordinata allo spazio disponibile. In caso di ambienti piccoli è preferibile installare una doccia al posto di una vasca ed è altrettanto sensato scegliere in questi casi un water a muro e rinunciare al bidet. Un piccolo lavandino incassato nel muro è meno ingombrante di un lavandino che appoggia su un piede o su uno zoccolo. Anche la scelta di materiali leggeri, lineamenti sobri ed una sistemazione generale ordinata contribuiscono a far sembrare l'ambiente più spazioso.

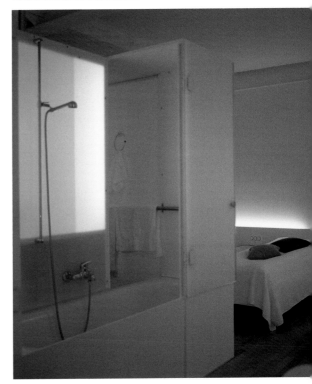

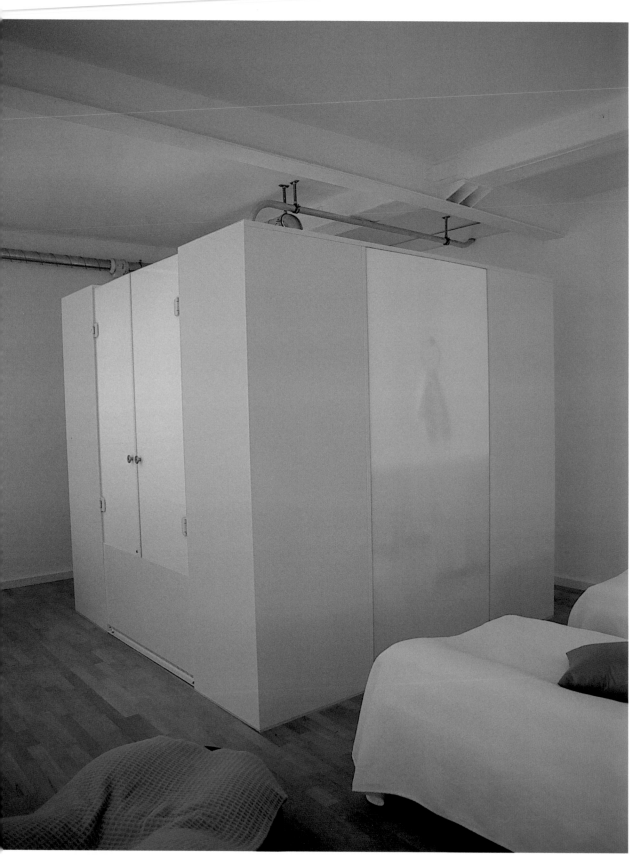

Enclosed bathrooms

Both pag...
Design by Belle van't H...
Photo © Virginia del Guid...

Bathrooms are generally separated from other rooms by a dividing wall. Free-standing elements and glass walls are aesthetically pleasing solutions for modern bathrooms that allow conventional dividing structures to be dispensed with.

Bäder werden gewöhnlich durch Mauern von anderen Wohnräumen abgetrennt. In modernen Bädern bieten freistehende Elemente und Glaswände attraktive Lösungen, so dass auf konventionelle Begrenzungen verzichtet werden kann.

En général, les salles de bains sont séparées des autres espaces de vie par des murs. Dans les salles de bains modernes, les structures monobloc et les parois de verre sont des solutions intéressantes pour remplacer les cloisonnements traditionnels.

Tradicionalmente, los cuartos de baño solían estar separados por tabiques de las demás estancias. El diseño moderno se vale de estructuras exentas y paredes de cristal para ofrecer soluciones atractivas que prescinden de las delimitaciones convencionales.

Solitamente, i bagni vengono separati dagli altri locali abitativi mediante muri. Nei bagni moderni vi sono spesso delle strutture libere o delle pareti di vetro, per offrire delle soluzioni interessanti che consentano di rinunciare alle limitazioni convenzionali.

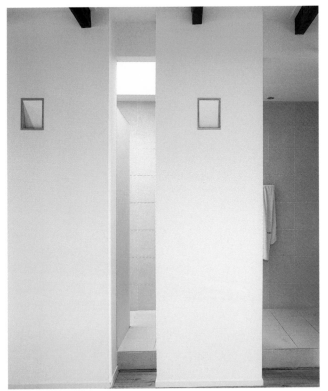
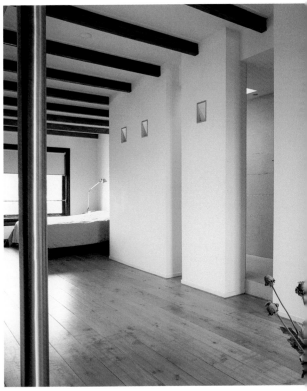

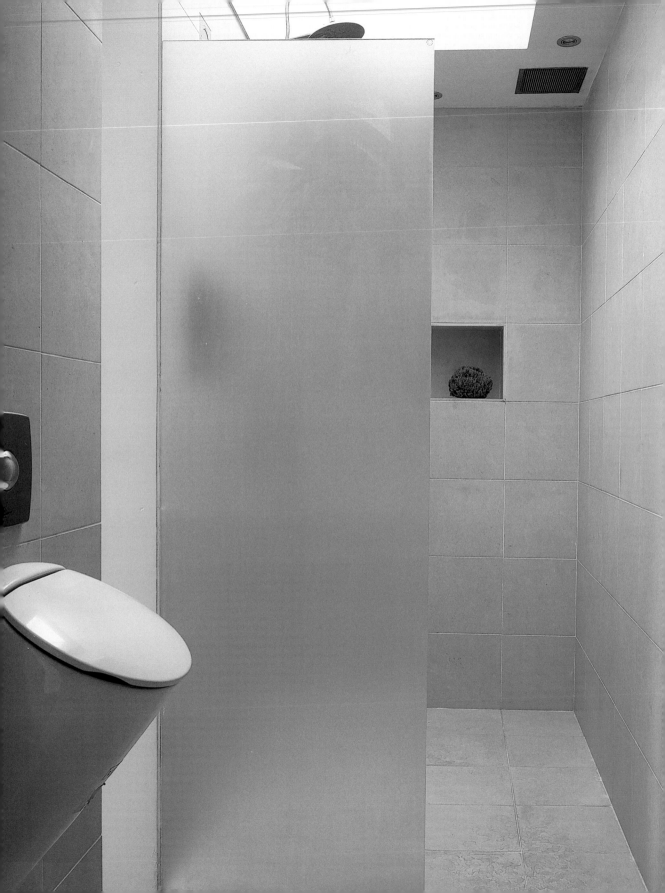

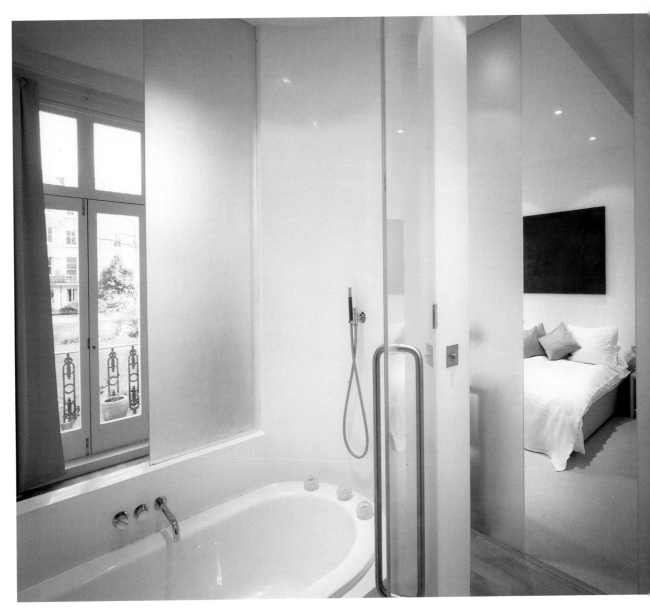

Both pages
Design by John Kerr
Photo © Chris Gascoigne/View

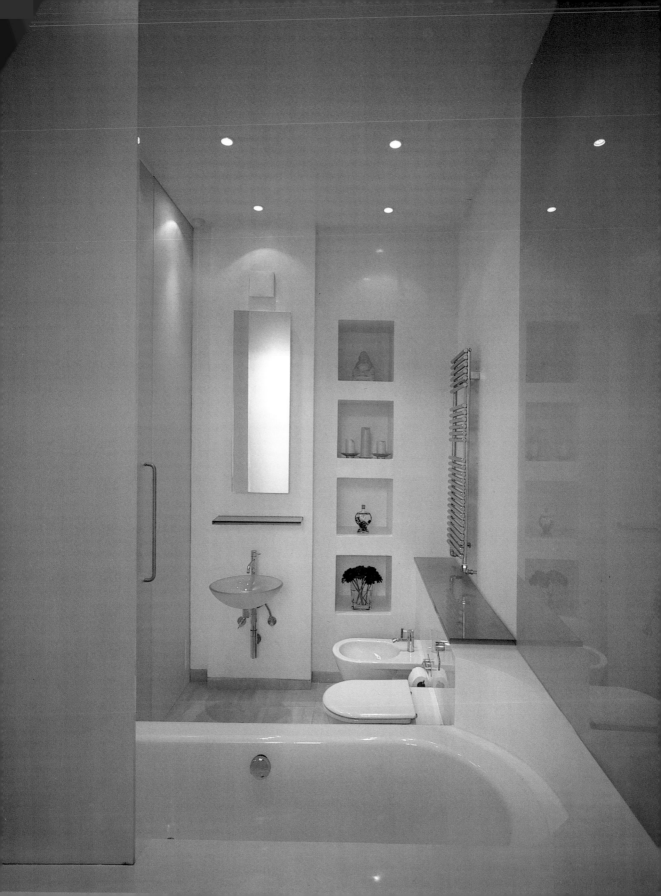

Both pag
Design by Siggi Pfundt/Form Werksta
Photo © Karin Heßmann/Art

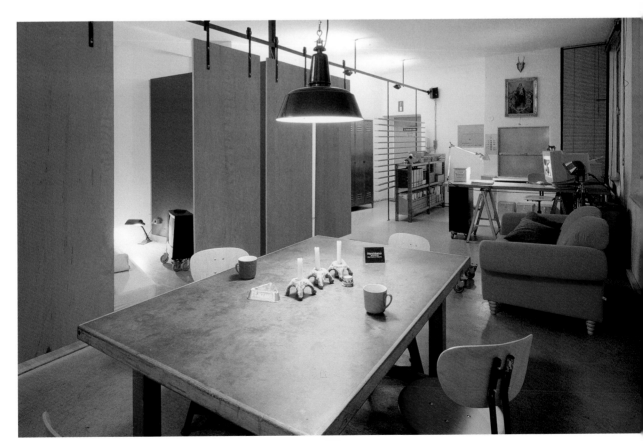

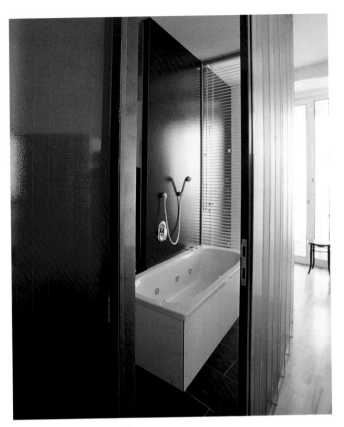

Photos © Markus Tomaselli/Rataplan

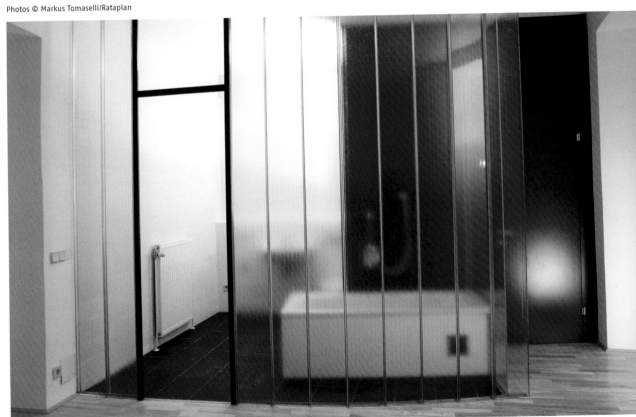

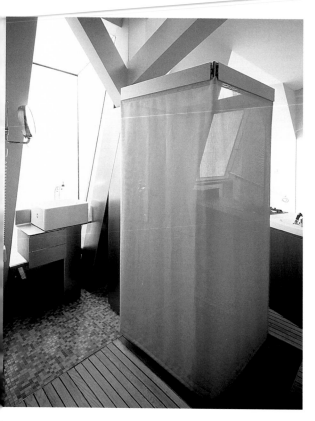
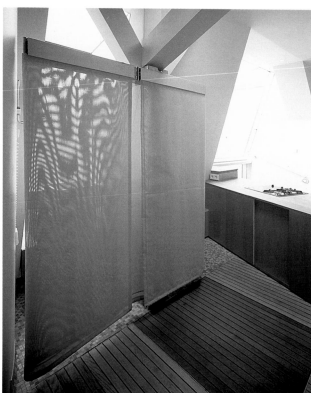

Design by Eichinger oder Knechtel
Photos © Margherita Spiluttini

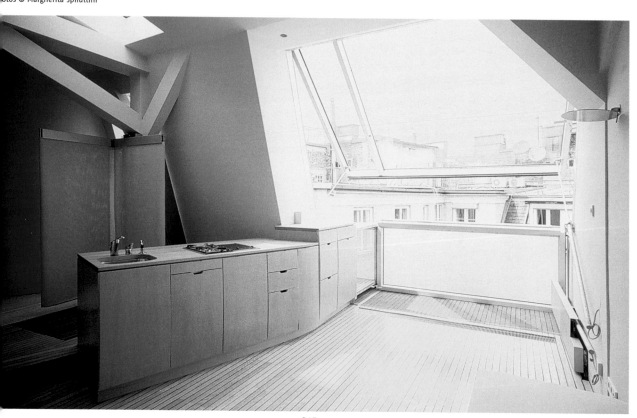

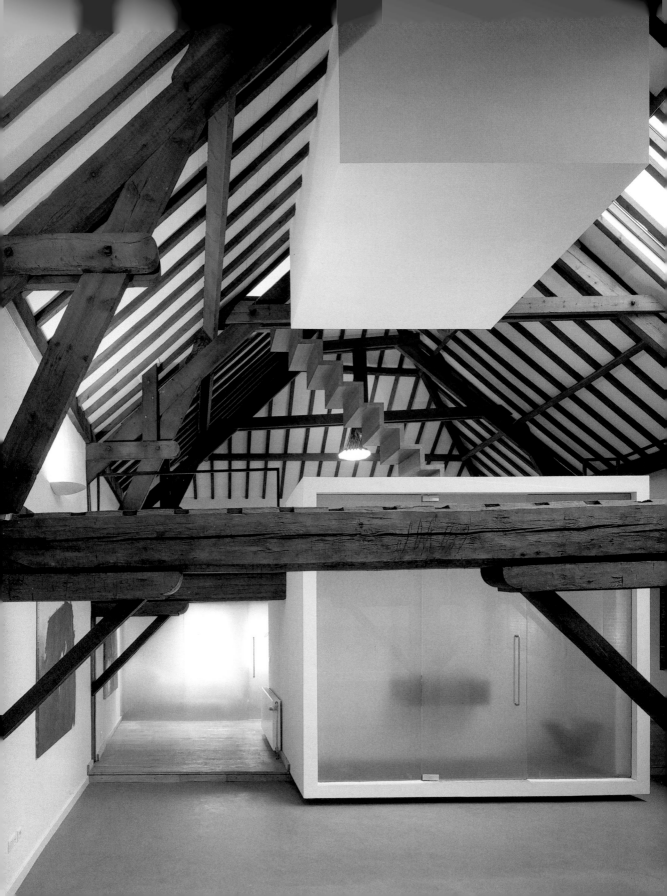

oth pages
esign by Fokkema Architechten
oto © Christian Richters

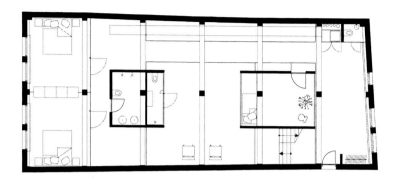

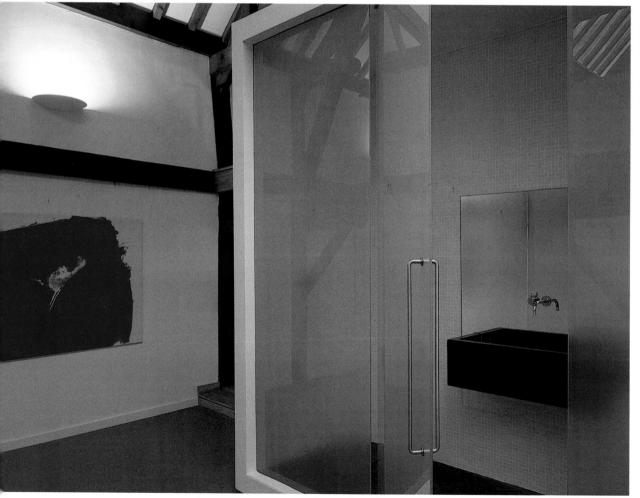

th pages
sign by Dick van Gameren (de Architechtengroep)
oto © Christian Richters

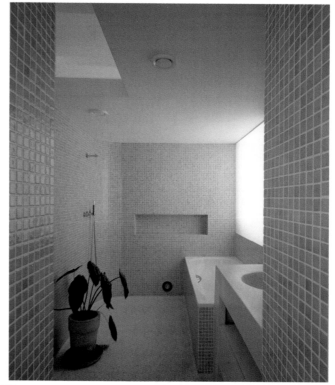

Both page
Design by Desai/Chia Stud
Photo © Joshua McHug

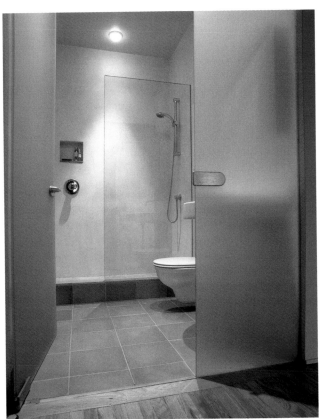

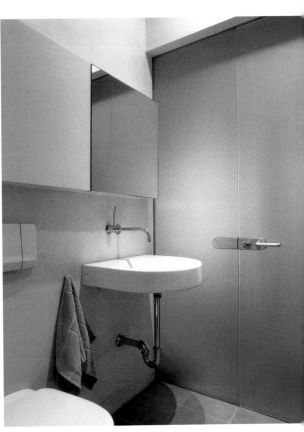

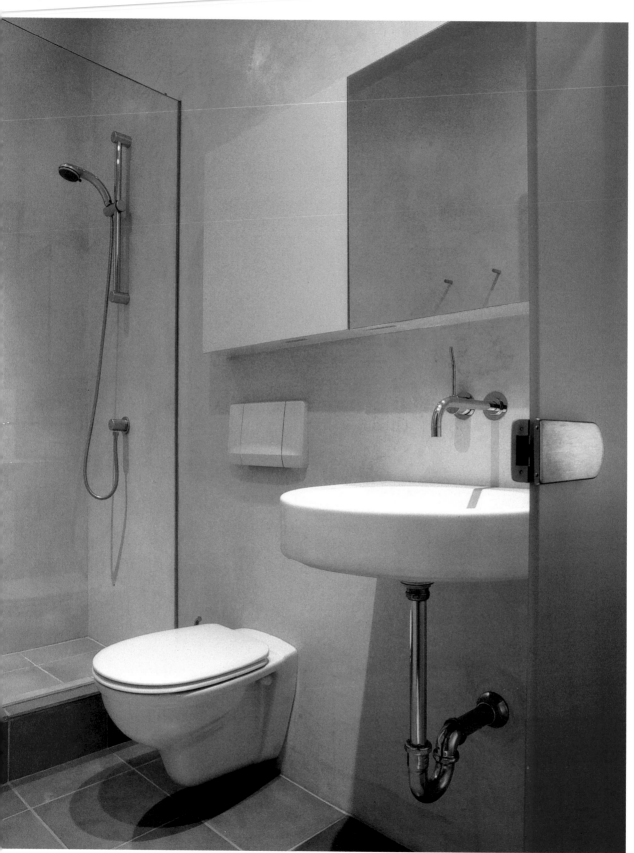

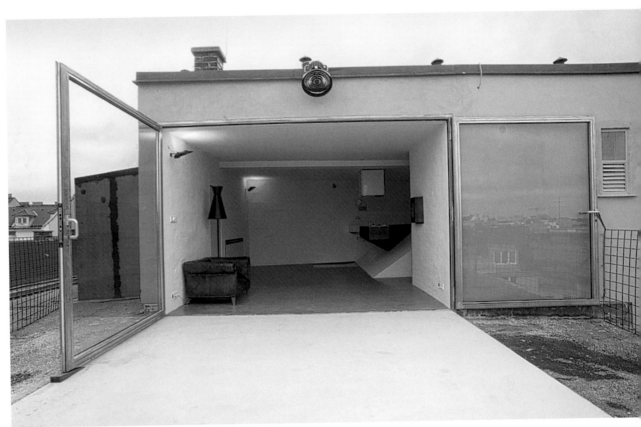

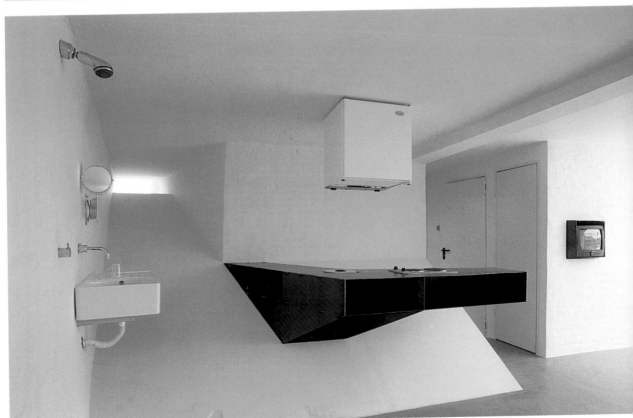

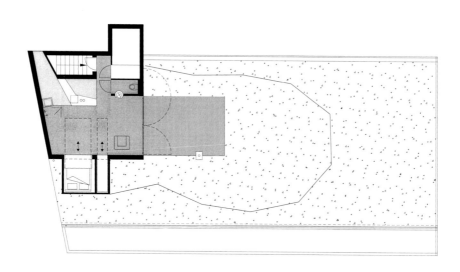

h pages
gn by Pool Architektur
to © Hertha Hurnaus

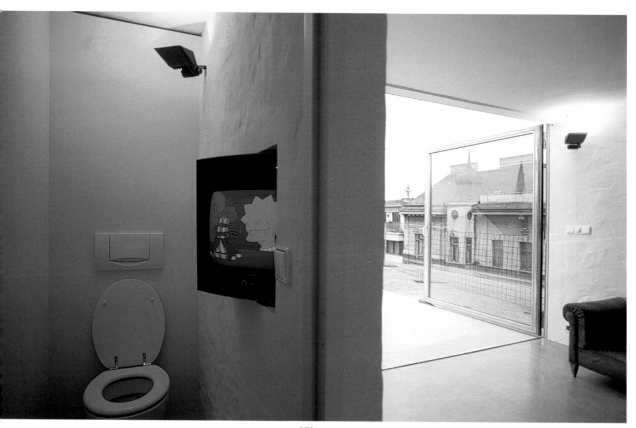

Exposed bathrooms

Both pa...
Design by Peter Tybergh...
Photo © Alejandro Baham...

Exposed bathrooms are a modern and space saving solution that is particularly suitable for single-person households. Privacy can be achieved for such bathrooms through the use of blinds.

Integrierte Bäder verkörpern einen modernen, raumsparenden Gestaltungsansatz, der besonders für Single-Haushalte geeignet ist. Durch die Verwendung von Sichtblenden muss auch hier auf Intimität nicht verzichtet werden.

Les salles de bains intégrées, créant un gain de place, fruit d'un concept moderne innovant, sont particulièrement adaptées aux célibataires. L'utilisation d'écrans visuels permet de ne pas renoncer au besoin d'intimité.

Los cuartos de baño integrados representan una posibilidad decorativa moderna que ahorra mucho espacio. Esta modalidad resulta especialmente adecuada para personas que viven solas. Gracias al uso de paneles separadores no hay que renunciar a la intimidad.

I bagni integrati rappresentano un concetto di allestimento moderno e di minimo ingombro che si presta molto bene per le case abitate da una persona sola. Grazie all'uso di schermi alla visibilità, anche in queste soluzioni si riesce a rispettare l'intimità dell'individuo.

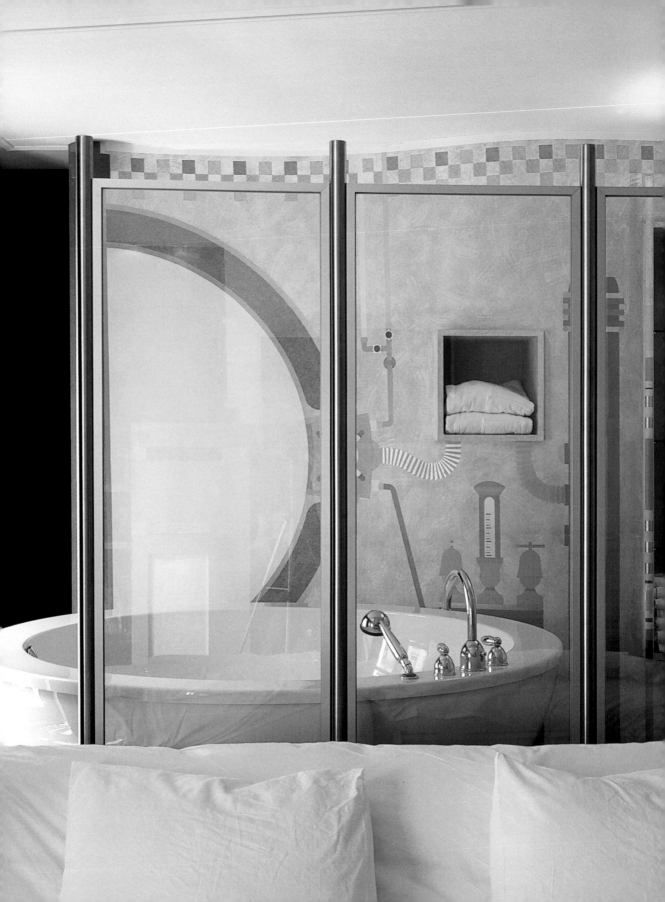

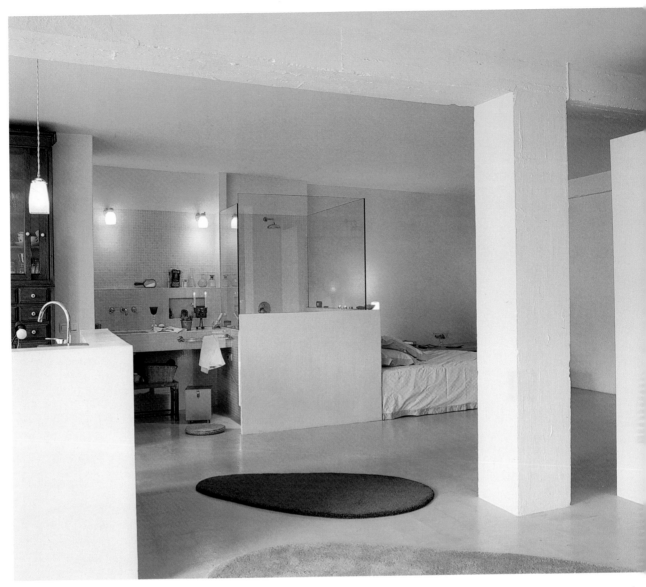

Both pages
Design by Anne Bugagnani, Diego Fortunato
Photo © Eugeni Pons

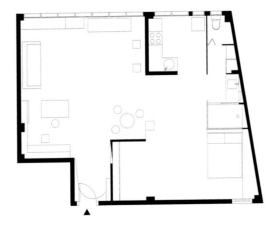

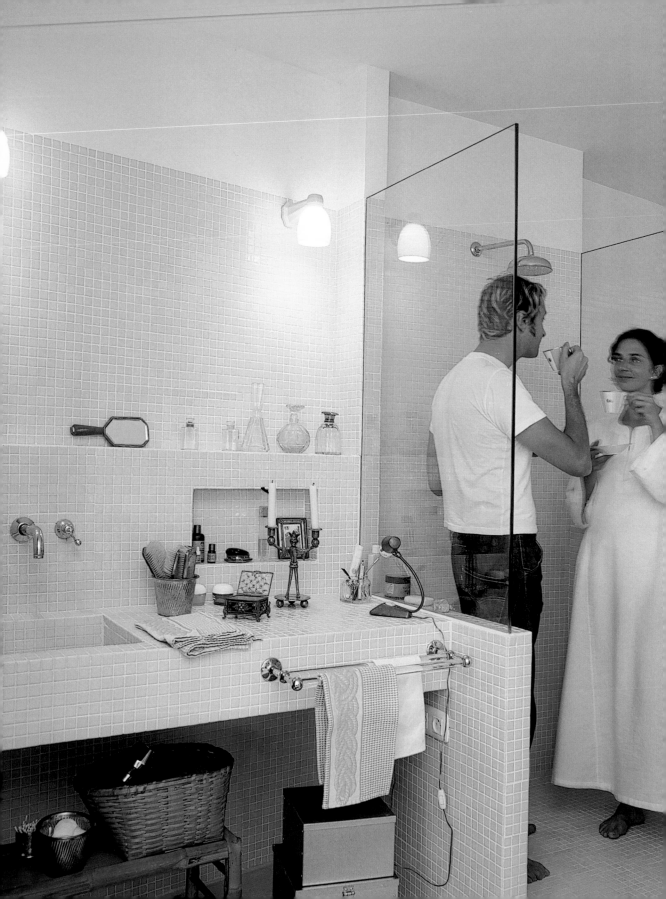

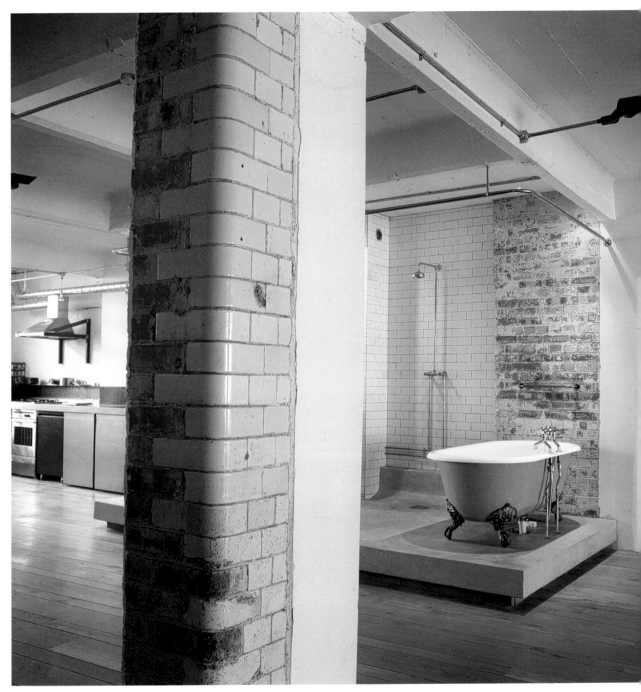

Both pages
Design by Blockarchitecture
Photo © Chris Tubbs

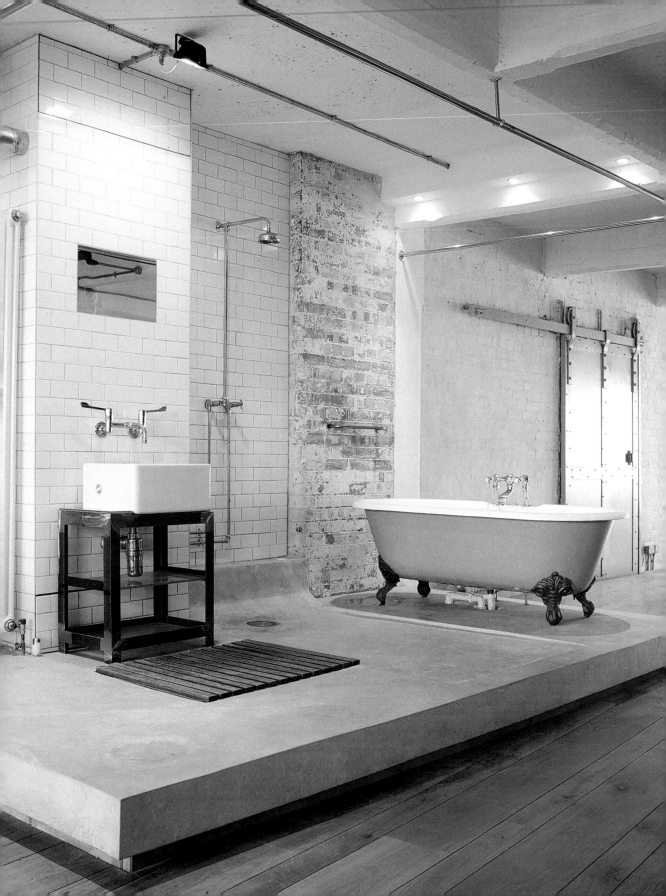

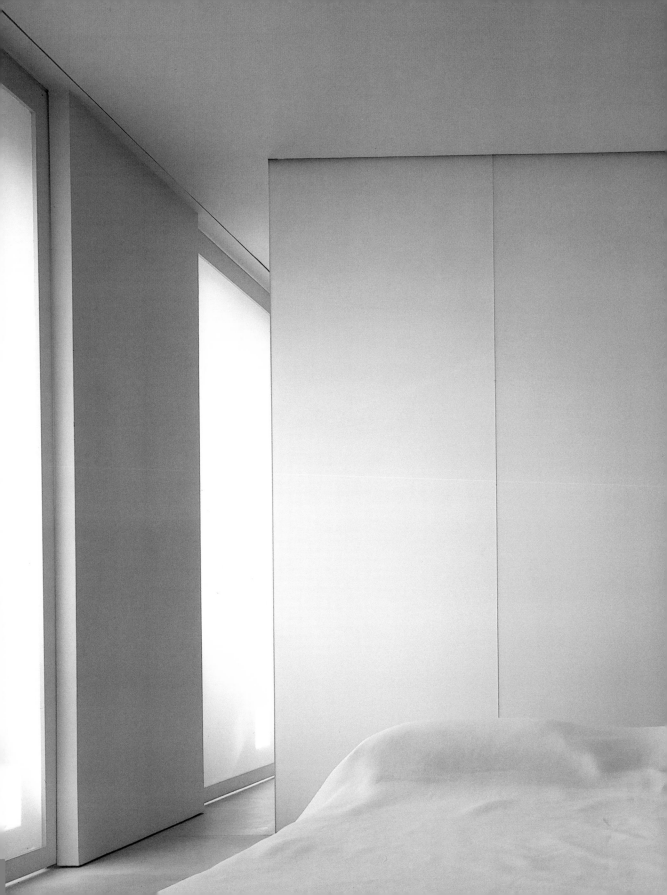

th pages
sign by Claudio Silvestrin
oto © James Morris/Axiom

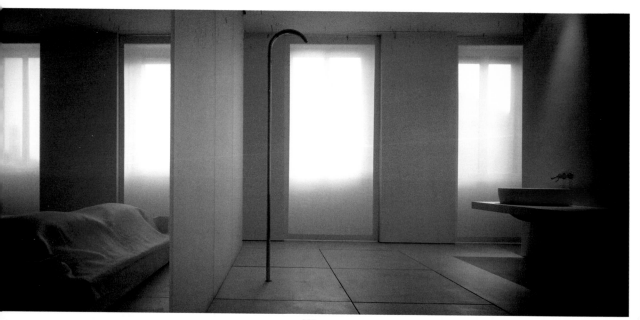

381

Design by Marco Savorelli
Photo © Matteo Piazza

Both photos
Design by Manuel Ocaña del Valle
Photo © Luis Asín

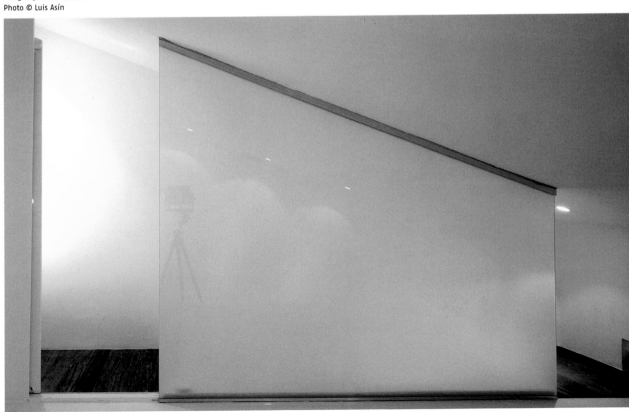

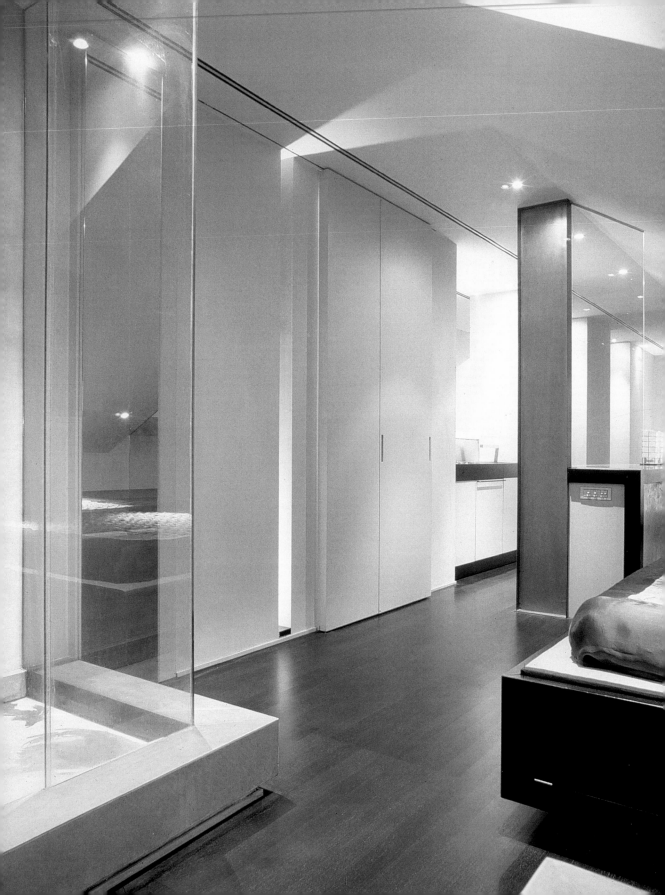

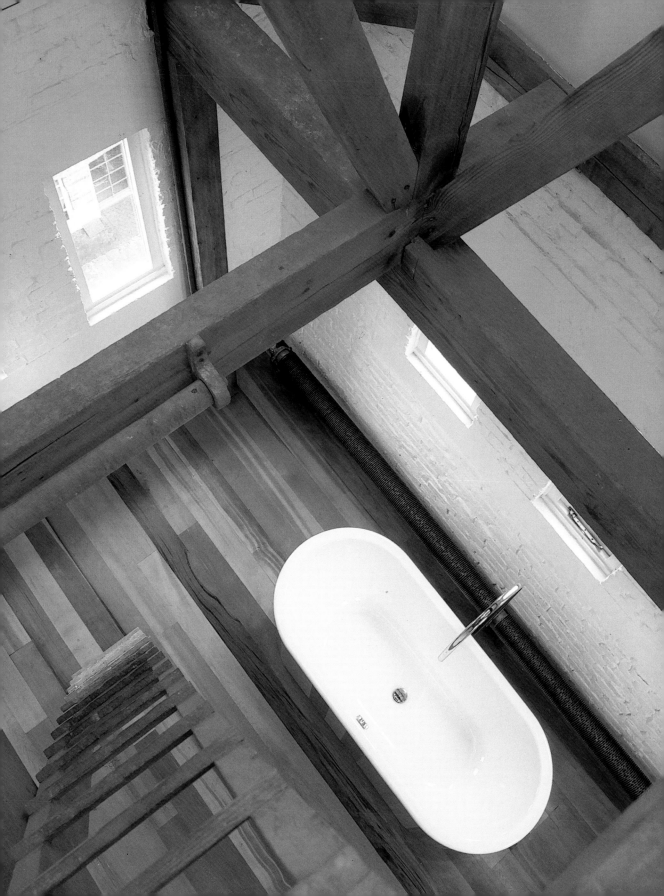

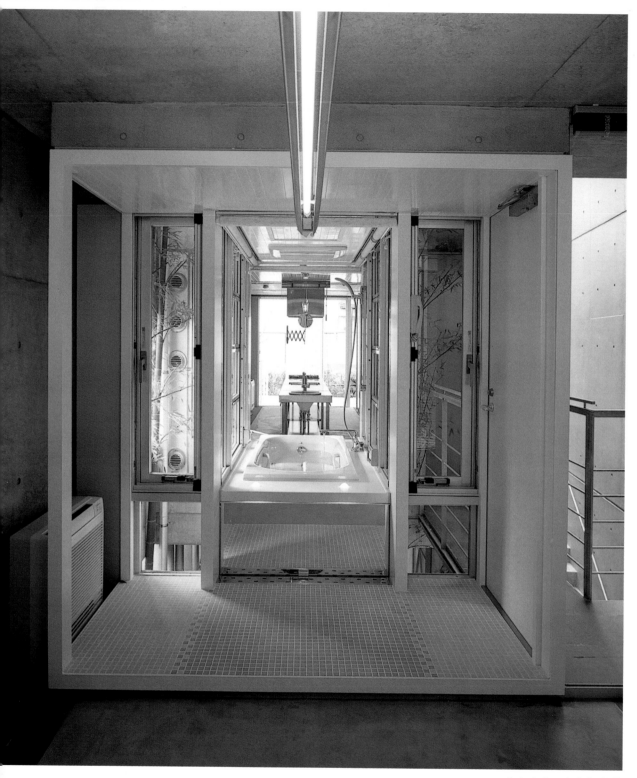

Design by Yamaoka Design Studio
Photo © Nacása & Partners

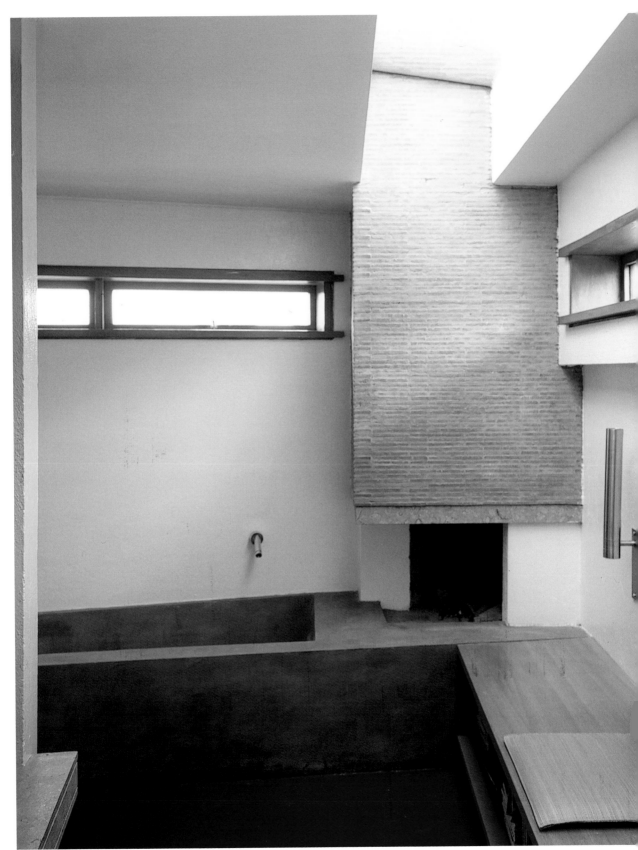

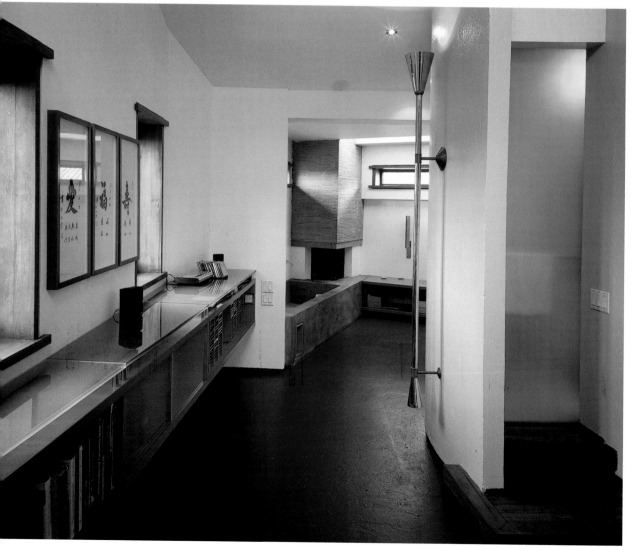

Both pages
Design by Desai/Chia Studio
Photo © Joshua McHugh

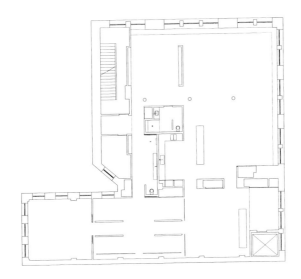

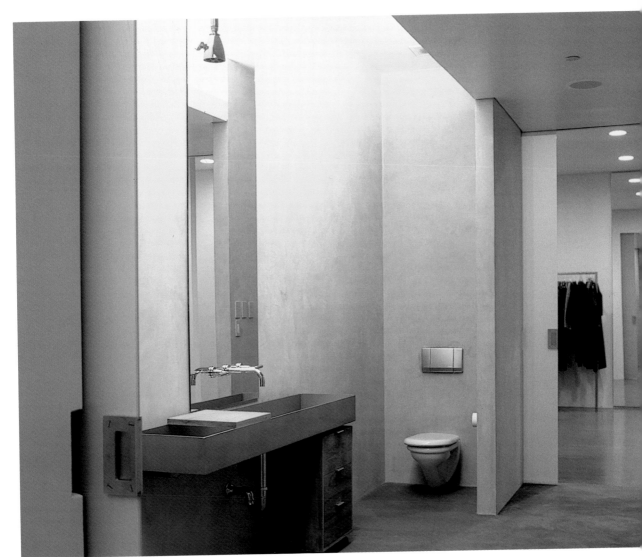

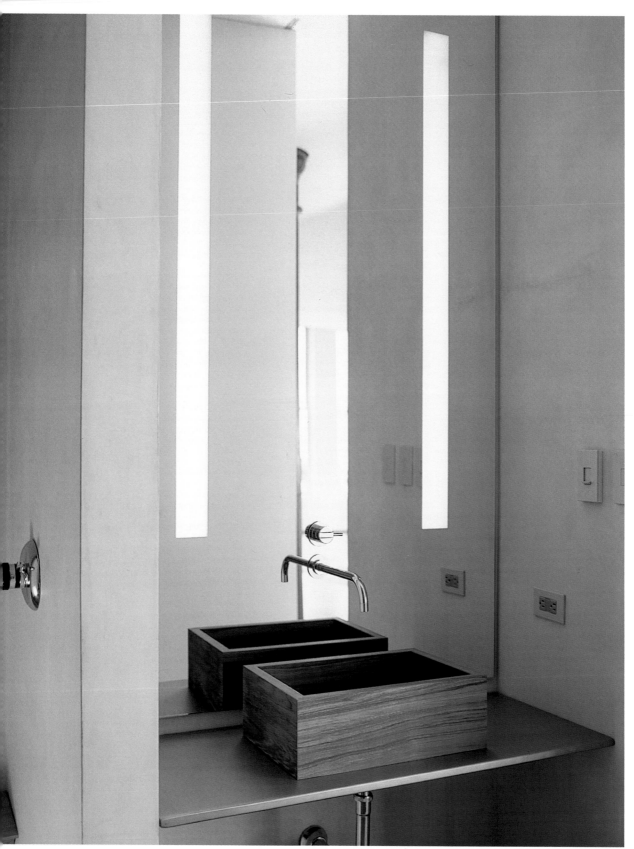

Both page
Design by Marco Savorel
Photo © Matteo Piazz

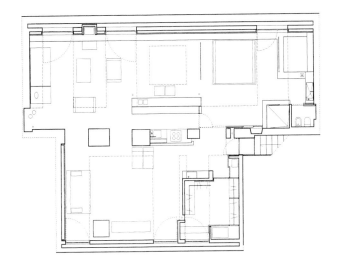

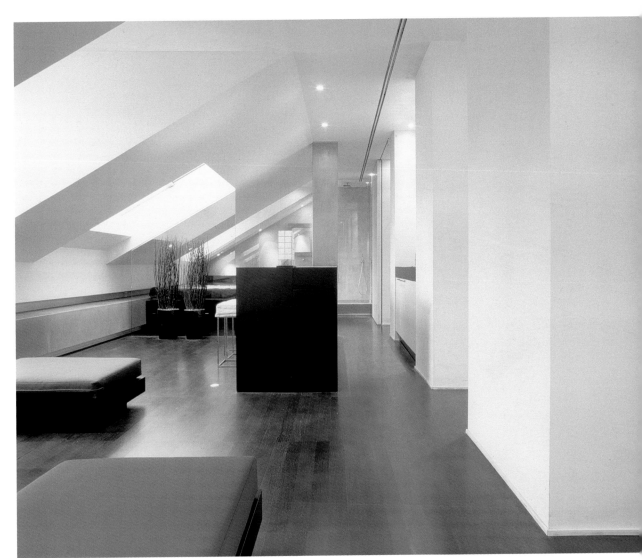

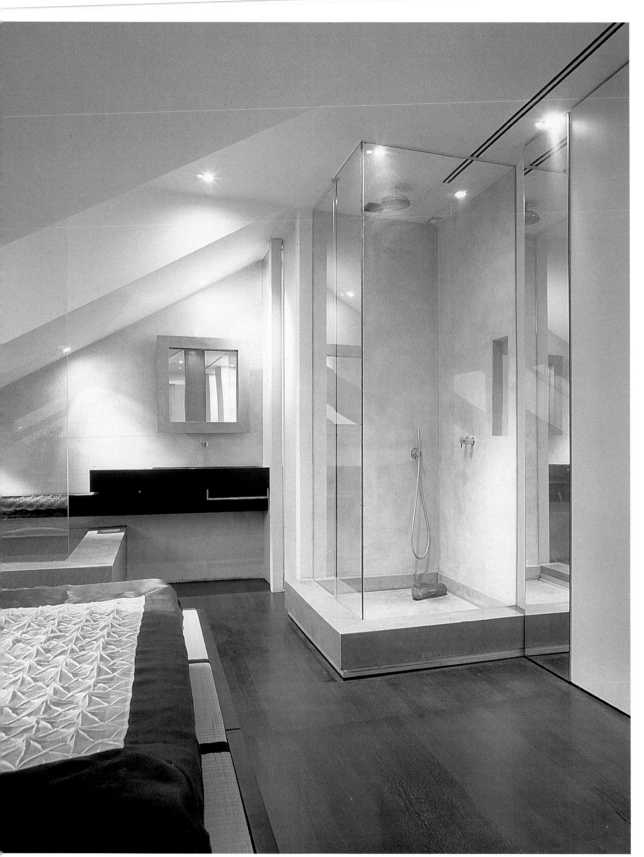

En suite bathrooms

Both page
Design by Christina Rodríguez and Augusto Le Monnie
Stylism by Ino Co
Photo © Pere Peri

En suite bathrooms are directly connected to a bedroom. Some are part of the room itself, but in such cases, factors such as ventilation must be taken into account.

Hierbei handelt es sich um ein Bad, das direkt mit dem Schlafzimmer verbunden ist. Eine Variante ist die Integration in den Schlafraum, allerdings muss man dabei Faktoren, wie zum Beispiel die Belüftung, berücksichtigen.

Il s'agit ici d'une salle de bains directement reliée à la chambre. Sa variante est l'intégration directe de la salle de bains dans la pièce, à condition de ne pas négliger certains facteurs comme l'aération, à titre d'exemple.

Este tipo de baño comunica directamente con el dormitorio. Una variante es su integración directa en la habitación; sin embargo, para ello hay que tener en cuenta ciertos factores, por ejemplo, una buena ventilación.

In questo caso si tratta di un bagno che è collegato direttamente con la camera da letto. Una variante a ciò è l'integrazione diretta del bagno nella stanza stessa; in tal caso si dovrà rispettare alcuni fattori, come ad esempio, un idoneo sistema di aerazione.

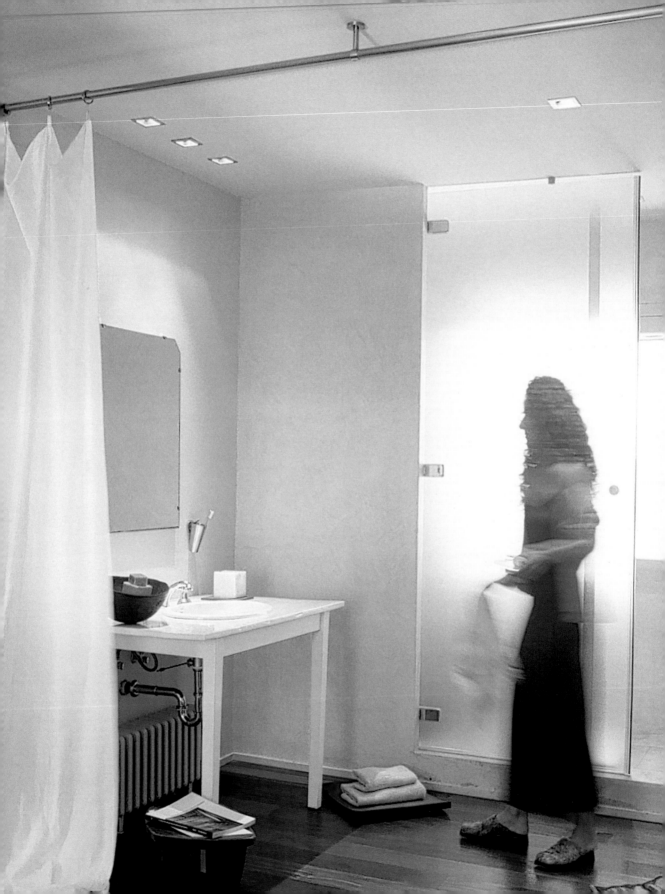

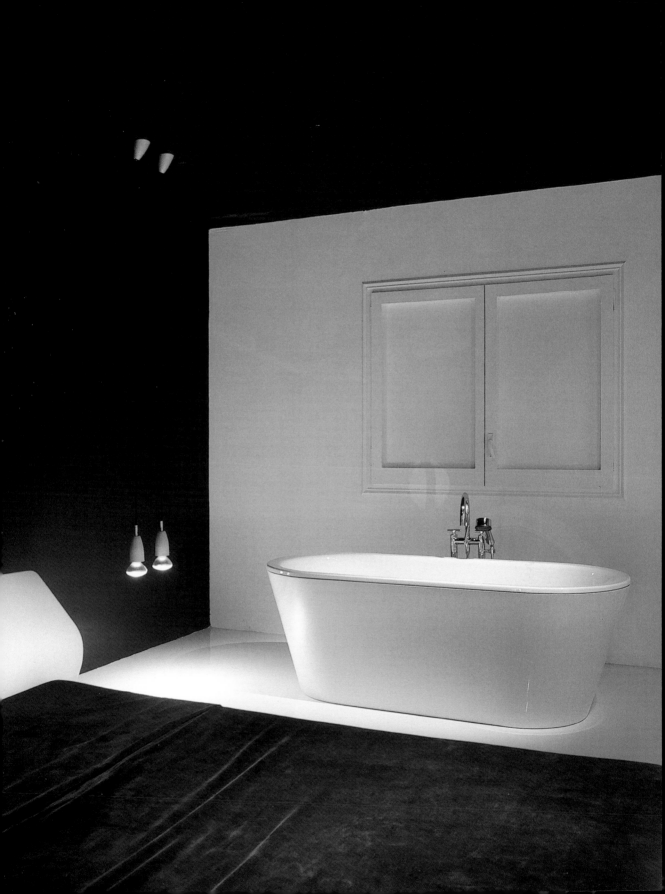

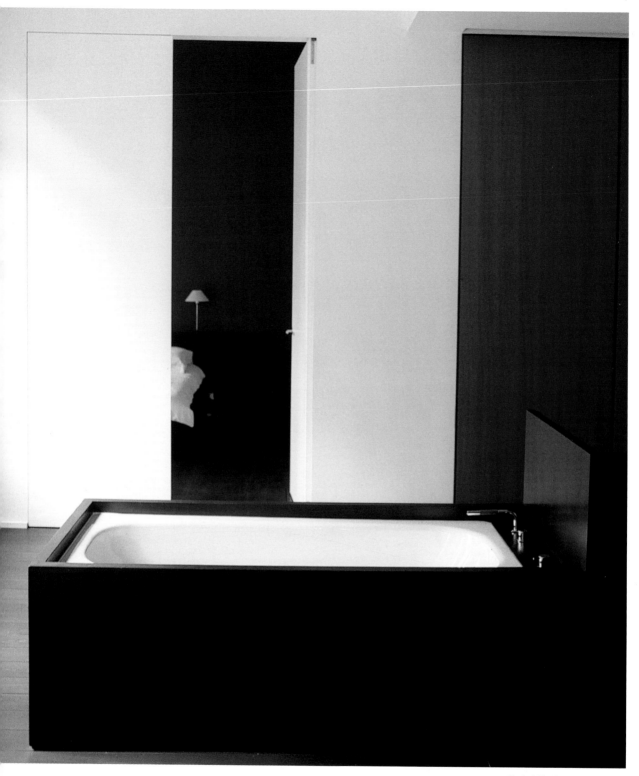

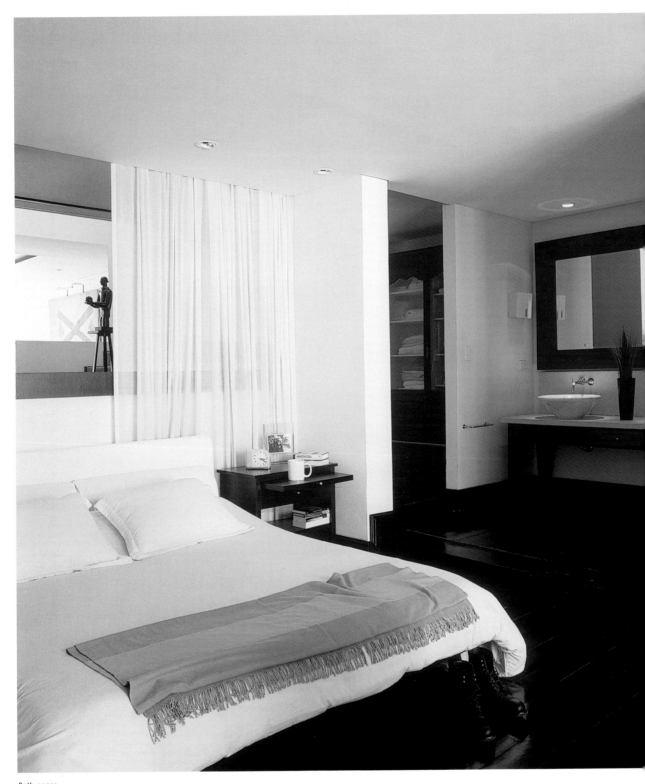

Both pages
Design by Pablo Chiaporri
Photo © Virginia del Guidice

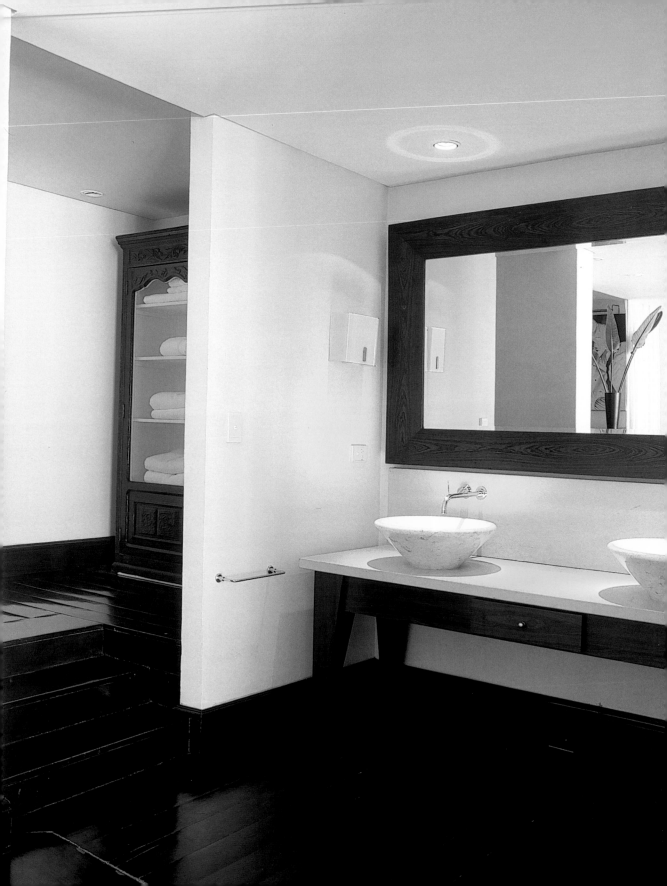

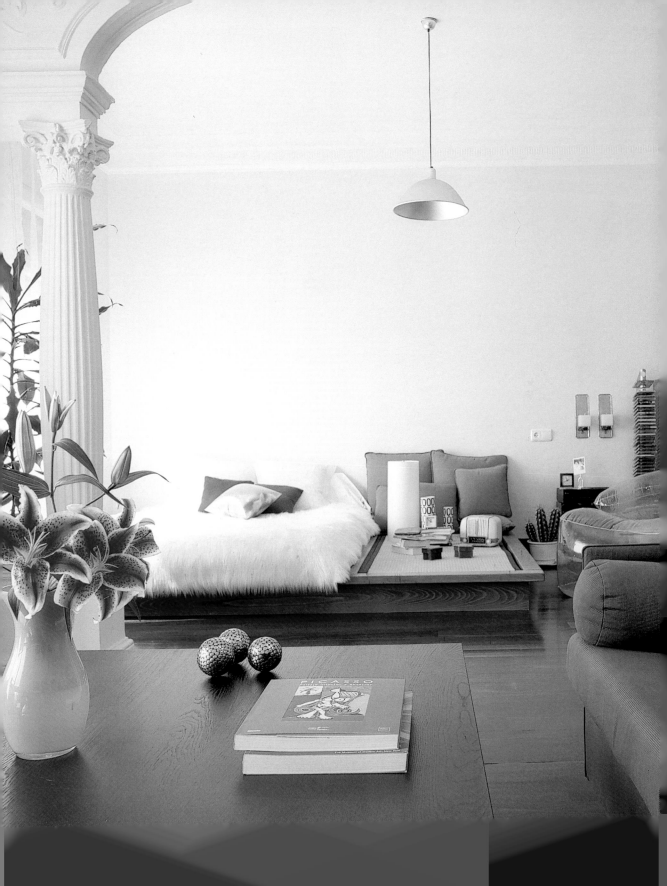

h pages
ign by Nacho Marta
to © José Luis Hausmann

Both pag
Design by Ayhan Oza
Photo © Bjo

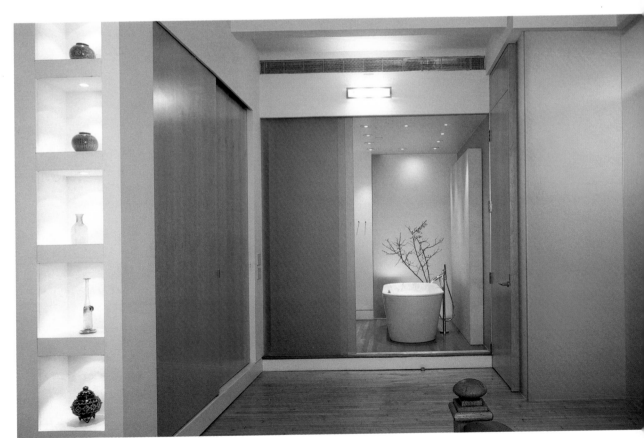

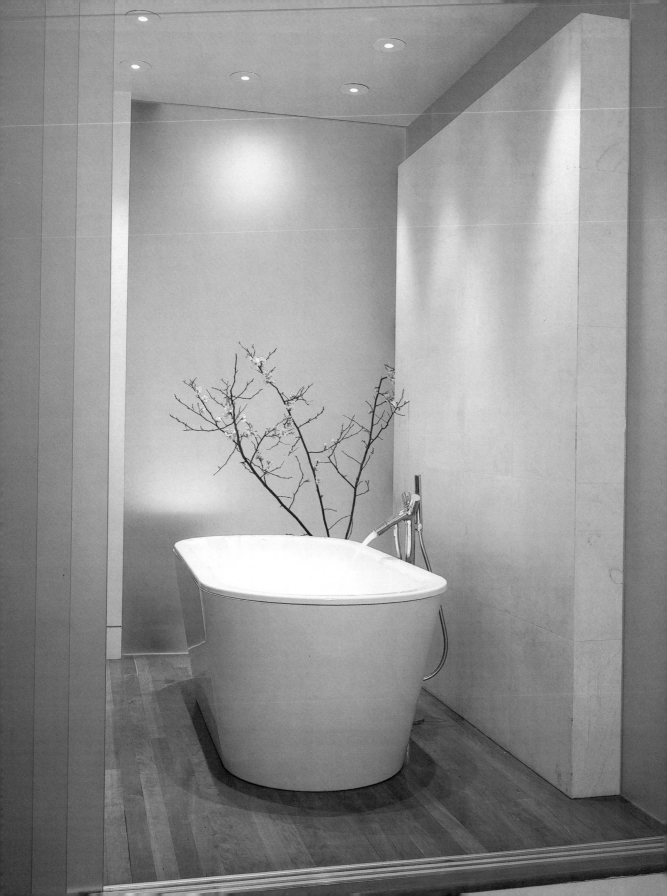

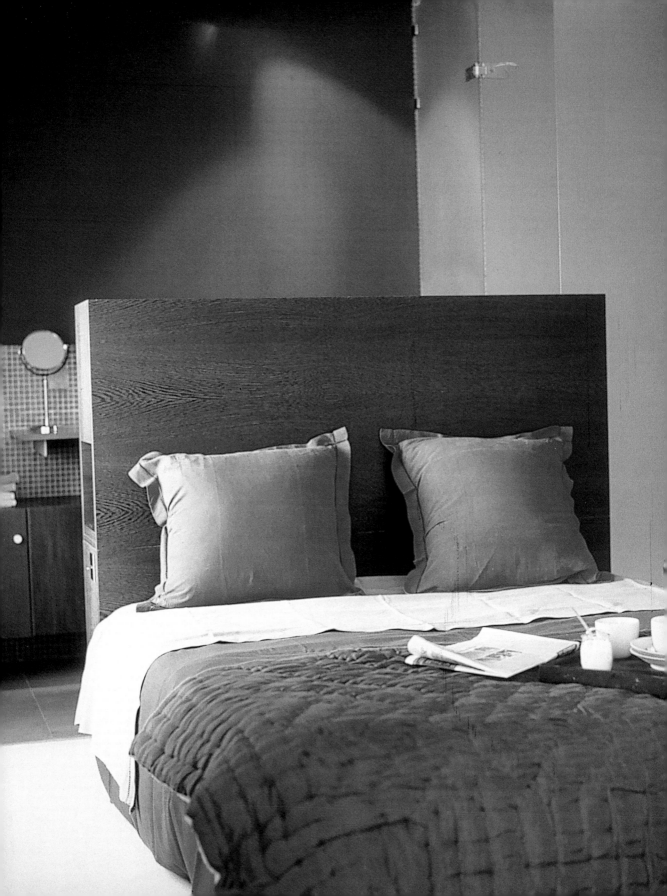

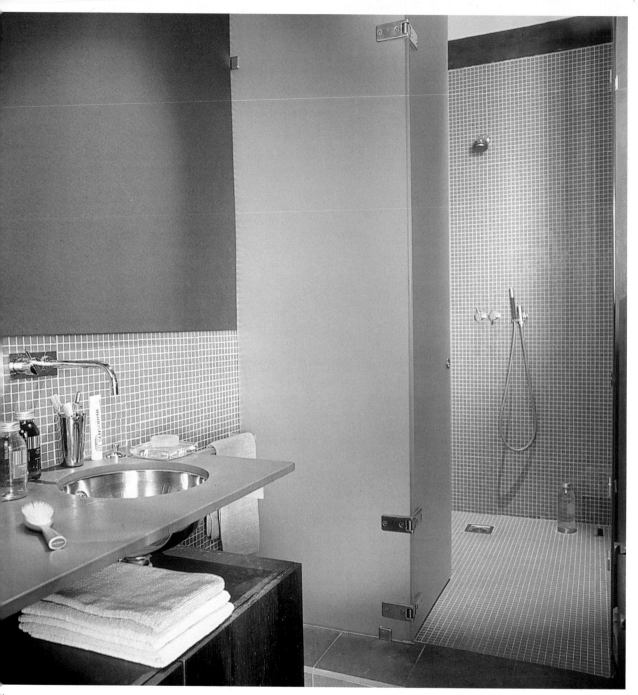

h pages
ign by Karin Léopold and François Fauconnet
to © Vincent Leroux/ACI Roca–Sastre

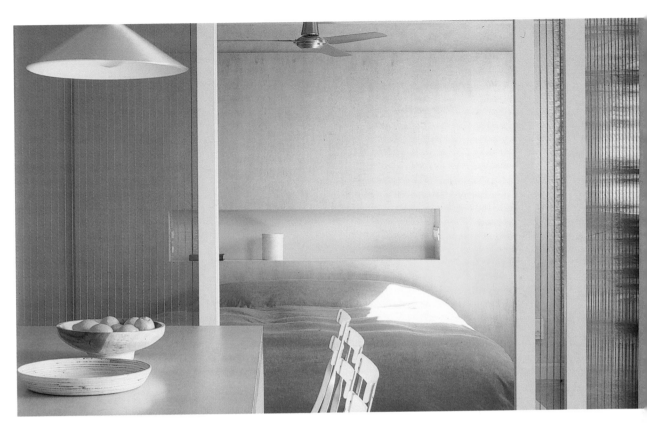

Both pages
Design by GCA Arquitectos
Photo © José Luis Hausmann

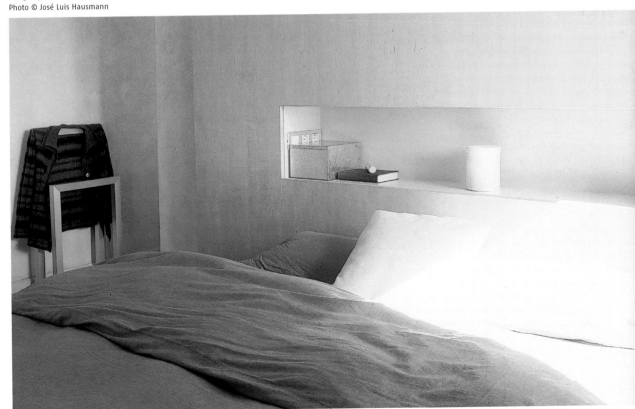

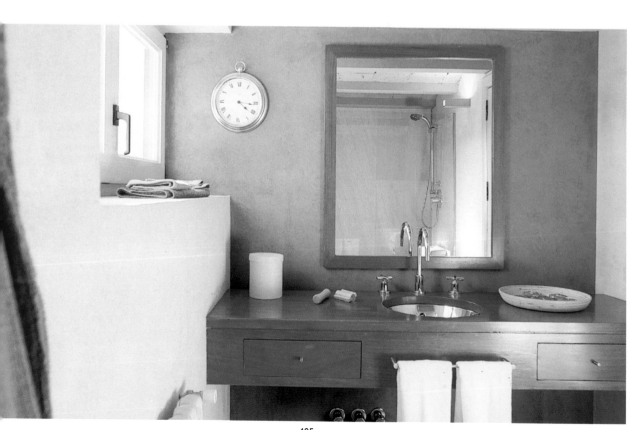

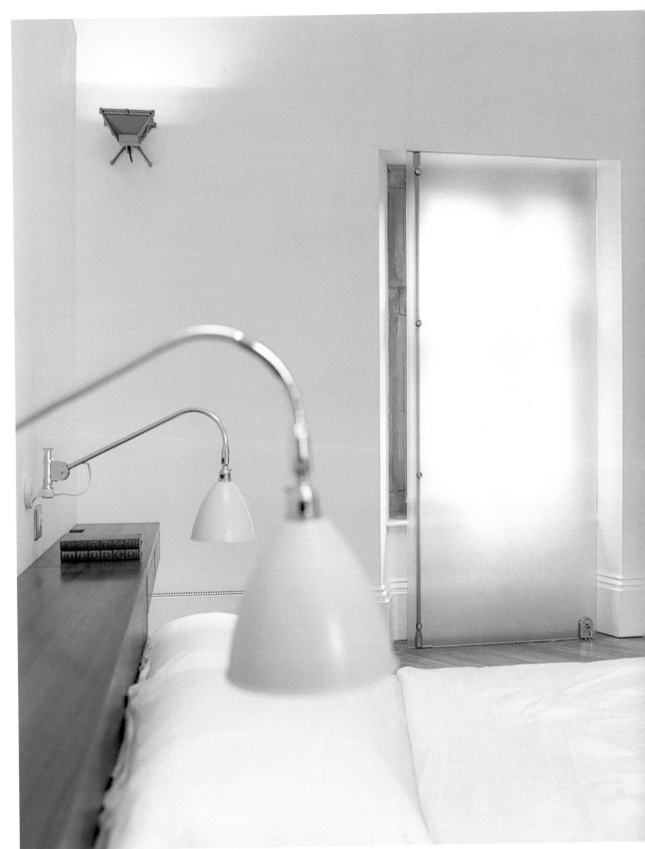

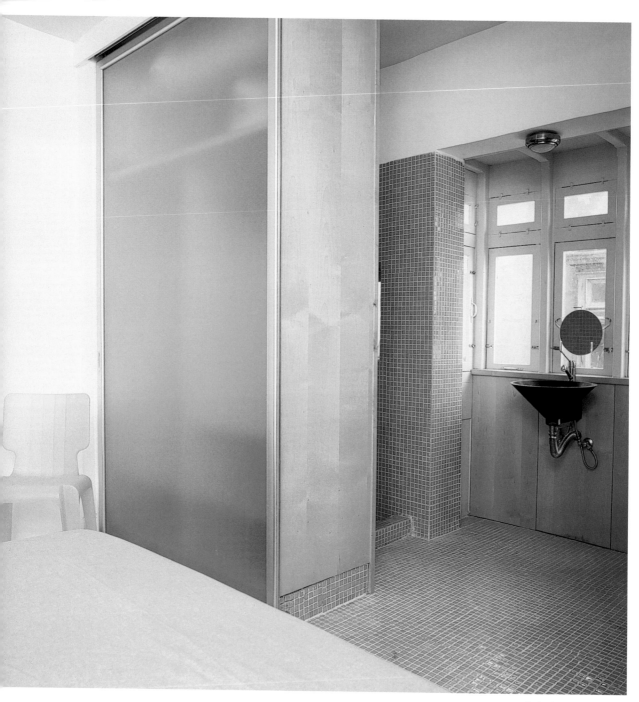

Design by Guillaume Dreyfuss
Photo © Kurt Arrigo

Design by Jorges Villo
Photo © Andreas von Einsiedel/Red Cove

Design by Pler Arquitectos
Photos © José Luis Hausmann

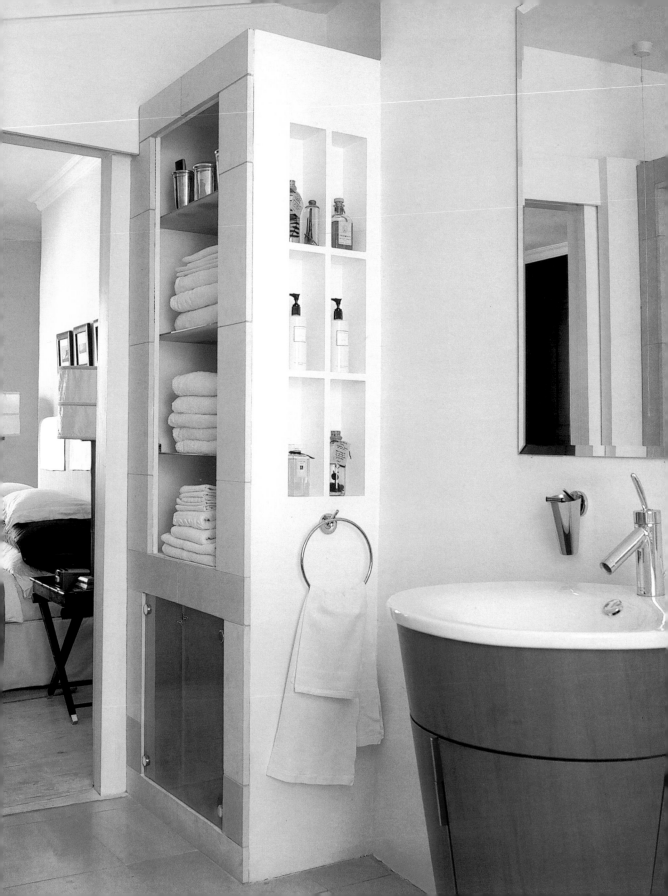

Small bathrooms

Small bathrooms can be given a more spacious feel through the use of abundant lighting and clear colors. In order to make optimal use of the available space in such bathrooms, it is best to install a shower instead of a bathtub and to opt for a built-in sink.

Kleine Bäder lassen sich durch viel Licht und helle Farben optisch vergrößern. Um den entsprechenden Platz optimal auszunutzen, empfiehlt es sich, eine Dusche statt einer Badewanne sowie eingebaute Waschbecken zu verwenden.

De la lumière en abondance et des couleurs claires donnent l'impression d'agrandir les petites salles de bains. Pour optimiser l'espace, la douche est préférable à la baignoire et les lavabos encastrés sont idéals.

Los cuartos de baño pequeños pueden resultar más amplios si se elige un acertado juego de luces y se hace una adecuada elección de colores claros. Para aprovechar el espacio de una forma óptima se recomienda la instalación de una ducha en lugar de la tradicional bañera y también de un lavabo empotrado.

Con l'utilizzo idoneo di tanta luce e di colori chiari si riesce a far sembrare più grandi i bagni piccoli. Per sfruttare lo spazio disponibile in modo ottimale è consigliabile preferire la doccia alla vasca ed utilizzare lavandini incassati nel muro.

Design by John Butterworth
Photo © Paul Warchol

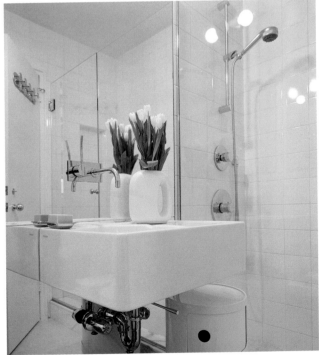

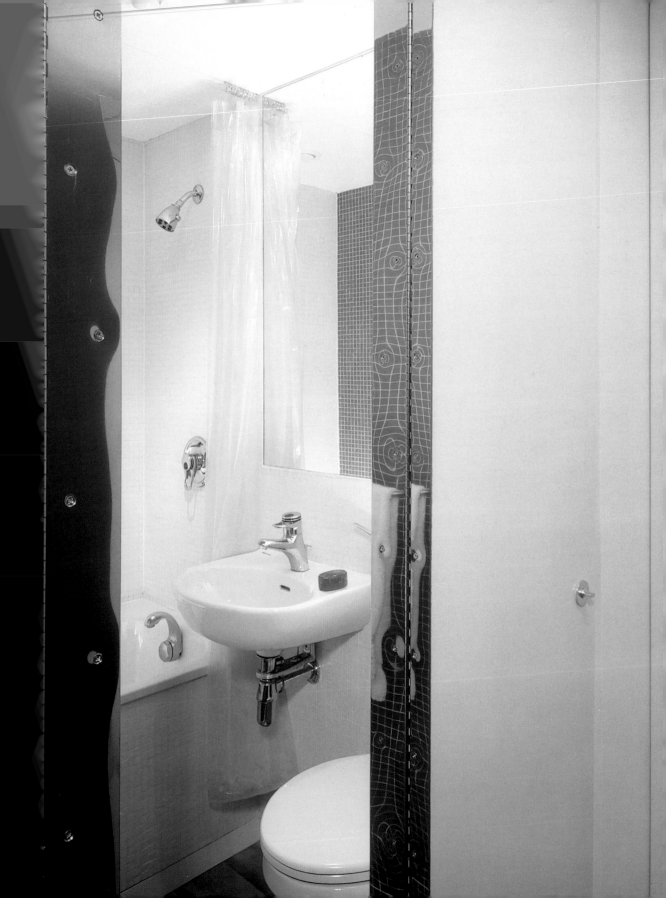

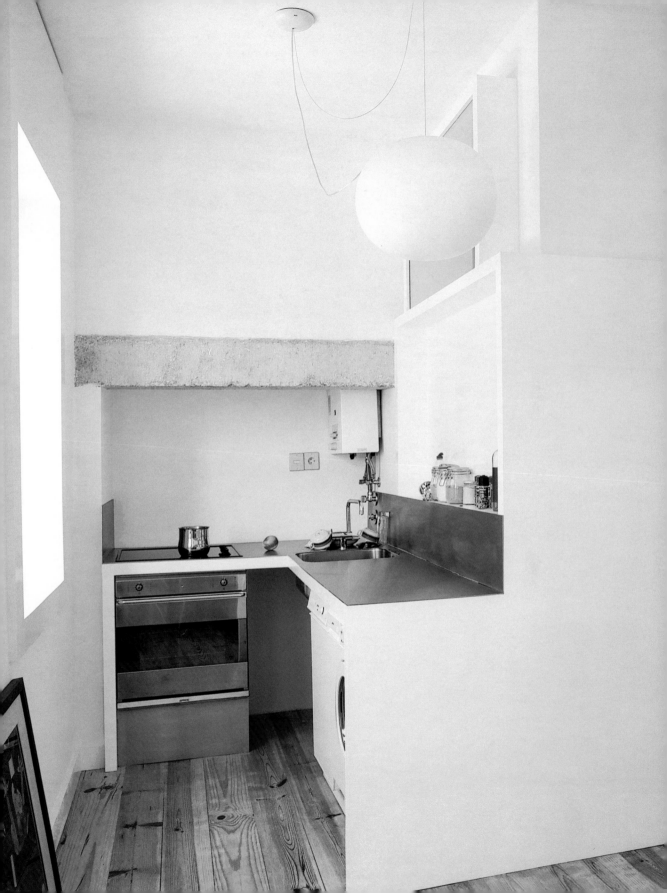

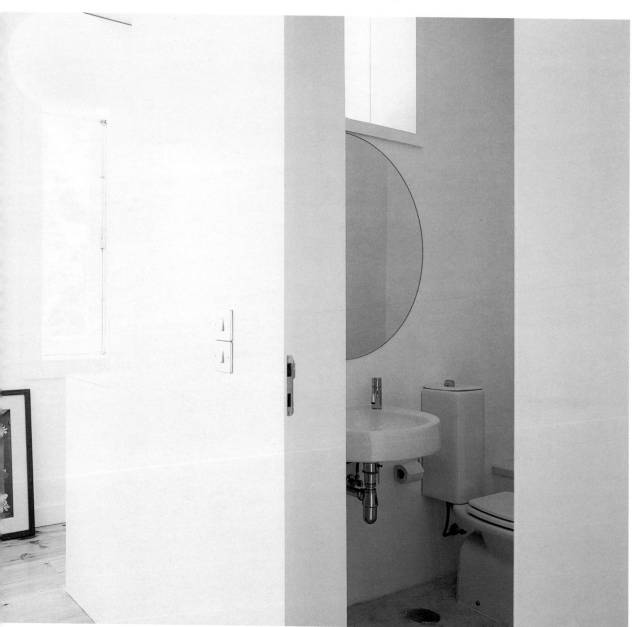

413

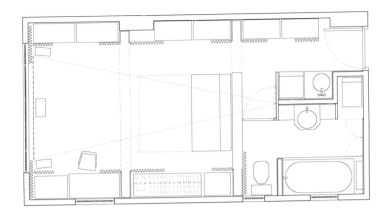

Both pages
Design by Gary Chang/EDGE (HK) Ltd.
Photo © Almond Chu

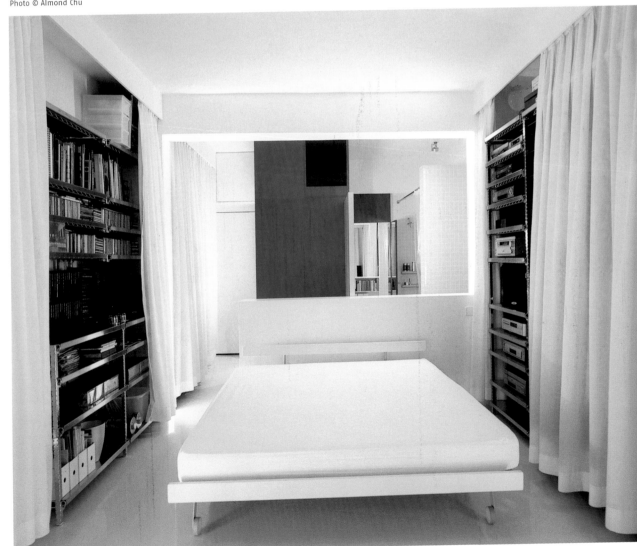

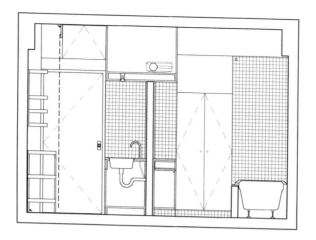

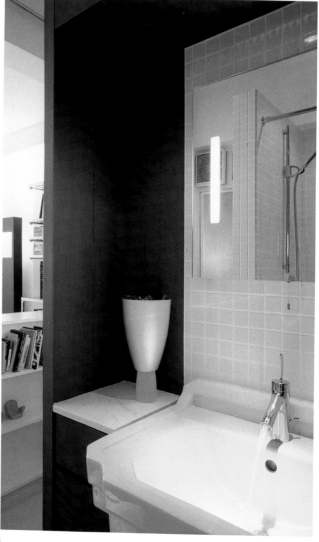

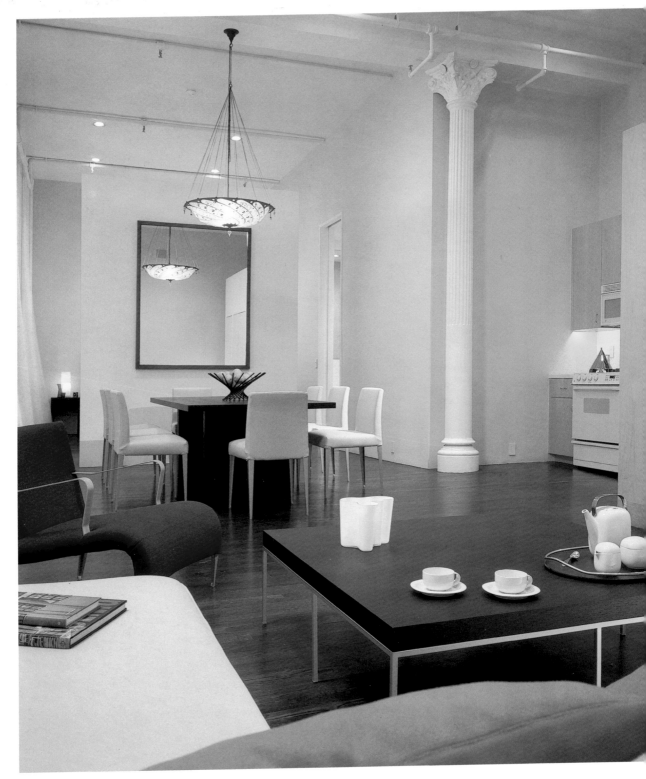

Both pages
Design by Harry Elson
Photo © Paul Warchol

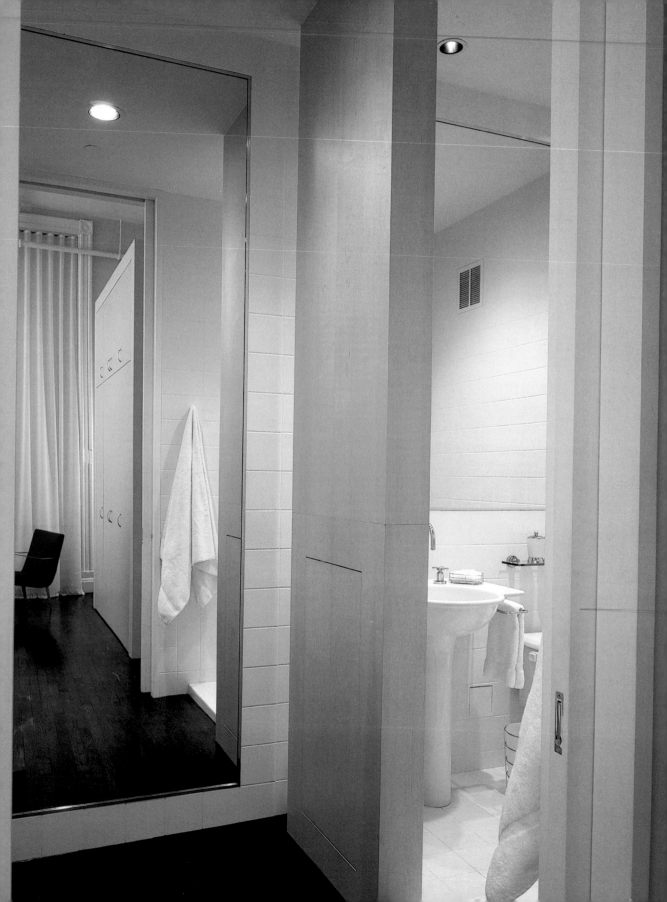

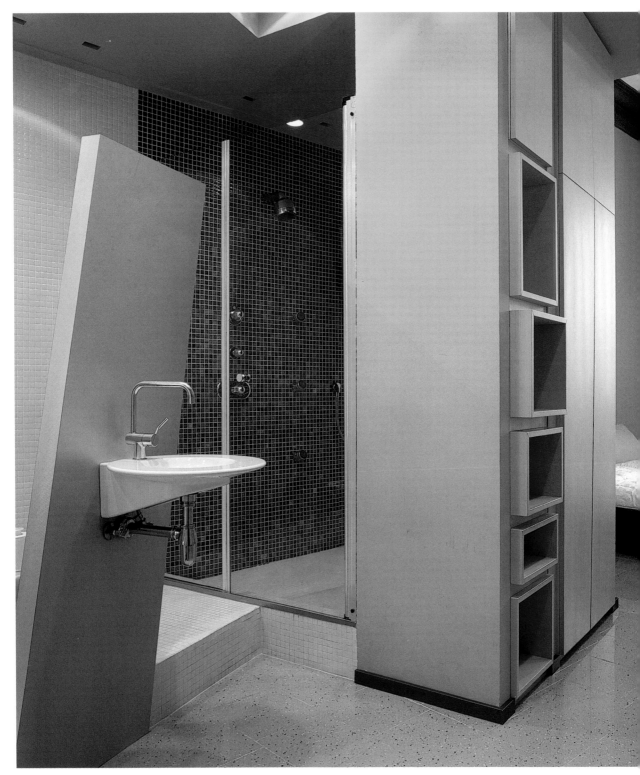

Both pages
Design by Navarro/Zalaja
Photo © Jordi Miralles

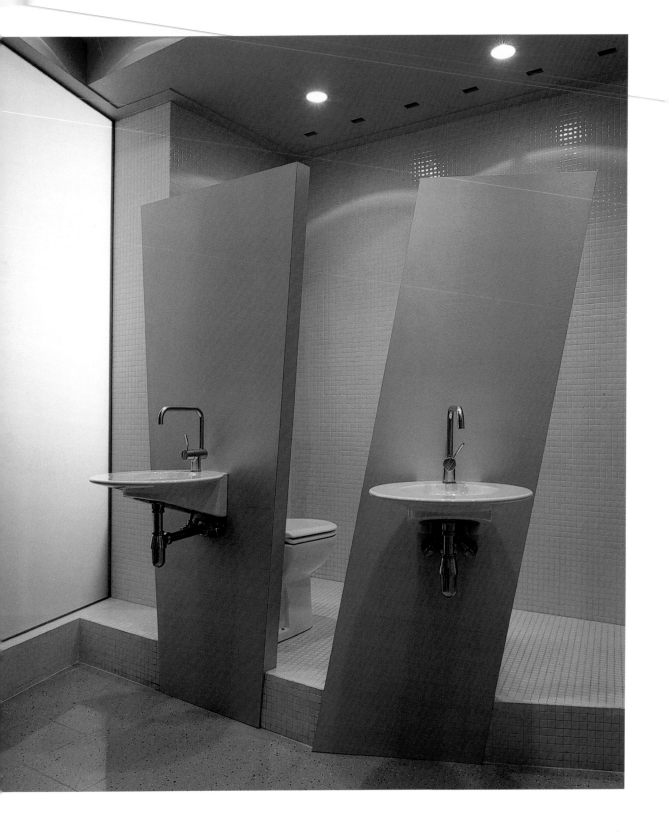

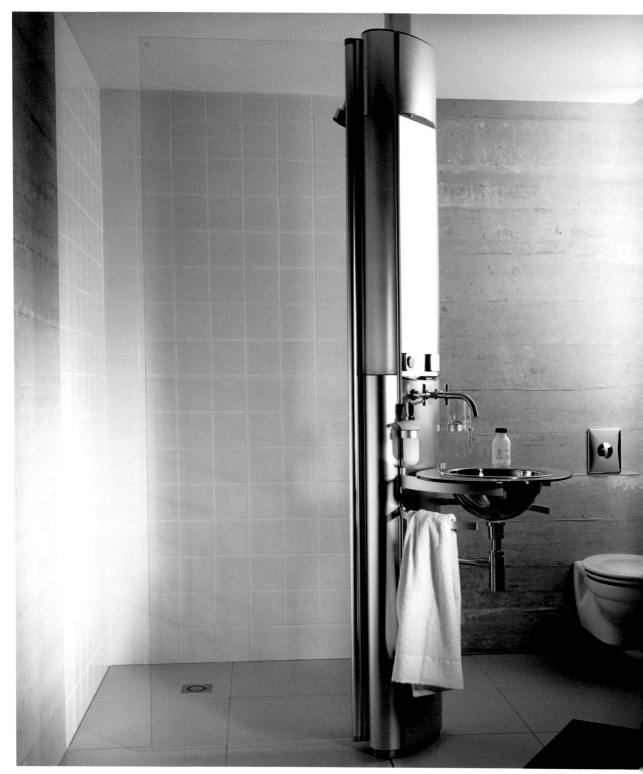

Both pages
Design by Dornbracht

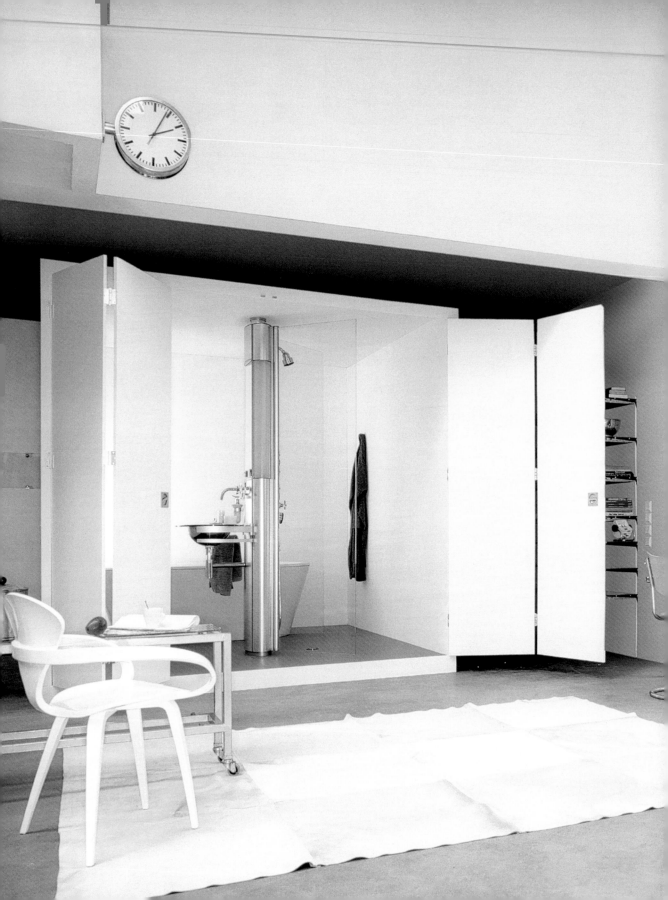

Fittings >>>>>>>>

In order for a bathroom to be optimally practical, the sink, bathtubs, shower, toilet and furnishings must work well together as an ensemble. The growing prevalence of a bathroom design culture has resulted in an increase in the number of bathroom furnishings and fixtures on the market.

Thus, for example, various styles of bathtubs are now available including avant-garde designs, classic bathtubs, and modern variants on traditional shapes with feet, as well as customized tubs made of materials such as wood or cement. Most bathtubs are 170 cm long and 70 cm wide. Bathtubs are also available that are suitable for use in narrower rooms.

Showers are a good solution for bathrooms with limited space. Shower walls should be at least 60 x 60 cm. Shower columns are suitable for particularly small bathrooms. These units consist of small panels made of stainless steel, meta-acrylate, wood or glass and are outfitted with armatures to which two or more shower heads are attached that enable the user to enjoy a water massage while showering.

Toilets, bidets and sinks should be stylistically and dimensionally suitable for the bathrooms in which they are installed. In most instances toilets and bidets are chosen from the same product line because they are generally juxtaposed. On the other hand, since the sink is in a different area of the bathroom, one can readily choose a different style of fixture.

Accessories such as soap dispensers, bowls, toothbrush mugs, mirrors, trolleys, toilet paper holders, and shelving lend bathrooms a distinctive decorative flair. The majority of these items combine practicality and beauty. This can be seen in fixtures such as highly decorative bath towel heaters that dry towels after a bath.

> The growing prevalence of a bathroom design culture has resulted in an increase in the number of bathroom furnishings and fixtures on the market.

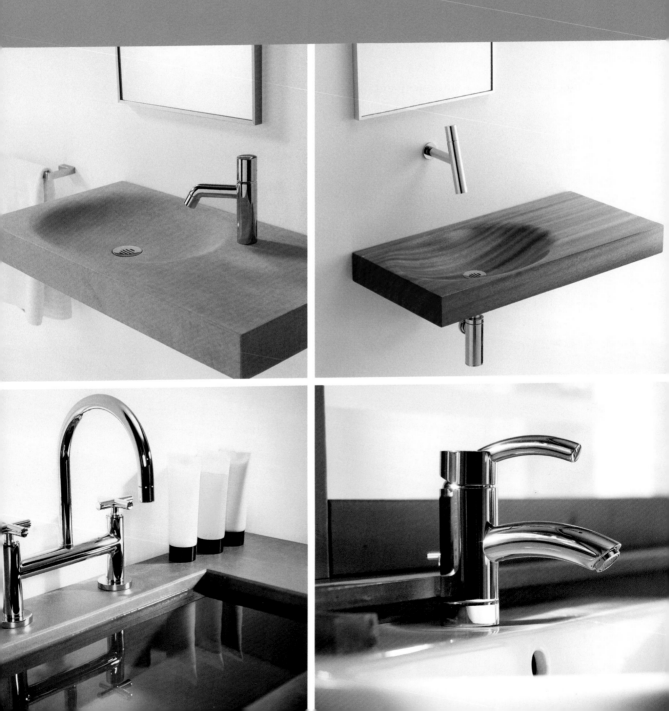

Sanitäre Einrichtungen und Accessoires

Eine durchdachte Komposition von Waschbecken, Badewanne, Dusche, Toilette und Mobiliar ermöglicht es, einen funktionalen Raum zu schaffen. Aufgrund der jüngsten Entwicklungen der Badkultur gibt es hierfür inzwischen eine umfangreiche Angebotspalette.

So bietet der Sektor der Badewannen verschiedenste Stile, angefangen bei avantgardistischen Designs, über klassische Stile bis hin zu modernen Versionen traditioneller Formen mit Füßen sowie individuell gefertigten Wannen aus Materialien wie Holz oder auch Zement. Die Standardmaße einer herkömmlichen Badewanne betragen 170 cm in der Länge und 70 cm in der Breite. Darüber hinaus gibt es Modelle, die sich an Räume von geringer Größe anpassen.

Die Dusche ist eine gelungene Alternative für Badezimmer mit wenig Platz. Die Duschwanne sollte eine Mindestgröße von 60 x 60 cm haben. Bei Bädern mit sehr eingeschränktem Platz sind Duschsäulen eine geeignete Alternative. Sie bestehen aus kleinen Paneelen aus rostfreiem Edelstahl, Metaacrylat, Holz oder Glas und sind mit Armaturen und mehreren Düsen versehen. Letztere ermöglichen dem Benutzer den Genuss einer Wassermassage.

Toiletten, Bidets und Waschbecken sollten sich dem Stil und dem zur Verfügung stehenden Platz anpassen. Im Allgemeinen ist es üblich, Toilette und Bidet aus der gleichen Modellreihe zu wählen, da sie normalerweise nebeneinander platziert werden. Da das Waschbecken in einem anderen Bereich des Badezimmers platziert wird, ist es wesentlich einfacher, sich hier für einen anderen Stil zu entscheiden.

Zubehörteile wie zum Beispiel Seifenspender, Schalen, Zahnputzbecher, Spiegel, Rollwägelchen, Toilettenpapierhalter und Regale geben dem Bad seine entscheidende dekorative Note. Die Mehrzahl dieser Accessoires verbindet eine äußerst praktische Funktion mit ausgefeilter Ästhetik. Dies zeigt zum Beispiel der sehr dekorative Handtuchheizkörper, der das Trocknen von Handtüchern nach dem Baden ermöglicht.

Fino by Sieger Design for Dornbracht

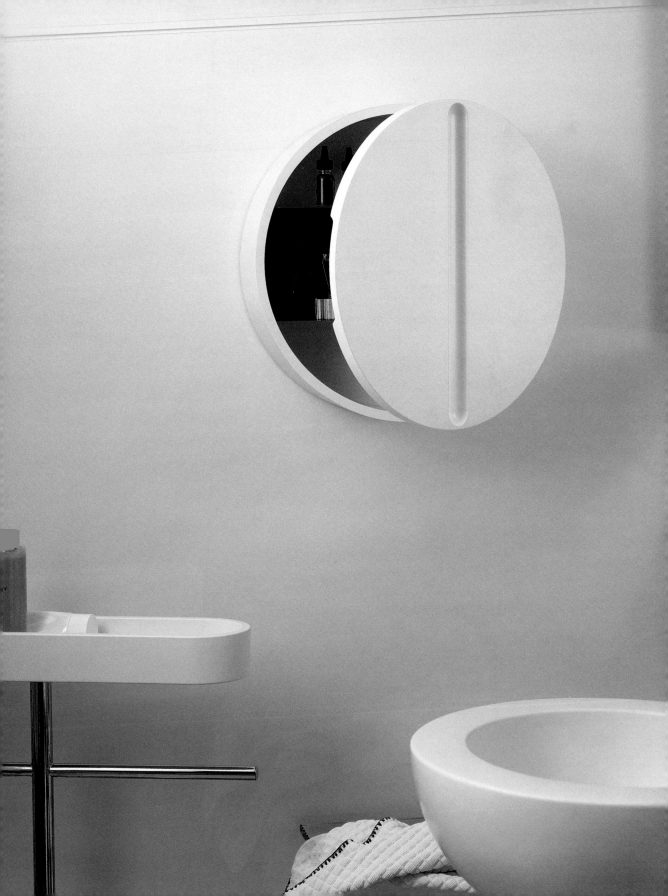

Installations sanitaires et accessoires

L'agencement ingénieux de lavabos, baignoire, douche, toilettes et mobilier permet de créer une pièce fonctionnelle. L'essor constant de la « culture » de la salle de bains s'accompagne d'une gamme d'offres très large.

Le secteur des baignoires propose un éventail de styles très variés allant du design avant-gardiste au style classique en passant par des versions modernisées de formes traditionnelles aux pieds à ou de baignoires fabriquées individuellement en bois ou aussi en ciment. Les mesures standards d'une baignoire traditionnelle sont de 170 cm pour la longueur et de 70 cm pour la largeur. Mais il y a également des modèles qui s'adaptent à des espaces plus petits.

La douche est la solution idéale pour les salles de bains étroites. Le bac à douche devrait avoir un minimum de 60 x 60 cm. Les colonnes de douche sont une excellente alternative pour les salles de bains limitées en place. Elles sont constituées de petits panneaux d'acier inoxydable, méthacrylate, bois ou verre et d'armatures munies de plusieurs buses procurant de délicieux hydromassages.

Toilettes, bidets et lavabos doivent s'adapter au style de la pièce et à la place disponible. D'habitude, on choisit les toilettes et le bidet dans la même gamme, car ils sont souvent disposés côte à côte. Le lavabo étant placé dans une autre zone de la salle de bains, il est plus facile d'élire un style différent.

Les accessoires, à l'instar des distributeurs de savon, coupelles, verre à dent, miroir, rangement sur roulettes, support de papier de toilette et étagères confèrent à la salle de bains la touche décorative finale. La plupart de ces accessoires conjuguent à merveille fonctionnalité et raffinement esthétique. Preuve en est, ce radiateur porte-serviettes très décoratif qui permet de sécher les serviettes après le bain.

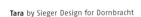

Tara by Sieger Design for Dornbracht

426

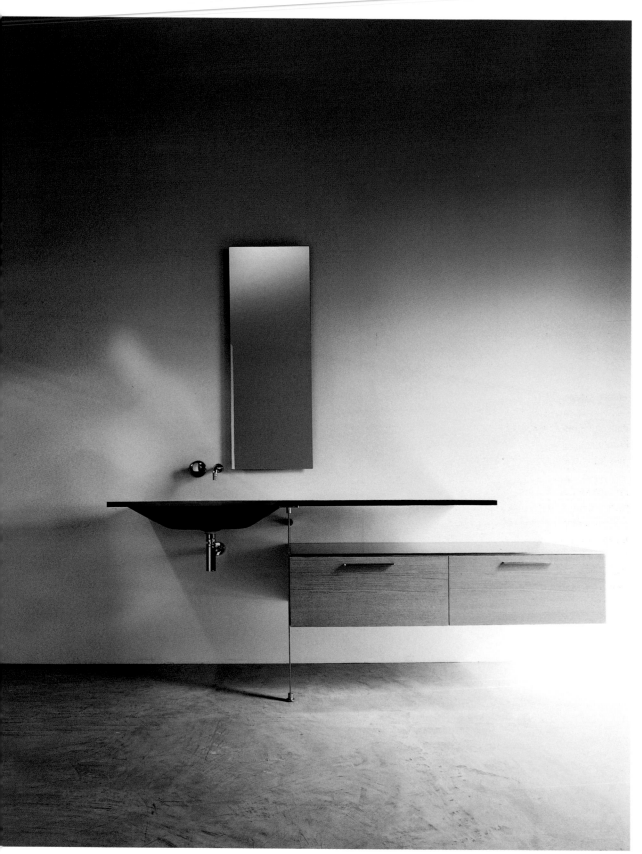

Instalaciones sanitarias y accesorios

Una cuidadosa y pensada composición de lavabo, bañera, ducha, inodoro y mobiliario puede lograr que el cuarto baño se convierta en un espacio funcional. Y es que gracias al desarrollo de la cultura del baño hoy en día el espectro de posibilidades es muy amplio.

Por ejemplo, los fabricantes de bañeras ofrecen una gran gama de estilos, desde el diseño más vanguardista hasta los modelos clásicos, pasando por versiones modernas de formas tradicionales con pies y acabados a medida en materiales como la madera e incluso el cemento. Las dimensiones estándar de una bañera corriente suelen ser 170 cm de largo y 70 cm de ancho. Pero existen todo tipo de modelos que se adaptan a espacios más pequeños.

La ducha es una estupenda alternativa para cuartos de baño reducidos. El plato debe tener una superficie de al menos 60 x 60 cm. En piezas de dimensiones muy modestas, las columnas de ducha resultan también una buena solución. Éstas suelen ser de paneles de acero inoxidable, metacrilato, madera o cristal, y están dotadas de griferías y varios tubos de chorro que permiten disfrutar del placer de un hidromasaje.

Por otro lado, inodoros, bidés y lavabos deben adaptarse al estilo escogido y al espacio disponible. El sanitario y el bidé suelen pertenecer a una misma serie, ya que acostumbran a instalarse uno junto al otro. El lavabo puede colocarse algo separado; en ese caso cabe la posibilidad de decidirse por otro estilo.

Finalmente, los accesorios como el dispensador de jabón, recipientes y bandejas, el vaso para los cepillos dentales, el soporte del papel higiénico o las estanterías se encargan de poner la nota decorativa. La mayoría de esos accesorios aúna una funcionalidad práctica con una estética cuidada. Un ejemplo perfecto son los decorativos radiadores que permiten secar las toallas en el mismo cuarto de baño.

MEM by Dornbracht

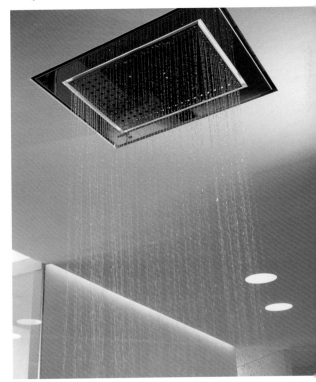

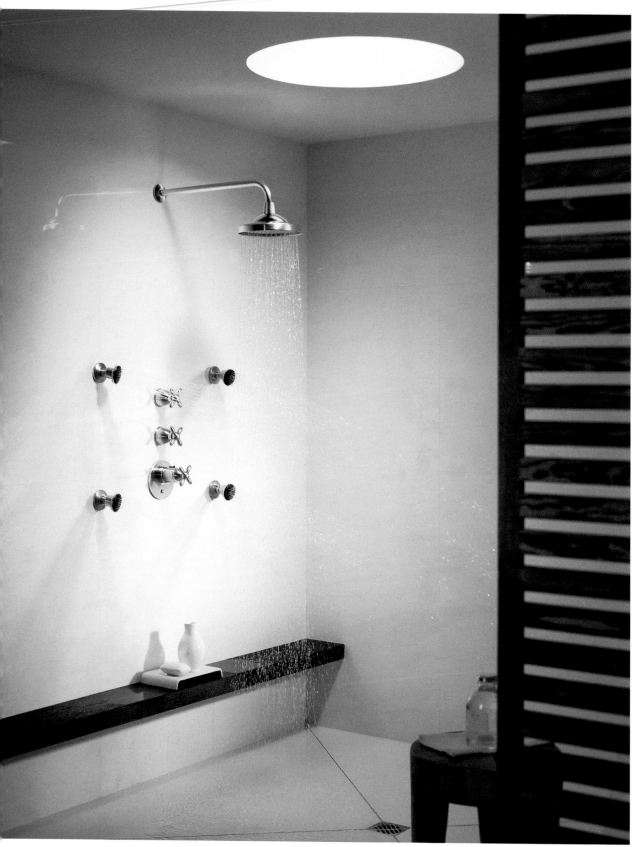

Articoli sanitari ed accessori

Una composizione ben studiata di lavandino, vasca da bagno, doccia, water e mobili consente di creare un ambiente funzionale. Grazie al continuo sviluppo della cultura del bagno vi è una vasta gamma di offerte.

Così il settore delle vasche da bagno offre degli stili diversissimi, a partire dai design all'avanguardia fino agli stili classici ed alle versioni moderne di forme tradizionali, con piedini nonché alle vasche individuali, realizzate in materiali quali legno od anche cemento. Le misure standard di una vasca tradizionale sono 170 cm in lunghezza e 70 cm di larghezza. Inoltre esistono dei modelli che si adattano ad ambienti di dimensioni più ridotte.

La doccia rappresenta un'alternativa riuscita per bagni con scarso spazio. La vasca della doccia dovrà essere non inferiore a 60 x 60 cm. Un'alternativa intelligente in caso di bagni con spazio molto ridotto sono le docce a colonna. Esse sono composte da piccoli pannelli in acciaio inossidabile, metaacrilato, legno o vetro e sono dotate di rubinetterie e di alcuni getti. Questi ultimi consentono all'utente il piacere di un idromassaggio.

Gli articoli sanitari quali toilette, bidet e lavandini dovranno adattarsi allo stile prescelto ed allo spazio disponibile. Generalmente si scelgono water e bidet della stessa serie di modelli, poiché normalmente essi vengono piazzati uno accanto l'altro. Visto che il lavandino viene piazzato in una zona diversa del bagno, è molto più facile sceglierlo in un altro stile.

Interiors by Dornbracht

Gli accessori come ad esempio erogatori di sapone, coppette portasapone, bicchieri portaspazzolino, specchi, carrellini, porta carta igienica e mensole, conferiscono al bagno la sua nota decorativa e decisiva. La maggioranza di questi accessori si caratterizza per la sua doppia funzione: quella essenziale e pratica e quella puramente estetica. Un esempio di ciò è un radiatore-portasalviette veramente molto decorativo che consente di asciugare le salviette dopo il bagno.

430

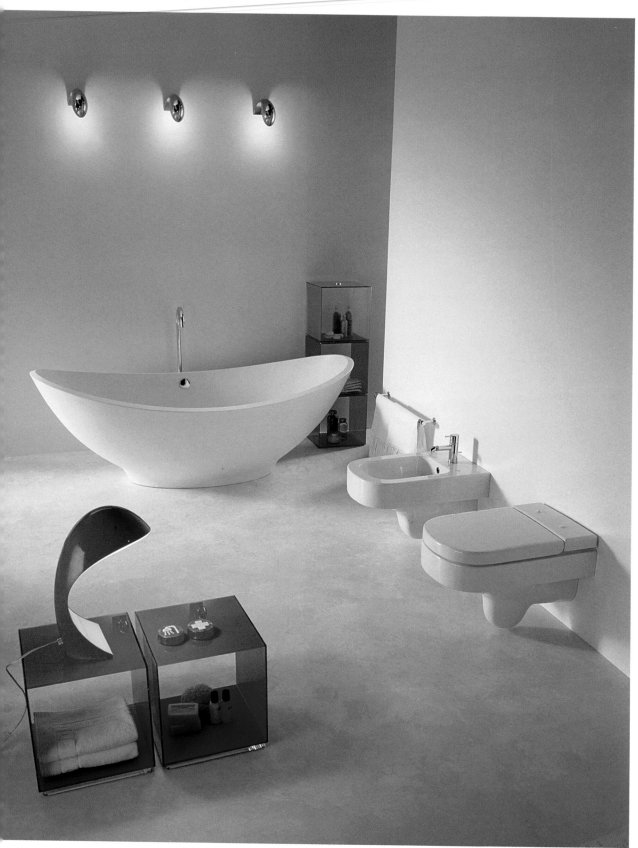

Bathtubs

Design by Ilse Crawfo
Photo © David Loft

Most bathtubs are made of acrylic or meta-acrylate because these materials are highly resistant, have excellent thermal retention properties and allow for the realization of a broad range of designs.

Die meisten Badewannen sind aus Acryl oder Metaacrylat hergestellt, weil diese Materialien widerstandsfähig sind, Temperaturen sehr gut halten und große Variationsmöglichkeiten im Design erlauben.

La plupart des baignoires sont en acrylique ou en méthacrylate, matériaux très résistants qui gardent très bien la chaleur et permettent une grande liberté de design.

La mayoría de las bañeras están fabricadas en acrílico o metacrilato porque son materiales muy fuertes que mantienen la temperatura y posibilitan grandes variaciones en el diseño.

La maggior parte delle vasche da bagno è realizzata in materiale acrilico od in metaacrilato, vista la resistenza di tali materiali e la loro capacità di mantenere la temperatura e visto il fatto che permettono grandi variazioni del loro design.

Design by Brooks Graham
Photo © Eugenia Uhl

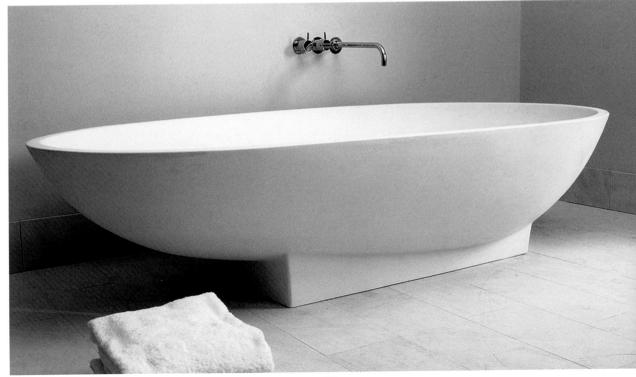

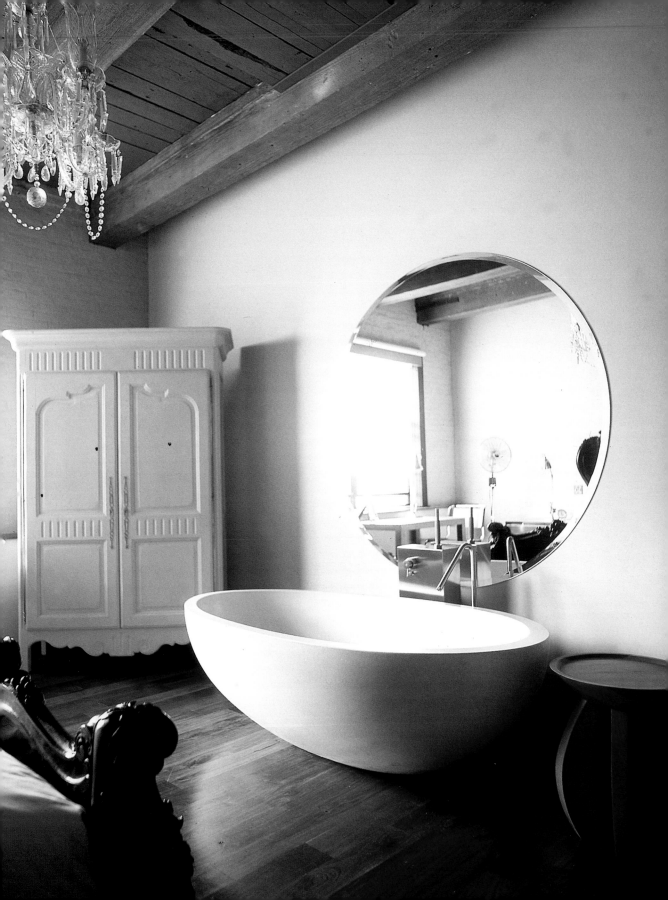

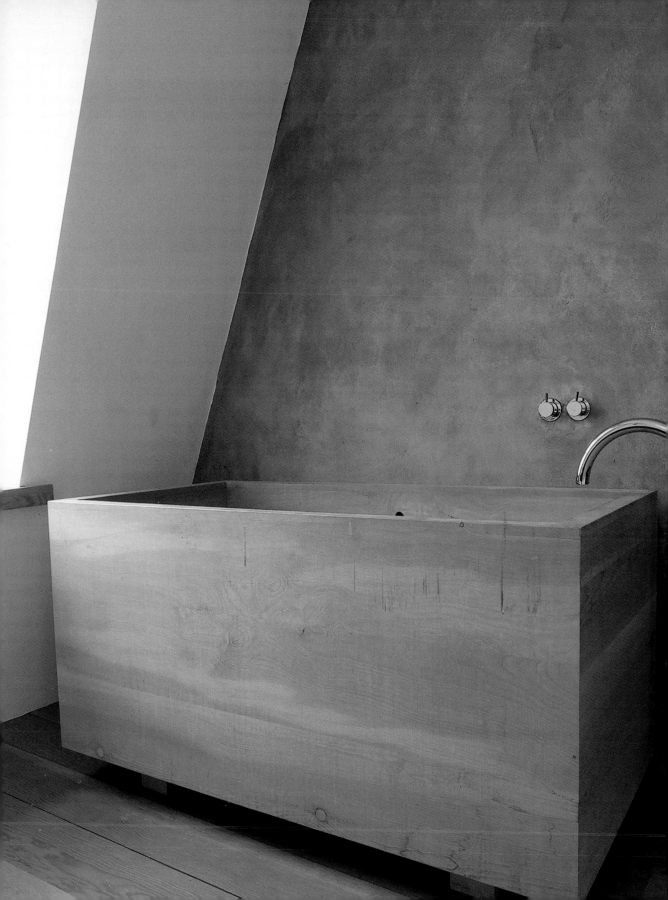

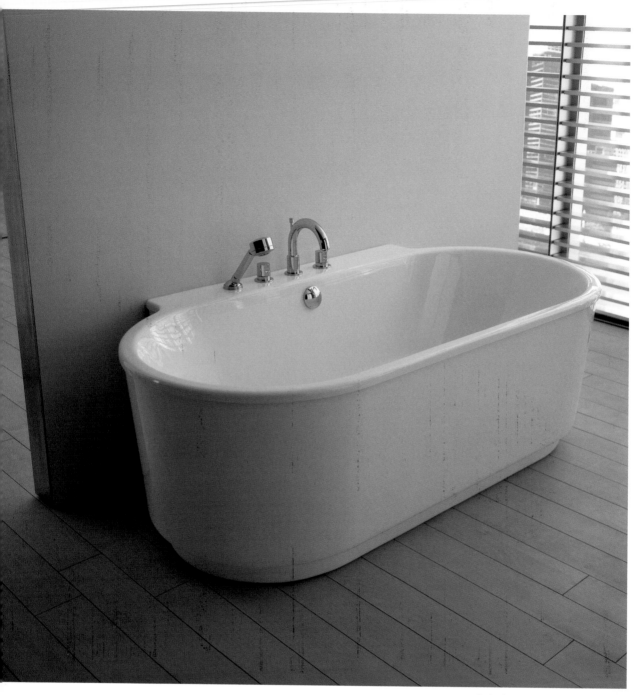

Design by Norman Foster for Hoesch Design

Design by Richard Martinet Architectu
Interior design by Andrée Putma

Design by Arts & Architecture
Photo © Laurent Brandajas

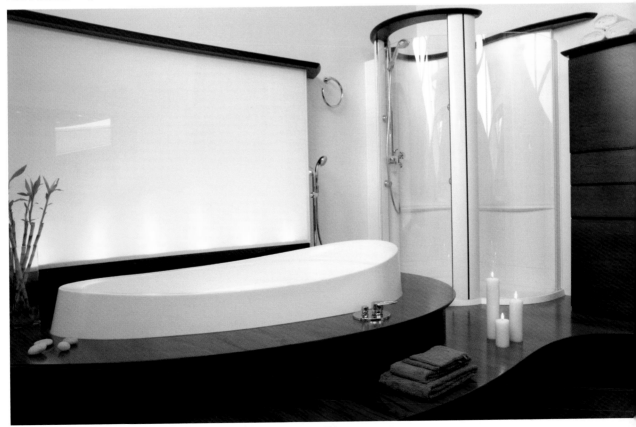

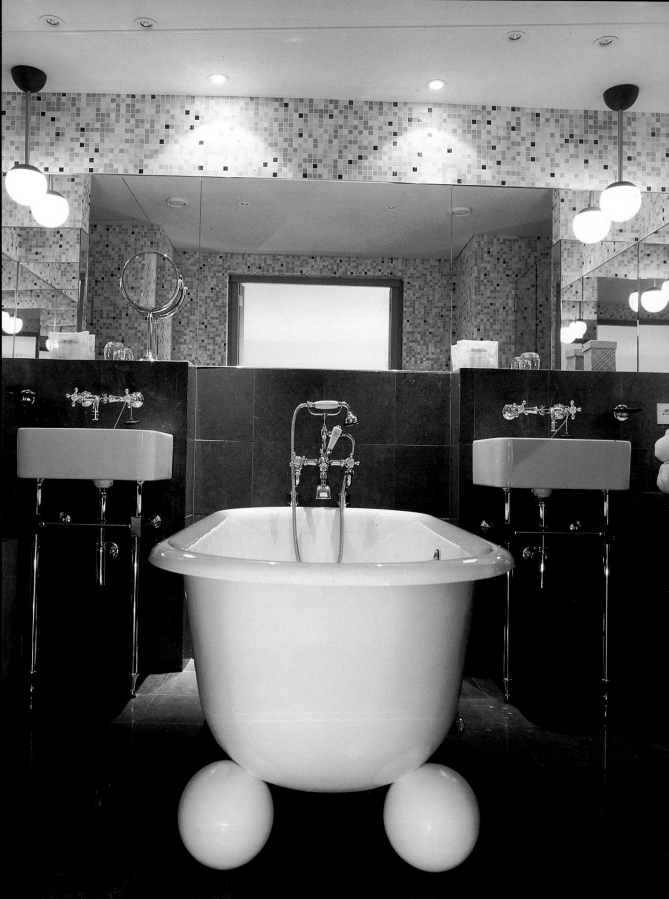

Both pages
Paio by Duravit

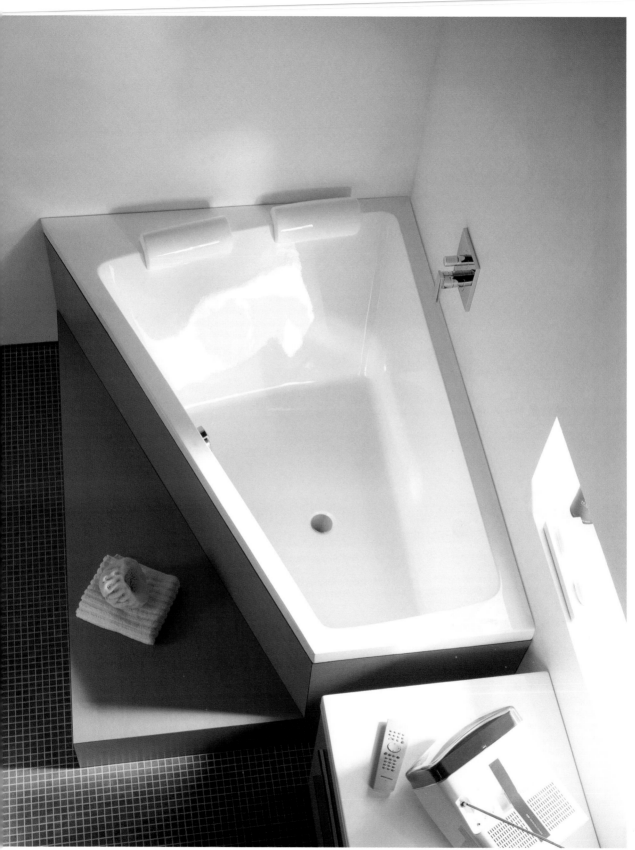

Both pages
Design by Philippe Starck for Hoesch Design

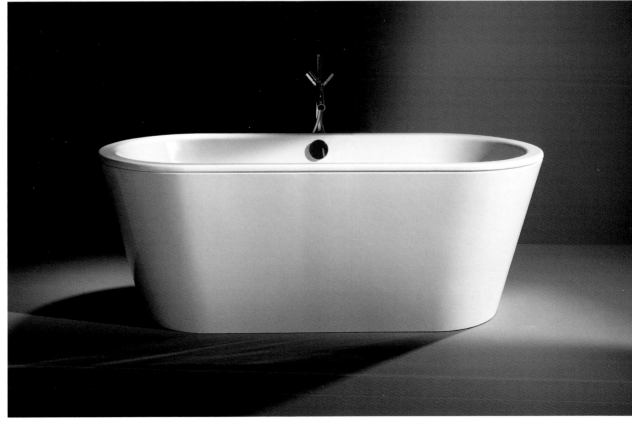

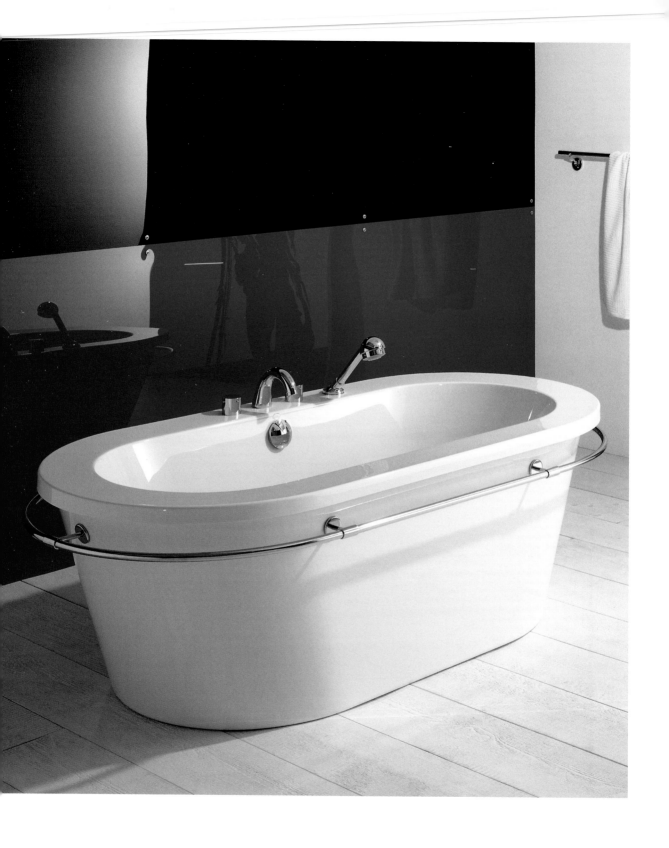

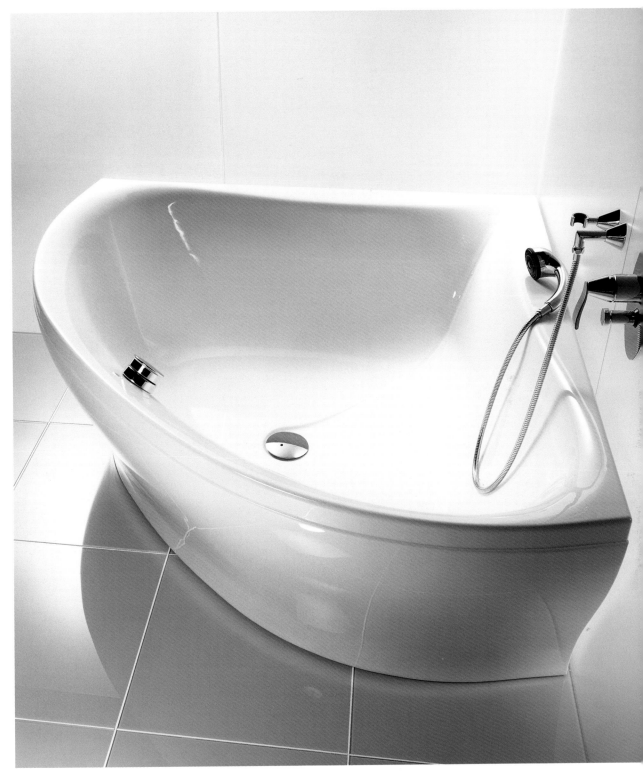

Both pages
Giorno by Massimo Iosa Ghini for Hoesch Design

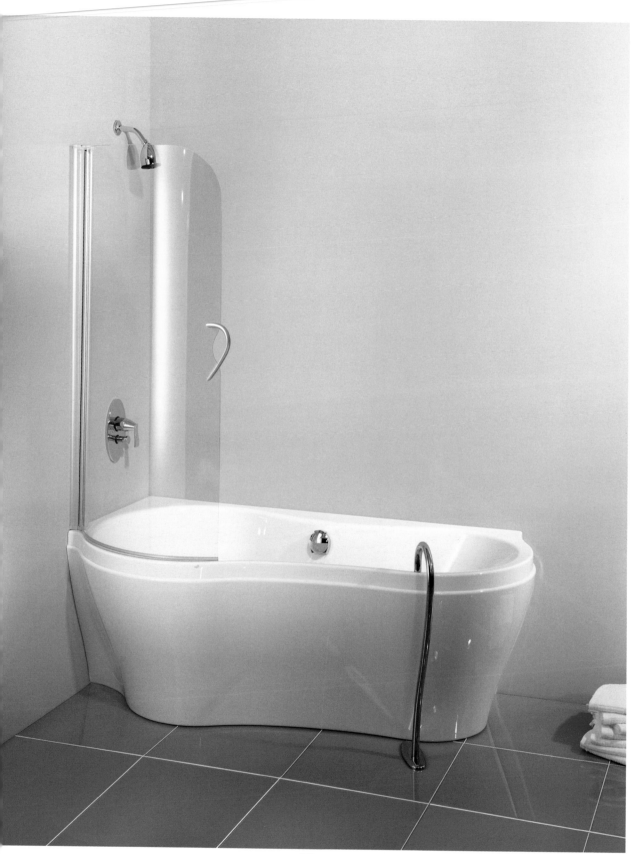

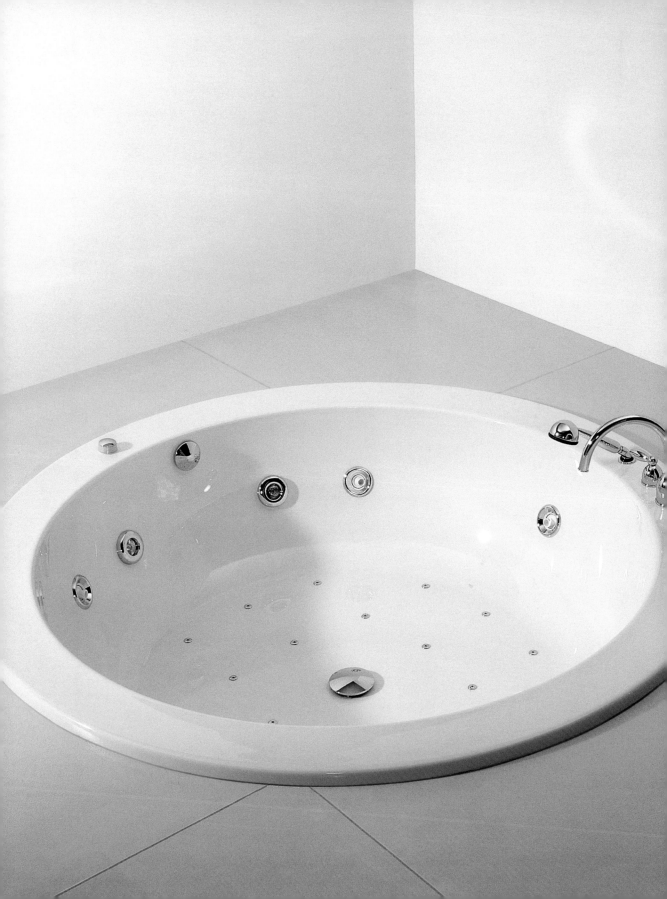

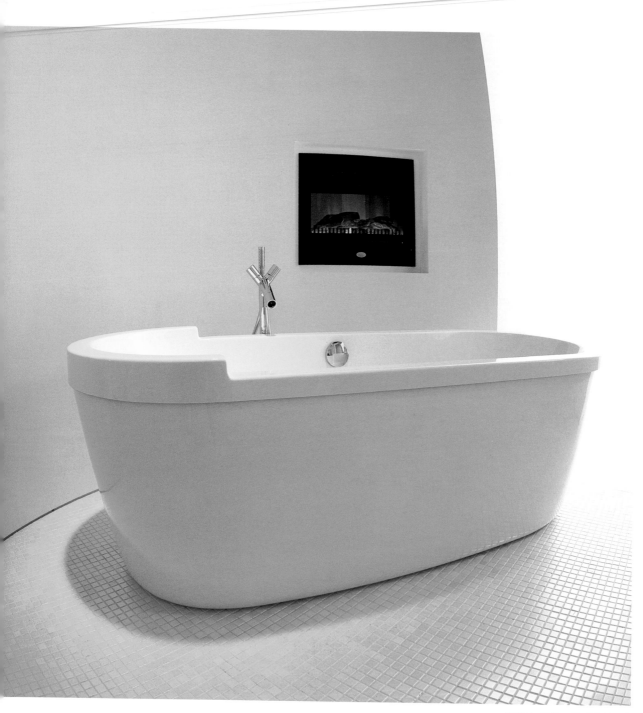

Design by Philippe Starck for Duravit

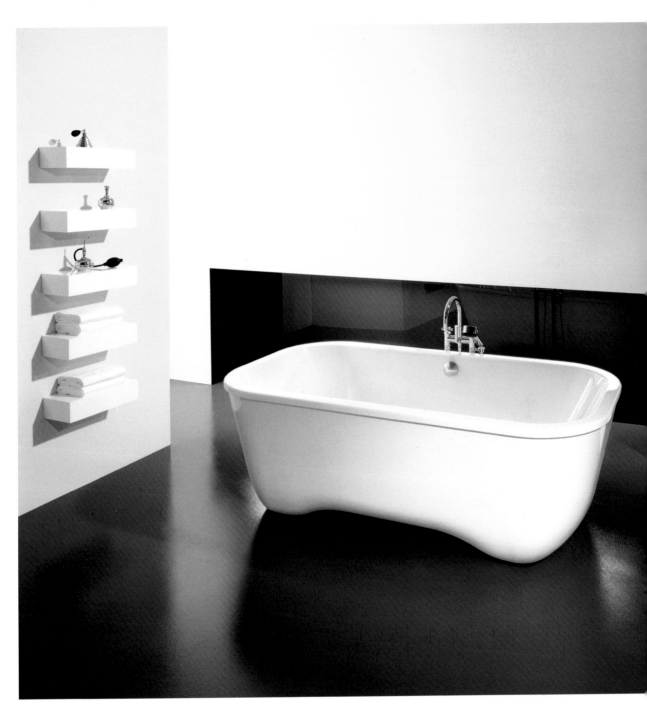

Design by Andrée Putman for Hoesch Design

Design by Daro for Dura

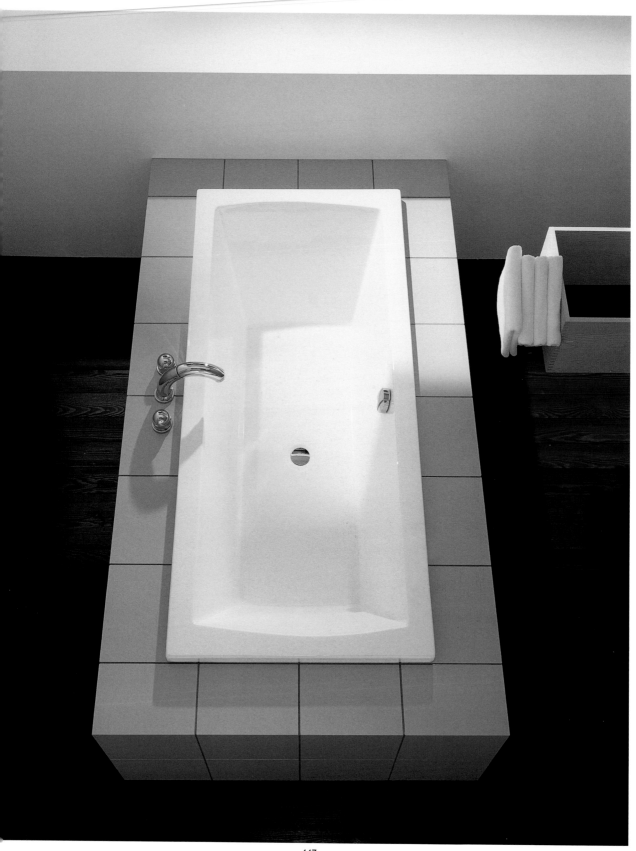

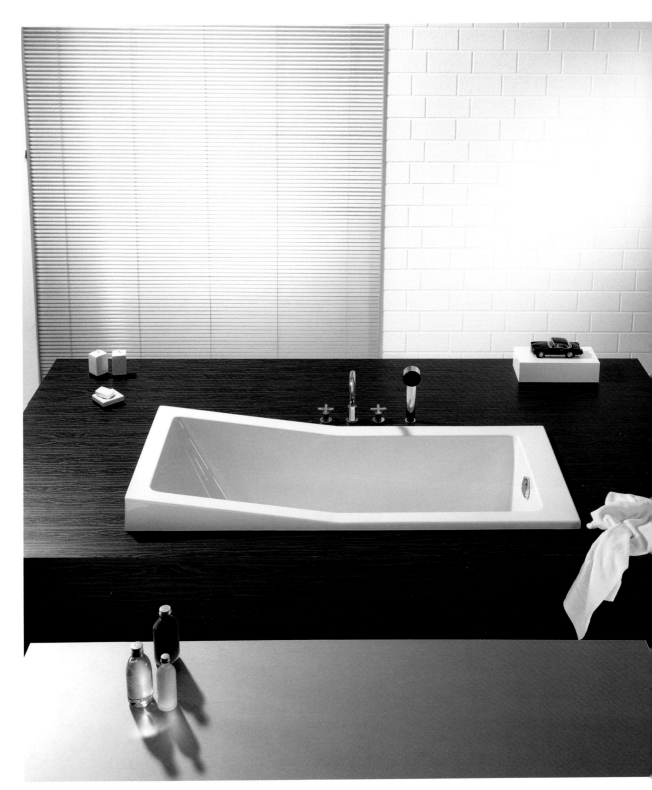

Design by Norman Foster for Hoesch Design

Avventura by Adolf Babel for Hoesch Des

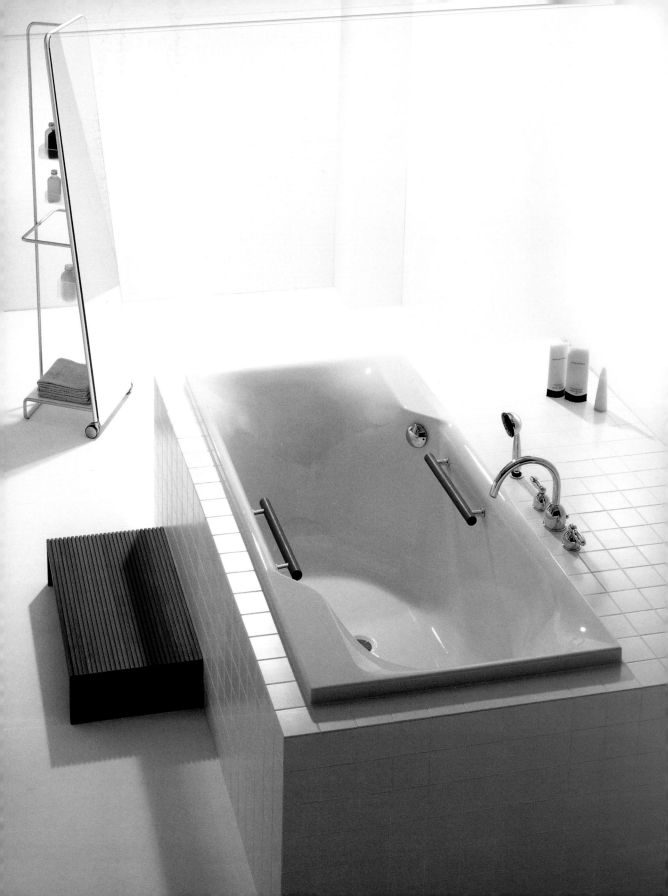

Showers

Interior design by Nancy Robbins, Lluís Vict
Photo © José Luis Hausma

It is generally advisable to install bathtubs in spacious bathrooms and showers in smaller ones. Shower columns constitute a good solution for bathrooms with little space.

Generell ist es empfehlenswert Badewannen für große und Duschen für kleine Räume zu verwenden. Dabei sind Duschsäulen eine gelungene Alternative für Badezimmer mit wenig Platz.

En général, il est conseillé d'installer des baignoires dans les grandes pièces et les douches dans les petits espaces. Les colonnes de douches sont une alternative idéale pour les petites salles de bains.

En general es recomendable colocar una bañera en los espacios grandes y una ducha en los más pequeños. Las columnas de ducha son la mejor alternativa para los cuartos de baño de dimensiones reducidas.

Generalmente si consiglia di utilizzare le vasche per i bagni grandi e le docce per i locali più piccoli. Le docce a colonna possono essere un'alternativa interessante per i bagni con poco spazio.

Birmingham Showerhead by Ann Sacks

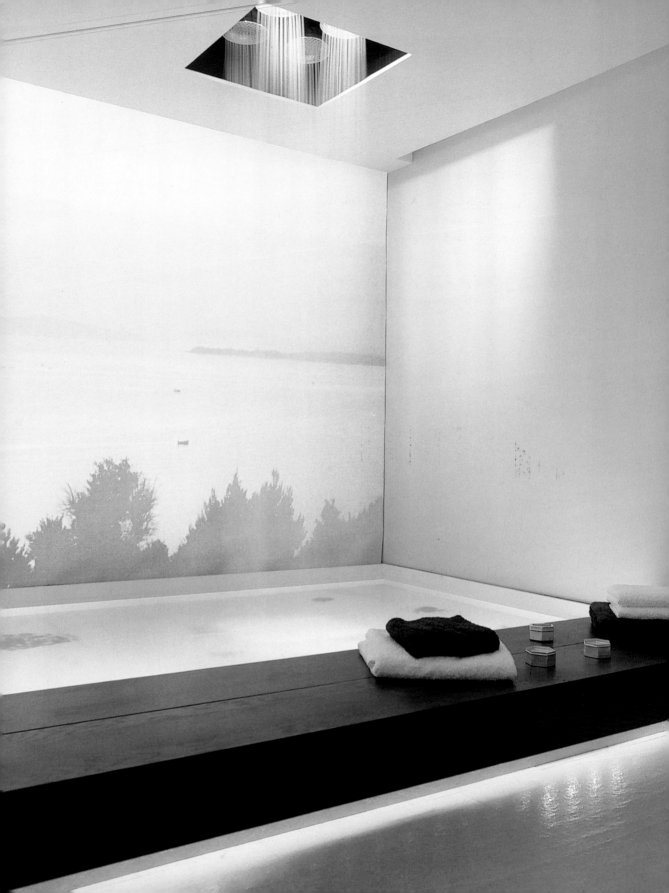

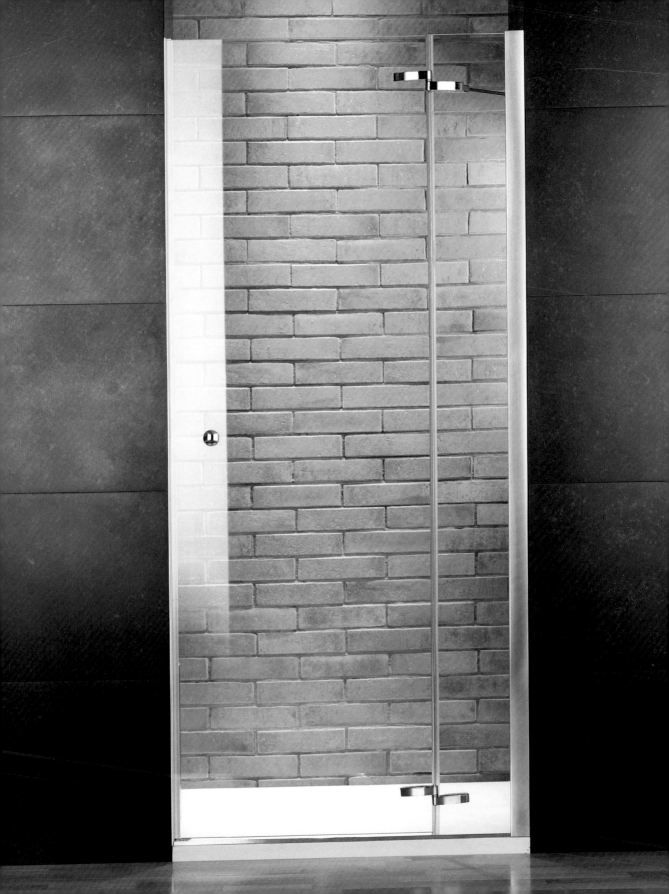

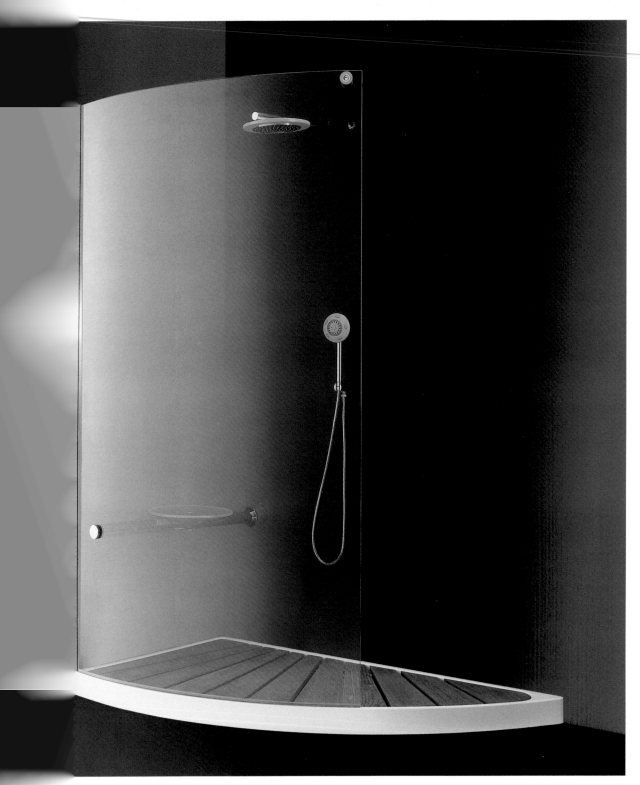

s for Cesana

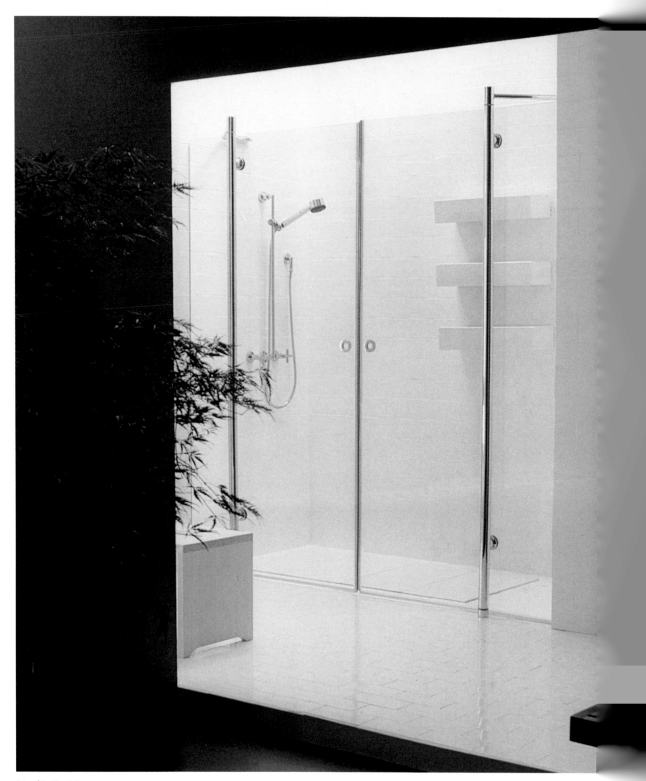

Tatami by Flaminia

Desi
Stylism
Photo © José

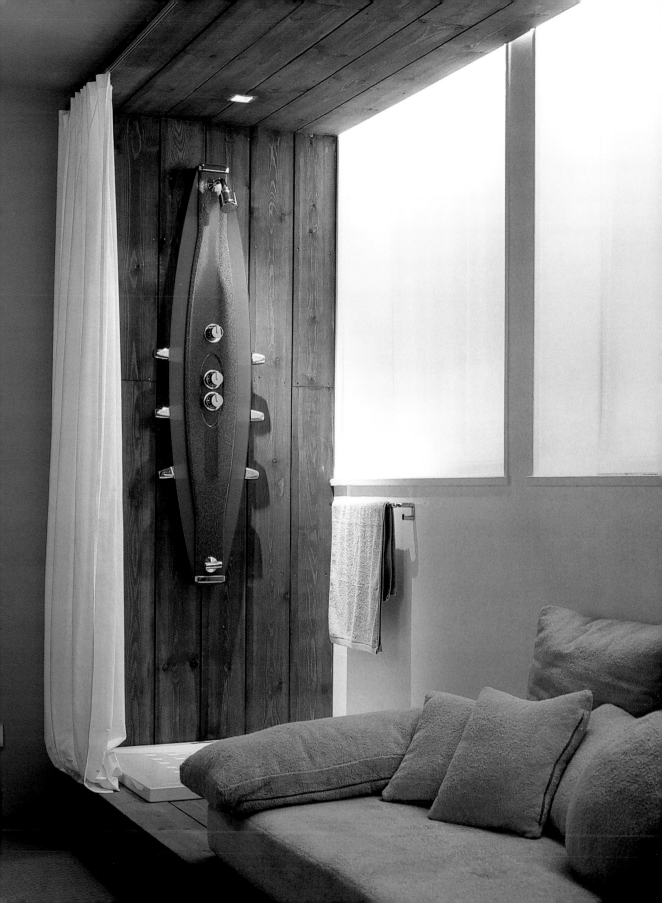

Design by Trentino
Photo © Nuria Fuentes

Photo © Ed Reeve/Red Cover

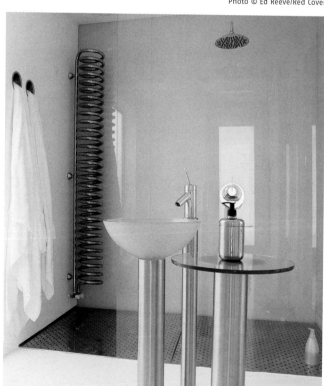

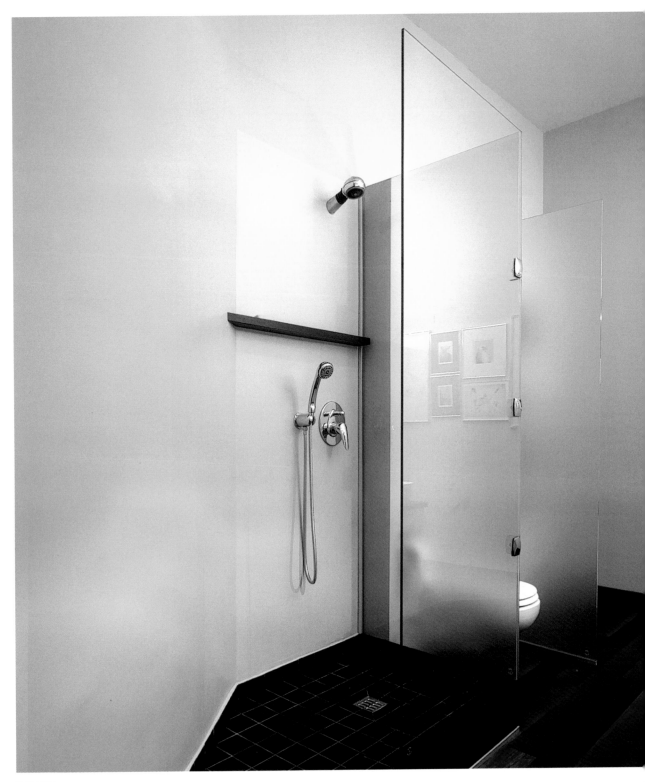

Both pages
Design by Hüffer Ramin
Photo © Werner Huthmacher

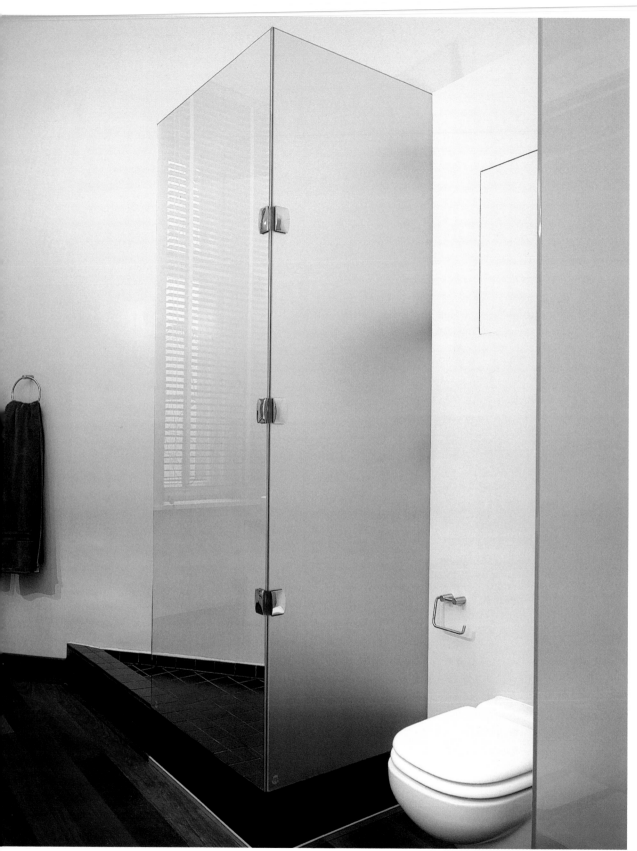

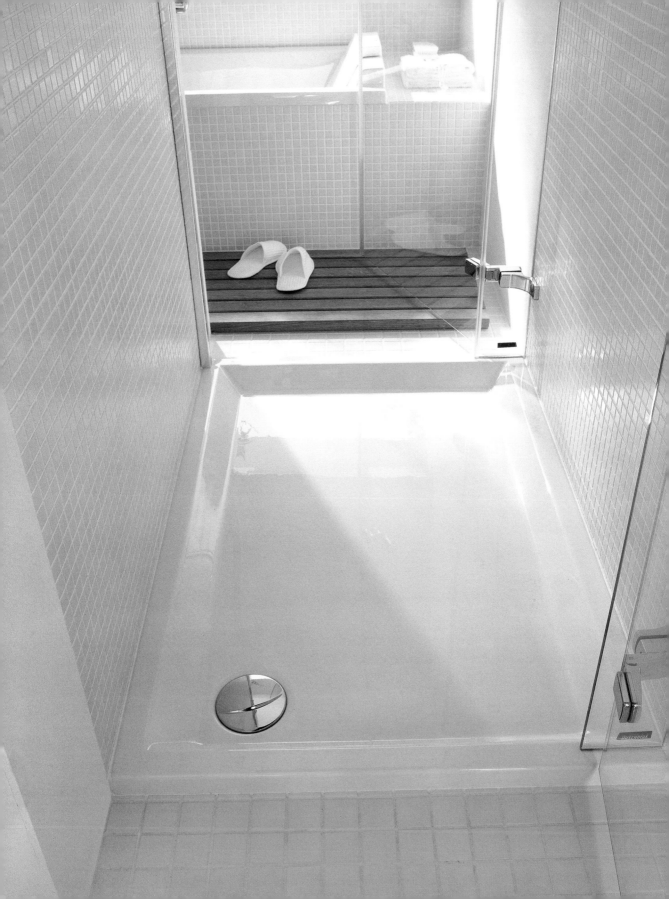

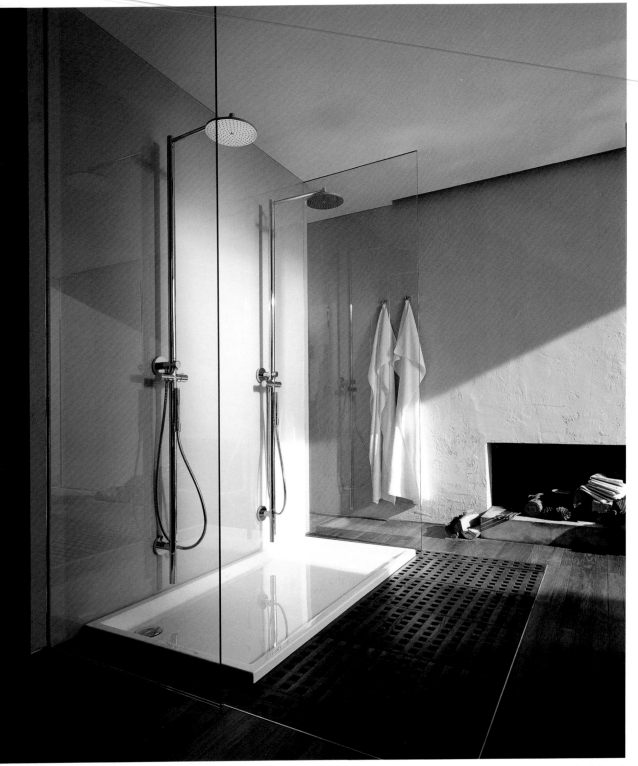

Design by Duravit

sign by Philippe Starck for Duravit

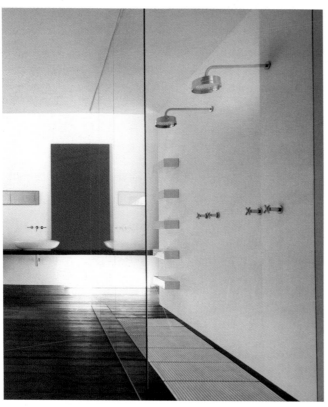

Tatami by Flaminia

Diametrotrentacinque by Davide Vercelli for Ritmonio

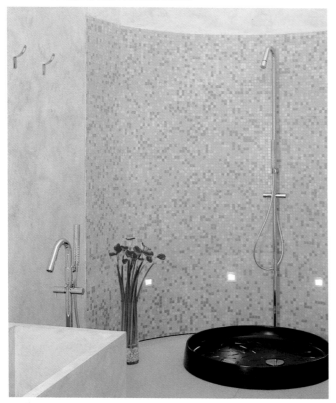

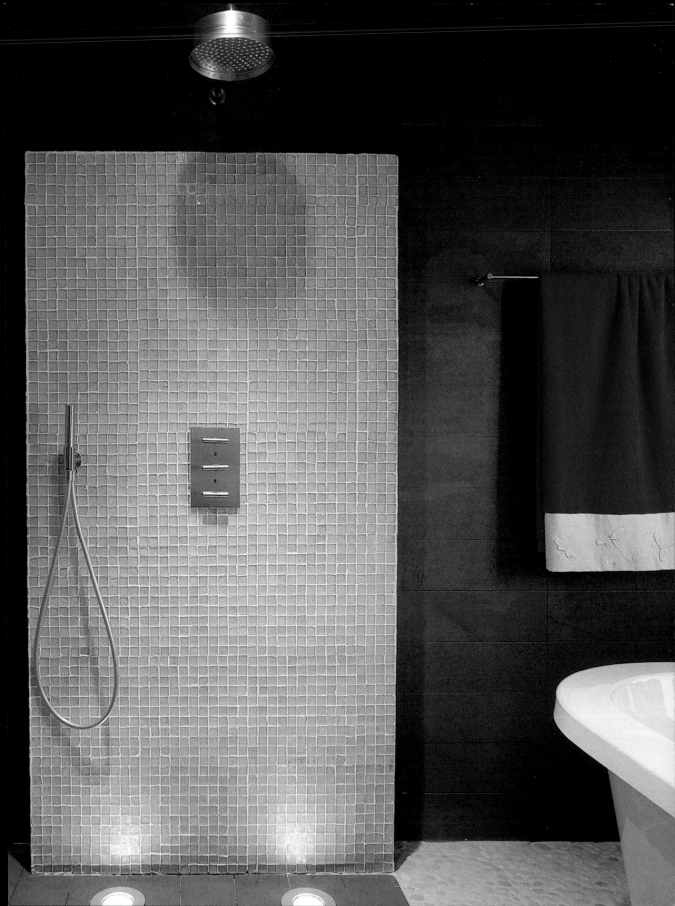

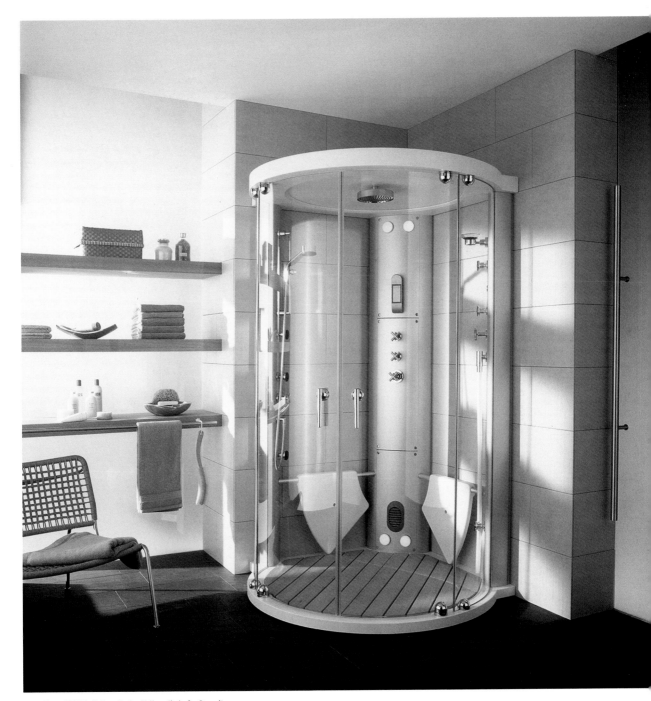

SensaMare 1100 by Yellow Design/Yellow Circle for Duravit

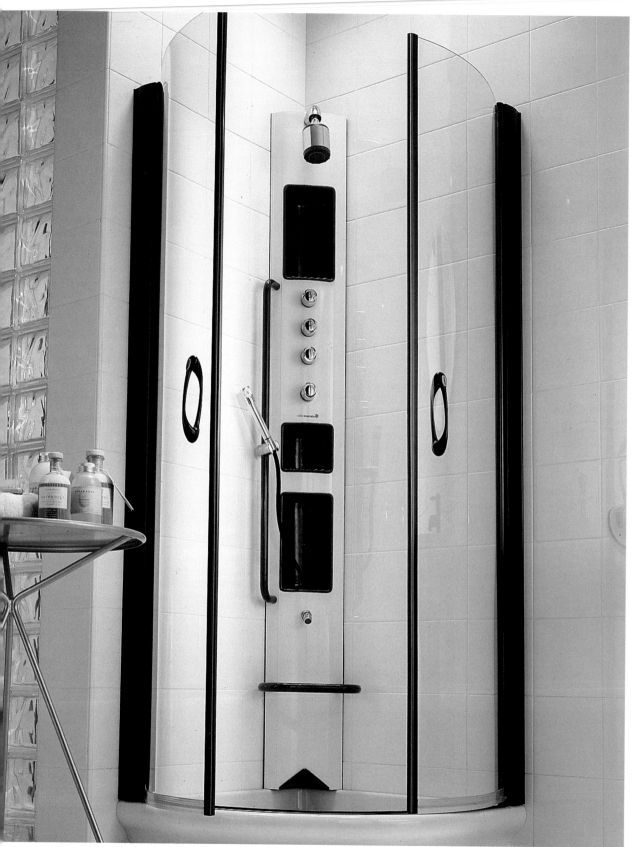

465

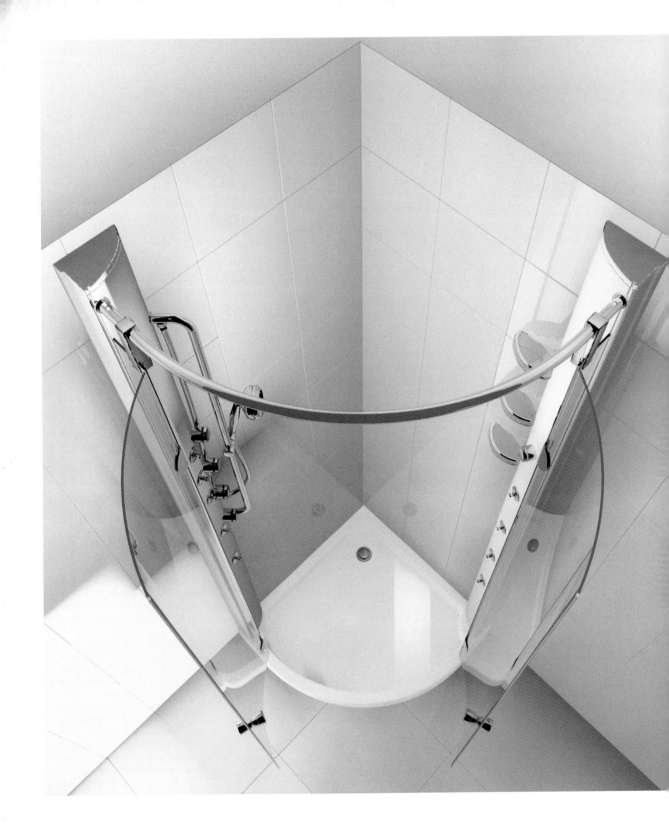

Axor Citterio by Antonio Citterio for Hansg

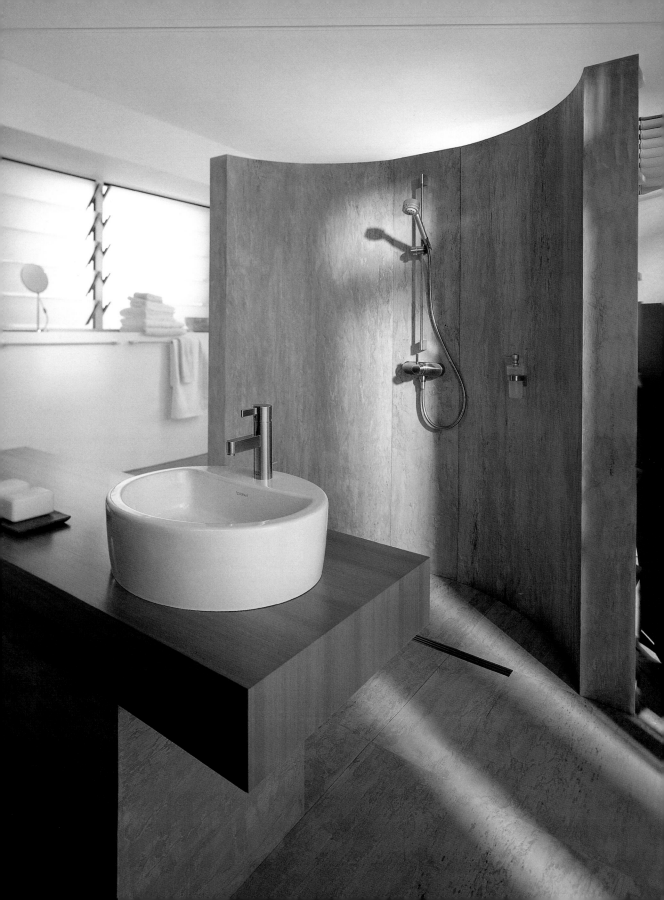

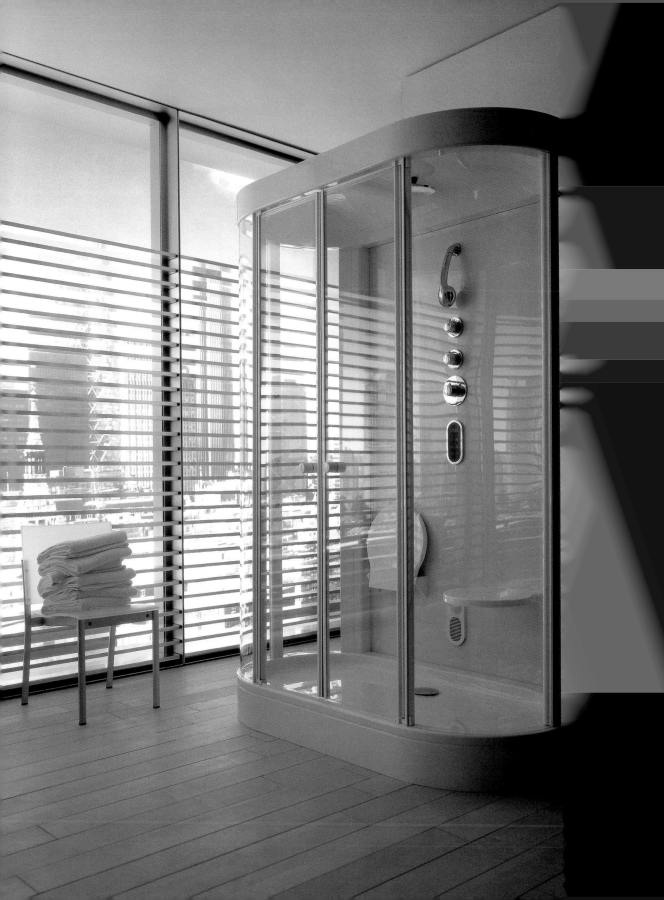

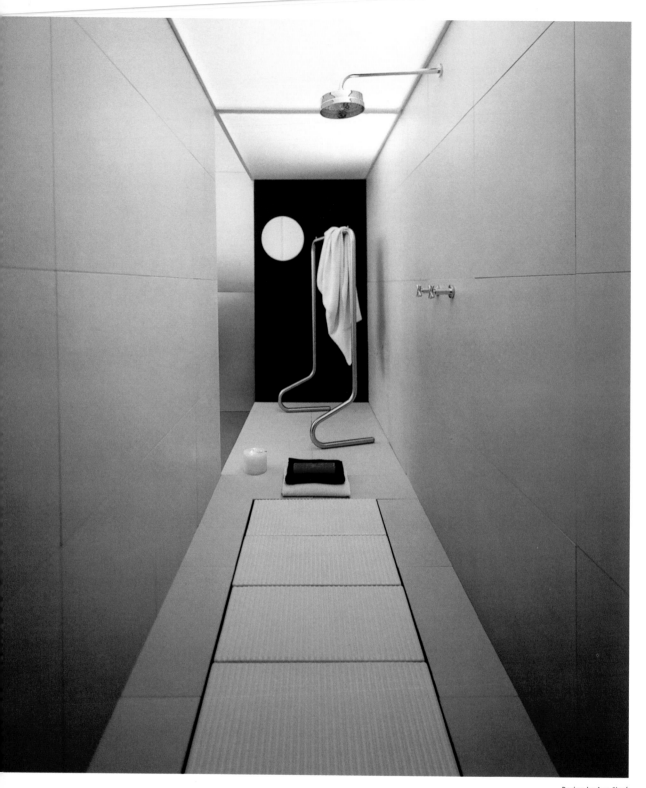

Design by Ana Simó
Photo © Nuria Fuentes

Sinks

Both pages
Pascal by Althea Cerami
Photo © Roberto Constanti

Sinks with pedestals take their cue from classic models and are generally the same style as the toilet and bidet. More modern designs are frequently outfitted with a storage shelf and can be either freestanding or built into a bathroom furnishing.

Waschbecken mit Sockel nehmen klassische Modelle wieder auf und werden normalerweise passend zu Toilette und Bidet verkauft. Neuere Designs beinhalten oft eine Ablagefläche, sind in ein Möbelstück eingebaut oder freistehend.

Les lavabos sur colonne ont rejoint les modèles classiques et sont vendus assortis aux toilettes et au bidet. Les modèles au design plus innovant ont un large plan de toilette, sont encastrés dans un meuble où suspendus.

Los lavabos con pedestal recrean los modelos clásicos y se suelen fabricar en el mismo estilo que las tazas y los bidés. Los diseños más modernos lo presentan integrado en una encimera, encastrado en un mueble o simplemente flotante.

I modelli classici riscoprono di nuovo i lavandini con colonna di sostegno; solitamente, essi vengono venduti abbinati al water ed al bidet. I design più moderni prevedono spesso una superficie di appoggio e sono o incassati in un mobile o liberi.

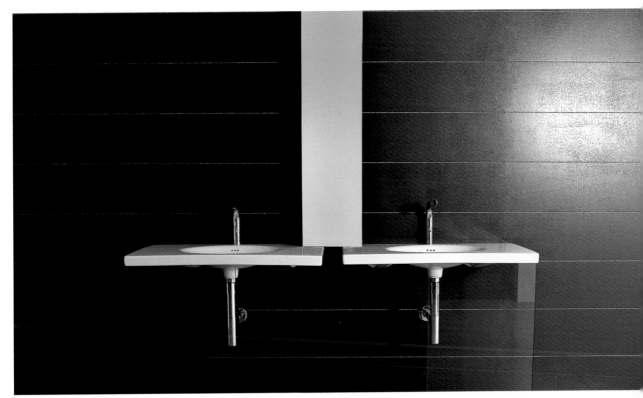

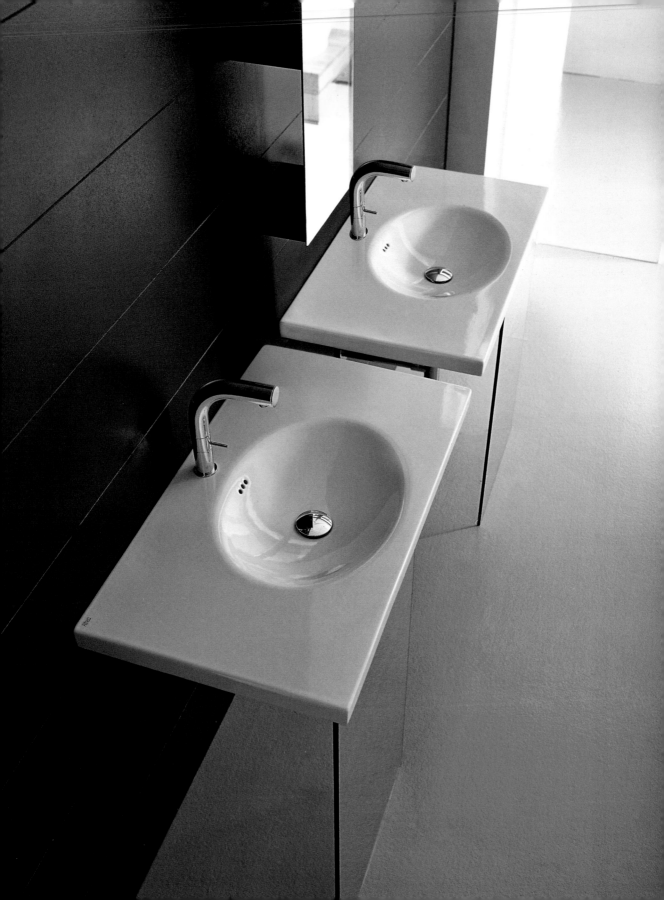

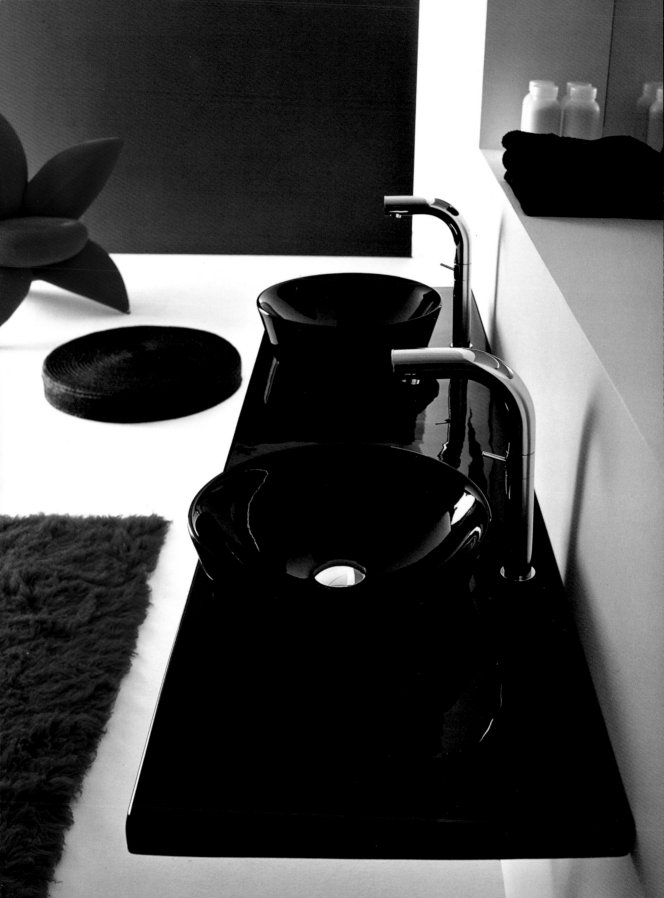

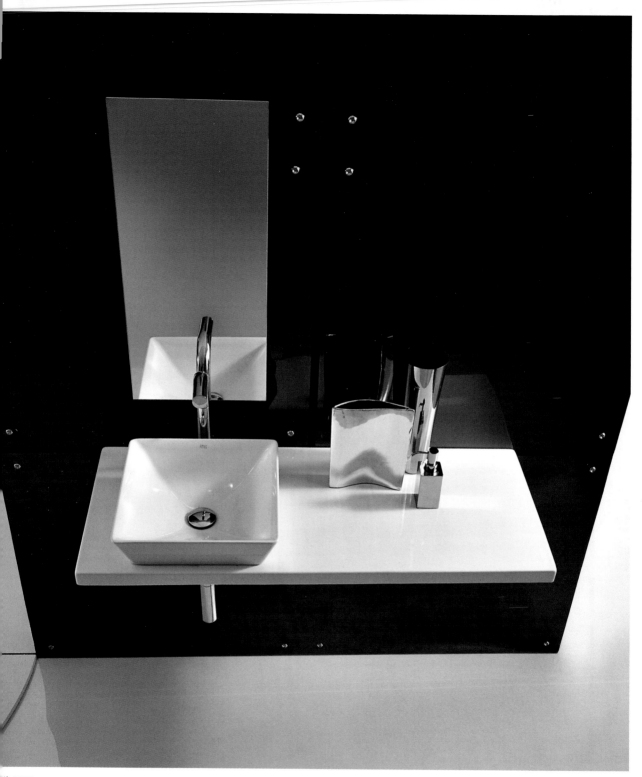

th pages
e by Althea Ceramica
oto © Roberto Constantini

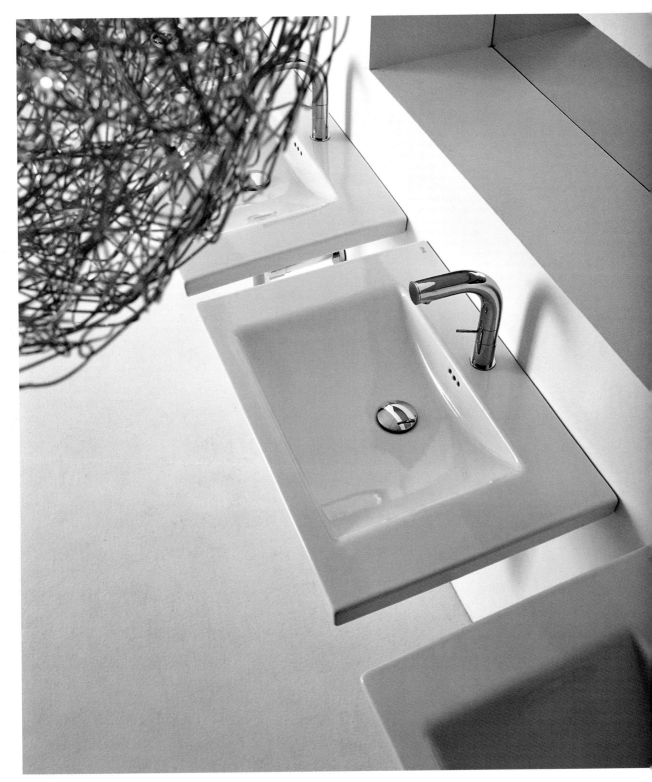

Kloc by Althea Ceramica
Photo © Roberto Constantini

Neo by San

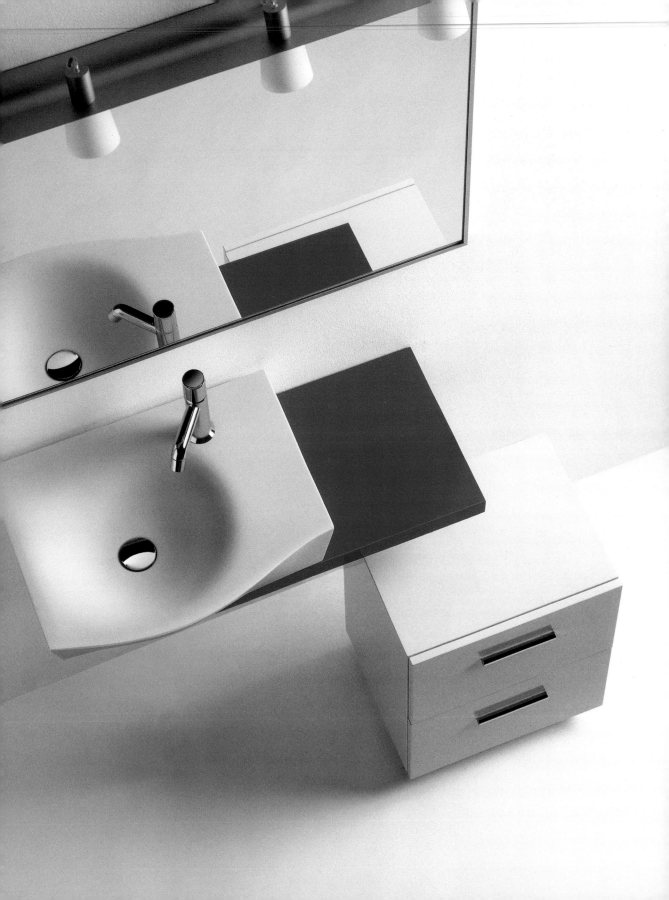

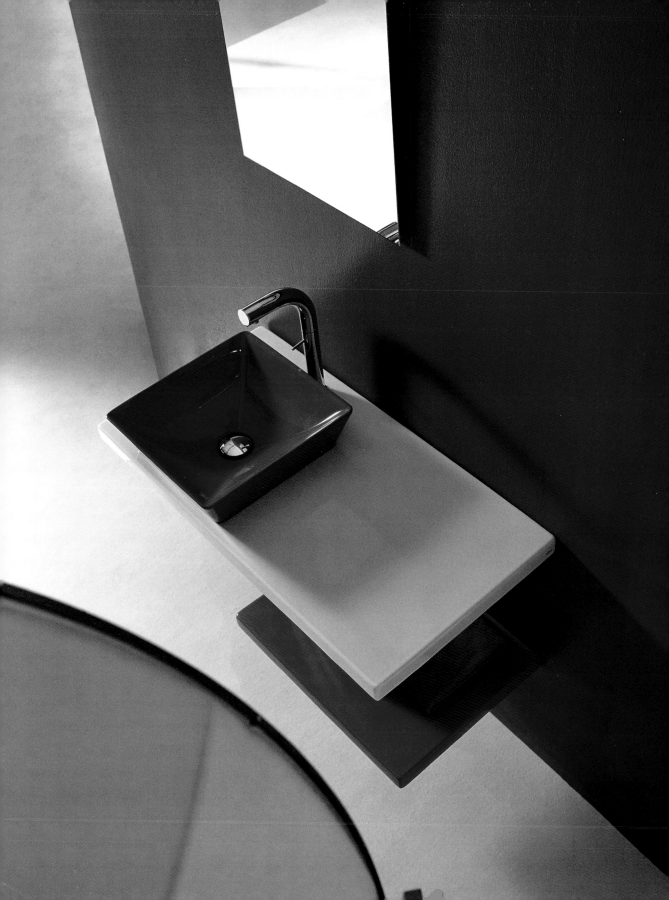

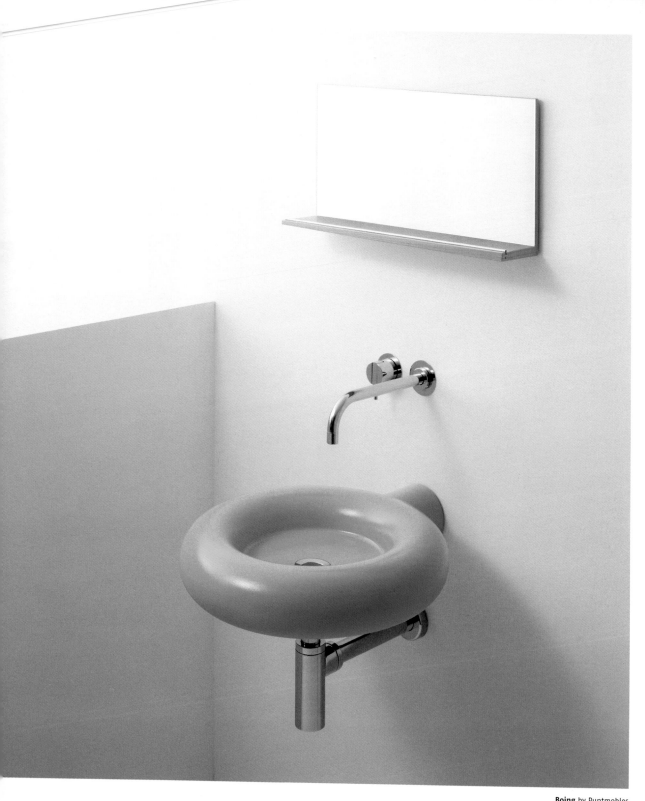

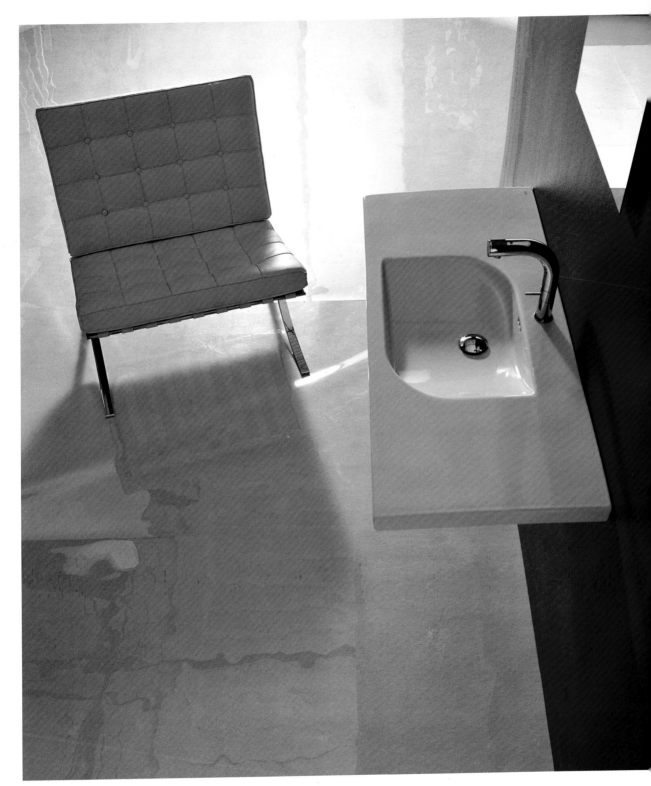

Play by Althea Ceramica
Photo © Roberto Constantini

Design by Flami

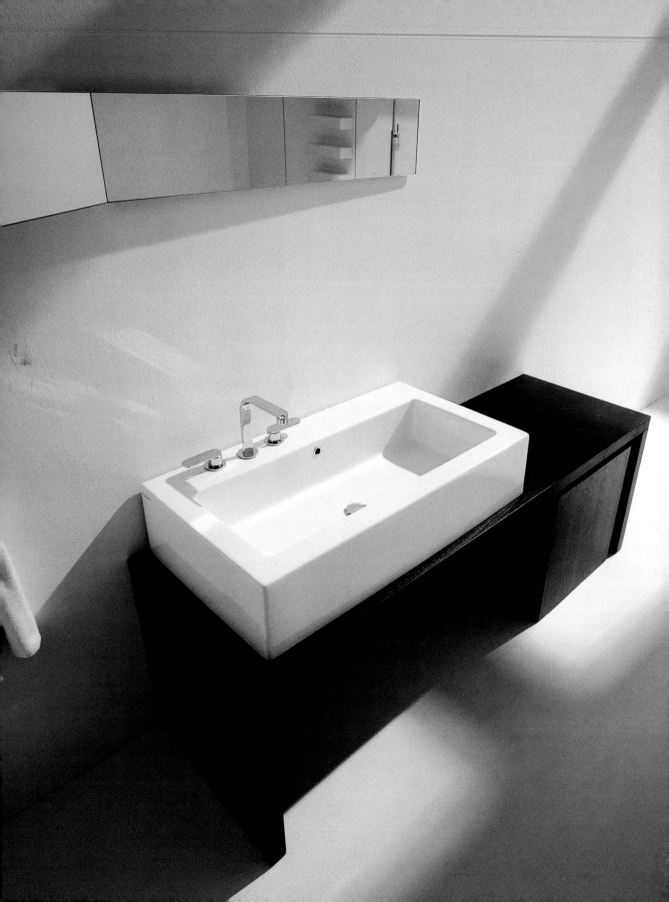

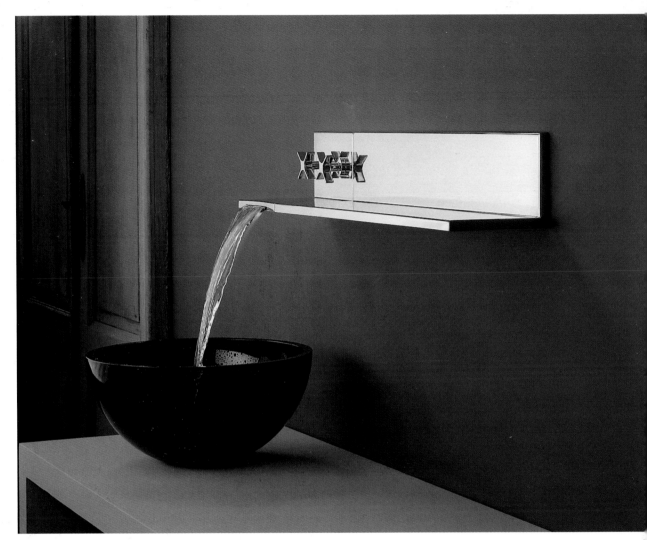

Waterblade by Peter Jamieson for Ritmonio

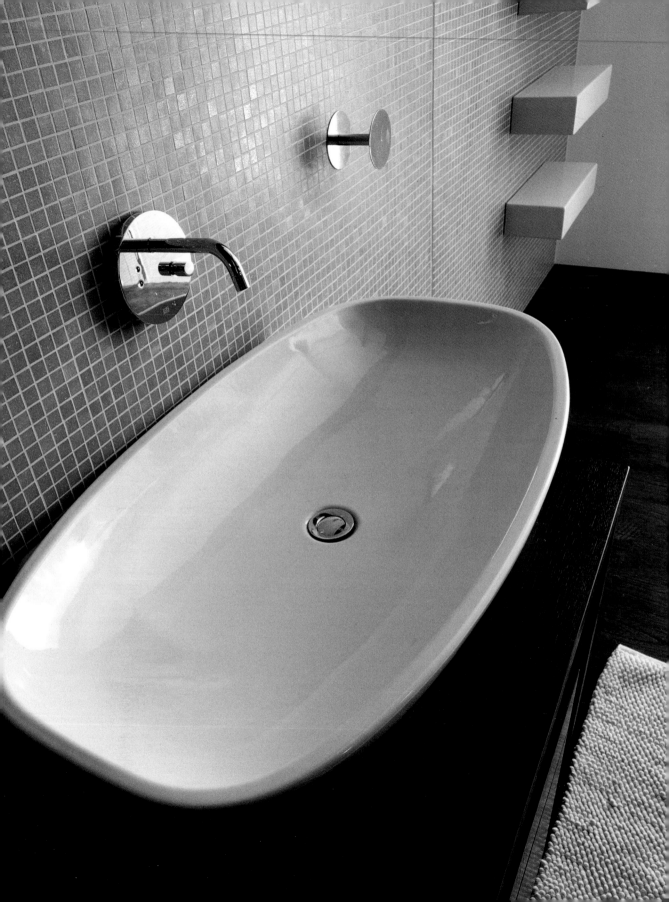

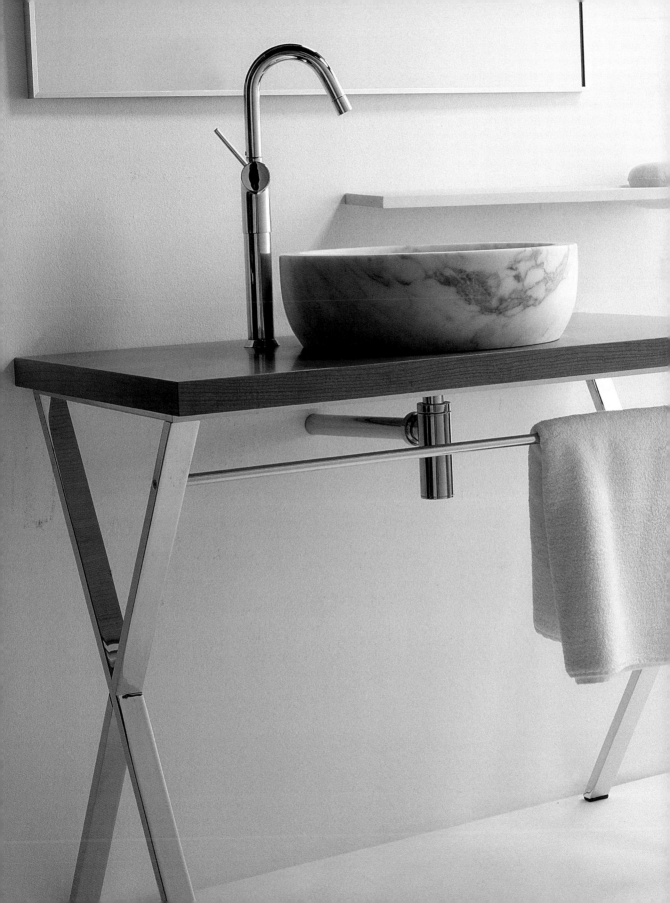

Design by Philippe Starck for Duravit

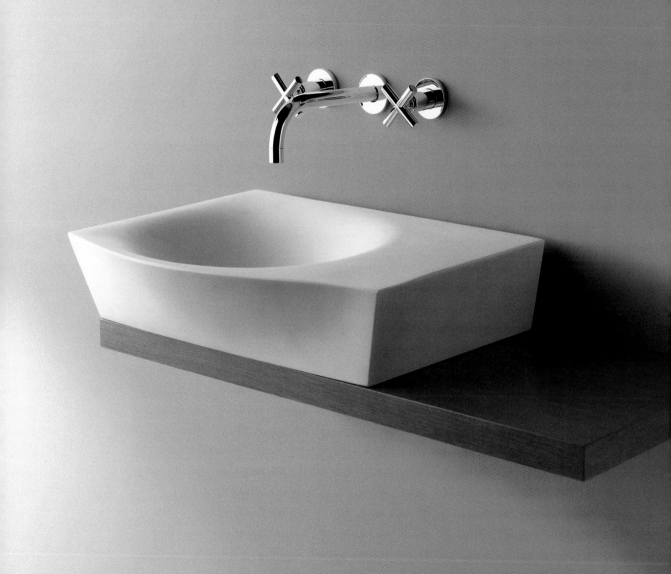

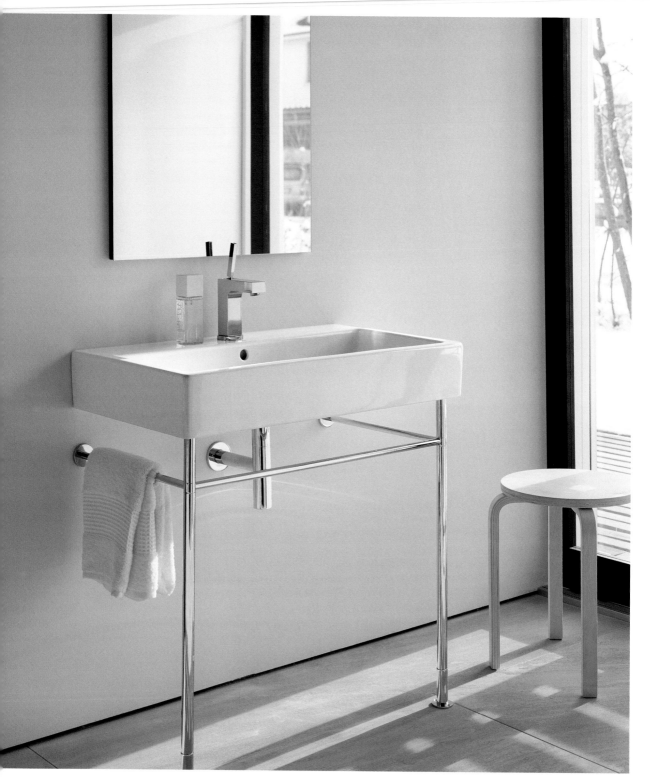

Vero by Duravit

by Sanico

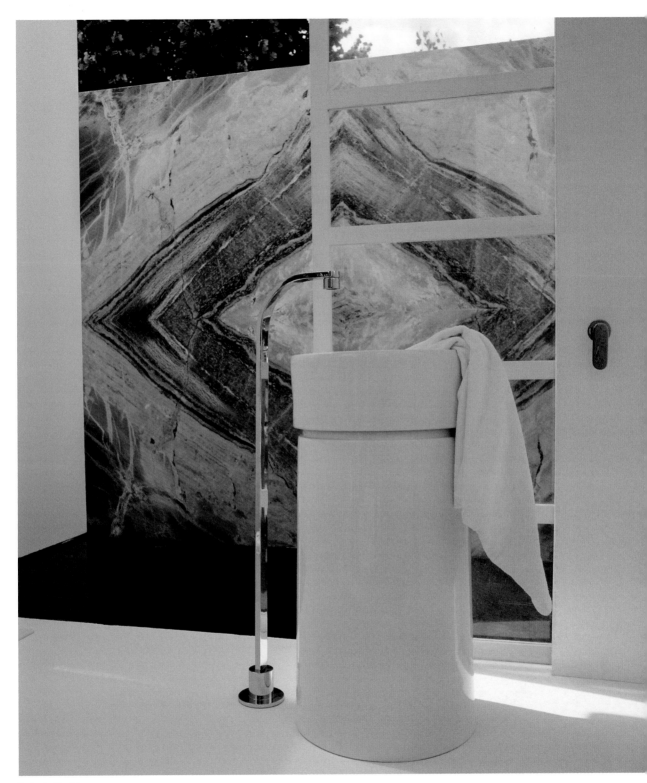

Design by Flaminia

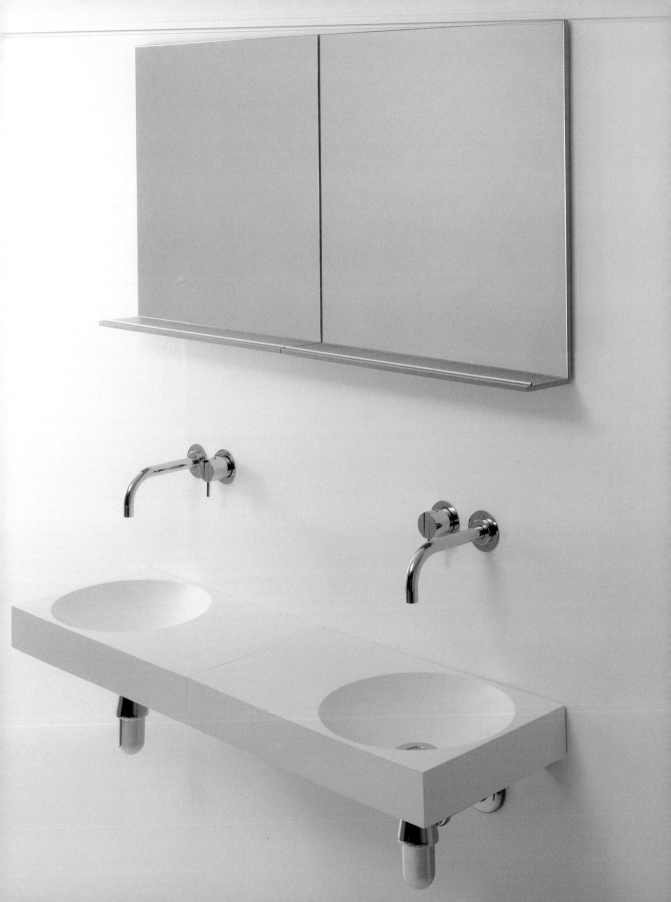

Toilets and bidets

Design by Stephen Varady Architectu
Photo © Stephen Vara

Today's toilets and bidets are available in a broad range of designs, materials and colors. The fixtures selected should be suitable for the design of the bathroom in which they are to be installed.

Ein großes Spektrum an Gestaltungsmöglichkeiten, Materialien und Farben kennzeichnet die aktuelle Angebotspalette von Toiletten und Bidets. Bei ihrer Auswahl ist es wichtig, den Badezimmerstil zu berücksichtigen.

Le large éventail de toilettes et bidets offre une grande variété de conceptions, matériaux et couleurs. Leur choix se fait en fonction du style de la salle de bains.

La actual oferta de inodoros y bidés se caracteriza por una ilimitada variedad de formas, materiales y colores. A la hora de elegir hay que tener en cuenta el estilo general del cuarto de baño.

L'attuale offerta di water e di bidet è caratterizzata da una vasta gamma di possibilità creative, di materiali e di colori. Nel momento della scelta è importante considerare lo stile generale del bagno.

Design by Ana Simó
Photo © Nuria Fuentes

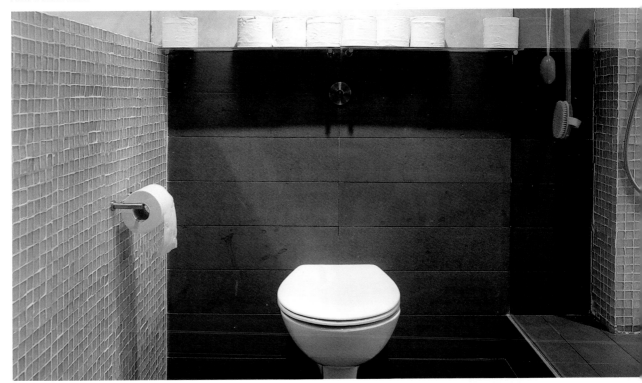

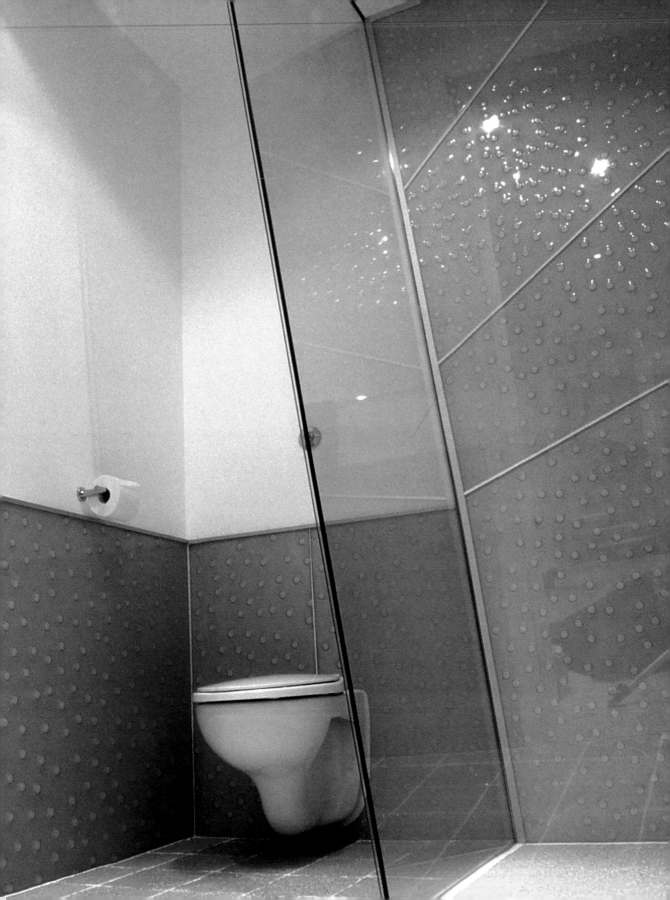

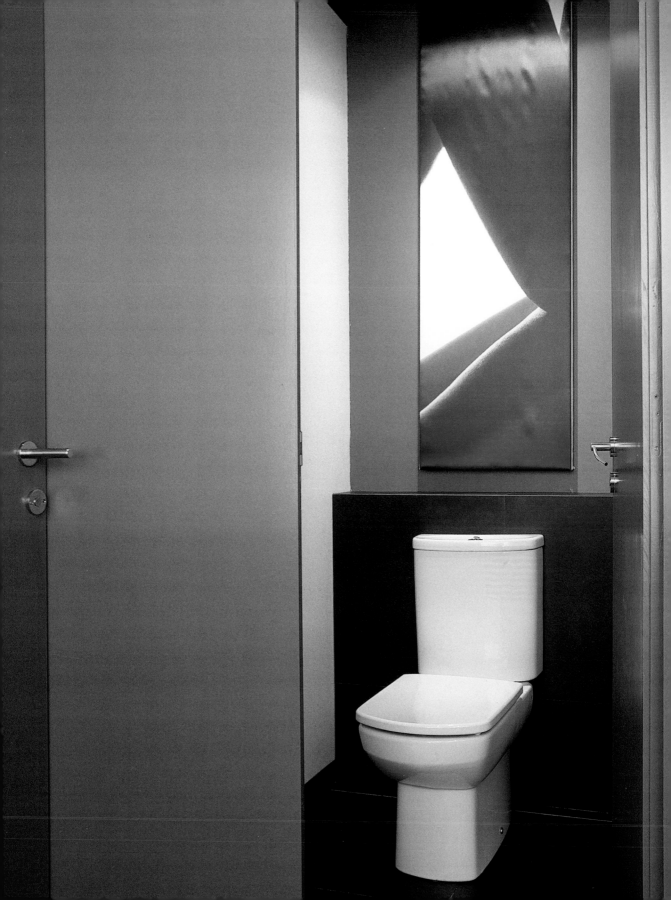

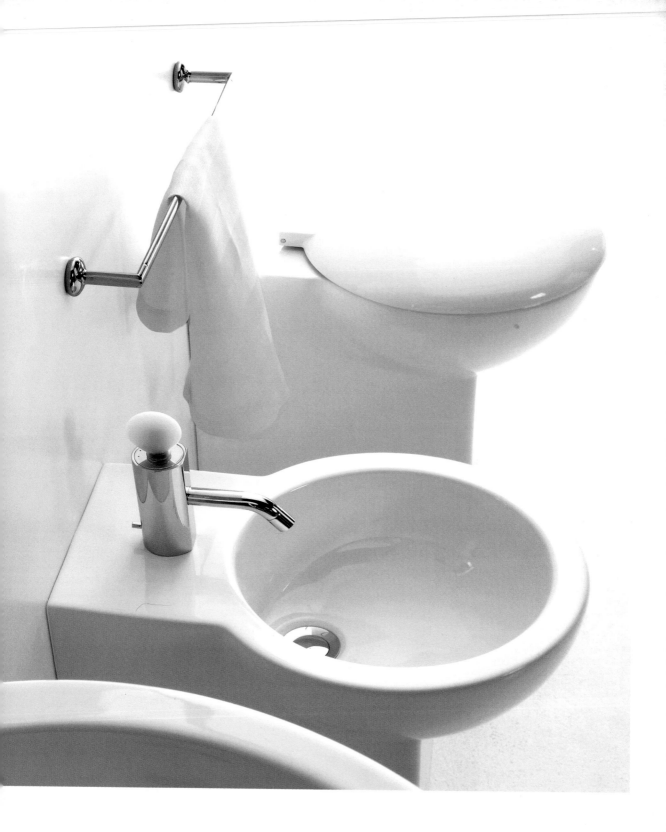

sign by A Prima
oto © Nuria Fuentes

Waterblade by Peter Jamieson for Ritmonio

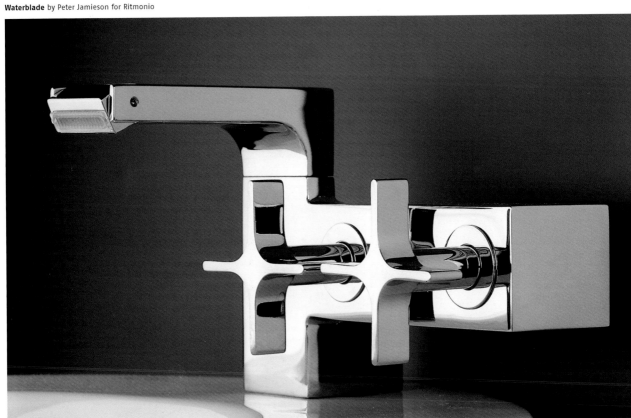

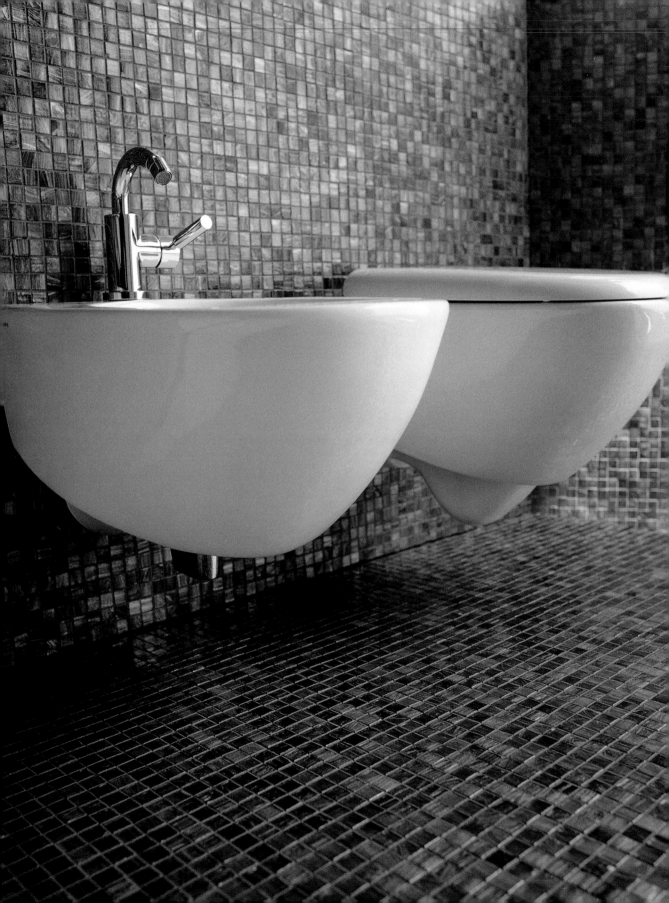

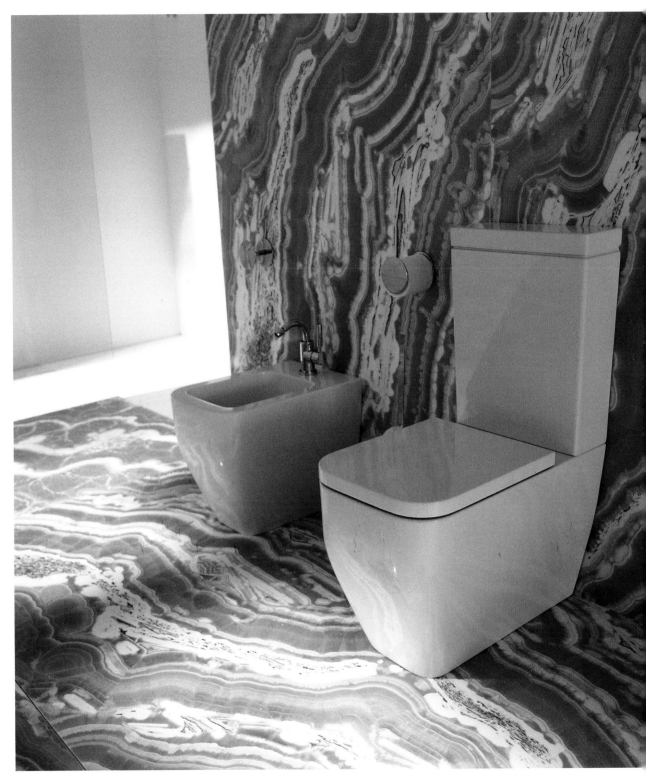

Both pages
Design by Flaminia

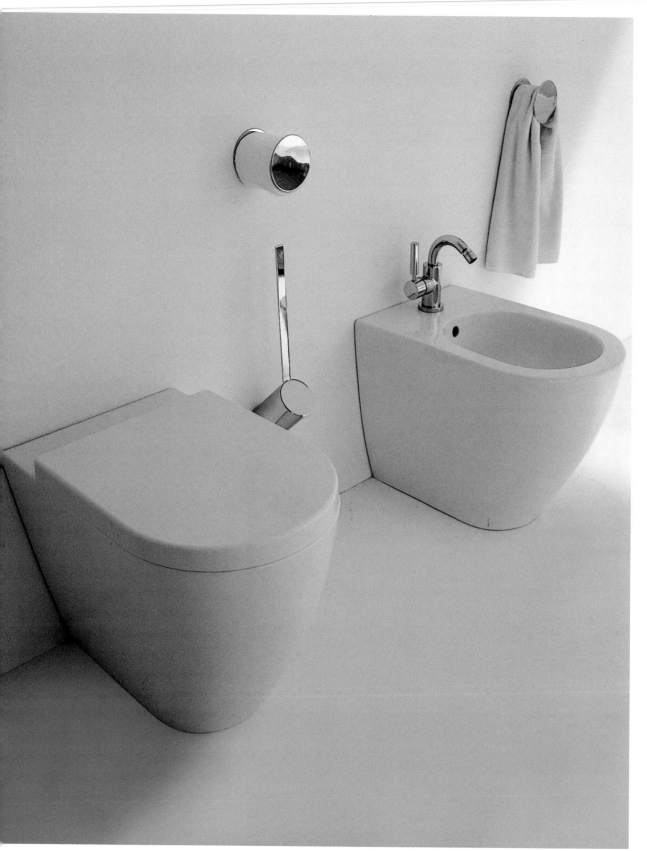

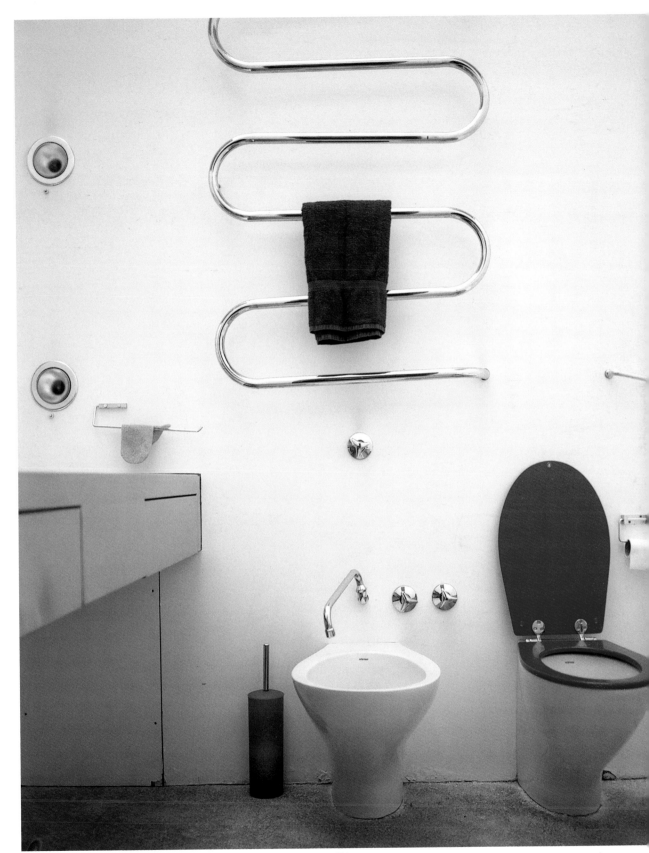

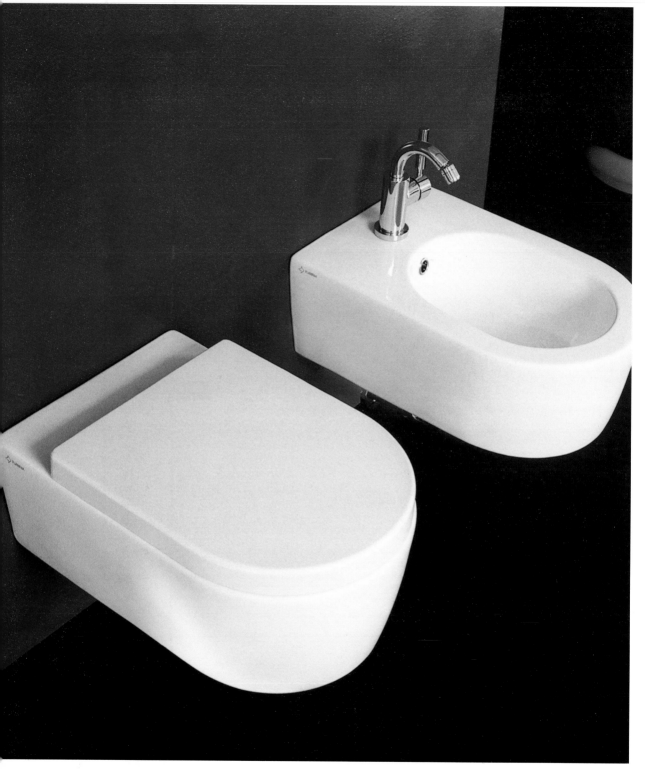

Design by Flaminia

sign by AB Rogers
oto © Winfried Heinze/Red Cover

Fixtures and accessories

Accessories such as soap dispensers, toothbrush mugs, mirrors, and shelving are indispensable for defining a bathroom's design and lend these rooms a distinctive decorative flair.

Accessoires, wie zum Beispiel Seifenspender, Zahnputzbecher, Spiegel und Regale sind unabdingbar für die Definition des Stils eines Badezimmers und geben ihm seine entscheidende dekorative Note.

Les accessoires, à l'instar de distributeurs de savon, verres à dent, miroirs et étagères, déterminent le style d'une salle de bains et la parent d'une touche décorative finale.

Los accesorios como, por ejemplo, el dispensador de jabón, el vaso de los cepillos dentales, el espejo y las estanterías determinan el estilo de un cuarto de baño, ya que se encargan de poner la nota decorativa.

Gli accessori, come ad esempio gli erogatori di sapone, i bicchieri portaspazzolino, gli specchi e le mensole, sono essenziali per definire lo stile di un bagno, conferendogli la nota decorativa decisiva.

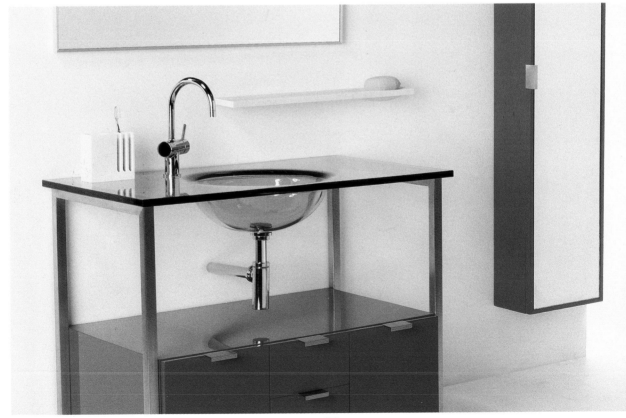

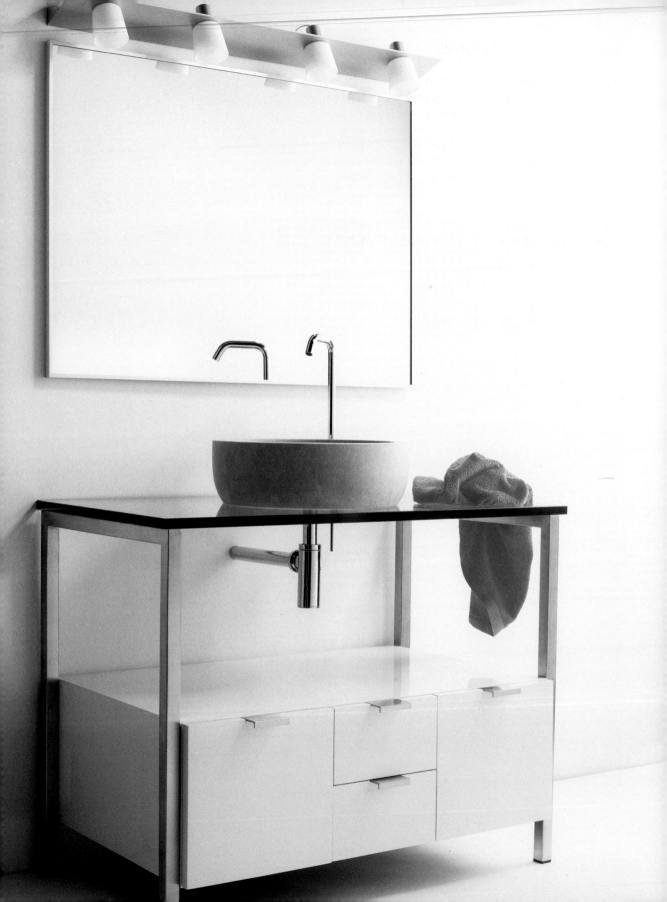

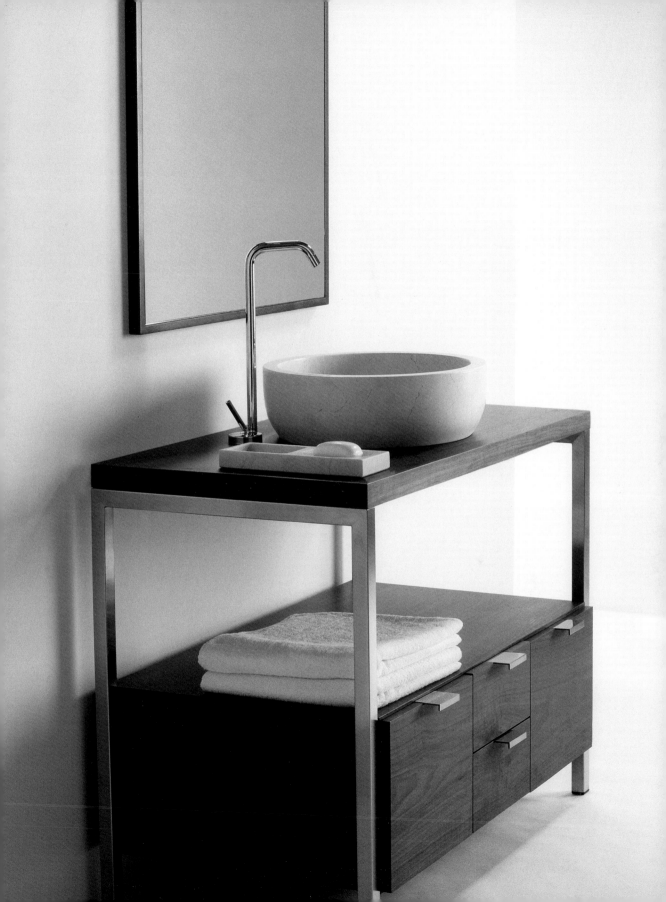

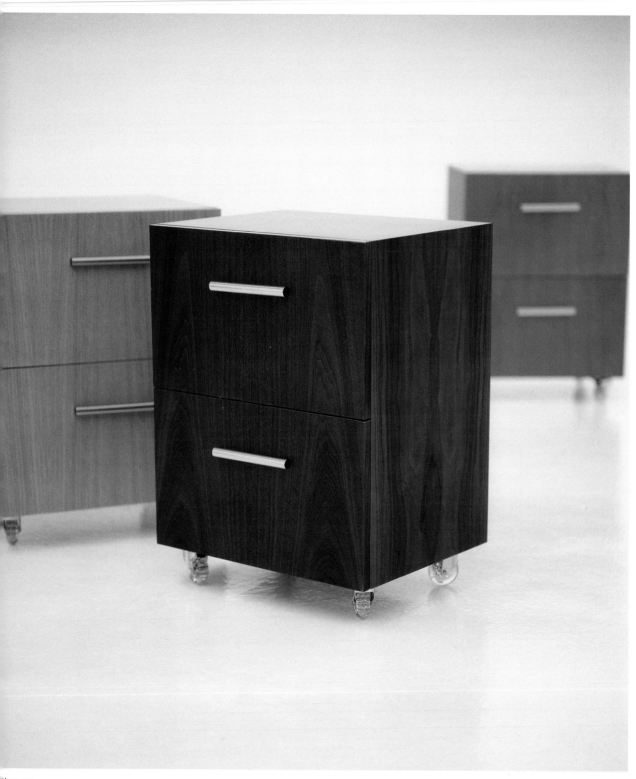

h pages
ɔana by Sanico

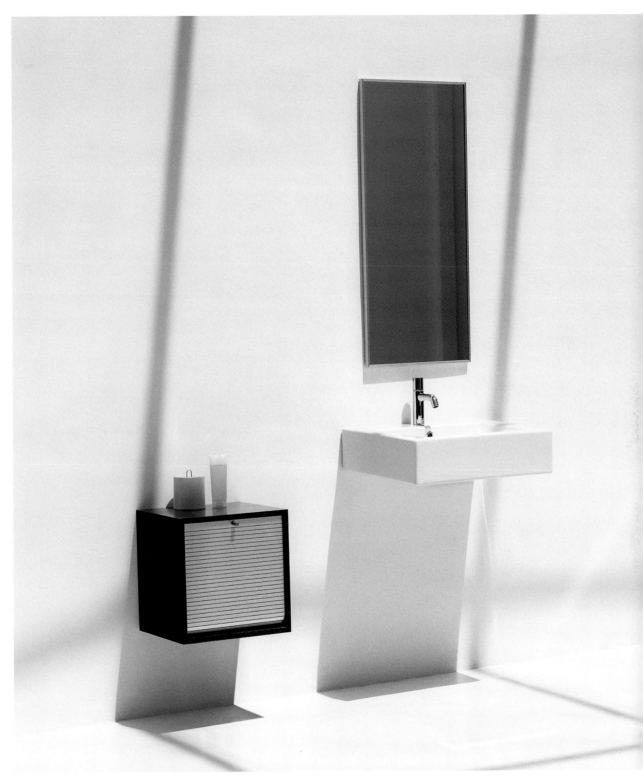

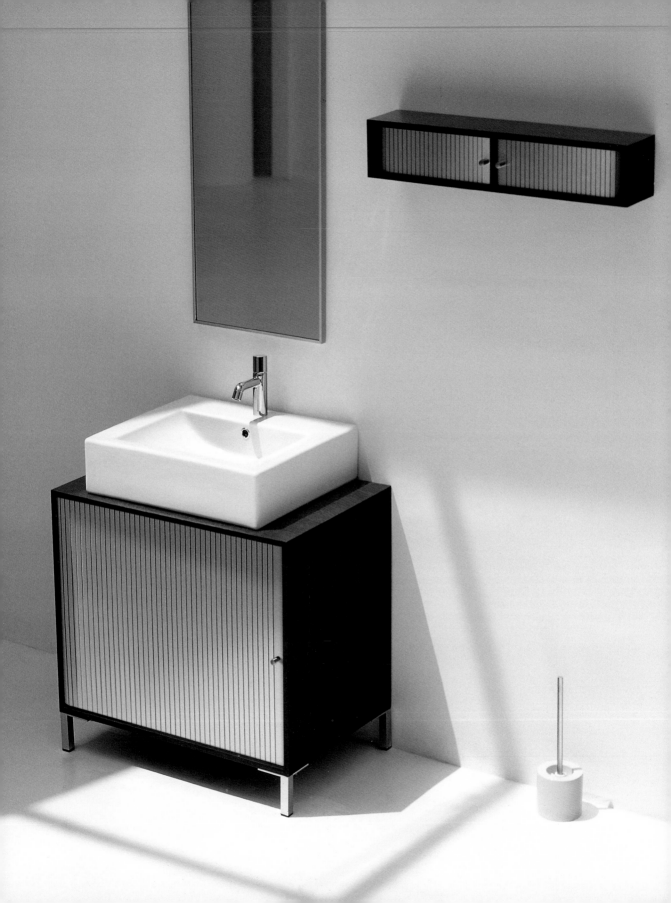

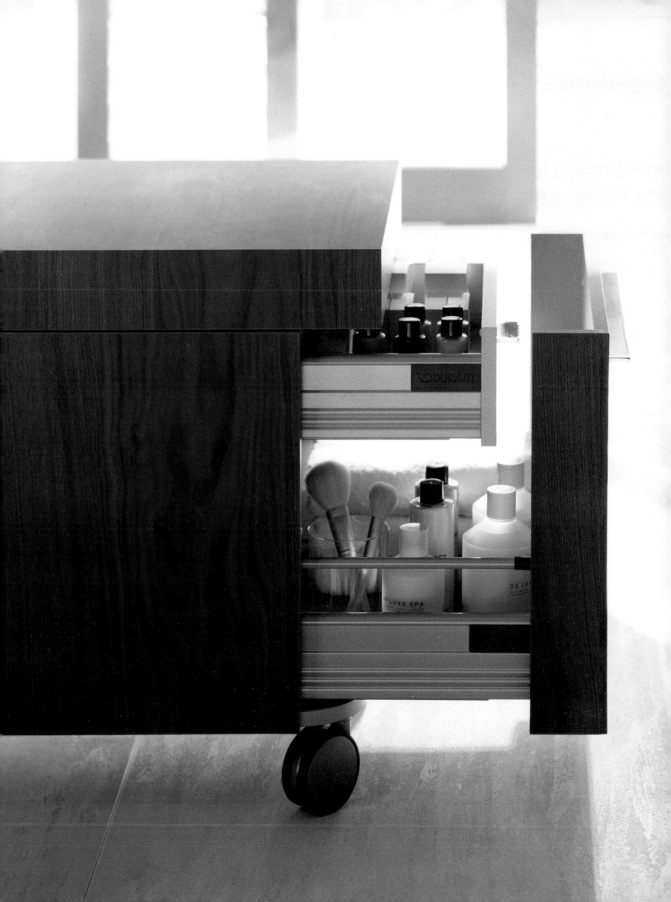

Tango by Sanico

Both pages
Habana by Sanico

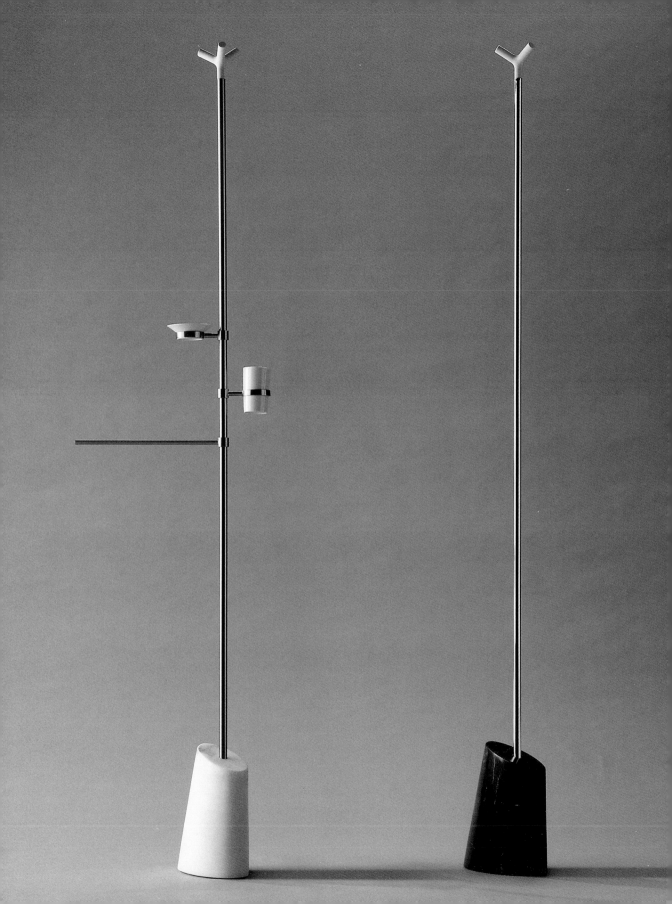

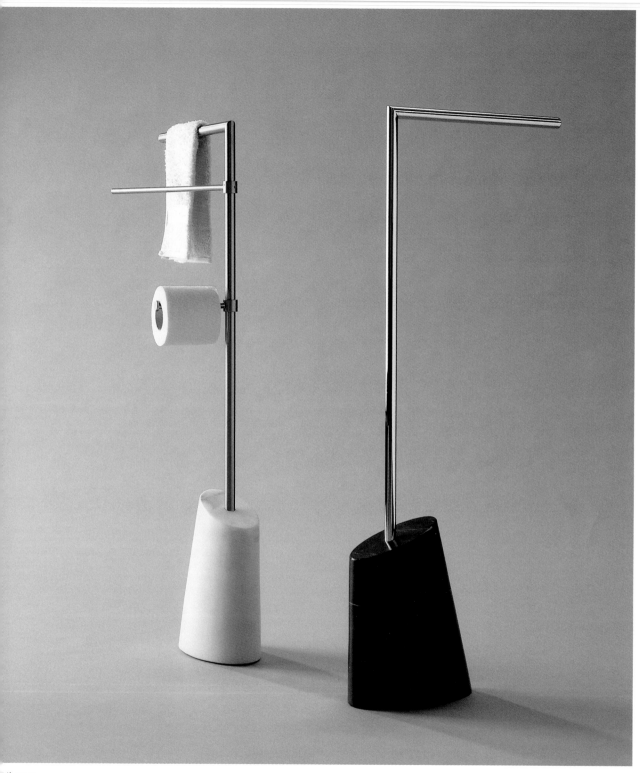

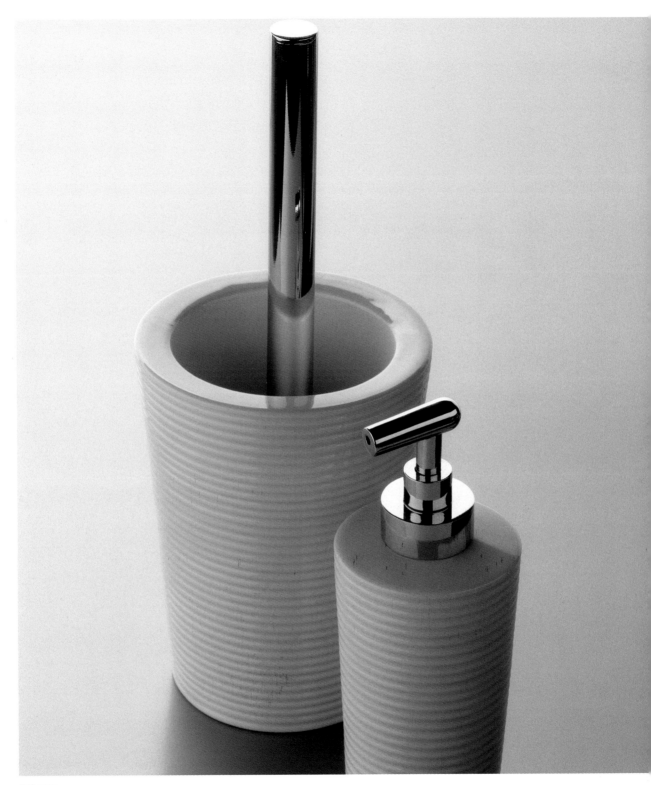

Both pages
Duo by Sanico

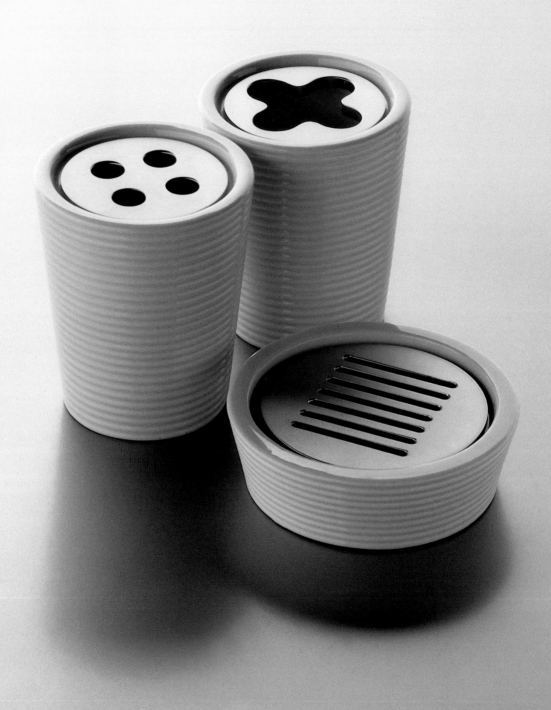

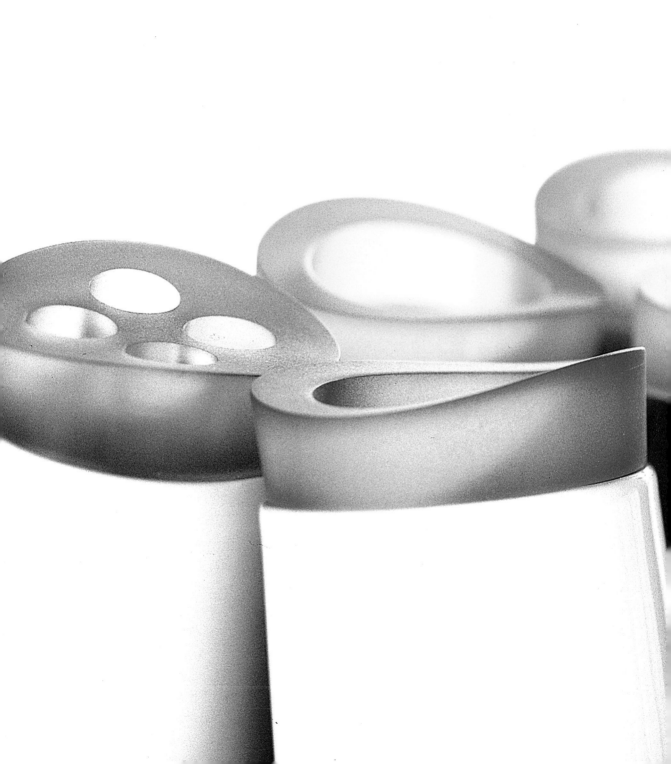

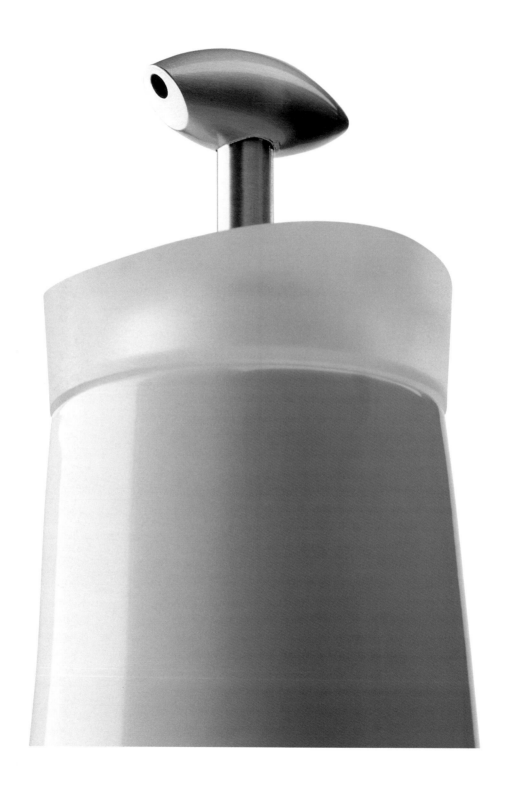

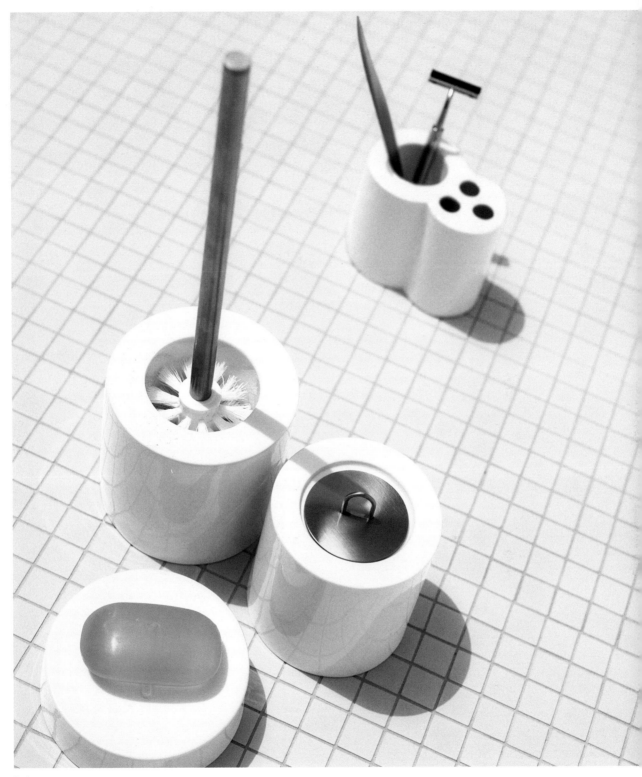

Both pages
Equis by Sanico

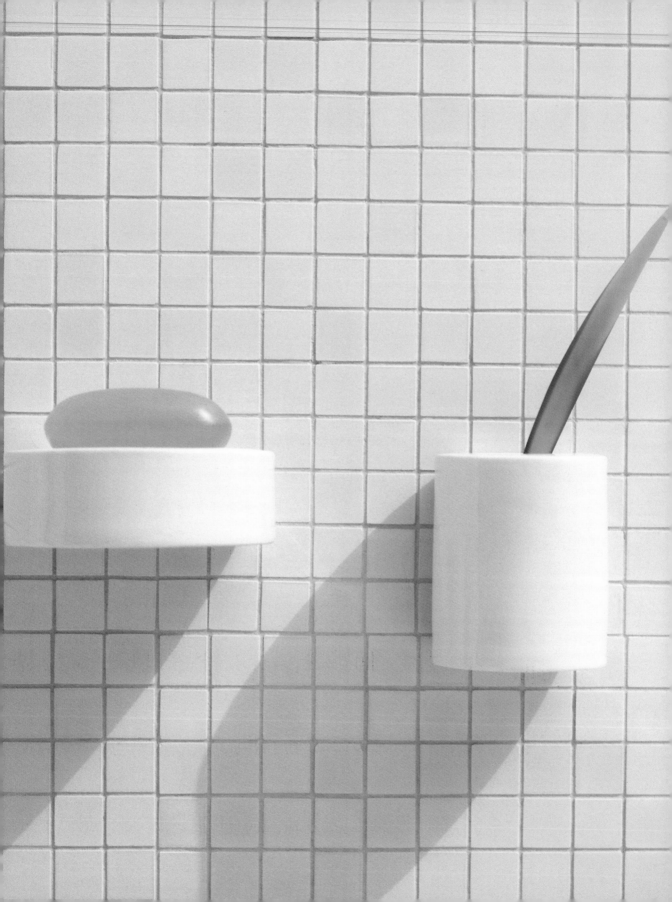

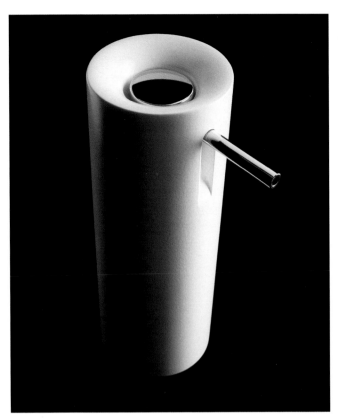

Both pages
City by Sanico

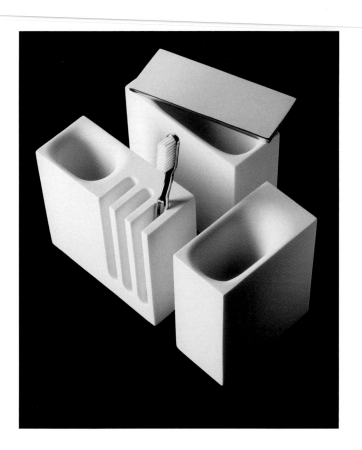

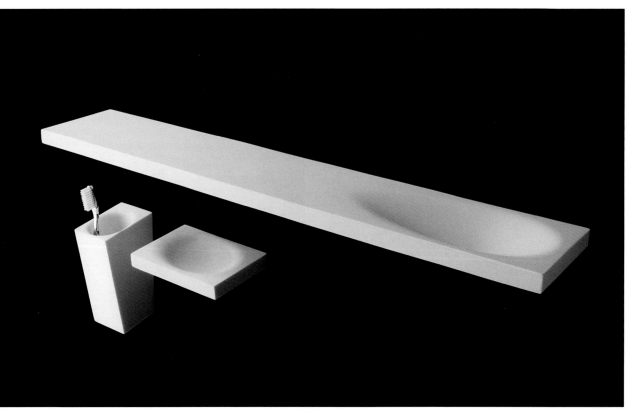

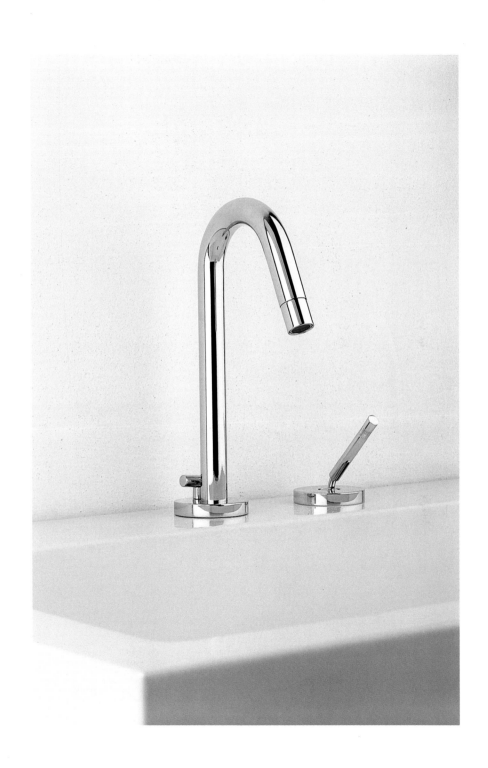

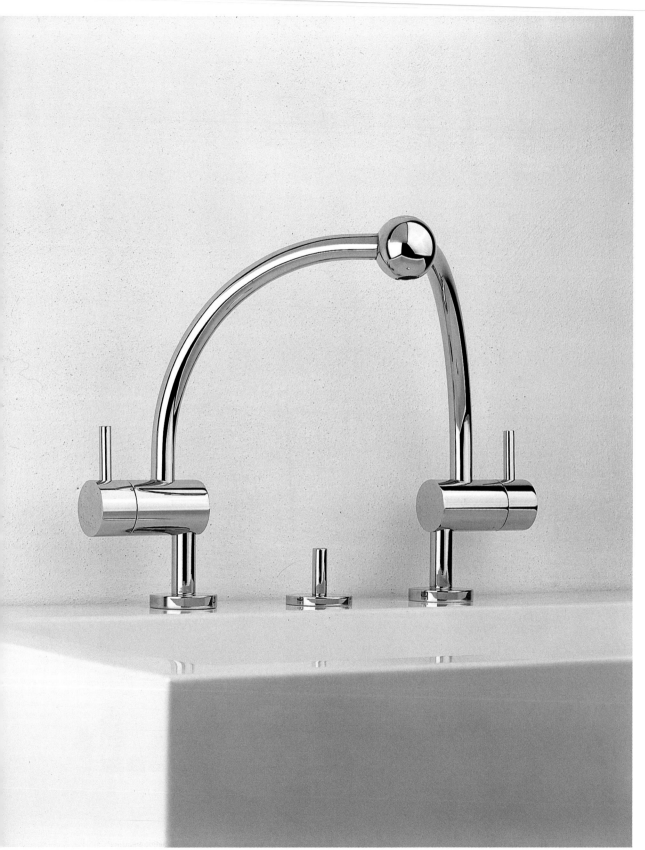

Design by Boffi
Photo © Duilio Bitetto

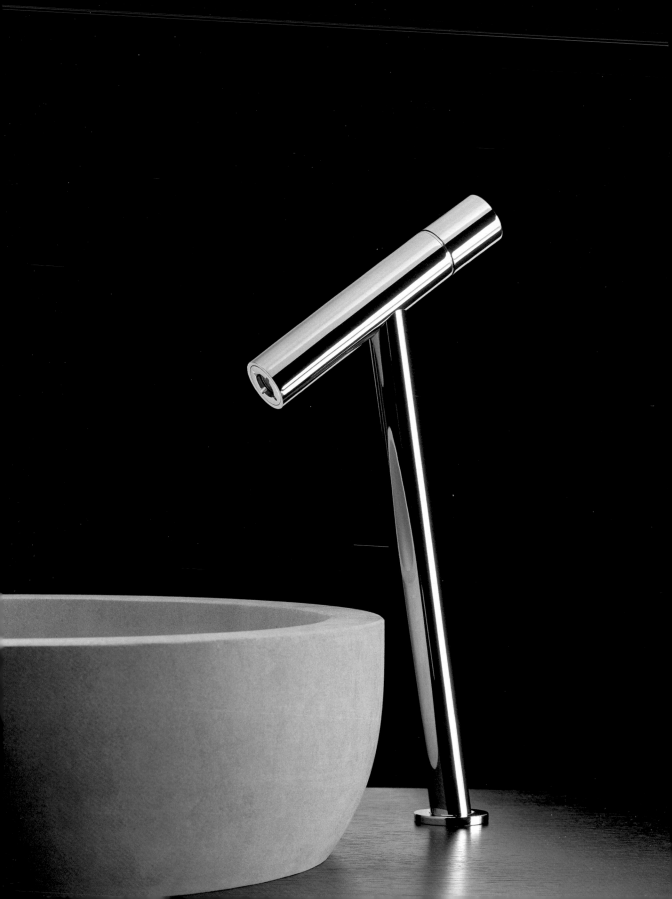

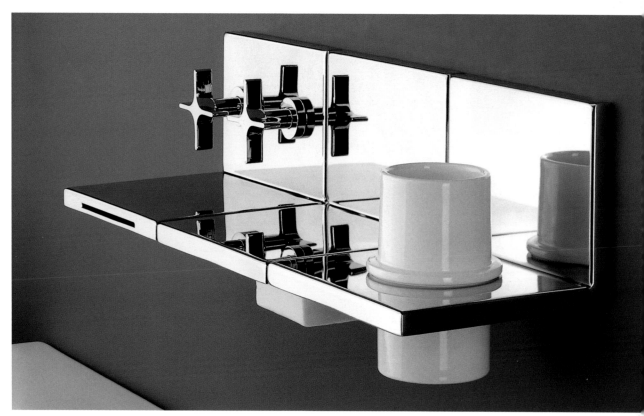

Both pages
Waterblade by Peter Jamieson for Ritmonio

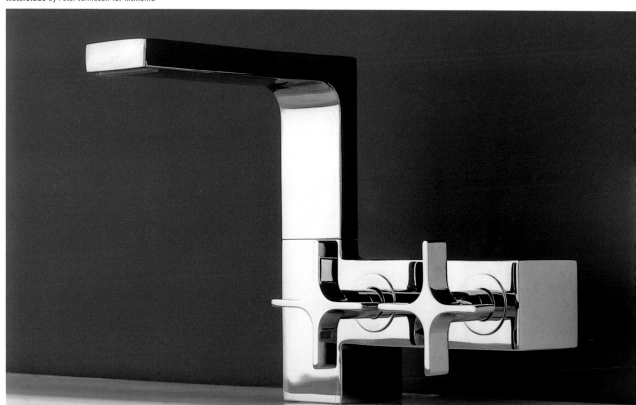

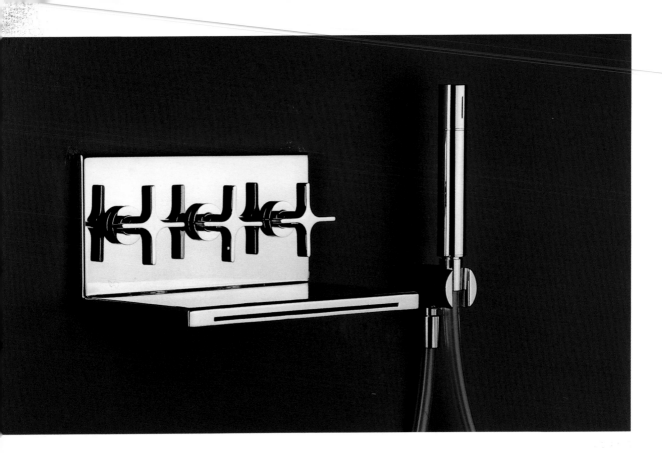

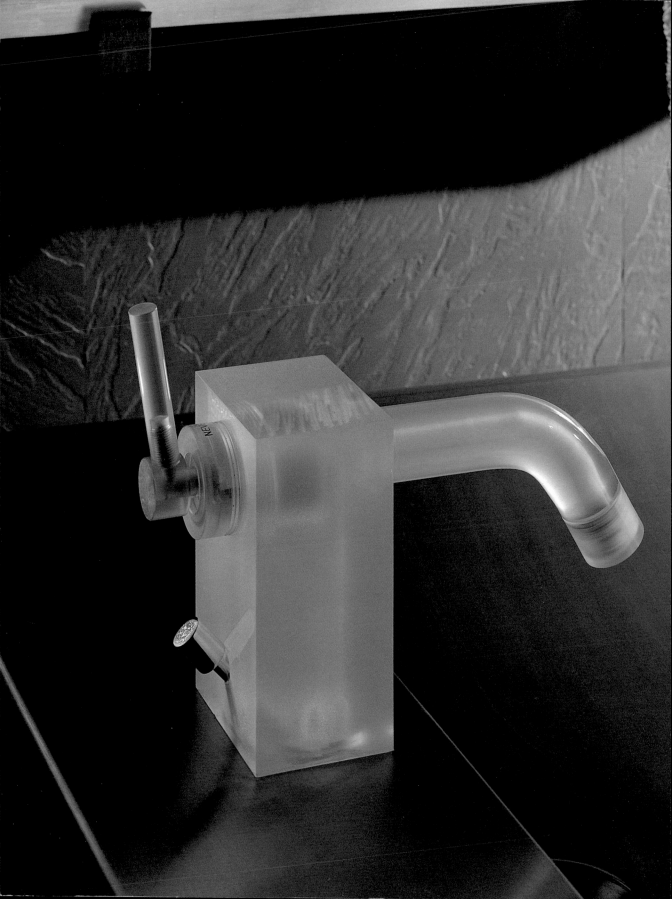

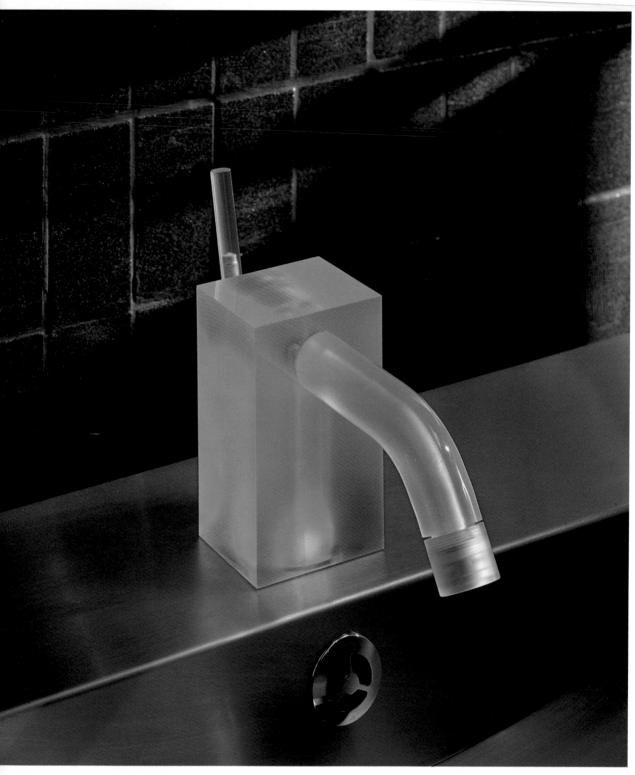

th pages

sign by Trentino

DIRECTORY

Althea Ceramica: **www.altheaceramica.com**

Boffi: **www.boffi.com**

Cesana: **www.cesana.it**

Dornbracht: **www.dornbracht.com**

Duravit: **www.duravit.com**

Falper: **www.falper.it**

Flaminia: **www.ceramicaflaminia.it**

Hansgrohe: **www.hansgrohe.com**

Hoesch Design: **www.hoesch.de**

Puntmobles: **www.puntmobles.es**

Rapsel: **www.rapsel.com**

Ritmonio: **www.ritmonio.com**

Sanico: **www.sanico.es**

Trentino: **www.trentino.es**

Design by Gary Chang–Edge Design Institute
Photo © Satoshi Asakawa, Howard Chang, Gary Cha

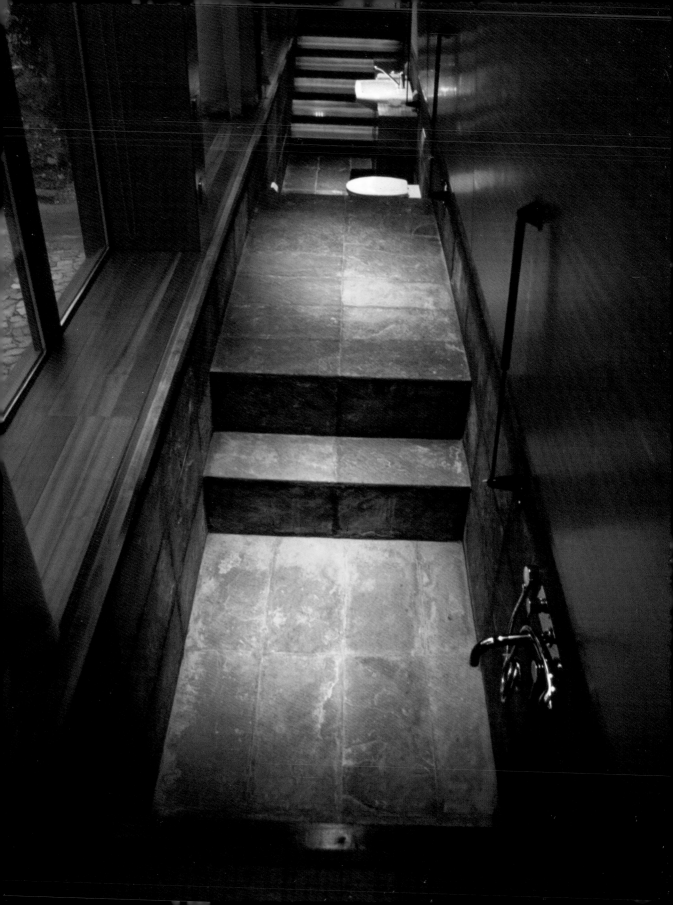